CAUGHT BY POLITICS

Studies in European Culture and History

edited by

Eric D. Weitz and Jack Zipes
University of Minnesota

Since the fall of the Berlin Wall and the collapse of communism, the very meaning of Europe has been opened up and is in the process of being redefined. European states and societies are wrestling with the expansion of NATO and the European Union and with new streams of immigration, while a renewed and reinvigorated cultural engagement has emerged between East and West. But the fast-paced transformations of the last fifteen years also have deeper historical roots. The reconfiguring of contemporary Europe is entwined with the cataclysmic events of the twentieth century, two world wars and the Holocaust, and with the processes of modernity that, since the eighteenth century, have shaped Europe and its engagement with the rest of the world.

Studies in European Culture and History is dedicated to publishing books that explore major issues in Europe's past and present from a wide variety of disciplinary perspectives. The works in the series are interdisciplinary; they focus on culture and society and deal with significant developments in Western and Eastern Europe from the eighteenth century to the present within a social historical context. With its broad span of topics, geography, and chronology, the series aims to publish the most interesting and innovative work on modern Europe.

Published by Palgrave Macmillan:

Fascism and Neofascism: Critical Writings on the Radical Right in Europe
by Eric Weitz

Fictive Theories: Towards a Deconstructive and Utopian Political Imagination
by Susan McManus

German-Jewish Literature in the Wake of the Holocaust: Grete Weil, Ruth Klüger, and the Politics of Address
by Pascale Bos

Turkish Turn in Contemporary German Literature: Toward a New Critical Grammar of Migration
by Leslie Adelson

Terror and the Sublime in Art and Critical Theory: From Auschwitz to Hiroshima to September 11
by Gene Ray

Transformations of the New Germany
edited by Ruth Starkman

Caught by Politics: Hitler Exiles and American Visual Culture
edited by Sabine Eckmann and Lutz Koepnick

Legacies of Modernism: Art and Politics in Northern Europe, 1890–1950
edited by Patrizia C. McBride, Richard W. McCormick, and Monika Zagar

CAUGHT BY POLITICS

HITLER EXILES AND AMERICAN VISUAL CULTURE

EDITED BY

SABINE ECKMANN AND LUTZ KOEPNICK

CAUGHT BY POLITICS
© Sabine Eckmann and Lutz Koepnick, 2007.

First published in 2007 by
PALGRAVE MACMILLAN™
175 Fifth Avenue, New York, N.Y. 10010 and
Houndmills, Basingstoke, Hampshire, England RG21 6XS
Companies and representatives throughout the world.

PALGRAVE MACMILLAN is the global academic imprint of the Palgrave Macmillan division of St. Martin's Press, LLC and of Palgrave Macmillan Ltd. Macmillan® is a registered trademark in the United States, United Kingdom and other countries. Palgrave is a registered trademark in the European Union and other countries.

ISBN-13: 978–1–4039–7488–4
ISBN-10: 1–4039–7488–8

Library of Congress Cataloging-in-Publication Data

 Caught by politics: Hitler exiles and American visual culture / eds. Sabine Eckmann and Lutz Koepnick.
 p. cm.—(Studies in European culture and history)
 Includes bibliographical references and index.
 ISBN 1–4039–7488–8 (alk. paper)
 1. Arts, American—20th century. 2. Modernism (Art)—United States. 3. Expatriate artists—United States. 4. Artists—Europe. I. Eckmann, Sabine. II. Koepnick, Lutz P. (Lutz Peter)

NX504.C38 2007
700.86'91—dc22 2006051377

A catalogue record for this book is available from the British Library.

Design by Newgen Imaging Systems (P) Ltd., Chennai, India.

First edition: January 2007

10 9 8 7 6 5 4 3 2 1

Printed in the United States of America.

CONTENTS

LIST OF ILLUSTRATIONS

ACKNOWLEDGMENTS

The idea for this anthology originated during a lecture series held at Washington University in St. Louis in spring 2001. We are indebted to the contributors of this volume for their engaging reflections on the exile of European artists, filmmakers, architects, and designers in the United States. Special thanks also to Gerd Gemünden, Martin Jay, Mike Lützeler, and Jonathan Petropoulos for their lectures during the initial program. We are grateful for the institutional support we received from the following units at Washington University: the Sam Fox School of Design and Visual Arts; the College of Arts and Sciences, in particular Edward Macias, Executive Vice Chancellor and Dean of Arts and Sciences; the Mildred Lane Kemper Art Museum; the Department of Germanic Languages and Literatures; the Department of Art History and Archaeology; the Committee on Comparative Literature; the Department of English; and the Department of History. We also appreciate the generous funds we received from the Deutscher Akademischer Austauschdienst (DAAD), the German General Consulate of Chicago, the American Council on Germany, and the St. Louis Holocaust Museum and Learning Center.

Rachel Keith provided invaluable help in preparing this book and its illustrations for publication. Thanks also to Sara Hignite, Jane Neidhardt, Stephanie Parrish, and Kimberly Singer for their support during earlier stages of the project. Peter Latta of the Filmmuseum Berlin—Stiftung Deutsche Kinemathek assisted in gathering various of the illustrations for this volume. Last but not least, we would like to express our gratitude to our series editors Eric Weitz and Jack Zipes, and to Farideh Koohi-Kamali and Julia Cohen at Palgrave for their enthusiasm about and open-minded support of this volume.

Introduction: Caught by Politics

Sabine Eckmann and Lutz Koepnick

I

The story has been told many times over, largely following one and the same model. An aspiring modernist artist gets caught in the web of Nazi persecution, not because of his or her political convictions but because of the Nazis' hostility toward modernist experimentation and aesthetic self-reflexivity. In order to avoid the censorship of modernism, our artist either adapts a rather moderate artistic style or chooses the path of exile to escape future violence. The streams of forced and voluntary dislocation are manifold: they crisscross the maps of unoccupied Europe as much as those of the New World, Asia, and even Australia. Repeatedly, however, we find our artist stranded at either coast of North America, a nation that was initially largely ignorant of what happened on the other side of the Atlantic, yet later became one of the principle powers in overthrowing Hitler's reign of terror.

But things, so our story continues, do not necessarily change for the better for our artist when trying to resume his or her artistic practice among New York skyscrapers, amid the Great Plains, or under California palm trees. The exile artists who lived in the United States in the 1930s and 1940s experienced U.S. society as one that was blatantly dedicated to the production of mass cultural goods, the standardization of aesthetic pleasures, the pursuit of figurative art, and the search for an endemic national style. America might be obsessed with modernity and the circulation of moving images, but it has little tolerance for the intricacies of European tastes and cultural expressions, let alone for the enigmatic codes of modernist art and aesthetic theory. Unable to translate the artistic language of the past into a viable idiom for the present, our artist thus encounters the state of exile as one of multiple dislocation and ongoing blockage (figure I.1). Existential survival in the New World seems possible only by doing what the Nazis wanted our modernist artist to do all along: to abandon modernism's foray

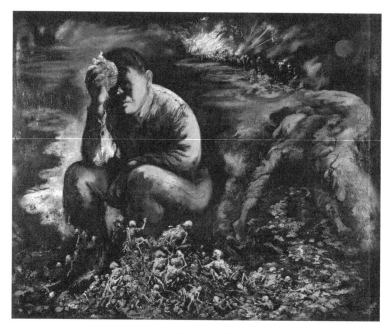

Figure I.1 George Grosz, *Cain or Hitler in Hell* (1945). Oil on canvas, 39 × 49".
George Grosz estate. Image courtesy of Museum Associates / Los Angeles County
Museum of Art. © Estate of George Grosz / Licensed by VAGA, New York.

into the abstract or nonfigurative. On the one hand, artists working in the
fields of design and film had to renounce the separation of the aesthetic
from other spheres of social action and had to redefine art as a repository of
practical meanings offering something for everyone and serving the needs
of the corporate world. On the other hand, artists operating within the
institutions of so-called high arts had to understand their practice of mod-
ernism as one detached not only from politics but also from all other realms
of society. The alienating and isolating character of modernity imagined in
Old World modernism was now encountered as a precondition in order to
practice modern art and participate in the American art world. In the face
of a present that is not so much different than what was left behind, in the
end our Hitler refugee experiences his or her American exile as a site of
painful inauthenticity. American culture around 1940 corrupts the
resources of personal creativity as much as it depraves the overall project of
modernist innovation. What is left for our artist to do, so the story con-
cludes, is either to make devastating compromises with the banality of the

new host culture or to embrace strategies of hibernation that allow both the artist's self and the prospects of modernism to outlast the combined damage of Nazi persecution, American mass culture, and an art world largely ignorant and even hostile toward exile.

Theodor W. Adorno, who emigrated to the United States in 1938 after a four-year sojourn in Great Britain, has given this story of multiple exile its no doubt most uncompromising and pessimistic formulation. Though part of the influential community of German and European exiles in Los Angeles, Adorno experienced his host country as void of cultural sensibilities and creative energies. Industrial culture here had rendered impossible the notion of art as a source of aesthetic negation, critique, and self-transformation. American mass culture fused popular tastes and remnants of European high art into user-friendly product packages. The logic of Fordist standardization dominated all aspects of cultural production and exchange to such an extent that no authentic response could be expected from anyone: "The most intimate reactions of human beings have been so thoroughly reified that the idea of anything specific to themselves now persists only as an utterly abstract notion: personality scarcely signifies anything more than shining white teeth and freedom from body odor and emotions."[1] Under these conditions, neither art in general nor modernist aesthetic practice in particular were able to thrive. For both were essentially tied to the idea of resisting automatized and predigested modes of reception; both hoped to speak in the name of the particular and incommensurable, of that which cannot be subsumed under a dominant logic of administering the world. By contrast, in its efforts to erase specificity, difference, and personality, American mass culture for Adorno turned out to be quite similar to German fascism, with the only principle distinction that the latter disciplined people's minds and emotions in the name of totalitarian politics, whereas the former did so in order to allow the market to radiate triumphant. Hitler exiles in America could therefore not hope to find a new home for themselves and for their modernist sensibilities. The best mode of conduct for the exile and his or her aesthetic vision was a suspended and uncommitted one, one that refused to entertain fantasies of being at home neither in one's American apartment or house nor even in the very idea of being a dispelled and displaced person. The exile's wrong life, as Adorno claimed in the most memorable sentence of *Minima Moralia*, cannot be lived rightly.[2] So disastrous are the consequences of living an exile's life in America that one must even abstain from seeing the traumatic change that takes place at the heart of one's own identity.

Adorno's desperate perspective has informed much of the writing on the fate of Hitler refugees in the United States: that is, the thousands of intellectuals, artists, writers, musicians, and filmmakers who left Europe in the

course of the 1930s in order to save their careers, moralities, and aesthetics from Nazi persecution. Accordingly, we have come to know the story of German and European exiles in America as one of loss, mourning, rupture, and inauthenticity; one in which gifted artists, especially those of Jewish descent as well as those actively engaged in political resistance, and daring modernists were either corrupted by the workings of industrial mass culture, overwhelmed by the dominance of populist American aesthetic tastes, or driven into self-destructive silence; one that bereaved the exiled subject of its most cherished means of self-expression and self-realization, its aesthetic vision, its precise language, its self-assured brushstroke; one that locked the exile into claustrophobic and melancholy theaters of the mind endlessly repeating the hopes of the past, yet unconnected to whatever could reinscribe these hopes in the present or prolong them into the future; and finally one that shipwrecked the prospects of aesthetic modernism, ran it aground between the Scylla of the total commodification of cultural materials in the United States and the Charybdis of the Nazis' totalitarian attacks on anything other than legible, popular, and monumentalist art.

Though *Caught by Politics* does not ignore the hardship of forced migration, this book seeks to complicate Adorno's bleak perspective. Our principal aim is to reveal the extent to which the paths of many European visual artists, architects, filmmakers, and film actors to the United States was driven by what Edward W. Said has called the contrapuntal dimension of exile: the way in which experiences of loss cause exiles to become inventive, creative, mobile, and resourceful, to negotiate a plurality of competing visions, experiences, and memories rather than merely to cling to static recollections of the past.[3] As recalled in the following study, the narrative of exile was not simply a story of traumatic loss and immobilizing discontinuity. In addition, it catalyzed certain artistic breakthroughs and much anticipated cultural transactions. While this book is far from denying the damage done to the personal lives and aesthetic aspirations of the exiles, it seeks to shed light on how forced emigration for some became a springboard for productive negotiations and ironic cultural masquerades, for symbolic mingling and performative hybridization, for individual transformation and historical self-redress. In some cases, in fact, the experience of exile, rather than plunging creative individuals into the pits of cultural banality, turned them into modernists in the first place, modernism here being understood as an aesthetic practice reckoning with the fundamental discontinuities, ruptures, contingencies, and temporariness of human existence in modernity. In contradistinction to Adorno's pessimism, what this book argues is that the exile's damaged life, far from burying the very prospect of modernist aesthetic practice, provided all kinds of resources—voluntarily or not—to rethink, to recalibrate, or to rediscover the diverse paths of European

modernism, including its relationship to other spheres of life and value. Adorno may have been right to claim that the exile's wrong life could not be lived rightly. But in recalling how various artists, architects, and film practitioners explored the forced displacement of individual lives and symbolic materials as a font of cultural productivity, this book hopes to complicate not simply the common image of the exile's damages, but also of the transatlantic voyages of modernism after 1930.

When investigating the vicissitudes of twentieth-century modernism, art historians today continue to understand the exilic production of German and European artists, intellectuals, and filmmakers as a decisive interruption of European modernism and therefore they marginalize these works in their accounts. The focus of *Caught by Politics*, by contrast, is on how modernism changed under the condition of exile and how the works of certain exiles allow us to come to a new understanding of the relationship between modernism and modernity during the 1930s and 1940s. Whereas many accounts continue to define modernism in strict opposition to the rise of both modern mass culture and political avant-gardism, as explored in this book, the narratives of exile artists and filmmakers in the United States give cause to develop more inclusive notions of aesthetic modernism in which mass cultural elements go hand in hand with different avant-garde sensibilities, competing political involvements, and opposing national narratives. The effort of tracing the paths of Hitler exiles and exploring the contrapuntal dimensions of forced displacement in the chapters of this book thus also serves the purpose of exposing the differential and unfixed structure of modernist culture itself and thereby of arguing against the more recent conception, and postmodern denigration, of modernism as unified, homogenous, and inherently totalitarian.[4]

The juxtaposition of visual artists, architects, and filmmakers in this volume is therefore far from accidental: it is systematic. Informed by normative distinctions between (good) autonomous art and modernist experimentation on the one hand, and on the other (bad) politically activist art, mass culture, and commercialized entertainment, postwar scholarship by and large avoided conceptual avenues that would have done adequate justice to the intricate renegotiations of modernist culture caused by the rise of Nazi Germany and the forced dislocation of thousands of European artists and intellectuals to the United States.[5] This scholarship was neither willing to recognize the ambivalent role of modernist elements in Nazi Germany itself nor prepared to speak about the extent to which modernist visual artists as much as auteur filmmakers, already during their Weimar careers, had traded with New World images, not simply in order to further their livelihoods but also to transform their respective visual and expressive languages. For many an exile, to move to the United States meant to reach

out for what one had secretly dreamed of, or been preoccupied with, all along. The exile's new host culture was thus often encountered not as something radically foreign and other but rather as strangely familiar: an imaginary replete with utopian fantasy and troubling anxieties.

In its efforts to detach autonomous art from mass cultural distraction, however, postwar scholarship has mostly been blind to this curious dynamic. Art historians read the fact of exile as a radical discontinuation of modernist sensibilities; film historians considered the relocation of creative filmmakers to Hollywood as Weimar art cinema's fall from grace; and architectural historians recalled the move of the architectural avant-garde from Europe to North America as a move of assimilation subjecting creative energies and social agendas to the demands of everyday design and commercial implementation. Though all three narratives seemed to share similar plots, they had to be kept separate in order to ensure their respective normative underpinnings. For it is precisely when considering all three narratives together that we come to realize that German and European modernism prior to Hitler and the moment of exile was already not entirely opposed to the popular, to commercial culture, and to the ever-increasing role of reproduction media; that the contrapuntal self-inventions of European exiles in the United States were quite able to infuse the much maligned American culture industry with modernist elements; and that, for this reason, we must think of the story of exile as a narrative that in the end unsettled the very distinctions postwar critics used to invoke in order to recall the trauma of exile. What damaged the exile's life was not the fact that American society in the 1930s and 1940s had little tolerance for avant-gardism and noncommercial culture. What was damaging instead was the fact that the experience of exile at once evidenced and extended a multiplicity of competing modernist projects in whose face nothing concerning the aesthetic or political implications of modern artistic works could be taken for granted anymore, including their very right to exist.

In mapping the disparate interactions between exiled artists, film practitioners, and architects and their host culture, the aim of *Caught by Politics* is to draw our attention to the fact that the paths of Hitler exiles and of European modernism in the 1930s and 1940s were inherently and productively messy affairs. Similar to the way in which German film culture already between 1929 and 1933 witnessed a potent blurring of the lines between commercial and modernist, avant-garde and industrial orientations, and in which German art saw a mingling of advanced modernism with traditional and figurative elements, so too did the fact of exile cause European artists, architects, and film practitioners, rather than to give up their modernist stances altogether, readjust their thinking about the relationship of aesthetic modernism and social modernity.[6] At times

the pressures for acculturation may have indeed led to a nostalgic fetishization of the past. In many instances, however, this need for redress produced a broader or diversified notion of modernist practice, that is, a form of popular modernism wherein the principle goal was to address and articulate the vernacular experience of modern society, a form that did not shy away from communicating painful experiences of blockage, displacement, contingency, and speechlessness.

The principle aim of *Caught by Politics*, then, is to recall the forced and voluntary transfer and transformation of European artists and art after 1930 to the United States as a story of performative self-transformation, aesthetic opportunity, and creative reorientation. Rather than recount this story as a fateful clash between the incommensurable realms of high culture and mass cultural diversion, Old and New World, aesthetic experimentation and industrial standardization, individual subjectivity and pragmatic rationality, this book describes the path of exile as one structured by unpredictable, albeit often dynamic, acts of cultural mingling. Former homes may have been lost, but new ones were also built with their windows wide open in order to indicate the temporariness, the contingency, the instability of the exile's itinerant life. But to recall the story of Hitler exiles in the United States as a story of individual self-transformation and multilateral exchange does not necessarily imply turning the exile's experience into a tale of unassailable triumphs and hence a preview of allegedly postmodern attractions. On the contrary. Though it is undeniable that exile, for some, brought the possibility of aesthetic departure and upward social mobility, exile studies must refrain from considering categories such as cultural hybridization and performative self-invention as being automatically progressive, as much of postmodern discourse would suggest. One of the consequent tasks of this volume is to reveal the involuntary moment—the syntax of blockage, violence, and painful displacement—that energized creative departures and fusions, as much as to sharpen our attention to the way in which the fact of exile forced an alternative modernism onto certain individuals rather than simply encouraging them to shed their old selves.

The exile of Hitler refugees in the United States, so our central contention, produced and participated in what we consider a second modernism: a modernism more diverse and pluralistic, and less self-assured and triumphant, than its original version; a modernism no longer eager to solve all the problems of the world with the help of rigorous and hermetic aesthetic formulae; a modernism willing to admit that failure and contingency belong as much to the experience of modernity as do the prospects of willful transformation and progress; a modernism liberated from its earlier feelings of omnipotence, its elitist visions of social reform, but still insisting that history has not yet come to an end and that the future might be able to

deliver one from the catastrophes of the past and present. It is by recalling the second modernism of European exiles after 1930 that we thus must also realize that postmodern art and theory today have often rather little to offer to address the throbbing challenges of a New World order in which global networks of command successfully manage hybrid identities, flexible hierarchies, and plural exchanges, yet leave us neither space nor time to come up with an alternative politics able to challenge the hubris of this new order. It is this second modernism that may offer an inspiring window on the location of art and the aesthetic after the failures and the increasing fading of postmodernism in our own age.

II

For those forced to live in exile, life resembles a walk through a house of mirrors where past and present face each other in endless instances of reflection. Bodies, faces, and identities appear multiplied, distorted by the power of refraction. Every move is frayed by disorientation and uncertainty; no step can be made without a kind of tentativeness as it will always remain unclear whether these probable movements carry one forward. For those finding themselves in a house of mirrors, it does not take long to see the mind playing tricks on the body or to experience puzzling disjunctions between perception, feeling, memory, and thought. Paul Gauguin's three grand questions, "Where do we come from? Who are we? Where are we going?" here quickly become routine, even though it would be futile for the visitor to think that he or she could ever discover answers as lucid as the Polynesian skies. And yet, in making us see our own perception, in making us hesitate about our next step, in surrounding us with ghostlike doubles and uncanny reflections, does not the hall of mirrors jar loose unknown insights about our normal locations in space and time? By putting us beside ourselves, does not the sight of uncanny doubles and dislocated images open a room for us to meet the unexpected, the long forgotten, the seemingly incommensurable, the new or other?

Caught by Politics recalls the path of European exiles in the United States as a journey through a house of mirrors. It not only chronicles the story of a profound dislocation and disorientation of European interwar modernism, but it also stresses the extent to which the exile's sense of confusion and uprootedness, of uncanny doubling and self-alienation, served as a source of creative experimentation, professional breakthrough, and dynamic interaction (figure I.2). While the exile's house of mirrors caused some to yearn for reified and nostalgic images of the past, it encouraged others to contest the power and trustworthiness of memory and develop alternative visions for the future. This book thus tracks the path of individual exiles

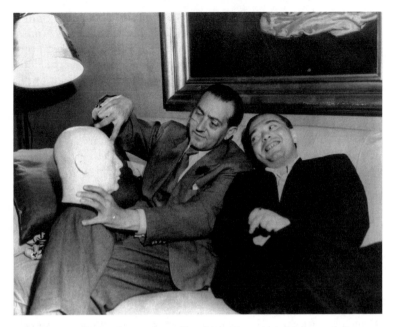

Figure I.2 Fellow Exiles Fritz Lang (l) and Peter Lorre (r) in Hollywood. Courtesy of Filmmuseum Berlin—Deutsche Kinemathek.

and European modernism in general as one between reflection and refraction, memory and future, reification and creative departure. Each chapter juxtaposes past and present, examining the extent to which the fact of migration led to some kind of dialogue with contemporary American culture and a concomitant reconfiguration of the exile's modernist agenda. While some of these chapters argue more at the biographical level, others such as Angela Miller's, Sabine Eckmann's, and Nora Alter's address the dislocation of entire artistic movements and discourses, the way in which interwar and postwar culture contested over the general impact of European exiles on American modernism and vice versa, and thus negotiated conflicted memories of the past in the present.

But due to its interdisciplinary intentions, *Caught by Politics* embraces the idea of exile as a structure of simultaneous reflection and refraction, of uncanny doubles and distorted mirror effects, also as the guiding principle of its overall architecture. Whereas the book's first part tracks the careers and itineraries of various artists and art movements, most of them associated with the realm of high art, in the second part our focus is on the exile of different architects, designers, and film practitioners whose medium of

expression is connected to a more practical, industrial, and mass cultural notion of the aesthetic. Mirroring both practices of exile in each other, *Caught by Politics* shows that the experience of dislocation produced a curious approximation of either development, stimulating high modernist artists to explore the artistic potentials of mass cultural expressions while simultaneously inducing the producers of moving images and architectural sites to incorporate modernist elements into their work in order to articulate experiences of disruption and suspension.

In the opening chapter, Françoise Forster-Hahn discusses the figuration of Old and New World during Max Beckmann's American period of exile. Although most critics have read Beckmann's American work as a self-sufficient concretization of autonomous art aimed at embodying his resistance to fascist politics while at the same time transcending reality onto a higher metaphysical realm, Forster-Hahn reconstructs his role as a university teacher in St. Louis, as well as his subsequent journey to and through the American West, as part of an attempt to engage in a dialogical fashion with the New World that opened up new aesthetic venues to encompass self and world, turning the exile's nomadic existence in between past and present into an engine of future creativity. Barbara McCloskey, in the next essay, takes a closer look at George Grosz's response to issues of race and racism during his temporary residence in Dallas, comparing his American work, a hybrid mixture of American regionalism and German new objectivity, with earlier images of this subject matter created in Weimar Berlin and New York. Similar to Forster-Hahn, McCloskey's examination of Grosz's Texan work sheds light on how Hitler refugees perceived their emigration to the United States as a continuation of careers that already in Germany had been bound up with ongoing processes of Americanization, and on how their work sought to reconcile Americanist fantasies of the past with American realities of the present. Next, Angela Miller turns the tables of analysis by reconstructing various American responses to the exilic practice of European surrealist artists in the United States in the 1930s and 1940s. According to Miller, the impact of surrealism on American culture and art of the time cannot be underestimated. Precisely because the reception of European surrealism in exile was one of many misunderstandings and mistranslations, it triggered a dynamic history of appropriations, repudiations, and transformations among American artists that profoundly reshaped the landscapes of contemporary American figurative and abstract art, lastly molding an endemic yet hybrid American modernism. In the final chapter of part one, Sabine Eckmann continues and expands on Miller's interest in the reception of refugee artists in the United States by exploring different national readings and political appropriations of their work throughout the postwar period. According to Eckmann, German postwar scholarship has

tended to read exile art as both a tragic displacement of Weimar modernism and as a representative of a "better" Germany, whereas American scholars have mostly emphasized the role of American culture as a democratic haven for refugee artists and modernist orientations. In either case, scholars have sought to claim exile art as a national heritage rather than to consider it as a hybrid product indebted to a multiplicity of cultural influences and political agendas. They have embraced the historical fact of exile in order to pursue the politics of a homogenous national identity, but in doing so obscured what the previous chapters by Forster-Hahn, McCloskey, and Miller reveal: the untidy dynamic and productivity of exile art as an art situated in between different cultural chairs.

In part two of *Caught by Politics* we shift our focus to the itineraries of European exiles whose work transcend the frame of a still image: architects, designers, filmmakers. Iain Boyd Whyte discusses the dissimilar, albeit equally jagged, trajectories of architects Jakob Detlef Peters and Karl Schneider from the modernist Berlin studios of Peter Behrens to Chicago and Los Angeles respectively in order to investigate the significance of biographical accounts for an assessment of exile. What makes both exiles' careers interesting is the way in which they, once in the United States, not only began to struggle with their own past, but sought for idioms that could translate European modernist sensibilities into viable industrial and commercial forms for American leisure and commodification, whether their tasks included the building of a Sears store in Chicago or the modeling of the Bullocks Wilshire Department Store in Los Angeles. Architectural concerns also play an important role in Noah Isenberg's successive chapter as it, among other things, investigates the reworking of Bauhaus modernism in Edgar Ulmer's American horror films of the 1930s. As he follows the tracks of the legendary filmmaker from Weimar cinema to Hollywood, Isenberg explores how this gifted director, driven by the exigencies of exile, sought to amalgamate avant-garde practices with extremely low-budget production schedules, things German with things American. In the following chapter, Lutz Koepnick continues Isenberg's inquiry by investigating the exile career of celebrated film actor Peter Lorre. Focusing in part on the 1935 horror production *Mad Love*, Koepnick argues that images of hands in Lorre's films encode potent struggles over issues of creative authenticity and self-expression, of physical dislocation and imaginative innovation; and that Lorre's performative style and accented enunciation cut across historical debates about the relation between autonomous art and popular diversion, between European high culture and the American culture industry. In the final chapter of this volume, Nora Alter sheds light on the American work of former Dadaist Hans Richter and his cooperation with fellow émigrés and American expatriate artists such as Marcel Duchamp, Man Ray, Hans Arp, Fernand Léger,

Max Ernst, and Richard Huelsenbeck. Richter's exile films, she argues, sought to complete the interrupted projects of the European avant-garde while simultaneously inscribing it into the history of American modernism. Though his later films were often driven by a kind of archival impulse, they were nevertheless instrumental in opening a creative door for what we have come to know as the essay film.

Mirrors, we have learned from Lacanian psychoanalysis, serve as sites for the construction of an imaginary sense of wholeness and self-identity. Importantly, however, as they rupture or complicate our perception of spatial continuity, mirrors can as well disturb our experience of place and of our own location within the topography of the present. At once connecting and separating the chapters of part one and part two, Renata Stih and Frieder Schnock's "You Know, This Isn't Bad Advice!!" maps the curious mirror stage of exile in this dual sense. Conceptual artists based in Berlin, Stih and Schnock's work over the past decade has been shaped by their interest in how memory functions in the social sphere and how it is reflected symbolically in the space of the city. Their contribution to this volume combines contemporary images of Los Angeles, *the* site of German and European exile during the 1930s and 1940s, with excerpts from historical dictionaries and manuals designed to enable the exile's linguistic survival and cultural adaptation in the New World. In six full-page plates, "You Know, This Isn't Bad Advice!!" confronts the expectations and everyday routines of European emigrants with the customs and cultural peculiarities of their host country. It merges and mingles texts and images in an effort not only to reconstruct the unsettled historical imaginary of Hitler exiles in the United States, but also to mark our own contemporary position in such a reconstruction. As it transports us back and forth across the discontinuities of time and space, Stih and Schnock's work thus draws our awareness to the fact that no recollection of exile and forced emigration can ever aspire to achieve a final sense of completion and roundness. To remember the exile's negotiations of past and present, whether it was experienced as agonizing or inspiring in nature, is to reiterate and reframe the signs of traumatic ruptures over time in the hope not of finally accomplishing a state of historical reconciliation but of recognizing the kind of violence that marked some of the exiles' most striking successes and modernist reinventions in their new environment. Stih and Schnock's contribution to this volume offers a broken mirror of the exiles' memories, hopes, displacements, and adjustments, at once reflecting and refracting the images of the past. Like this entire project, their work insists that any artistic or academic effort of bringing closure to the American imaginary of Hitler refugees would mean to impose yet another exile onto the exiles' life and work. To tell the story of exile is to resist our desire for compelling and neatly integrated stories.

Notes

1. Max Horkheimer and Theodor W. Adorno, *Dialectic of Enlightenment*, trans. John Cumming (New York: Continuum, 1995), 167.
2. Theodor W. Adorno, *Minima Moralia: Reflections from Damaged Life*, trans. E. F. N. Jephcott (London: New Left Books, 1951), 38–39.
3. Edward W. Said, "Reflections on Exile," *Out There: Marginalization and Contemporary Culture*, ed. Russell Ferguson et al. (Cambridge, MA: MIT Press, 1990), 357–366.
4. See, e.g., Boris Groys, *The Total Art of Stalinism: Avant-garde, Aesthetic Dictatorship, and Beyond*, trans. Charles Rougle (Princeton: Princeton University Press, 1992). For recent important revaluations of the legacy of modernism, see in particular T. J. Clark, *Farewell to an Idea: Episodes from a History of Modernism* (New Haven: Yale University Press, 1999); and Fredric Jameson, *A Singular Modernity: Essay on the Ontology of the Present* (London: Verso, 2002).
5. For exemplary texts, see Clement Greenberg, "Modernist Painting," *Clement Greenberg: The Collected Essays and Criticism*, ed. John O'Brian (Chicago: University of Chicago Press, 1993), IV: 85–93; Werner Haftmann, *Verfemte Kunst: Malerei der inneren und äußeren Emigration* (Cologne: DuMont, 1986); and Anthony Heilbut, *Exiled in Paradise: German Refugee Artists and Intellectuals in America, from the 1930s to the Present* (New York: Viking Press, 1983).
6. For an insightful case study, see Thomas Elsaesser and Malte Hagener, "Walter Ruttmann: 1929," *1929: Beiträge zur Archäologie der Medien*, ed. Stefan Andriopoulos and Bernhard J. Dotzler (Frankfurt a. M.: Suhrkamp, 2002), 316–349.

PART I
EXILE AND THE REVALUATION OF HIGH ART

Chapter One

Max Beckmann in California: Exile, Memory, and Renewal

Françoise Forster-Hahn

> *Your advice to come to America for good—I would like to follow [it], since this country has really always appeared in my mind as the final destination for the last part of my life.*
>
> —Max Beckmann, *Briefe*, III:43

When Max Beckmann confessed his vision about a future in America to Israel Ber Neumann in March 1939, he was in Paris on his last trip outside Amsterdam before war broke out in September of that year. The enforced isolation during his exile in Amsterdam only ended after 1945 with his first postwar journey to France in March–April 1947 and then, of course, more dramatically with the Beckmanns' departure for the United States on August 29 of that year. Shortly before this departure, Beckmann had emphasized in a letter to Stephan Lackner his firm conviction that this "new transformation"—namely his moving to America—was part of "his life's program," his *Lebensprogramm*—as if he was to follow a predestined fate.[1] Already in 1945, immediately after the end of the war, he had begun to study English, a language that he finally mastered more proficiently than he often made his audience believe. Beckmann had always wanted to emigrate to the United States, but it was only two years after World War II that he managed to obtain a visum. After a brief stay in New York, he arrived at the end of September 1947 in St. Louis to start his teaching job at Washington University. The discourse on Beckmann's American years primarily focuses on St. Louis and New York. Little attention has been paid to his stay from June to August 1950 in California where the Beckmanns spent some vacation time in Carmel and where the artist taught summer school at Mills College (figure 1.1). It was the last summer of Beckmann's

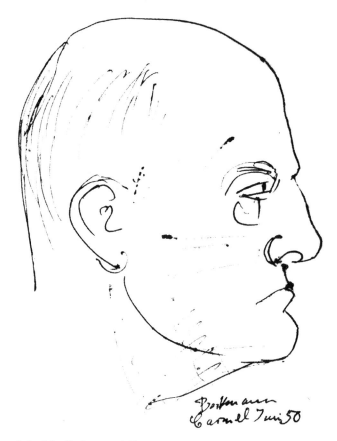

Figure 1.1 Max Beckmann, *Self Portrait at Big Sur* (1950). Ball point pen on wove paper, DIMS. Photo courtesy of Max Beckmann Archiv Murnau. © 2006 Artists Rights Society (ARS), New York / VG Bild-Kunst, Bonn.

life invigorated by the multifarious impressions of the Pacific West, but deeply overshadowed by the Korean crisis.

If Beckmann was so thoroughly convinced that his coming to America was a profound part of his life's course, can we then simply characterize these so-called American years from 1947 to his death in 1950 as a part of his exile? Only—as I shall argue—if we apply to the term exile or the exilic a broad definition that includes the experiences of constant shift and a complex interfacing of memories of the past, real and imagined, with the keen consciousness of the present and its opportunities for renewal.

Conditions of exile can be defined as both exile from self, which is the psychological and emotional state of otherness and alienation, as well as the historical, political process of displacement, rupture, and loss. Often the sense of self-exile and the forced historical state of exile converge and overlap, as they did in the case of Max Beckmann. Vilém Flusser who also experienced "unsettledness," emigration, and exile wrote extensively not only about his own personal experiences, but theorized the exilic as a dialectical state and a "state of transcendence."[2] Analyzing the difference between the emigrant and the refugee he concludes that the immigrant "is partially opened to the new contingence" and is therefore "able to assimilate the new contingence and assimilate himself into it. . . . And at those points where he chooses to retain pieces of his old contingence, he is able to act on the new one as well."[3] It is this dialectical relationship between the memory of the past and the feeling of liberation in the present that energized Beckmann in his last years in America. The exilic, I shall argue, is not only an incessant condition but also one that is open to and figured by the possibility of liberation and renewal. The tension between these two seemingly contrary experiences has shaped biographies as much as it has shaped creative work: a dynamic process is set into motion by the many opposing but interrelated layers of dislocation and regeneration, of memory and liberation, of alienation and creative invention.

As his images and texts so intelligibly reveal, Beckmann himself was deeply aware about how this intricate intertwining of past and present was shaping both himself and his work. Responding to news about people of his past ("old ghosts") the artist articulated his state of mind in a letter to his first wife: "[I] am mixing together comfortably second Avenue Kaiser Wilhelm Gedächtniskirche Roky Mountens [sic] and Ringstr 8. A nevertheless entertaining picture of life, chimerical in 234 East [and] opalescently dissolving into funny soap bubbles and ending in the realm of dark dreams."[4] Disjointed areas of his life—far apart from each other in time and emotional experience—are here united in two consciousness-flowing sentences without comma or conjunction. By blending the reference to his home and studio in Berlin—that he had shared with his first wife Minna (1907)—with his present New York residence—where he lived with his second wife Quappi (1949)—Beckmann reflects upon a tenuous state of imagination and illusion that dissolves "into funny soap bubbles." Soap bubbles, of course, are a symbolic motif that he had often used in his images—for the last time in his triptych *The Beginning* (figure 1.2).

The Beginning—as we shall see—blends past and present in an imagined autobiographical collage that is far more poetic in conception than is, for instance, the layering of past and present in a landscape scene where Beckmann transformed a 1937 landscape of Baden-Baden in 1949 into a

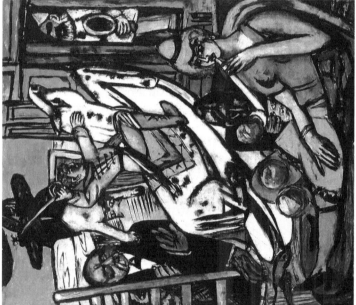

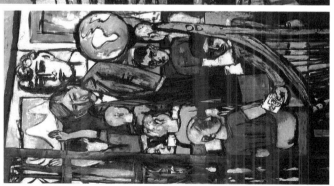

Figure 1.2 Max Beckmann, *The Beginning* (1932–47). Oil on canvas, 69 × 125 1/2″. Metropolitan Museum of Art, New York. Bequest of Miss Adelaide Milton de Groot (1876–1967), 1967 (67.187.53a–c). © 1999 Artists Rights Society (ARS), New York/VG Bild-Kunst, Bonn.

scene of the American West, *Funicular Railway in Colorado*.[5] While here the layering of past and present also assumes a physical dimension—actually painting the present location over the past one—the mental process of conjoining one with the other appears also in written form when Beckmann describes the new country by referring to the familiar in the old one characterizing Carmel as "so to speak 'Schwarzwald with Pacific ocean together.' "[6]

The most intricate and poetic "mixing together" of disparate moments in Beckmann's life can be decoded in his triptych *The Beginning*, whose "autobiographical connotations" Horst W. Janson, another German emigrant in St. Louis, already keenly recognized. In his obituary Janson linked some of the scenes of *The Beginning* to Perry Rathbone's written account of Beckmann's childhood in the catalogue of the retrospective exhibition in St. Louis in 1948.[7]

Max Beckmann completed two of his nine triptychs in the United States: *The Beginning* (1946–1949) and *The Argonauts* (1949–1950). *The Beginning*, now in the Metropolitan Museum of Art, was begun in Amsterdam, where Beckmann lived in exile from 1937 to 1947. The work was completed in St. Louis in April 1949. He first referred to the painting as *Puss in Boots*,[8] thereby clearly indicating the first stage of his work on the center panel. However, he later gave the triptych a biographical connotation by naming it *L'Enfant* or *L'Enfance*,[9] but also *Jeunesse*,[10] and finally, *The Beginning*.[11] He used the German term *Kindheit*[12] only once for the triptych even though he made his diary entries primarily in German, increasingly mixing, however, his native language with terms and phrases from French, Dutch, and English. Thus, while the language of the diary itself mirrors the alienation and growing distance from his native country, the choice of terms in the foreign languages also signify the developing familiarity with the cultures of the countries in which the artist lived after he was forced to flee Nazi Germany.

The Beginning, like all of Beckmann's triptychs, is a highly complex and enigmatic one that has been subjected to a wide variety of readings ever since it was first exhibited at the Buchholz Gallery in New York in 1949.[13] While the triptych in its complicated structure and encoded motifs encapsulates many layers of meaning, the sources and documents seem to confirm at least *one* facet, namely the autobiographical nature of the painting.[14] The artist as a boy appears in different contexts in all three panels: riding on a white rocking horse in the center, gazing out of a window in the left, and sitting in a classroom in the right panel. Moreover, the triptych's spatial construction embodies the time frame and different levels of reality depicted in the three scenes. The center panel offers the spectator a view into the boy's actual world, a garret, crowded with five figures, toys,

and a *Puss in Boots* hanging from the ceiling;[15] a motif that most certainly is taken from the French version of the fairy tale *Le Maître Chat ou le Chat Botté* where *Puss in Boots* is hanging from the ceiling to better catch rats and mice.[16] It is a crammed composition that is constructed as if we were observing a scene on stage from below. This large center panel is bracketed by two narrower and shorter side panels: on the right, a scene in a schoolroom seen through a window, and on the left, an interior where the boy, dressed as a king, gazes through a window into the outside world and experiences a heavenly vision or watches an organ-grinder and a traditional German Christmas time procession. Beckmann carefully prepared the composition of the three panels and their interrelationship as two preparatory drawings for the side panels demonstrate.[17]

In the following, I shall focus only on the right panel. This scene seems to fuse pictorial motifs far less tangible with actual incidents remembered— such as the one in the right foreground where a boy passes on a drawing: as a boy, Max Beckmann amused himself during boring school lessons by drawing erotic images that he passed to his classmates.[18] In the far-left background, as a punishment, a boy stands up facing the wall, arms stretched out high and covering part of a landscape picture. Also in the background, the stern figure of the teacher is surrounded by a green globe showing America, a large plaster cast of an antique bust, and two pictures on the wall, one displaying an exotic landscape with steep yellow mountains. The antique bust, standing monumentally and in an elevated position represents the cultural tradition of the curriculum and is flanked, indeed almost crammed in, by the green globe and the yellow landscape that seem to allude not only to the teaching of but also to the longing for the faraway, unknown world. A globe was part of Beckmann's possessions accompanying him all the way to his last apartment in New York. We know that he liked to "play" Indians and was so fascinated with the possibilities of adventures in exotic countries that he wanted to explore them; once secretly, he even tried to be hired as a steward by a freight-shipping company. The laconic response to his letter of application was simple: he was too young to be considered.[19] Beckmann finished *The Beginning* while he resided in St. Louis in 1949, and the exotic mountain landscape of his childhood schoolroom almost anticipates—but actually relates to—the *Landscape in Boulder* (1949), a landscape that does not depict a specific topographical site, but rather is a composite vision of the Western territory.[20] The collage-like overlapping in *The Beginning* of memory, past and present biographical experience, and imaginary scenes of the foreign create a multilayered and enigmatic image that has eluded any literal decoding or fixed reading of meaning. The exilic here is figured as both displacement from the past and renewal in the present. It is the very tension of this duality that energizes Beckmann's work during his last years in the United States.

If as a child Max Beckmann dreamed and fantasized about the exotic and faraway lands, his vision was obviously shaped by a long literary and pictorial tradition of the Americas in the European mind. This imagination fused scientific exploration and fact with imaginative narrative construction and picture-making, and was kindled in the early nineteenth century by Prince Maximilian's publications and Karl Bodmer's illustrations.[21] Later, Karl May's tales of the American Wild West stimulated the imagination of generations of Germans. In 1927, only a few years before his emigration to the United States, Georg Swarzenski, the art historian and friend of Beckmann, published a small book about his first trip to the United States that he titled *Europäisches Amerika* (European America). In the introduction, Swarzenski reflects upon the feelings of "tension" and curiosity that the European experiences in expectation of the New World. "What is the reason"—he asks—"for this sensational attitude? Perhaps contemporary America, related to Europe, still awakens in the subconscious the idea of Indians and fire-eaters, stories of adventurers, run-aways, distant relatives, which grandfather told. In fact, it is not the impression of reality, but a feeling for the inexhaustible future possibilities of the country which produce such phantastic attitude."[22] As Swarzenski emphasizes, the fictional image of the New World by far dominated any rational knowledge of the modern United States.

The mythologizing of America in Weimar Germany during the 1920s was powerful indeed. Whether in the poetic imagination of Bertolt Brecht or in the accounts of modernist urbanism and architecture in Richard Neutra's *Wie baut Amerika?* (1927)[23] or Curt Glaser's *Amerika baut auf!* (1932)—in Beckmann's library with a dedication[24]—it is the myth of America that shaped the imagination of the New World: of the *Gigantenstadt* New York as a *Riesenurwald* (primeval forest) in the words of Beckmann[25] or of the "primitive *Wüstenlandschaft*" that Neutra describes around Palm Springs.[26] It is perhaps no surprise that Beckmann recommended to his students in Frankfurt to read Dos Passos's *Manhattan Transfer*.[27] As Göpel hypothesizes, Beckmann was fascinated by the overlapping of simultaneous events in the narrative, a strategy he transferred to his picture making.[28]

Intrigued by the history of the country, especially the West, Beckmann explored the Rocky Mountains when he taught summer school in Boulder, Colorado in 1949. A year later, he accepted an invitation from Mills College, Oakland, to teach summer school in California. Despite a serious heart condition he undertook trips to the "gold country" to explore the legendary pioneering years of California's past: he traveled to Carson City, Virginia City, and Reno writing about these experiences in his diaries and letters. Even though Boulder, Colorado reminded Beckmann of Garmisch Partenkirchen,[29] the landscape of the West must also have triggered

memories of his childhood imagination. In 1949, when he finished his trip-tych *The Beginning*, the City Art Museum in St. Louis organized a comprehensive exhibition about the frontier in the Mississippi-Missouri territories: *Mississippi Panorama*. A catalogue with a personal dedication was in Beckmann's library.[30] Here, the artist could test European imagination against American historical scholarship.

After the celebrations for the honorary doctoral degree that Washington University awarded him on June 6, 1950, Beckmann and his wife traveled by train to California where they briefly stopped in Los Angeles. There—the artist must have known—a flourishing and vibrant group of German and Austrian émigrés had created a productive and dynamic community whose manifold contributions to the culture of the city have only recently been recognized. When, in the late 1930s and 1940s, a wave of German and Austrian intellectuals reached California, these emigrants surely did not only settle on the West Coast in the hope of building a new life through employment in the film industry. Theodor W. Adorno, Bertolt Brecht, Lion Feuchtwanger, Thomas and Heinrich Mann, Richard Neutra, Arnold Schönberg, Bruno Walter, and Franz Werfel—to name just a few of the most prominent ones—formed a vital community in Los Angeles. These artists did not simply import European avant-gardism. Rather the immediate experience of their new environment infused their own work. The condition of exile—so often only identified as one of loss and displacement—also embraced the experience of the opposite, a deep sense of liberation and rejuvenation. One of those emigrants who left her mark on the cultural map of Los Angeles was Emmy "Galka" Scheyer (1889–1945).[31] When she decided in 1925 to settle in California—rather than in New York—she believed that what she called "the last frontier" would be more receptive to the European avant-garde than the East Coast.

Emmy "Galka" Scheyer, collector and energetic promoter of European avant-garde art, art dealer and art educator, first settled in the Bay Area, where she became intensely involved with the Oakland Art Gallery, whose "European representative" she became. Primarily known as the tireless promoter of The Blue Four (Feininger, Kandinsky, Klee, and Jawlenksy) she was engaged in a far wider range of cultural enterprises. If one singles out one project as a signature for the myriad activities in which "Galka" Scheyer immersed herself during her California years, it is the house and gallery that Richard Neutra designed for her in the Hollywood Hills. This house may well stand as a metaphor for the experience of exile itself. The purchase of the land and the construction of the house itself around 1933 converge precisely with Scheyer's trip to Paris and Germany, when Hitler's rise to power abruptly put an end to her stay. This twist of historical events irrevocably changed her condition from one of personal and voluntary exile to a state of forced political banishment from her native country. The house is thus

more than an extravagant modernist project: it comes to represent the very tension of the exilic, a sense of suspension between loss and rebirth.

Under the new political circumstances the house, which was originally planned as a satellite of the Oakland Art Gallery, came to embody Scheyer's experience of political exile: "Germany was just too much for me and so I decided suddenly to go back to California into the sun and I built a house on top of the mountains, to have a beautiful home for my pictures, to be able to look into space and forget. [sic] humanity. I did build a home, 200 feet high, and I have not yet been able to forget humanity because the act of building a house brings you rather too close to them."[32] The act of building the house thus inhabits the space between rupture and loss, liberation and regeneration.

The house did not become merely a container for Scheyer's picture collection, but also a sign of the creative reinvention of the self. Neutra's glass box, with an almost total dissolution of solid walls, was by no means an ideal space for a picture gallery. After much conflict between architect and client, Neutra proposed a compromise: removable panels to accommodate the art, without, however, "permanently closing off" the outdoor view. Located at the crossroads of the old and the new, the house with Neutra's thin walls of glass provides but a fragile separation of the inside and outside. Reading a photograph that captures Scheyer balancing precariously on the balustrade of her balcony seems to convey the dual role of the house as container of memories of the "old," that is, the art of the old continent, and, with its unobstructed views into the wide spaces of the Los Angeles basin, offering a gaze into the unlimited possibilities of the future. Beckmann, of course, did not see "Galka" Scheyer's house, but his experience of California triggered a very similar feeling of liberation and a profound awareness of the inescapable intertwining of past and present.

Beckmann's experience of California, the wide open spaces of landscape, the climate, the sounds and scents of nature kindled a feeling of freedom and renewal. After their vacation in Carmel, Beckmann and Quappi continued on to Oakland, the ultimate destination of their trip to the West Coast, where Beckmann taught summer school. Mill's summer school program was well known for its Creative Art Workshop. The summer session was held for both men and women, and the visiting professors at Beckmann's time were, among others, the French dramatist René Lenormand, the composer Darius Milhaud, and members of the Budapest String Quartet.[33] Beckmann taught a two-unit course called Painting in which he emphasized the "[e]xercising of memory and imagination."[34] At Mills College, memories of the past and challenges of the present were put into sharp focus for the artist, when he saw the exhibition of his work that another German emigrant, the art historian Alfred

Neumeyer, had organized in the Mills College Art Gallery.[35] Neumeyer had brought together twenty-five paintings—twenty-four from the Morgenroth-Lackner collection in Santa Barbara—and prints and drawings from the Buchholz Gallery in New York. A mimeographed catalogue list with a "Preface" by Alfred Neumeyer and a brief essay by Stephan Lackner were printed.[36]

This carefully prepared exhibition prompted the artist to muse in his diary about how "strange it was to see the old stuff again."[37] While the fragrance of his favorite trees, the eucalyptus, reminded him of his present location, the reunion in California with the work dating from his Berlin and Paris periods kindled "sad memories."[38] This interfacing of old and new identity was poignantly expressed in the changes of the artist's signatures.

While Beckmann was painfully touched by the memory of the past that the sight of these old works evoked in him, he nevertheless made a physical intervention in some of his paintings, layering so to speak, past and present. Lackner writes, "While his pictures were hanging in the Mills College exhibition . . . , Beckmann signed a number of them, according to my wishes. . . . Some of them had been signed in the old German or gothic handwriting: these signatures he overpainted now and resigned them in Roman characters, to make them more readable, and perhaps, because his feelings had become more internationalized."[39] Already in 1948—upon the receipt of his visum—Beckmann had joyfully expressed this sense of renewal: "und bin damit gewissermassen schon halber Amerikaner" [and with this I am already so to speak half an American].[40] Despite his precarious health, he explored his new environment and was enthralled by California's open spaces, its deserts, its bright lights, and the views of the Pacific Ocean. All along, he often experienced the new sites by prefiguring the pictures in his mind that he might paint in the future, such as *San Francisco, Park in California, Mill in Eucalyptus Forest (Mills College)*. So, when he visited San Francisco, Beckmann made a "wide-angle view" of the city, a drawing that expanded across two pages of his diary,[41] which he later, in his New York studio, transformed into the painting (figure 1.3).

A year before, Beckmann had written to Benno Reifenberg, the German author of a new monograph on him: "You are quite right, sometimes I already appear to myself as a phantom, in all these different lives countries cities and human beings into which a 'teasing' fate has thrown me. . . . The more one gets around, the more one also sees the repetition of one and the same, especially when the foreign luster of the language slowly vanishes."[42] Brecht had put it similarly when he wrote, "I saw the Old approaching, but it came as the New."[43] Beckmann was keenly aware of the liberating effect of America, similar to Flusser's experience of London after he had been

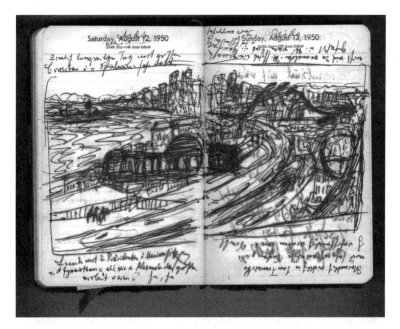

Figure 1.3 Max Beckmann, Study for the painting *San Francisco* (1950). Diary of Max Beckmann, entry dated August 12–13. Image courtesy of Columbia University Rare Book and Manuscript Library, New York. © 2006 Artists Rights Society (ARS), New York / VG Bild-Kunst, Bonn.

forced to flee from Prague: "I was overcome by that strange dizziness of liberation and freedom."[44] When Beckmann observed the giant sea lions on a small island off the coast of Carmel, he reflected that "it was indeed a strange and great impression, how one of the sea lions stood diagonally, like an old mythological mammoth against the sky.—Liberty and infinity in the horizon of the sea."[45] Back in New York, Beckmann transformed this experience into his painting *Sea Lions*.[46] Within the context of historical and biographical coordinates we may read Beckmann's image of the sea lions as a symbol of "freedom and infinity" even though the painter transferred the animals in this picture into a circus: that is into captivity, as if he had merged in this image his love of the circus, a primarily European experience, with his immediate sight of the Pacific Ocean.

His forced exile in Amsterdam and the brutal conditions of war and German occupation had inspired a profound reconceptualizing of a national icon, the reinvention of Goethe's *Faust*. Beckmann's conception of the character Faust radically challenged and ultimately deconstructed the nationalistic and heroic interpretations of Goethe's tragedy that had

dominated the reading in his home country since at least the second half of the nineteenth century.[47] In America, the much anticipated last phase of his *Lebensprogramm*, created a precarious, but invigorating balance between past and present: "The Old approaching, but it came as the New." On January 10, 1946, Beckmann had reflected in one of the small notebooks in which he listed his pictures:

> Novo Centissimo—10 januar 1946
> erhielt Ausfuhrvergunning für
> Exposition in New York.
> Damit fängt die Welt wieder für mich
> an, so sie im Spätherbst 1932 in
> Frankfurt a/m aufhörte.
> 14 Jahre exilé
> et condamné
> nun wieder frei—sehen wir was weiter kommt
> Novo Centissimo 1946
> in Amsterdam.[48]

In this brief sigh of relief about the new opening of the world after fourteen years of imposed exile, Beckmann expresses his feeling of liberation in four languages. The overwhelming experience of instability and displacement, of the shifting divides of cultures and languages, forced the questioning of any fixed national identity or the authoritative status of cultural icons. Not bound to any temporality, the sense of suspension between past and present, loss and rebirth, the sense of flux between "sad memories" and the vision of "liberty and infinity," as Beckmann articulated it, circumscribes a very unique space for the act of re-creation, or as another "nomad" of the twentieth century articulated it so succinctly, "Exile, no matter the form, is the incubator of creativity in the service of the new."[49]

Notes

I am grateful to the University of California, Riverside, for an extra-mural research grant that supported research in Germany. My sincere thanks go to Mayen Beckmann in Berlin and to the librarians at Mills College, Oakland, who kindly gave me access to unpublished material, and to the Kunstbibliothek, Staatliche Museen-Preußischer Kulturbesitz, Berlin, whose staff greatly facilitated my work there as well as to Dr. Christian Lenz and Dr. Christane Zeiller, Max Beckmann-Archiv, Munich. My grateful appreciation to Barbara Wotherspoon who patiently and with great expertise put this manuscript into its final form.

1. Max Beckmann, *Briefe*, ed. Klaus Gallwitz, Uwe M. Schneede, and Stephan von Wiese, with the collaboration of Barbara Golz (Munich: Piper, 1993–1996), III: 177.

2. Vilém Flusser, *The Freedom of the Migrant: Objections to Nationalism*, trans. Kenneth Kronenberg, ed. Anke K. Finger (Urbana: University of Illinois Press, 2003), 83.
3. Ibid., 23.
4. Max Beckmann, *Briefe*, III: 282.
5. Erhard Göpel and Barbara Göpel, *Max Beckmann: Katalog der Gemälde* (Bern: Kornfeld & Cie., 1976), I: 479 (No. 790).
6. Max Beckmann, *Briefe*, III: 326.
7. H. W. Janson, "Max Beckmann in America," *Magazine of Art*, 44.3 (March 1951): 89–92. Janson refers to the "Introduction" by Perry Rathbone, *Max Beckmann*, in the catalogue of the retrospective exhibition, printed in the *Bulletin of the City Art Museum of St. Louis*, 33.1/2 (May 1948): 11–22.
8. Göpel and Göpel, *Max Beckmann*, I:477–479 (Nos. 292–294). In his diary Beckmann first refers to a dream and then to the first sketches of "Puss in Boots." See Max Beckmann, *Tagebücher, 1940–1950*, compiled by Mathilde Q. Beckmann, ed. Eberhard Göpel (Munich: Albert Langen-Georg Müller, 1955); new enlarged ed. with preface by Friedhelm Fischer (Munich: Albert Langen-Georg Müller , 1979; repr. 1984). First references, April 13, 1946; October 3, 1946; October 11, 1946; October 20, 1946.
9. Max Beckmann, *Tagebücher*, entries of January 5, 1947 and January 8, 1947.
10. Ibid., entry of January 15, 1947.
11. Ibid., entry of March 21, 1949.
12. Ibid., entry of March 18, 1949.
13. A review in the *New York Times* of the exhibition at the Buchholz Gallery (October 1949) refers to *Beginning* as "an almost rollicking saga of childhood." In their catalogue Erhard and Barbara Göpel give a very thorough account of the references in the diaries to the evolution of the painting, its earlier literature, and also advance their own reading of the triptych. The most engaged readings can be found in Charles S. Kessler, *Max Beckmann's Triptychs* (Cambridge, MA: Harvard University Press, 1970), 77–86; Friedrich Wilhelm Fischer, *Max Beckmann: Symbol und Weltbild. Grundriss zu einer Deutung des Gesamtwerkes* (Munich: Wilhelm Fink, 1972), 202–205; Gert Schiff, "The Nine Finished Triptychs of Max Beckmann: Marginalia for Their Interpretation," *Max Beckmann: The Triptychs* (London: Whitechapel Art Gallery, 1981), 20; Peter Beckmann, *Max Beckmann: Leben und Werk* (Stuttgart and Zürich: Belser, 1982), 13–17; Mathilde Q. Beckmann, *Mein Leben mit Max Beckmann*, 2nd ed., trans. Doris Schmidt (Munich: Piper, 2000), 161–163; *Max Beckmann. Retrospektive*, exhibition catalogue, ed. Carla Schulz-Hoffmann and Judith C. Weiss (Munich: Prestel, 1984), 310–312; and Reinhard Spieler, *Max Beckmann: Bildwelt und Weltbild in den Triptychen. Mit einem Beitrag von Hans Belting* (Cologne: Dumont, 1998), 146–152, 159–161. Recently exhibited in Paris, London and New York: Max Beckmann, ed. Sean Rainbird (London: Tate Publishing, 2003), 140–141 (No. 84).
14. Mathilde Beckmann, *Mein Leben mit Max Beckmann*, 161–163. Peter Beckmann (*Max Beckmann*, 16) identifies the older gentleman in the center panel as Max Beckmann's uncle and guardian.
15. While numerous readings of the cat hanging from the ceiling—a scene that does not occur in the Brothers Grimm's fairy tale—have been put forward, it is most likely that Beckmann had the French version by Charles Perrault in mind. See Peter Beckmann, *Max Beckmann*, 16. Also Göpel and Göpel, *Max Beckmann*, I:477 (No. 789).

16. Charles Perrault, *Les Contes de Perrault. Dessins par Gustave Doré*, ed. P.-J. Stahl (Paris: Didot Frères et Fils, 1862), 29.

17. Herwig Guratzsch, ed., *Max Beckmann: Zeichnungen aus dem Nachlass Mathilde Q. Beckmann* (Cologne: Wienand, 1998), 49–50 (No. 253). The sketches are entitled *Leierkasten* and *Schule*. The latter is dated "5 Okt. 46."

18. Beckmann was the first to relate the story. See his letter to his publisher Reinhard Piper, who had asked the artist in 1923 to provide him with an autobiographical account. Max Beckmann, *Briefe*, I:230–231. The story then develops in several versions as in the account of Perry Rathbone, Quappi Beckmann, Peter Beckmann, and others.

19. Mathilde Beckmann, *Mein Leben mit Beckmann*, 115.

20. Göpel and Göpel, *Max Beckmann*, I:487 (No. 802).

21. Maximilian Prinz zu Wied, *Reise in das innere Nord-America in den Jahren 1832 bis 1834*, 2 vols. with an atlas illustrated by Karl Bodmer (Koblenz, 1839–1841). English edition: *Travels in the Interior of North America* (London: Ackermann, 1843). The exhibition of Bodmer's images in Paris in 1836 was the first comprehensive public presentation of the American West on the European continent. Maximilian's papers and about 400 drawings by Karl Bodmer are now in the Joslyn Art Museum, Omaha, Nebraska.

22. Georg Swarzenski, *Europäisches Amerika. Sonderdruck aus der Frankfurter Zeitung* (Frankfurt, 1927), 11–12. A copy of the privately printed booklet, dedicated to Max Beckmann, was in his library. See Peter Beckmann and Joachim Schaffer, eds., *Die Bibliothek Max Beckmanns* (Worms: Wernersche Verlagsbuchhandlung, 1992), 501.

23. Richard Neutra, who arrived in Los Angeles in 1925, completed the manuscript for *Wie baut Amerika?* (Stuttgart: Julius Hoffmann, 1927) in 1926.

24. Curt Glaser, *Amerika baut auf!* (Berlin: Bruno Cassirer, 1932). A copy with a dedication to the artist was also in Beckmann's library. See Beckmann and Schaffer, *Die Bibliothek Max Beckmanns*, 479.

25. Max Beckmann, *Briefe*, III: 186 and 286.

26. Neutra, *Wie baut Amerika?* 77.

27. Erhard Göpel, "Gegenwart Max Beckmanns. Erinnerungen aus der holländischen Zeit," *Max Beckmann zum Gedächtnis 1884–1950. Internationale Kunstausstellungen München 1951* (Munich: Prestel, 1951), 7.

28. Ibid., 7.

29. Max Beckmann, *Briefe*, III: 267 and 274.

30. *Mississippi Panorama*, ed. Perry T. Rathbone (St. Louis: City Art Museum of St. Louis, 1950). The exhibition was on display from October 10 to November 27, 1949, that is at a time when Beckmann had already left. See also Beckmann and Schaffer, *Die Bibliothek Max Beckmanns*, 493.

31. For a biographical summary of Scheyer's life and a catalogue of her collection, see Vivian Endicott Barnett, *The Blue Four Collection At the Norton Simon Museum* (New Haven: Yale University Press, 2002), especially the essay by Barnett, "Galka Scheyer: The Transformation from E.E.S. to G.E.S.," 11–21. In the following I am basing my narrative on Nadine M. Flores, *Galka E. Scheyer—Agent of the Blue Four: A Cultural and Political Interpretation of the Oakland Gallery Years, 1926–1938*, MA thesis, University of California, History of Art, Riverside, 1992.

32. Flores, *Galka E. Scheyer*, 164. In a letter of August 31, 1933 to Piet Mondrian she conveyed that the experience (in Germany) was so traumatic that she did not have the courage to continue (Flores, *Galka E. Scheyer*, 61).

33. Papers, documents, and photographs regarding Beckmann's visit are in the Library of Mills College.

34. The Summer Session Catalogue lists Beckmann's course under the Creative Art Workshop and reproduces a photograph of him.

35. The correspondence regarding the exhibition between Alfred Neumeyer and Morgenroth-Lackner in Santa Barbara and Curt Valentin at the Buchholz Gallery in New York as well as the mimeographed catalogue brochure of five pages and installation photographs are also at the Mills College Library.

36. Stephan Lackner's essay ("New Paintings by Max Beckmann," mimeographed brochure [Oakland: Mills College, 1950], 2–3) was written according to Neumeyer "shortly after the war."

37. Max Beckmann, *Tagebücher*, entry of July 12, 1950.

38. Ibid., entry of July 5, 1950.

39. Stephan Lackner, *Max Beckmann* (New York: Abrams, 1991), 112.

40. Max Beckmann, *Briefe*, III: 223.

41. Göpel and Göpel, *Max Beckmann*, I:501 (No. 823). Lackner (*Max Beckmann*, 122) relates the painting of San Francisco to Beckmann's diary entry of August 13, 1950, when the artist visited the city and also drew a "wide-angle view" across two pages of the diary: "Was at last really in San Francisco and saw astonishing things which I'll probably paint" (Max Beckmann, *Tagebücher*, 398–399). *West-Park* or *Park in Kalifornien* (Göpel and Göpel, *Max Beckmann*, I:502 (No. 824) and *Mühle im Eukalyptuswald* (*Mills College*) (Göpel and Göpel, *Max Beckmann*, I:502–503 [No. 825]) are in a private collection.

42. Max Beckmann, *Briefe*, III:247.

43. Bertolt Brecht, "Five Visions, Parade of the Old New," *Plays, Poetry and Prose. Poems 1913–1956*, ed. John Willett and Ralph Manheim (London: Eyre Methuen, 1976), 323.

44. Flusser, *Freedom of the Migrant*, 3.

45. Max Beckmann, *Tagebücher*, 393–394.

46. Göpel and Göpel, *Max Beckmann*, I:504–505 (No. 829).

47. See Françoise Forster-Hahn, "The Ambiguous Duality Between Hero and Devil: Max Beckmann Reinvents Goethe's *Faust* in his Amsterdam Exile," *Memory & Oblivion: Proceedings of the XXIXth International Congress of the History of Art held in Amsterdam, 1–7 September 1996*, ed. Wessel Reinink and Jeroen Stumpel (Dordrecht: Kluwer Academic Publishers, 1999), 949–958.

48. Mathilde Beckmann, *Mein Leben mit Max Beckmann*, 40–41.

49. Flusser, *Freedom of the Migrant*, 87.

Chapter Two

Exile for Hire: George Grosz in Dallas

Barbara McCloskey

Mr. Grosz will spend about two weeks in Dallas . . . taking sketches and getting a true feel of Texas; a Texas he had dreamed of for 41 years, but had never actually seen.

—*The Daily Times Herald*, Dallas, 1952

I

Texas loomed large in George Grosz's first imaginings of the American frontier. In a 1915 drawing, *Texas Picture for My Friend Chingachgook*, he gave his fantasies visual form in a work dedicated to the Indian protagonist of James Fenimore Cooper's popular Wild West stories. The hard-bitten cowboy, exotic Indian, and salacious prostitute of *Texas Picture* inhabit a world of sexual license and frontier justice. Rendered in a graffiti-like style, they become stock characters in this and other works that date from the early period of Grosz's career.

As for other artists of the German vanguard, Grosz's imaginary Wild West filled both a psychic need and a political program.[1] Donning feathered headdress and transforming his studio into a wigwam, he adopted the role of Indian as an artistic gesture designed to establish his countercultural, avant-garde credentials. The radical otherness of his Wild West—lawless, erotic, and filled with peril—became an imaginary alternative to tradition-bound Wilhelmine society. As the quintessential Wild West "outsider," Grosz also underscored his growing awareness of himself as a political dissident whose works only became more strident in their condemnation of German bourgeois life in the coming years. Notorious for his bitterly satiric images of the 1920s that assailed church, state, and capitalist exploitation,

he left for the United States just days before Hitler became chancellor in 1933.

In 1952, nearly twenty years after his emigration to New York City, Grosz was given the opportunity to match his early vanguard fantasies against the reality of the "American frontier" for the first time. Jewish department store magnate Leon Harris, Jr., asked the famous exile from Hitler's Germany to visit Dallas in May of that year in order to produce a series of images of the city. Entitled *Impressions of Dallas*, the $15,000 commission brought Grosz face to face with "a Texas he had dreamed of for 41 years, but had never actually seen."[2]

Dallas of the 1950s was a far cry from the Wild West that had so captivated Grosz's youthful imagination. While cowboys (i.e., urban cowboys) could indeed still be seen wandering the city's streets, African-Americans now replaced Indians as "other" in Dallas's racial economy. The city's urban fabric, dominated by a forest of skyscrapers, had long since crowded out the Texas prairie. Instead, tall, gleaming buildings testified to Dallas's growing stature as a modern financial center of the American Southwest.

While no longer a frontier town, Dallas was nonetheless culturally in thrall to a frontier ethic whose real-life brutality and lawlessness exposed the benign escapism of Grosz's early fantasies. Fictional shoot-outs between cowboys and Indians held scant resemblance to the real-life wave of racial violence between the city's white majority and African-American population that gripped the city in the early 1950s. Such clashes became all the more acute as Dallas began to feel the incipient phases of the Civil Rights Movement and pressure from both African-Americans and some among the city's entrepreneurial elite, including Leon Harris, to bring itself into the modern era.

In what follows I explore the relationship between exile and Grosz's response to and renderings of Dallas's environs and people during this critical period. The *Impressions of Dallas* commission was a unique experience for Grosz. The first large-scale semicommercial undertaking of his career, the project brought him into direct contact with the needs and desires of his patron, for whom he produced a sizable, though artistically unremarkable, series of images. Given the inferior quality of his Dallas works, Grosz scholars have thus far accorded them only passing attention.[3] Their conventional representational style furthermore places Grosz's *Impressions of Dallas* well outside general histories of modernist innovation that still give pride of place to the ascendancy of abstract expressionism in the New York art world during the cold war.

Viewed from the perspective of exile studies, however, Grosz's Dallas commission provides an ideal forum for exploring the kinds of cultural contacts and confrontations, including their traumatic aspects, that comprise

the exile experience. The commission temporarily removed Grosz from the rarified atmosphere of a New York art world that allowed, and even cultivated, his identity as a prized European exile artist. In Dallas, Grosz was thrust into a situation where that identity and his artistic vision were forced to reckon with the realities—cultural as well as commercial—of an America he had yet to know and experience. The Dallas project, in short, confronted Grosz's relative cultural isolation for a brief, telling, and disorienting moment with the imperatives of assimilation. And, significant to the understanding of exile in this case, it also placed his work between the realms of commerce and art.

The *Impressions of Dallas* series, which we shall explore in detail, consists of a group of large-scale oil paintings in which Grosz dutifully commemorated the oil, cotton, and cattle industries that formed the backbone of Dallas's historic rise to economic preeminence. He also, more provocatively, turned his attention to the contrast between the city's wealthy white inhabitants and impoverished black population in watercolors that formed part of the project. Commissioned by a Jewish entrepreneur, rendered by a persecuted German artist, and addressing in part the experience of the city's vilified African-Americans, Grosz's *Impressions of Dallas* brought together the sensibilities and interests of three outsiders—indeed three "exiles"—from Dallas's white majority culture. His works subtly underscored the tension between modernization and racism that characterized the city during this period. The Dallas commission also, as we shall explore, marked a decisive change in the meaning of exile as it pertains to Grosz's life and art.

II

From the time of his emigration to the United States in 1933, Grosz's turbulent Weimar career shaped his reception in his new surroundings. Periodic press reports in U.S. left-wing art journals and newspapers followed his early activities as the leading artist of the German Communist Party. Accounts also informed American readers about developments in his three sensational censorship trials of the 1920s. Familiar to mainstream U.S. art audiences were Grosz's many bitterly satiric images that took aim at German militarists, government officials, bourgeois hypocrisy, and the rise of fascism during the Weimar years. Prior to his departure from Berlin in 1933, he endured increasingly shrill attacks from members of Germany's nationalist right who pilloried Grosz as the country's "cultural bolshevist #1." His timely arrival in the United States shortly before Hitler became chancellor spared him the tragic fate of those who remained behind.

Grosz accepted a teaching position with the Art Students' League in New York at the urging of John Sloan. Sloan was president of the school's

board at that time and an admirer of the socially critical work for which Grosz had become internationally famous. Immediately upon his arrival in the United States, however, Grosz declared—to his new public in published interviews and to his friends in private correspondence—his determination to establish his career on wholly new terms. Unlike other members of the German exile community, Grosz was bent on assimilation and rejected any notion of eventual return to Germany.[4] He supported himself and his family during these years through teaching, exhibitions, and illustration contracts with several popular U.S. journals including *Esquire* and *Vanity Fair*.

By the mid-1930s, landscapes, nudes, portraits, and allegorical paintings done in the manner of the Old Masters had replaced the political satire for which Grosz had become known during his Weimar years. Though some commentators decried the change in Grosz's art, the established U.S. art world nonetheless embraced him. He was able to take leave of teaching at the Art Students' League in 1936 in order to devote his entire time to his work. A Guggenheim Fellowship in 1937, renewed in 1938, confirmed his favorable recognition on a national scale. Moreover, in 1948, museum directors and art critics voted Grosz as one of the most important living American artists.[5]

As atrocities began to mount in Europe, however, and the number of refugees into the United States began to grow, Grosz found it more difficult to sell his work. European surrealists and other vanguardists fled cultural and political repression for the United States. They prepared the way for the emergence of abstract expressionism and its rhetoric of universalism. Grosz's work shared the fate of Regionalism, American Scene, and social realist art that remained rooted—too rooted for the changing sensibility of the U.S. art scene—in the specificity of figurative representation and the political ideologies, nationalism and socialism among them, with which such tendencies had become identified.

Unlike many of his fellow figurative artists, however, Grosz experienced the perversity of increased media attention to the details of his life at the same time when his ability to make a living from his art began to flounder. This attention was heightened particularly after the staging of the Degenerate Art Show in Munich in 1937, where Grosz's work, along with that of other artists proscribed under the Nazi regime, was held up for official pillory. With dwindling possibilities to sell his work, Grosz reluctantly submitted during these years to extended interviews in the *New Yorker* magazine and to the writing of his autobiography. Such endeavors held an increasing fascination for the U.S. public regarding Germany, its culture, and Grosz as one of his native country's persecuted.[6]

Thwarted in his attempts at American assimilation by changing events, Grosz thus found himself once again as the German "exile." His new public

wanted more of his work of the 1920s and showed waning interest in his U.S. career. Commentators and critics alike also associated him more and more with the stereotype of Germanic irrationalism and disturbed temperament that gained fresh currency in light of unfolding events.[7] In his art, Grosz began to explore the experience of exile through a series of introspective self-portraits. He turned his attention to the torment of war and the nature of Nazi evil in a number of large-scale allegorical oil paintings, whose haunting quality received favorable critical attention but, again, failed to sell. On more than one occasion, he envisioned himself as a German Salvador Dali, whose outrageous antics since his own exile to the United States had captivated media attention over and above that garnered by his art.

In an effort to shore up his flagging income, Grosz grudgingly returned to teaching at the Art Students' League in 1941. Within the space of a few years, his initially positive response to his new circumstances had turned to disillusionment. His problems with alcohol also became more acute. Grosz cultivated an open disdain for the crass commercialism he now associated with the U.S. art scene. While he still refused any thought of return to Germany, his sentiments nonetheless began to mirror those of other German exiles who imagined an unbridgeable divide between the European high cultural tradition they claimed for themselves and the unremarkable offerings of a mass culture they had long associated with the United States.

In addition to teaching, Grosz also signed a contract in the early 1940s with the former newspaper reporter, public relations expert, and artists' agent Reeves Lewenthal. Lewenthal was head of the Associated American Artists (AAA), which he founded in 1934. He was among the first to tailor the art market to the economic realities that had dramatically redefined the United States as a culture of consumerism since the turn of the century. Lewenthal brought his advertising "know-how" to bear in an aggressive program of mass marketing that presented art as cultural amelioration for Depression-era economic despair. Convinced that "American art ought to be handled like any other American business," Lewenthal shared none of the art world's characteristic qualms concerning art's commodity status.[8]

In the AAA's early years, Lewenthal hired artists to do inexpensive prints for retail outlets and mail order. By October 1934, the AAA had contracts with some fifty department stores nationwide for the display and sale of its prints. In the late 1930s, Lewenthal expanded his business by opening a spacious gallery on Fifth Avenue in New York City and later added branches in Chicago and Beverly Hills. His innovative Art for Advertising Department, which linked artists with corporate clients, persisted into the 1940s. By the time Grosz signed on with Lewenthal in the early 1940s, the AAA styled itself as the "largest commercial art gallery in the world."[9]

In a letter written in 1943 to his artist friend Arnold Rönnebeck Grosz bemoaned his new AAA contract. Three hundred and fifty artists belonged to the AAA, Grosz surmised, with around twelve to fourteen more joining each month. Lewenthal was convinced that "only a happy man pays for little oil paintings," in Grosz's words, and therefore barred surrealism and abstraction—in short, anything complex, challenging, or disturbing—from the walls of the AAA. Lewenthal slanted his offerings instead in the direction of Regionalism and American Scene work.[10] Among the more recognized artists who signed on with the gallery, Thomas Hart Benton made $20, 000–$30, 000 a year through AAA sales between the mid-1930s and late 1940s; John Steuart Curry, who joined Lewenthal's enterprise in 1941, received $4,000 in commissions in the first three weeks.[11] Lewenthal arranged contracts for Benton, Curry, and other artists to do advertising work for tobacco, oil, and other large business clients of the AAA. In her study of this decisive phase in the relationship between art and commerce, Erika Doss enumerates works produced by Benton, Curry, and other artists who adapted their production to the expressed advertising needs of their new corporate patrons. The 1930s and 1940s also mark the ascendancy of corporate art patronage as an explicit instrument of cultural legitimacy. The story of entrepreneurial largesse toward the arts during this period has long been recognized as part and parcel of efforts to reverse public hostility to big capital that had emerged during the Depression years.

Grosz too was given at least one corporate advertising contract, in this case with the Delta Brush Manufacturing Corporation. An advertisement for the company's brushes appeared in the March 1949 issue of *American Artist* magazine. It features a Grosz self-portrait donated by the AAA for the layout, with a text that rehearses the, by then familiar, association of Grosz with a quintessentially "German" temperament, characterized by his "haunted expression" and "violent paintings." Grosz's identity as an artist *and* as a famed German exile became the vehicle for ascribing value to the product whose sale the ad was intended to promote. The Delta Brush ad was followed immediately in the *American Artist* magazine by an extended interview with Grosz. Conducted by Philadelphia critic, Dorothy Grafly, the interview made passing references to Grosz's life in the United States while focusing first and foremost on his embattled career in Wilhelmine and Weimar Germany.[12]

By the late 1940s, Grosz's exile notoriety had thus become a form of cultural capital that allowed him, more as a media personality rather than as an artist, to sustain a modest living. His status appears not to have been lost on Leon Harris, Jr., the twenty-five-year-old Jewish department store owner who, through Lewenthal's mediation, hired Grosz to do his *Impressions of Dallas* in 1952. This was Lewenthal's first success, after several previous

attempts, to entice Grosz into accepting opportunities for such semicommercial work.[13] Like many entrepreneurs of his generation, Harris well understood the role art could play in matters of corporate and, in this instance, civic legitimacy. Harris was one of a handful of successful Dallas businessmen who constituted the city's "oligarchy" in a town where civic and corporate culture were one and the same. His commission of Grosz came at a time of bitter, even violent, struggle between traditionalism, entrepreneurial capitalism, and halting attempts to modernize the city socially and culturally in a way that kept pace with its meteoric rise as a major center of national commerce.

Harris was the grandson of Adolph Harris, who founded the A. Harris & Company Department Store in Dallas in 1886. After graduating from Harvard in 1947, Leon Harris, Jr., along with his cousin Arthur Kramer, Jr., served as vice president and president of the store, respectively. By the 1950s, Harris Department Store ranked second only to Neiman-Marcus as a major retailer of clothing and apparel; both stores established Dallas as a national center of fashion during this period. Known for his liberal views (as well as his fiery and impetuous personality), Harris was impatient with Dallas's entrenched traditionalism in artistic as well as political matters. He shared the views of some in the business oligarchy who claimed responsibility for fostering greater cultural openness in a city deeply in thrall to religious fundamentalism, racism, and hostility to the new and different. "It is the duty of local institutions who have prospered in a community to help those civic organizations which contribute to the artistic and intellectual life of that community," Harris insisted.[14]

The *Impressions of Dallas* commission was intended to commemorate A. Harris & Company's sixty-fifth anniversary. Part of Grosz's series was also earmarked as a gift to Dallas's bastion of civic culture, the Dallas Museum of Fine Arts (DMFA, now the Dallas Museum of Art), on whose board of trustees Harris served at various times throughout the 1950s and 1960s. From its original incarnation as the Dallas Art Association of 1903, the DMFA's trustees were drawn from the elite of the city.[15] In 1929, Arthur L. Kramer, Harris's uncle and then president of the Harris Department Store, took over as president of the Dallas Art Association. He remained in that capacity until 1940. During his tenure, Kramer transformed the Dallas Art Association from a cultural association dominated by women into a "more professional" organization under the direction of the city's men of business. The revamped Dallas Art Association focused on fund-raising, management, and, above all, the use of the arts as an instrument in building the kind of image deemed appropriate to the city oligarchy's entrepreneurial aspirations.

In 1936, the Dallas oligarchy was successful in its bid to have the annual State Fair of Texas permanently sited on the fairgrounds, now called Fair

Park, in east Dallas. The State Fair, nominally staged by and for the people of Texas, came to serve first and foremost the economic and political purposes of the Dallas oligarchy. This event continues to bring state and national attention, as well as a considerable amount of tourist revenue, to Dallas each year. The co-opting of the State Fair in 1936 was thus a Dallas public relations and commercial coup of the first order. From it emerged the so-called Citizen's Council, founded by R. L. Thornton, chairman of the Mercantile National Bank and longtime president of the State Fair of Texas. The Citizen's Council became the formal organization of the Dallas oligarchy, whose ranks grew from 100 leading Dallas entrepreneurs in 1936 to some 200 members by the late 1940s. The Citizen's Council prided itself as a group of "yes and no men" who answered to no one, including the local government and their own companies, in taking swift, autocratic action in matters of politics and economy in the city.

An admiring article on "The Dynamic Men of Dallas" published in *Fortune* magazine in 1949 described the activities of these "yes and no men" as a model for the efficient, well-run city *cum* corporation. In true oligarchic fashion their sense of decorum or, more precisely, their financial self-interest in promoting Dallas as a safe place to do business, exerted its restraining influence (read censorship) most notably on the workings of the city press. "There is no public sin in Dallas," the *Fortune* article noted. "Unlike most of its rivals, [the city] is not amused by violence or the excesses of its citizenry; it does not even mention them. Over a weekend in which San Antonio papers cheerily recorded six killings, six robberies, two rape cases, and a minor riot, Dallas papers observed no local disturbances whatsoever."[16]

A new Dallas Museum of Fine Arts was built in the middle of Fair Park and opened to the public on June 6, 1936. Each year, the DMFA hosted an exhibit on the occasion of the State Fair of Texas. The first DMFA Fair exhibits were in keeping with the conservative tastes of the majority of the board of trustees. These included a display of British portraits in 1938, Spanish masters in 1939, and the obligatory exhibits of Texas and Southwest artists. In 1943, Jerry Bywaters was made director of the DMFA and oversaw the unveiling of Grosz's *Impressions of Dallas* at the Museum for its contribution to the State Fair in 1952. The works were then slated to tour Texas and adjoining states throughout the following year.[17]

A former student of John Sloan's at the Art Students' League, Bywaters belonged to the school of Texas regionalist painting but was nonetheless committed to the promotion of contemporary and internationalist tendencies in the art world. In 1927, he toured Europe and in 1928 traveled to Mexico to meet the Mexican muralists Diego Rivera and José Clemente Orozco. His State Fair show of 1948 featured fifty-one works by Rivera, David Alfaro Siqueiros and Rufino Tamayo. For State Fair shows in 1949

and 1951, he took advantage of loan exhibitions from the Art Institute of Chicago and the Museum of Modern Art. This allowed him to introduce the notoriously squeamish Dallas art public to works by leading European modernists, including Braque, De Chirico, Dali, Gauguin, Kokoschka, Matisse, Picasso, and Tanguy, among others. Bywaters attempted to develop his more progressive curatorial vision over and against the aesthetic provincialism of the DMFA board. Harris and Stanley Marcus, fellow board member and owner of Neiman-Marcus Department Store, were among the few dissenting voices on the board during this period. The majority of the trustees, Marcus remembered, were intolerant of anything other than art devoted to "birds, beasts, and angels with their clothes on."[18]

Bywaters used the fact that the DMFA had neither endowed funds nor the collection of older museums as a pretext for bringing in traveling shows from the Museum of Modern Art and other prestigious East Coast museums. He also built up education and community outreach programs. Grosz's work *Funeral Third Class* appeared along with a preparatory study for Picasso's *Guernica* in one such loan show from the Museum of Modern Art in 1946.[19] In his acquisitions plan, Bywaters stressed the purchase of works by contemporary U.S. artists over those by Europeans, which were both beyond the financial reach of the institution and, no doubt, the traditionalist cultural threshold of the board. Lewenthal's AAA, with its emphasis on benign representational art, served as an important source of acquisitions for Bywaters. The AAA's relationship to the DMFA lagged during World War II but revived thereafter when the Museum was once again in a financial position to purchase new works for the collection.

In 1945 Lewenthal arranged reduced prices for the DMFA on works by Rafael Soyer, Adolf Dehn, William Gropper, Grosz, and Benton among others.[20] The board approved the acquisition of Benton's *Prodigal Son* for $1, 200 and Grosz's nude study *Model Arranging Her Hair* for $275.[21] Bywaters wrote to Lewenthal expressing his pleasure that the trustees had supported his purchase recommendations, adding, "As you can imagine it took some doing, since our folks aren't entirely apace of some ideas of American art." Bywaters asked Lewenthal to publicize the recent acquisitions to help put the DMFA back on the art-buying map.[22]

From 1952 to 1954, Stanley Marcus served as president of the DMFA board of trustees. During his term, he used the DMFA as a platform for forging the role of the business community in the arts and attempting to goad Dallas's cultural aspirations in the direction of recent artistic tendencies. As part of this effort, he spearheaded the DMFA exhibit, Some Business Men Collect Contemporary Art. Held in April 1952, the show included fifty-three works by Matisse, Picasso, and other leaders of the international avant-garde. Attention focused not on the works but on

the business records and photos of the various corporate barons from Dallas and across the nation who loaned pieces from their private collections for the purpose. "The implication was strong," Bywaters observed laconically, "for local businessmen to expand their reputations by buying contemporary art."[23] Grosz's work and status as an exile provided, under the circumstances, the desirable cachet of European vanguard cultural traditions in the acceptable guise of representational art. In the spirit of Marcus's message, Harris commissioned Grosz for works intended not solely for his private collection but also for a city in which business leaders such as Harris styled themselves as economically, politically, and culturally vanguard .

Grosz arrived in Dallas with Lewenthal on May 13, 1952. They were greeted at the airport by Harris and photographers who took several photos as the first installment of Grosz's publicized trip to the city.[24] Press reports noted his infamy as a degenerate artist as well as his long-standing desire to visit the Southwest.[25] Newspaper coverage of his arrival and travels around Dallas were featured alongside headlines on the Korean War, the Soviet Union's strengthening control in Eastern Germany, and the upcoming November presidential election battle between Dwight Eisenhower and Adlai Stevenson. True to the city's penchant for journalistic censorship, the extreme racial tension and violence that gripped Dallas at the time went largely unremarked.

Grosz stayed at the luxurious Adolphus Hotel, built by beer magnate Adolphus Busch of the Anheuser-Busch Brewing Association in 1912. Located in the heart of downtown, the hotel's ornate Beaux Arts façade of brick, granite, and slate was in 1952 (and remains today) one of the few oases of historicist architecture in a city relentlessly dedicated to the new. Grosz spent two weeks there sweltering in the hot Texas sun and developing sketches for later translation into oils, watercolors, and drawings.[26]

The majority of Grosz's *Impressions of Dallas* works were devoted to recording the changing built environment in Dallas's downtown where the City of Towers aspired to a skyscraper profile rivaling that of New York City.[27] Since the end of the World War I, Dallas's business leadership showed a growing fondness first for the streamlined façades of early skyscraper architecture and later for modernism's glass and steel aesthetic as an expression of entrepreneurial progress and corporate power. Modernist architecture, with its disavowal of tradition, also supplied the changing city with a certain measure of readymade, ideologically useful amnesia. Towering monolithic façades progressively expunged traces of Dallas's past—as well as its present—that tried to make claims on the city other than those put forward by its oligarchy and conservative white majority.

In works such as the watercolors *Old and New, Shopping Center, Right Out of the Plains*, and *The Growing City*, Grosz rendered the evolving urban

center in a grid of crisscrossing linear washes. In their architectonic form and tremulous watercolor indeterminacy, such mirage-like images captured the city's growing rectilinearity in its finished and unfinished aspect. For other watercolors such as *Dallas Broadway, A Dallas Night,* and *Streetcorner at Night,* Grosz adopted a semiabstract style of kaleidoscopic splashes of color. The images convey through montage a disjointed and frenetic pulse that lends the city an air of fast-paced modernity. Advertising signs, street lamps, and featureless city dwellers collide and disperse in an urban environment saved from total anonymity by the city's fashion trademark of ten-gallon and panama hats. In *A Dallas Night,* Grosz included the city's red-winged Pegasus logo that graced the top of Dallas's tallest building of the time, the twenty-nine story Magnolia Petroleum Building built in 1922.

In her discussion of Grosz's Dallas *Impressions,* Kay Flavell notes a difference between Grosz's renderings of Dallas and his earlier engagement with New York City's urban experience shortly after his immigration there in 1933.[28] For his New York cityscapes of the early 1930s, Grosz made numerous random sketchpad notations that reveal the artist's casual curiosity about his new environment. These notations eventually made their way into drawings and watercolors that detailed the facial features, gestures, attire, and interactions of the city's various urban types. Other works devoted to New York's architectural profile are rendered with a spatial immediacy that suggests Grosz's sensory immersion in the city's forest of multistory façades. By contrast, his Dallas images rely on semiabstraction as well as distant panoramic views that signal an apparent detachment of the artist from his urban subject. The formal character of some of the works also indicates Grosz's hesitant attempt to adapt his characteristically representational art to gestural abstraction. Whether such stylistic experiments were undertaken on Grosz's initiative or at Harris's request remains unknown. The awkwardness of Grosz's Dallas watercolors suggest in any event a physical as well as psychic distance between the artist and his subject and a less than promising effort to adapt his art to the current directions of the U.S. vanguard.

For the signature pieces of the commission, a series of large-scale oil paintings, Grosz avoided the formal experiment of his watercolor renderings of the city. Largest among these, measuring nineteen and a half inches by twenty-nine and a half inches, was the oil painting entitled *Dallas Skyline.* A surviving press photo records the trip taken by Grosz and Lewenthal to the western outskirts of the city where Grosz began work on the piece. Decked out in ten-gallon hats, the two recline somewhere on a grassy plane near the banks of the Trinity River. Grosz has cast off his jacket in the hot Texas sun, while Lewenthal retains a sweltering, business-like

decorum in full suit and tie. The artist directs his attention not to Dallas's downtown, but rather to Lewenthal. He makes notations on his sketchpad as Lewenthal speaks and gestures toward (and presumably interprets for Grosz) the features of the city skyline. The photo makes vivid the hierarchical relationship between artist and entrepreneur and the commercial mediation that constituted Grosz's "authentic" experience of the Texan "Wild West" in 1952.

Distant and iconic, the city rises up in Grosz's *Dallas Skyline* from an endless flat plain. Striated clouds form a radiant backdrop to the city's multistory façades. Grosz places particular emphasis on Dallas's logo-like Magnolia Building and its winged Pegasus, although the photograph makes clear that the structure was already facing competition as the tallest edifice in the city from surrounding office blocks. As part of its prideful image of the self-made, Dallas holds fast to the story of its unlikely beginnings and the force of entrepreneurial will that made the city what it is today. A settlement located on a flat plot of blackland soil in the midst of the desolate Texas prairie, Dallas was established in the 1840s. Far removed from trade routes or ports, early Dallas claimed its first coup when it convinced the state to run major rail lines through the town to connect the settlement to the rest of the Southwest and beyond in the 1870s. From that point forward, Dallas made its climb from isolated backwater to a major center of commerce that eventually evolved into the undisputed banking and insurance capital of the Southwest. Grosz's image, with the Dallas skyline looming up mirage-like in a vast expanse of open land, captures this sense of the "miraculous" that continues to animate Dallas boosterism down to the present day. In a watercolor version of the Dallas skyline, entitled *Flower of the Prairie*, Grosz obligingly depicts the city suspended in midair and surrounded by an aureole of blue light.

The Civil War era saw Dallas emerge as a haven for slaveholders who held themselves exempt from emancipation long after the conclusion of the war. With an uncurtailed supply of black slaves, slaveholders built an empire that by 1900 positioned the Dallas region as the largest supplier of cotton in North America. In the 1930s, oil was struck 100 miles east of the city, making Dallas the financial capital of the region's vast oil industry.

In a nod to city tradition, the other oil paintings in Grosz's *Impressions of Dallas* series commemorate the triumvirate of historic Dallas resources—cotton, oil, and cattle. Grosz had never handled these themes before and their rendering clearly presented him with difficulties. Artistic precedent took the upper hand over immediate experience in at least two of the works, furnishing Grosz with a well-established, indeed canonical, visual history on which to draw in formulating his compositions. For *Cotton Harvest, Dallas*, for instance, Grosz made use of Millet's prosaic images of rural labor.

Celebrated works of critical realism, Millet's sidelong views of gleaners and sowers drew attention to the ruddy and coarsened features of impoverished rural life in mid-nineteenth century France. Grosz's harvesters, by contrast, shed this critical dimension. They present their backs to us, backs that barely break the infinite horizon of cotton that stretches out before them. Faces turned away, those whose ceaseless and exploited work made Dallas's cotton empire possible remain anonymous. Cotton harvesting bags slung over their shoulders also aestheticize the mechanical, repetitive motion of the five pickers. The bags appear not burdensome but instead like silken trains of bridal gowns that follow in the processional wake of the harvesters as they move in stooped synchrony over the field.

For his commemoration of the Dallas oil industry, Grosz's models were likely those of Charles Sheeler and other Precisionists whose gleaming, hard-edged renderings of industry fed the techno-fetishism of 1920s culture. However, Grosz's vision in *Oil Refining* is less affirmative and more infernal. Behind the silhouetted tanks and fence that block our entrance to the site, stacks loom up in a desolate landscape of fiery orange light and smoke. A switchback recessional plane leads the eye past brick factory sheds into a far distance that allows no relief from the refinery's hellish and dehumanized space. The emphatic architectonics of the *Oil Refining* composition echo and invite comparison with the rectilinearity of the watercolor cityscapes in Grosz's *Impressions of Dallas*. The work reveals the city's grimy underside that gave rise to its majestic towers and economic prowess.

Grosz used a similar switchback compositional structure for the third and last oil painting in the series devoted to Dallas's foundational industries. The work depicts Longhorn cattle herded through a paddock that zigzags from the foreground to the distant horizon. In *Cattle*, emphasis rests not on the diminutive cowboy who appears on horseback at the far end of the run but rather on the powerful forms and seemingly limitless numbers of cattle that flow in a steady stream into the immediate foreground. This version of *Cattle*, which is now in the Dallas Museum of Art collection, is significantly reworked from Grosz's first attempt at the theme. A photo of the earlier rendering shows only a clutch of Longhorns in the foreground (most of which were preserved in the later version) with a cowboy who looms over them from the middle ground. The cowboy sits astride a round-bellied, peg-legged horse whose awkwardness of form derives more from Grosz's early Wild West caricatures than observation of nature. The poor rendering of the horse and rider is matched by the incongruous spatial relationship of the composition as a whole. The Dallas Museum of Fine Arts returned *Cattle* to Grosz, allegedly because some cracks had appeared on the surface.[29] Grosz took the opportunity to rework most of the composition, opting for a more consistent use of recessional space and a greater emphasis on the large herds

and abundant natural wealth of the Dallas cattle industry. While reworking the canvas, Grosz wrote with thinly disguised irony to his brother-in-law Otto Schmalhausen, that he was now reduced to painting cows. "Thank God the cows aren't life-size, like those of dear old Rosa Bonheur," he quipped.[30]

Grosz's handling of the *Impressions of Dallas* oil paintings and semiabstract urban watercolors showed the tension of the semicommercial conditions under which they were produced. Grosz later complained about the difficulties involved in trying to appease the interests of Harris and others who evidently often intervened in the project.[31] Coupled with his unfamiliarity with the various motifs he was asked to render—cows, cotton pickers, refineries, and the like—most of the works in the series were judged at the time and continue to be assessed as less than satisfactory. A few of the watercolors, most especially *In Front of the Hotel* and *A Glimpse Inside the Negro Section of Dallas*, have been spared the oblivion of the rest, however. They regularly make their appearance in summary histories of Grosz's career, not the least because they tap more directly into the sort of work in caricature and portrayal of human types for which Grosz became acclaimed in his earlier career. More typical of the art he produced outside of commercial circumstances, these works thus assume the status of a less orchestrated, more authentic expression of Grosz's response to his Dallas environs. They are, as shall be discussed in the following, nonetheless mediated in significant ways by assumptions, Grosz's and his patron's, that shaped his artistic response to the motif.

In Front of the Hotel captures the panoply of types that might have crowded the street on any given day in front of the Adolphus Hotel (figure 2.1). A woman and a young black newspaper seller function as a pair of mobile bookends that frame a stationary cluster of four men who idle on the city sidewalk. A well-fed Texas businessman in a ten-gallon hat and tan jacket grins broadly. He looks in the direction of another man wearing a rumpled, checked shirt who stands slouching with a toothpick clenched between his teeth in the right foreground of the composition.[32] The unshaven and impassive face of this second figure is matched by that of a farmer standing in the middle ground with hands stuck into the pockets of his overalls. Ringed by the other figures in the composition is an urban cowboy who crouches in rolled-up dungarees, hobnail boots, and a string tie while balancing a cigarette with urban sophistication between the fingers of his left hand.

The four men appear to be variously admiring and kibitzing about the woman who primly strides past them on the city street. Grosz portrays her like a model lifted directly from the pages of Harris's department store advertising. She wears the cinched-waste skirt and cutaway jacket that were

Figure 2.1 George Grosz, *In Front of the Hotel* (1952). Watercolor on paper, 18 1/2 × 14 1/8". Dallas Museum of Art, gift of A. Harris and Company in memory of Leon A. Harris, Sr. © Estate of George Grosz / Licensed by VAGA, New York.

then the height of women's fashion. As one Dallas commentator informs us, the "fetching" attractiveness of the city's women was yet another confirmation of the robust masculinism that made the city what it was:

> Everything in Dallas is bigger and better; the parties are plushier, the buildings more air-conditioned, the women better dressed, and the girls more fetching. And in all of these things it is, finally, a monument to sheer determination. Dallas doesn't owe a thing to accident, nature, or inevitability. It is what it is—even to the girls—because the men of Dallas damn well planned it that way.[33]

Grosz's talent for rendering urban types thus folds seamlessly into the boosterism that was intended to characterize the *Impressions of Dallas* series as a whole. But the work also underscores the hierarchies and exclusions on which the city's self-congratulatory image was based. The privileged moment of idleness enjoyed by the white men in *In Front of the Hotel* contrasts not only with the white woman but also with the black newspaper boy who balances a stack of papers on the top of his head as he moves away down the city sidewalk. Gender and race combine in this and other works in the *Impressions of Dallas* series that touch, however obliquely, on the central problem of ethnic relations residing at the violent core of the modernizing city whose profile Grosz's works were intended to capture.

The city's robust modern architecture, along with its aesthetic of amnesia, must indeed be seen against the backdrop of the miserable black slums that choked the Trinity River basin, Mill Creek, and other areas that ringed the city center during this period. As the trend toward urbanization began to make itself felt in the black community during and after World War II, a vicious "housing shortage" conveniently cropped up under jerry-rigged interpretations of the law that kept the city's blacks from purchasing homes in white neighborhoods. Violence against blacks increased in the 1940s as more edged their way into the middle class thereby threatening to blur the increasingly permeable divide that kept the city segregated along race and class lines. In the early years of the twentieth century, Dallas had been a national "epicenter" of Ku Klux Klan violence; by the late 1940s it was once again a flashpoint of racial conflict.[34]

Leon Harris's uncle, Arthur Kramer, Sr., was foremost among the Dallas oligarchy in his efforts to rally support for cleaning up the city's slums.[35] As a national phenomenon, such slum "clearance" had the effect not of improving the lives of the black citizenry but rather of facilitating corporate land development while concentrating blacks in "projects." Dallas, despite whatever altruistic motivations Kramer might have entertained, was no exception to this deplorable rule.[36] Harris appears to have shared his uncle's particular brand of liberalism and a sympathy for progressive causes no

doubt shaped by some of his own experiences as a prosperous Jewish retailer in a city riddled with ethnic hatred. In the 1950s and 1960s, painted swastikas appeared from time to time on Jewish-owned stores. Harris, like other Jewish entrepreneurs, also endured the predictable round of exclusions from the city's swank country clubs.[37]

In 1977, Harris published *Merchant Princes* in which he tells the story of the great department store dynasties of the Filenes, the Strauses, the Gimbels, the Marcus family, and the Harrises. He focuses his attention on the remarkable story of how many Jewish department store owners, based on their own family histories of hardship and discrimination, assumed a leading role in promoting social reform and progressive causes.[38] Harris's own "otherness," in short, may well have attuned him to broader issues of discrimination in the city he asked Grosz to commemorate.

After a series of bombings of middle-class black homes in the city, the Citizen's Council of business oligarchs (not the city government, it should be noted) convened a grand jury in 1951 to look into the crimes.[39] The inquest revealed that support for the instigators of these acts and the roots of racism burrowed deep into the white middle-class community, including its religious and civic leadership. The Citizen's Council, however, took no decisive action based on its findings. As Jim Schutze describes in his study of Dallas's race politics during this period, the city oligarchy made a show of its opprobrium in an effort to keep Klan violence at bay but not to eliminate it altogether. No effort was expended, in other words, to push for appropriate legislation and enforcement of justice; no demands were made to begin integration, economic redress, and the stamping out of racism once and for all. Schutze calls this pernicious and historic compromise between business and Dallas's majority white culture "The Accommodation." The grand jury of 1951 nonetheless marks the widening gap that began to emerge between the entrepreneurial elite of the city, whose abhorrence of racial violence was grounded at the very least in its negative implications for business, and a white middle-class population still beholden to racism, vigilantism, and intolerance.

As blacks became more empowered with the first kindling of the Civil Rights Movement, their protests began to mesh with cold war paranoia in the minds of the white majority who readily construed black anger as communist conspiracy. Until 1952, Dallas had voted democratic with the rest of the Dixie-Crat South. But in this election year, which pitted republican Dwight Eisenhower against democrat Adlai Stevenson (who enjoyed the support of Dallas's black leadership),[40] the city swung decisively to the Republican Party.

Grosz's own response to issues of race and racism in the United States had already begun to take shape during his years as a vanguard artist in

Wilhelmine and Weimar Germany. Like many artists of his generation, Grosz framed his notions of black culture within the rhetoric of the primitive that emerged first and foremost within the context of German colonialism and was later elaborated in responses to American jazz. Grosz's early caricatures of African blacks conform well to the stereotypes of virility and spontaneity that deemed blacks the desired "other" in the European primitivist imaginary. As a Communist Party member in the 1920s, Grosz was also familiar with the party's indictment of the U.S. legacy of slavery and persistent racial discrimination as central to the American capitalist system of class exploitation. After his emigration to New York, Grosz used his perception of the city's black community as a deliberately provocative means of distancing himself from the Communist Party cause. In letters to his radical friends then in exile, Grosz claimed that African-Americans were much better off than imagined. The cars and fancy cloths he saw sported by African-Americans on his trips through Harlem in the early 1930s gave the lie, he insisted, to Communist Party assumptions about the United States and the capitalist system that defined it.[41] In the few representations of African-Americans that Grosz produced during his first years in New York, he eschews outright stereotype in favor of gentle caricatures that emphasize an elegance and refinement in accord with his new vision of the black "other." Grosz found his selective fantasy of African-American life challenged by the black experience in Dallas.

Grosz's most direct exposure to Dallas's African-American communities appears to have come from a chance encounter with a cowboy whom he met one day on the city street.[42] *Cowboy in Town* depicts his obliging tour guide, who, after posing for Grosz, introduced the artist to areas marginal to the downtown's skyscraper opulence. On the city's west end, Grosz saw Dallas's nineteenth-century Romanesque-style courthouse and the city founder's log cabin, which he later committed to watercolor. In *Refreshments on the Way*, he recorded life outside the city center in an image of a cowboy in front of a drive-up refreshment stand. In a work entitled *Old Negro Shacks*, Grosz responded with an aestheticizing eye to the squalid living conditions of much of the city's black population (figure 2.2). The term "old" in the title accounts not only for the rough-hewn timbers and ramshackle fences Grosz uses to describe the houses he depicts in this work, but it also engages the conceit that such conditions are a "thing of the past" and out of step with current conditions. Indeed, Grosz's representation appears based more on prosaic images of nineteenth-century rural life than on the reality of cramped tin shacks, poverty, and sewage-choked streets that characterized Dallas's ghetto communities in the early 1950s and beyond. In *Old Negro Shacks* puffs of green watercolor suggest large shade trees. Together with broad porch awnings the trees provide respite from the hot Texas sun. A woman

Figure 2.2 George Grosz, *Old Negro Shacks* (1952). Watercolor on paper, 19 × 26 1/4". University Art Collection, Southern Methodist University, Dallas, UAC.1961.08.

seated in front of one house and a man walking a young girl in front of another suggest a community in which the sense of family, despite hardship, remains unbroken. Seen within the context of other images in the series, however, *Old Negro Shacks* provided a poignant reminder of how Dallas's economic "miracle" was grounded in the cultural logic of race that pitted white affluence against black disenfranchisement and chose to see whiteness as the city's future and blackness as a thing of its past.

Grosz also visited Deep Ellum, the commercial and entertainment area of the black ghetto, located on the eastern fringe of the downtown theater and shopping district. A columnist for the *Dallas Gazette*, one of the city's "Negro Weeklies," described Deep Ellum thus in 1937:

> Down on "Deep Ellum" in Dallas, where Central avenue empties into Elm street is where Ethiopia stretches forth her hands. It is the one spot in the city that needs no daylight saving time because here is no bedtime, and working hours have no limits. The only place recorded on earth where business, religion, hoodooism, gambling and stealing goes on at the same time without friction. . . . Last Saturday a prophet held the best audience in this "Madison Square Garden" in announcing that Jesus Christ would come to Dallas in person in 1939. At the same time a pickpocket was lifting a week's wages from another guy's pocket, who stood with open mouth to hear the prophesy.[43]

Grosz rendered this "Harlem of Dallas" in a work entitled *A Glimpse Inside the Negro Section of Dallas* (figure 2.3). Vivid, satiny stains of watercolor give form to the black hair, brown cheekbones, and red ribbons, lips, and shirts of the people whose faces crowd Grosz's composition. The full moon poised over the palm tree in the background marks this as a nighttime scene in this sleepless realm of "no daylight saving time." Light reflects off of the awnings and filters through glass windows that line the street. *A Glimpse Inside the Negro Section of Dallas* serves as an inverse pendant to Grosz's renderings of Dallas's white community in other works in the series, most suggestively with the watercolor *In Front of the Hotel* discussed earlier.

In *In Front of the Hotel* the erotic economy of the watercolor was contained within the image's narrative framework. There, Grosz organized the looks and actions of the men around the charms of the woman who passed them by on the city street. In *A Glimpse Inside the Negro Section of Dallas*, by contrast, narrative structure gives way to montage. Grosz gives prominence to the two women's faces that occupy the central axis of the composition. The heads of three men appear on either side and behind them. The men direct their attention away from, rather than toward, the women in their midst. The artist/viewer is instead placed in the position of desiring observer with an illicit "glimpse" inside this forbidden, feminized, zone of Dallas city life. In the case of the two male profiles that appear to the left and right of the center foreground, Grosz appears to have recycled depictions from his earlier New York repertoire of street types.[44] Recycling of motifs coupled with the montage-like arrangement of the composition underscores the perception that this is a work weighted more toward primitivist imaginings of the "other" rather than observation from nature. Grosz beckons our gaze through his detailed handling of the broad features, lush makeup, and beribboned finery of the women whose faces he presents to us. Their lavish appearance contrasts markedly with the chaste restraint of the white woman in *In Front of the Hotel*.

Grosz returned to Dallas on October 2, 1952 for a reception at the Harris Department Store and the Dallas Museum of Fine Arts prior to the opening of his *Impressions of Dallas* exhibit. *Old Negro Shacks* and *A Glimpse Inside the Negro Section of Dallas* were included in the suite of works that were ready for unveiling at the State Fair of Texas between October 4 and November 9.[45] The white mainstream press response to Grosz's work was brief, polite, and minimally informative. Bob Brock, art critic for the *Daily Times Herald* simply noted the presence of "the world famous artist's impressions of Dallas" at the DMFA Fair exhibit and reserved the lion's share of his coverage for the Texas Art Exhibition that was also hosted by the DMFA at this time. It featured some 741 works by 441 Texas artists.[46] Grosz's work was drowned out in general Fair coverage as well. The white

Figure 2.3 George Grosz, *A Glimpse Inside the Negro Section of Dallas* (1952). Watercolor on paper, 26 1/4 × 19". Dallas Museum of Art, gift of A. Harris and Company in memory of Leon A. Harris, Sr. © Estate of George Grosz / Licensed by VAGA, New York.

mainstream presses focused instead on the festival's livestock contests, rodeos, Jerry Lewis and Dean Martin's vaudeville review, the unveiling of "Big Tex" (a fifty-foot papier mache cowboy), and the Cotton Bowl game. The black press, meanwhile, concerned itself primarily with the question of whether blacks were welcome to attend the Fair at all.[47] Since the 1930s, African-Americans had only been admitted on a special day set aside for them. It was called Nigger Day in the 1940s and was redubbed Negro Achievement Day by Fair officials in 1950. In 1953, the Fair was finally opened to blacks for the duration of the festival. They continued to be banned from the Midway and restaurants, however, and could only go on rides "where separate facilities [were] available and no contact [was] involved." Strategic posting of signs indicated Negro areas at various amusement attractions.[48] The nature of public response to Grosz's vision of Dallas, including his portrayals of the city's black population, thus remains impossible to gauge from the meager press coverage accorded to his work in the State Fair.

Privately, however, Leon Harris appears to have been less than satisfied with the lackluster initial results of his commission. Grosz wrote to Harris as the exhibit was nearing the end of its third week saying he had heard that Harris was "not completely satisfied." Grosz was anxious to do what he could to give him "absolute compensation." He added, "Of course there are always persons who criticize, who think they know better and very often it is nothing but envy. Please let me know what you suggest, in order to straighten out some creases in our friendship."[49]

Grosz came away from the Dallas commission with a ten-gallon hat and a pair of cowboy boots—in addition to a much needed $15,000. But his encounter with the Texas prairie, Grosz confided to his friend Rudolf Schlichter, had been a melancholy one. It held for him none of the romance he imagined in his youthful readings of the Wild West.[50] The Dallas commission was, moreover, "disgusting work, because I 'sold' myself (this time out of a pure need for money)," he later complained to his onetime patron Felix Weil.[51]

Works from the commission were shown again in 1954, this time at the Associated American Artists Gallery in New York. The exhibit coincided with a major retrospective of Grosz's work at the Whitney Museum. Press response to his *Impressions of Dallas* was again minimal and not terribly positive. A review in *ArtNews* praised several of Grosz's Dallas watercolors, but it reserved negative judgment for the oil paintings with their "unpleasantly crusty surfaces and soft composition."[52]

The Dallas chapter in Grosz's career did not end in 1954, however. The following year, his life and art became embroiled in the mounting wave of reaction in the city that this time swept through the Dallas Museum of Fine

Arts. In 1952, Congressman George Dondero delivered his infamous speech "Communist Conspiracy in Art Threatens American Museums" before the U.S. House of Representatives. Sensing the McCarthyist chill, Bywaters, in his role as director of the DMFA, called on the board to form a standing committee on art and politics. In March 1955, the Public Affairs Luncheon Club, a political affairs social organization of Dallas women, charged the Museum with favoring subversive (i.e., abstract) art. More ominously, they claimed the Museum was "promoting the work of artists who have known communist affiliations to the neglect of . . . many orthodox artists, some of them Texans, whose patriotism . . . has never been questioned."[53] Their list of the objectionable included Joseph Hirsch, Chaim Gross, George Grosz, Jo Davidson, Picasso, Rivera, and Max Weber. In the coming months, their charges were joined by those of the Daughters of the American Revolution, the Veterans of Foreign Wars, the American Legion, and a host of local arts clubs.[54] Stanley Marcus, as president of the Dallas Art Association, attempted, along with Bywaters, to diffuse the situation by taking it directly to the Dallas public. Inviting visitors to judge for themselves, they hung inside the Museum entrance several abstract pieces along with three works by so-called communist artists: a portrait by Rivera, a scene of workers by Joseph Hirsch, and Grosz's *Model Arranging Her Hair*. Despite this show of bravado, however, the Museum, taking its cue from the city's newly minted policy of political duplicity, opted for an "accommodation." *ArtNews*, championing the cause of artistic freedom, scornfully reported the DMFA board of trustees' final action in the matter. While claiming support for open artistic expression, the board nonetheless instated a policy against the exhibition of known communist or communist-affiliated artists, regardless of the quality or content of their works.[55]

III

Did Grosz's inclusion of racial difference in his *Impressions of Dallas* contribute to his later denunciation as a negative, "communist" influence on the part of Dallas's cultural Cold Warriors? Given the series' virtual lack of reception, the answer to this question remains unknown. Had Grosz's images been more accomplished and provided a more critical view of Dallas, this initial obliviousness and later condemnation might well be chalked up to a cultural climate predisposed to disavowal and fear of anything that challenged the status quo.

True to their intended purpose, however, the works affirm the largely benign vision of Dallas championed, one assumes, by Grosz's patron, Leon Harris. A Dallas outsider by virtue of his Jewish ethnicity, Harris was also very much an insider when it came to the political and economic fabric of

the city. Grosz's own outsider status likely became enlisted in the Dallas commission as part of Harris's larger entrepreneurial aims (shared by a growing number among the business community) to include Dallas's "others" within that fabric.

But Grosz's outsider perspective did little to help him "see" and capture the realities of the city he came to render. Reaching back into his repertoire of stereotypes and assumptions about "blackness," Grosz produced images of Dallas's African-American community that, in the end, avoided challenging the kind of primitivist thinking that subtended Dallas racism in the first place. Blacks were, nonetheless, represented in the *Impressions of Dallas* as part and parcel of a city inclined—in some cases criminally—to erase their presence altogether. While Grosz was thus not able to "see" the realities of Dallas black life, his own experiences of persecution and displacement may, however, have inclined him, along with his patron, to allow Dallas's persecuted and displaced to be "seen" as part of the city's structure. Such inclusion challenged the status quo only insofar as it furthered a process consonant with the goals of political liberalism and entrepreneurial capitalism during the incipient phases of the Civil Rights Movement. The greatest challenge, in the end, seems to have been experienced by Grosz himself who was forced to reckon with the fundamental change the Dallas commission signaled and demanded in the meaning of exile as it pertained to his life and art.

As part of the German vanguard in the Wilhelmine and Weimar years, Grosz had adopted "exile"—in the guise of the Indian—as an artistic metaphor and mode of critical detachment from his cultural environs. With his flight to the United States in 1933, however, exile became for him the lived experience of political persecution and banishment. In the shadow of World War II, and with the burgeoning growth of the U.S. culture industry, Grosz came to experience his outsider status anew as a double displacement in which his exile assumed the commodity form. As an exile for hire, Grosz's work on the Dallas project thus forms part of a larger history concerning the relationship between European exile and the U.S. culture industry during the World War II years. His experience of exile and commodification provide vivid testimony to a postwar conjuncture in which exile as existence "outside" came more and more to describe experience "inside" a New World order increasingly given over to globalized capital, communications, and culture. The difference and otherness that Grosz's life and art had come to represent through the epochal tragedies of World War II became thereafter both symptom of and catalyst for a changing world order in which the displacement of exile has lost much of its exceptionalism and assumes an evermore normative, but nonetheless traumatic, character.

Notes

I thank Leon Harris, Jr.'s widow, Ms. Jane Wolfe, and Stanley Marcus for sharing with me their memories of Leon Harris and the Dallas art scene in the 1950s. I am grateful to Sammie Morris and the other archivists of the Dallas Museum of Art for making museum documents available to me and their help in getting reproductions of Grosz's *Impressions of Dallas*. Thanks also to Ellen Niewyk of the Southern Methodist University Archives, Nathan Augustine of the Meadows Museum of Art at Southern Methodist University, and Candis Wheat of the Great State Fair of Texas archives for their generous research assistance.

1. On Grosz, the German avant-garde and the Wild West, see Beeke Sell Tower, ed., *Envisioning America: Prints, Drawings, and Photographs by George Grosz and His Contemporaries, 1915–1933* (Cambridge, MA: Busch-Reisinger Museum, 1990); and Sherwin Simmons, "Chaplin Smiles on the Wall: Berlin Dada and Wish-Images of Popular Culture," *New German Critique*, 84 (Fall 2001): 3–34.
2. "Grosz Arrives to paint Dallas in Fortnight," *Dallas Daily Times Herald*, May 14, 1952, sect. 15, p. 3.
3. M. Kay Flavell, *George Grosz: A Biography* (New Haven: Yale University Press, 1988), 273–277; Hans Hess, *George Grosz* (New Haven: Yale University Press, 1974), 241–243; and Birgit Möckel, *George Grosz in Amerika, 1932–1959* (Frankfurt A. M.: Peter Lang, 1997), 184–185.
4. In his autobiography, Grosz described his sharp differences with the exiled Thomas Mann on this subject. He also voiced his disdain for Mann's continued allegiance to German culture in the 1930s. See George Grosz, *A Little Yes and a Big No: The Autobiography of George Grosz* (New York: Dial Press, 1946), 313–321. See also M. Kay Flavell, "Barbed Encounter: A Study of the Relationship between George Grosz and Thomas Mann," *German Life and Letters*, 38 (1984): 110–124.
5. *Look*, February 3, 1948, 44.
6. I treat this subject at greater length in "Hitler and Me: George Grosz and the Experience of German Exile," *Exil: Transhistorische und transnationale Perspektiven*, ed. Helmut Koopmann and Klaus Dieter Post (Paderborn: Mentis, 2001), 243–258.
7. Donald Gordon, "On the Origin of the Word 'Expressionism,' " *Journal of the Warburg and Courtauld Institutes*, 29 (1966): 368–385; and Pamela Kort, "The Myths of German Expressionism in America," *New Worlds: German and Austrian Art, 1890–1940*, ed. Renée Price (New York: Neue Galerie, 2002), 260–293.
8. Erika Doss, *Benton, Pollock, and the Politics of Modernism: From Regionalism to Abstract Expressionism* (Chicago: University of Chicago Press, 1991), 156. See also Erika Doss, "Catering to Consumerism: Associated American Artists and the Marketing of Modern Art, 1934–1958," *Winterthur Portfolio*, 26.2/3 (Summer/Autumn 1991): 143–167.
9. Doss, *Benton, Pollock, and the Politics of Modernism*, 161.
10. George Grosz, letter to Arnold Rönnebeck, September 19, 1943, in George Grosz, *Briefe, 1913–1959*, ed. Herbert Knust (Reinbek bei Hamburg: Rowohlt, 1979), 321.
11. Doss, *Benton, Pollock, and the Politics of Modernism*, 156–166.

12. Dorothy Grafly, "George Grosz: Painter and Prophet," *American Artist* (March 1949): 20–24, 64–65.
13. Flavell, *George Grosz: A Biography*, 338, chapter 8, note 1.
14. Bob Brock, "Noted Artist G. Grosz to Paint Dallas Scenes," *Dallas Times Herald*, May 11, 1952.
15. For this and other information relating to the DMFA, I draw primarily on Jerry Bywaters, *Seventy-Five Years of Art in Dallas: The History of the Dallas Art Association and the Dallas Museum of Fine Arts* (Dallas: Dallas Museum of Fine Arts, 1978), n.p.
16. Holland McCombs and Holly Whyte, "The Dynamic Men of Dallas," *Fortune*, February 1949, 98–103, 162–166.
17. "George Grosz is Adding Last Touches to 'Impressions of Dallas' for Fair," *The Dallas Daily Times Herald*, September 22, 1952.
18. Telephone interview with Stanley Marcus, July 12, 2001.
19. *20th Century Drawings* (Dallas: Dallas Museum of Fine Arts, 1946).
20. Reeves Lewenthal, letter to Jerry Bywaters, February 9, 1945. Bywaters Special Collections, Hamon Arts Library, Southern Methodist University, Dallas, Texas.
21. These works were put on exhibit at the DMFA, along with pieces by Stuart Davis, Max Weber, and others. See Jerry Bywaters, *An Exhibition of Contemporary American Paintings and Sculpture* (Dallas: Dallas Museum of Fine Arts, 1945).
22. Jerry Bywaters, letter to Reeves Lewenthal, February 12, 1945. Bywaters Special Collections, Hamon Arts Library, Southern Methodist University, Dallas, Texas.
23. Bywaters, *Seventy-Five Years of Art in Dallas*, n.p.
24. Clint Grant, photo of Leon Harris, Jr., Reeves Lewenthal, and George Grosz for *The Dallas Morning News*, May 13, 1952. Collections of the Texas/Dallas History and Archives Division, Dallas Public Library.
25. See "Grosz Arrives to Paint Dallas in Fortnight," *Dallas Times Herald*, May 14, 1952; P. L. J. Wilson, "Grosz Noted in Two Kinds of Painting," *Dallas Times Herald*, May 11, 1952; and Brock, "Noted Artist G. Grosz to Paint Dallas Scenes."
26. Newspaper reports indicate that Grosz's initial visit lasted two weeks. A 1982 recollection on the part of Harris and Bywaters, however, claims that he remained there for two months. See Becky Duval Reese, *Texas Images and Visions* (Austin: Archer M. Huntington Art Gallery, University of Texas at Austin, 1983), 88.
27. Some of the works from this series can no longer be located and reports on its full extent vary. Grosz worked intermittently on the project into 1953. Those currently in possession of the Dallas Museum of Fine Arts include the oil paintings *Cattle, Oil Refinery, Cotton Harvest, Dallas (Cotton Pickers), A Skyline of Dallas*; and watercolors *A Glimpse inside the Negro Section of Dallas, A Dallas Night, The Growing City, Cowboy in Town, In Front of the Hotel*, and *Street Corner at Night*. Works located at the Meadows Museum of Southern Methodist University include watercolors *Right Out of the Plains, Shopping Center, Flower of the Prairie, Dallas Broadway, Old Negro Shacks*, and *Old and New, The First House of Dallas and the Old Courthouse*. The watercolors *Refreshments on the Way, The Moon Romantic over Dallas*; and two drawings

Study of a Texas Saddle and *Study of a Hide* are also part of the series, but their whereabouts are unknown. See correspondence between Leon Harris and Southern Methodist University for his and Arthur Kramer, Jr.'s sale of several of the works to the Meadows Museum in 1961: "List of Art Objects Acquired in 1961," Bywaters Special Collections, Hamon Arts Library, Southern Methodist University.

28. Flavell, *George Grosz: A Biography*, 273, 276.

29. Ibid., 273.

30. George Grosz, letter to Otto Schmalhausen, March 19, 1953, in Grosz, *Briefe*, 464. Also cited in ibid., 274. See also the letter from Grosz to Leon Harris on May 14, 1953 informing him that the painting had been completed and returned to the DMFA. George Grosz Archive, Houghton Library, Harvard University, bMS Ger 206 (625).

31. George Grosz, letter to Otto Schmalhausen, March 19, 1953, in Grosz, *Briefe*, 463–464.

32. This figure may represent Grosz's attempt to render a member of Dallas's sizeable Mexican community. In an interview published in the German émigré journal *Aufbau* Grosz described the Dallas commission. He claimed to have toured the city and produced several images of Dallas's cowboys and Mexicans. The fact that we cannot tell the ethnic identity of this figure, however, is perfectly in accord with the race thinking that prevailed not only in Dallas during this period, but also the rest of the country. Racial difference in the United States was organized along a black-and-white divide. As Jim Schutze maintains in his study of Dallas race politics during this period, Mexicans were regarded as white, though of a lesser order to be sure. See Jim Schutze, *The Accommodation: The Politics of Race In an American City* (Secaucus, NJ: Citadel Press, 1986), 71. On the increasing centrality of black-white relations in United States society as a whole during and after World War II, see Michael Denning, *The Cultural Front: The Laboring of American Culture in the Twentieth Century* (London: Verso, 1997), 36.

33. McCombs and Whyte, "Dynamic Men of Dallas," 101.

34. Schutze, *The Accommodation*, 5.

35. *Fortune* described this as Kramer, Sr.'s "pet project." See ibid., 165.

36. Schutze, *The Accommodation*, 63.

37. Ibid., 101; and telephone interview with Stanley Marcus, July 12, 2001.

38. Leon Harris, *Merchant Princes: An Intimate History of Jewish Families Who Built Great Department Stores* (New York: Harper & Row Publishers, 1977).

39. Schutze, *The Accomodation*, 21.

40. See November election coverage in the *Dallas Express*. See also Louis Margot, III, *"The Dallas Express": A Negro Newspaper. Its History, 1892–1971, and Its Point of View*, Masters of Science thesis, East Texas State University, 1971.

41. George Grosz, letter to Wieland Herzfelde, August 23, 1932, in Grosz, *Briefe*, 160.

42. Grosz described his encounter to a reporter covering his trip to the city. See "George Grosz is Adding Last Touches to 'Impressions of Dallas' for Fair," *Dallas Daily Times Herald*, September 22, 1952.

43. By the "Negro weekly" *Dallas Gazette* columnist J. H. Owens (July 3, 1937), in *The WPA Dallas Guide and History* (*1936–42*), 294; repr., Dallas Public Library and University of North Texas Press, 1992.

44. Möckel, *George Grosz in Amerika*, 185. The earlier image appeared in *Vanity Fair* (November 1934), 36.

45. The *Impressions of Dallas* catalogue lists the following works as having been included in the exhibit: the oil painting *The Skyline of Dallas*; watercolors: *Skyline of Dallas, The Flower of the Prairie, The Growing City, The Moon Romantic over Dallas, In Front of the Hotel, Cowboy in Town, Street Corner at Night, Dallas Broadway, A Glimpse Inside the Negro Section of Dallas, Old Negro Shacks*, and *Dallas Night*; and drawings: *Study of a Texas Saddle*, and *Study of a Hide*.

46. Bob Brock, "Museum Fair Exhibition is Variety-Packed Show," *Dallas Daily Times Herald*, October 5, 1952. Grosz's exhibit did receive national attention in *Time* magazine. See "Wine's Better than Acid," *Time*, November 17, 1952, 98–99.

47. " 'All Citizens Welcome on All Days' says State Fair Official," *Dallas Express*, October 4, 1952.

48. Schutze, *The Accomodation*, 94; Nancy Wiley, *The Great State Fair of Texas: An Illustrated History* (Dallas: Taylor Publishing Company, 2000), 158.

49. George Grosz, letter to Leon Harris, October 24, 1952 in the George Grosz Archive, Houghton Library, Harvard University, bMS Ger 206 (folder 625).

50. George Grosz, letter to Rudolf Schlichter, January 14, 1953, in Grosz, *Briefe*, 460. Also cited in Flavell, *George Grosz: A Biography*, 275.

51. George Grosz, letter to Felix Weil, June 10, 1953, in Grosz, *Briefe*, 467.

52. "Reviews and Previews," *ArtNews*, 52.10 (February 1954): 42; and Bob Brock, "New Yorkers to 'See Dallas,' " *The Daily Times Herald, Dallas*, January 24, 1954. Grosz had used a special wax pigment he made himself; see George Grosz, letter to Otto Schmalhausen, March 19, 1953, in Grosz, *Briefe*, 464.

53. "Resolution on the Promotion of the Work of Communist Artists," Public Affairs Luncheon Club of Dallas, March 16, 1955, quoted in Francine Carraro, *Jerry Bywaters: A Life in Art* (Austin: University of Texas Press, 1994), 173.

54. Carraro, *Jerry Bywaters*, 186.

55. A. F., "Editorial: Shame in Dallas," *ArtNews*, 54.4 (Summer 1955): 23.

CHAPTER THREE

"WITH EYES WIDE OPEN": THE AMERICAN RECEPTION OF SURREALISM

Angela Miller

I

In the 1930s and early 1940s, surrealist ideas and practices, with their emphasis on the unconscious, the irrational, and the accidental, significantly broadened both the painterly and the narrative possibilities open to American artists. The cultural impact of the surrealist émigrés in the 1940s was prepared by the prior decade of transatlantic exchange. Following a period of experimentation and negotiation, American artists would effect a transvaluation of surrealism by bringing to bear a range of new postwar cultural, scientific, and broadly philosophical influences. Together, the two phases of encounter with surrealism—the 1930s and the 1940s—furnished a vital catalyst that would give new energy and definition to native tendencies while introducing new practices and propelling American art beyond its conservative grounding in the idea of art as a mirror of the social.

The impact of this great "flight of culture" that swept European intellectuals, artists, and scientists out of war-torn Europe to the United States was a subject of concern to American observers in the 1940s, a period of increased anxiety about America's relation to European culture. *Fortune Magazine*, voice of Henry Luce's "American Century" vision of the future, asked "whether, during American trusteeship, Europe's transplanted culture will flourish here with a vigor of its own, or languish for lack of acceptance, or hybridize with American culture, or simply perish from the earth."[1] The horticultural metaphor would prove to be prophetic of the crossbreeding of ideas and practices that transformed both European surrealism and American art. In the 1930s and 1940s, world events dramatically exceeded the existing languages of American art, opening the generation of that

period to a consideration of new means. In this climate, no American artist with his or her eyes open could remain unaware of surrealism. Its impact was felt across a wide spectrum of styles and approaches, evident from the various terms in use at the time: social surrealism; magic realism; symbolic realism, fantastic art; postsurrealism; and Superrealism. The artists discussed below, though frequently working in isolation from one another, engaged in a common effort to Americanize and domesticate surrealism. The European émigrés were in turn transformed by their encounter with American art and culture, a story told elsewhere in this volume.[2]

Exile became a catalyst: a prelude to an intellectual and cultural encounter that transformed and reshaped both Europeans and Americans. The surrealists around André Breton experienced multiple exiles that left the movement internally divided. Even before their migration across the Atlantic they had been rejected in 1935 from the Communist Party. Those still active in the movement turned away from the capacious embrace of the Popular Front, unwilling to concede the revolutionary force of imagination to the requirements of a united opposition to fascism. The United States to which Breton and his colleagues fled beginning in the late 1930s represented in effect a second displacement. Following its passage across the Atlantic, the American reception of surrealism stripped it of the political force it had wielded in the hands of Breton and his collaborators. Helena Lewis among others observed the depoliticizing of surrealism in the United States, "enthusiastically received on the aesthetic plane but stripped of its ideological content."[3] Surrealist texts were not widely available in translation until the mid-1940s, attenuating a more nuanced theoretical and political understanding of the movement.[4] In addition, the surrealists themselves confronted a linguistic barrier (sometimes self-imposed, as in the case of Breton). Removed from its European context, the surrealist equation between personal transformation and psychic liberation, on the one hand, and political and social revolution on the other, was vitiated. As Breton would famously pronounce, " 'Transform the world,' Marx said; 'change life,' said Rimbaud. These two watchwords are one for us."[5]

Yet this scenario of a movement politically gutted in its passage across the Atlantic represents only part of the story, and is more accurate in describing the institutional reception of surrealism than its assimilation by artists. In phase one of the American reception, American critics and artists on the left both attacked surrealism, and struggled to reground the European language of dream, temporal and spatial dislocation in a landscape of social meanings. In phase two, abstract painters working in 1940s New York transformed the hermetic surrealist unconscious—emancipated from the political moorings that had secured the movement within the European context—into something open-ended in meaning and dynamically relational.

A process so often envisioned as loss, exile thus found a startling and unexpected issue in the decades preceding and during World War II, a sea change yielding new ideas and expressive forms. Despite its diminished political and artistic potency following its New World migration, surrealism furnished the opportunity for American artists to seize its lessons and its example in order to create something new. Displaced from its original social and historical context, surrealism found a rebirth in America, inspiring a range of appropriations, objections, repudiations, and transformations among American artists. Creating their own response to surrealism, they both acknowledged its influence and reshaped it in a manner that addressed American political, collective, and historical needs.

II

From the mid-1920s on, surrealism had a growing presence in American art and culture, to such an extent that the arrival in New York of surrealist artists from France beginning in 1939 may have seemed anticlimactic.[6] Well before the quickening surrealist presence in the United States, the movement had already become well known through galleries and museum exhibitions.[7] Initially, surrealism's influence was limited to individual artists; Peter Blume encountered it as early as 1926 through personal exposure to the surrealist-influenced American poet Alanson Hartpence.[8] By 1925, when Virgil Barker used it in an essay for *The Arts*, it had entered the critical lexicon.[9] The early surrealists (Hans Arp, Max Ernst, and Joan Miró, along with Giorgio De Chirico, whose work predated surrealism but who was an important inspiration for the surrealists in both Europe and the United States) were on view in an international exhibition of modern art at the Brooklyn Museum in 1926. In the latter years of the 1920s de Chirico, Miro, and the French surrealist/magic realist Pierre Roy were all exhibited in New York City galleries. The first major museum exhibition devoted exclusively to the movement was held at the Wadsworth Atheneum (1931) and was reprised at the Julien Levy Gallery in 1932.[10]

But it was Salvador Dali, arriving years before the main migration of European artists that began in 1939, who broadly shaped the first phase of American reception. For most Americans, Dali *was* surrealism, a perception that remained true on a popular level well into the 1940s.[11] Along with de Chirico, Dali was the most widely exhibited of those artists loosely associated with surrealism by audiences in the United States by the late 1920s and 1930s. More than anyone else linked to the movement, Dali was also the target of American criticism of surrealism. In surveying the American critical response to surrealism in the 1930s, therefore, we should keep in mind that their target was a version largely conditioned by the egomaniacal and

publicity—hungry artist who virtually commandeered the American sense of surrealism as a movement. This situation contributed to the sometimes profound misreading of the political nature of surrealism in its European prewar context.

The predominant practice through much of the 1930s, social realism, revealed a conflicted legacy for politically oriented artists. No other language carried such historical authority in representing the social and economic injustices of capitalism. Yet tied to a naturalist language of art, social realism would be significantly redefined through its encounter with surrealism. Well prior to the arrival of the French exiles in the late 1930s, there were numerous signs of dissatisfaction with social realism. Painter and writer Charmion Von Wiegand, writing for the leftist journal *Art Front*, expressed a common restlessness: "[T]he old, literal naturalism is failing to register esthetically in the face of the vast social passions and portents of doom and regeneration."[12] For those looking for alternatives to social realism, André Breton opened a new world to artists: "[T]he magic power of the imagination is put to very feeble use indeed if it serves merely to preserve or reinforce that which already exists. That is an inexcusable abdication."[13] The force of imagination in unsettling the appearance of natural social relations, the ability to imagine a world that did not follow the established laws of logic, conventional representation, or relations of space and time, carried the power of revolutionary change for Breton and fellow surrealists.[14] Breton's quarrel with the Communist International is well known; their repudiation of his effort to reconcile Marx and Freud, social revolution and psychic liberation, led eventually to the ouster of the surrealists in the mid-1930s. The surrealist emphasis on the liberating power of the unconscious and the irrational created a contentious relationship not only with the Communist Party but also with numerous American critics and artists on the left, who remained intrigued, nonetheless, by the possibilities the movement offered.

Beginning in the mid-1930s, American critics on the left struggled to negotiate a path between servile imitation of Europe (the criticism often directed at the American Abstract Artists) and what many among them took to be the xenophobia of Regionalism.[15] The art of Thomas Hart Benton, John Steuart Curry, and Grant Wood was not only renounced by many on the left for its dangerous appeal to nationalism, but also for its alleged repudiation of modernity and its socially regressive mythologies. The art historian Meyer Schapiro condemned Regionalism for "detach[ing] art from fantasy and drama and from the more massive and disturbing reality of passions and conflicts."[16] Schapiro's remark reveals the growing importance of fantasy as a mode peculiarly suited to expressing the character of modern events on the international stage.[17] For Americans familiar

with this history, the challenge posed by surrealism was clear: to refocus both means and ends away from the individual psyche to the issue of the social order itself.[18] Artists Walter Quirt and James Guy turned to surrealism because "it permitted the contraction of time and space,"[19] and, by extension, vastly expanded the narrative possibilities of painting. Just as the earlier American reception of cubism had brought about a paradigm shift in how artists understood the relationship of the painted to the real world— revealing the arbitrary nature of pictorial construction—surrealism offered a way out of the constraining laws of nature, creating a new pictorial language. Holger Cahill, head of the New Deal Federal Art Project, found surrealist tendencies in many of the works shown at the 1939 World's Fair exhibition American Art Today: "Surrealism has given the artist a new daring in the use of narrative, and an enhanced power of emotional statement through unusual handling," enriching the "dried facts of illustration with a warmth of fantasy" unusual in American art up to that time.[20]

Surrealism thus offered a way beyond the impasse of naturalism. Yet it also raised a number of problems that social surrealism would attempt to answer, if only with mixed success. For many American artists on the left surrealism represented an inversion of correct Marxist materialism, as noted with doctrinal precision by critic Samuel Putnam for the left journal *Art Front* in 1937: "The Surrealist proposes not to change the world, but the reflection of the world in consciousness. He is being utterly false to Marxist principle by asserting that consciousness conditions being, not being consciousness."[21] The materialist position of the Communist Party was that psychic life was directly shaped by social conditions and had no independent existence apart from the social environment. The European surrealist ambition to bridge Marx and Freud was ill served by this frequently reductive model.

Although it expanded the range of expressive possibilities available to American artists, surrealism was attacked for the same inconsistencies that had gotten it in trouble with the Communist International, namely its call for revolution while insisting on freedom from the "control of reason."[22] One solution proposed by American critics on the left was to incorporate certain features of surrealist form while transvaluing its content. Grace Clements pointed to "postsurrealism," which condensed multiple perspectives into aesthetically unitary compositions, as a movement beyond the double bind of naturalist reification and surrealist subjectivism.[23] "Postsurrealism" was one of a series of labels circulating during these years, bearing a specific West Coast provenance, characterized by enigmatic narratives, often minute illusionism, and fantastical juxtapositions of ordinary things.[24]

More lyrical and less programmatic in its political claims, postsurrealism synthesized European surrealism, insistent on the power of the unconscious,

with the American commitment to willed creation and aesthetic agency. Postsurrealism was founded in 1934 by two California artists—husband and wife Lorser Feitelson and Helen Lundeberg—during a period when the southern California scene was fertilized by the presence of a rich community of émigrés, including Eugene Berman, Rico Lebrun, and Mexican artists José Clemente Orozco and David Siqueiros. Along with Clements, the movement came to include Philip Guston, Reuben Kadish, Lucien Labault, and Knud Merrild. Ranging from the De Chirico-inspired work of Clements to the precisely painted psychological narratives of Feitelson, the postsurrealists stressed intellectual content and the conscious inscription of aesthetic order over the "subconscious psychic meanderings"[25] of the surrealists.

Indeed Lundeberg and Feitelson readily assigned allegorical content to their work in a manner antithetical to Breton and his followers.[26] Movements such as postsurrealism, Clements argued, represented a response to the new demands for an art "which subjectively will express the social aspirations of today," while at the same time embodying new "scientific and psychological contributions." Her criticisms of contemporary art focused on the inadequacy of inherited technique and approach: "the old scaffoldings" could no longer support the demands of new subject matter. Clements identified a "paradigm crisis" in which the existing languages of art failed to serve the expressive needs of a generation dealing with major social conflict. She called for an art that (unlike social realism) incorporated the revolutions of both cubism and surrealism. Any form still limited by the perspectival and mimetic language of the past would not serve the pressing historical needs of the present. Appropriately for a discussion of developments in painting occurring in Hollywood, Clements cited montage as well as collage as new principles for generating meaning in painting. She acknowledged the contribution of surrealism in juxtaposing unrelated objects as a means of creating "an entirely new and significant meaning."[27]

Clements's call for new forms was in the service of an art that diagnosed, rather than simply represented, the nature and origins of social conflict and the "inherent contradictions" of capitalism. Yet if surrealism offered one direction for uncoupling art from a stultifying naturalism, it failed on several other counts, according to the leftist critique of surrealism, expressed most articulately by Charmion Von Wiegand. In a review of the Museum of Modern Art's exhibition Fantastic Art, Dada, and Surrealism in 1936, Wiegand identified a persistent concern she shared with other left critics: Was surrealism to be understood as critique, or as mirror of the social malaise of advanced capitalism? Was it diagnosing "the sickness of the world," or merely giving back its reflection? As was so often the case, Wiegand directed her criticisms at Salvador Dali: "He has dramatized in

correct academic perspective—the more concretely to realize horror—the obsessions and neuroses of society today—the sadism, the destructive egotism, the sexual perversions, the infantile regressions, the remnants of primitive magism, atavistic fossils from humanity's historic dawn." Wiegand's emphasis on surrealism's atavism measured her doubts concerning its revolutionary potential: "Intellectually, they [the surrealists] make the step across the great divide between the death of an old culture and the birth of a new one." Yet, she continued, despite their allegiance to revolution, they remained "enchanted with the art of corruption and with the swift rhythm of disintegration in a dead universe."[28] She concluded by calling them reactionary romantics enthralled by evil and linked Dali in particular to the "methods of Fascist persecution and violence." Yet in a bow to dialectics, she anticipated "new shoots of life" springing from the putrefaction of surrealism. "The art of the future, which will strive for a new humanism on a social basis will inevitably turn its face toward the world of reality again." This new art would incorporate the technical and formal inventions of surrealism into a redeemed revolutionary order.[29] Margaret Duroc, writing in *Art Front*, called surrealism "a false medium for the revolutionary artist," whose occult imagery "separates the artist from his audience."[30] Once again she objected to the sexual obsessions of the surrealists (invariably inspired by the example of Dali), with their reductive focus on the unconscious.

This chorus of critics of surrealism, with its emphasis on the unwholesome, unhygienic, and otherwise monstrous qualities of the unconscious, represented a highly selective view. American uneasiness with this version of the Freudian unconscious was consistent with the historical reception of Freudian ideas in the United States more generally. From the first sustained contact with Freud in the early 1900s, American intellectuals emphasized the therapeutic and salubrious effects of renewing contact with unconscious energies—a source of psychic integration rather than a grisley dig through the archaeology of the mind.[31] This focus on the therapeutic power of the unconscious left them ill prepared for the often graphic nature of surrealist fantasy. Julian Levy recalled his own role in popularizing surrealism for a U.S. audience: "I wished to present a paraphrase which would offer Surrealism in the language of the New World, rather than a translation in the rhetoric of the old." With its manifestos and stern pronouncements issued by Breton, surrealism—as Levy wrote later—"would have collapsed of its own rigidity."[32] In its transatlantic passage, surrealism would throw off the burden of European politics to be reborn, freed to explore the New World of the unconscious as a realm of innocence and delight.

Another source of Americans' uneasy relationship to surrealism was its associations with illustration.[33] "Illustrative," as Peter Busa put it decades

later, was "the dirtiest word you could call an artist."[34] Early abstract expressionists also distrusted the illusionistic basis of much surrealist art; as Adolph Gottlieb stated in his essay "The Portrait and the Modern Artist," "it is not enough to illustrate dreams."[35] Surrealism also reflected American artists' anxieties about an art tainted by commodification and market values.[36] Dali's easily identifiable style, along with de Chirico's, became the stock-in-trade of sophisticated advertising, converting surrealism from a vanguard style to a set of conventions directed at a new class of high-end consumers. By 1938 *Scribner's Magazine* could proclaim that "Surrealism, which was once considered 'a weird thing for weird people,' [wa]s being used to sell goods."[37] From its origins in the Parisian avant-garde it moved effortlessly to the windows of Bonwit Teller, which played on surrealist fetishism by advertising a "Surrealist Sandal." Surrealism's associations with advertising undermined its revolutionary claims with American artists on the left; its irrationalism was now linked to another kind of desire, liberating the imagination not in the service of revolution, but of consumption. Americans' conception of surrealism, shaped by its commercial involvements, overlooked the movement's doctrinaire rejection of moneymaking and commerce—a cardinal sin for the official members of the surrealist movement, leading to excommunication of more than one member, including Dali himself.

Key to the American left's distrust of surrealism was its apparent surrender of artistic will and reason, a surrender linked to the practices of psychic automatism. Surrealists such as Ernst devised a range of techniques, from collage to frottage, flottage, and decalcomania, for exploiting the accidental associations contained within the image. American critics continued to value the integrative work of the artist, repeatedly expressing discomfort with the fetishized fragment, a recurrent feature of Dali's work. Social realist Ben Shahn probably had Dali in mind when he targeted "that quagmire of the so-called automatic practices of art, the biomorphic, the fecal, the natal, and . . . other absurdities."[38] Dali's work would come to be synonymous with the most monstrous extremes of a surrealism dedicated to the unedited contents of the unconscious. These concerns shaped the first phase of the encounter with surrealism, issuing in social surrealism, the first ideologically explicit reworking of European surrealism.[39] In contrast to psychic automatism, social surrealism brought the logic of the unconscious—displacement, projection, and inversions of real-world relations—into the full light of artistic awareness and made these processes available as artistic resources. By bringing the unconscious under artistic control, social surrealism rejected the European surrealist programmatic surrender to the unconscious. This refusal to grant artistic authority to the unconscious extended to the beginnings of abstract expressionism. Robert Motherwell,

for instance, associated surrealism with the eclipse of humanist motives: "To give oneself over completely to the unconscious is to become a slave."[40]

Social surrealism, in the hands of its leading exponents—Walter Quirt, Louis Guglielmi, and James Guy—attacked the irrationalities of capitalism with nightmarish scenarios of lynching and other scenes of human misery set against symbols of capitalist power. Social surrealists systematically reforged what they perceived as the European movement's weak link between the psychic and the social, employing disjunction, distortion, and projection in situations whose primary logic was social. Although the fantasy element figured prominently in the varieties of American surrealist practice, social surrealist works such as Louis Guglielmi's *Phoenix* embodied a doctrinaire vision in which historical dialectics produced a new more rational and humane social order, in a manner antithetical to European surrealism. *Phoenix*, painted in two versions, the first in 1934, shows a "dialectical materialist progression" from the distant view of factories, which for Guglielmi represented "the darkness of industrial enslavement," to a middle distant view of a human arm emerging from rubble, to the foreground portrait of Lenin, the phoenix rising from the ashes of industrial capitalism.[41] Walter Quirt, a member of the Communist Party, gave his paintings such programmatic titles as *Traditions of May 1st, Middle Class and the Crisis, Opium of the People*, and *The Future is Ours*. According to Quirt, surrealism suggested vital new directions for art, drawing on the "rich material" of the unconscious mind "impossible to unearth with conscious method." Having said this, however, he attacked surrealism, according to one review, "repeatedly and quite viciously," for dealing in fear and terror, "fascist emotions," rather than "hope [and] cheerfulness," which were "revolutionary emotions."[42] Like many of his contemporaries, Quirt distrusted the irrational as a double-edged sword. Capable of unleashing powerful creative forces that could be directed at the renewal of art, surrealism was toying with black magic—those dark destructive powers associated with the reign of terror in Europe.

Like other vanguard movements in American art of the late 1930s, social surrealism remained committed to "subject matter, communication and the purposes of art," in the words of critic Elizabeth McCausland.[43] This emphasis was echoed by artist and committed leftist Louis Lozowick in *Art Front* in 1936: "Where the Surrealist postulates irrationalism and automatism, the revolutionary artist must substitute reason, volition, clarity."[44] Grace Clements also faulted surrealism for giving itself over to the unconscious, calling instead for "a cerebral art rather than an emotional one, . . . calculated in its organization."[45] The link between automatist practices, surrender of artistic will, and resulting failure of the art to communicate a message was a common one in these years, and would have

important consequences for the American transformation of surrealism. American critics compared Quirt, who functioned "as a rational human being, not as a reflex mechanism for his irrational thoughts and feelings," favorably to Dali.[46] Kenneth Burke, in an article on his friend the artist Peter Blume, put it more bluntly: Blume, unlike his surrealist contemporaries, "does not trifle with enigmas."[47]

Yet the American insistence on the communicative power of art opened an ideological minefield. If the enigmas of surrealism represented the dangers of subjectivism, another pressing danger lurked in the call for an art that communicated to a mass audience. Naturalistic art in the 1930s occupied a wide political spectrum ranging from art painted for the Nazis to the socialist realism called for by the Communist International. In the 1940s, artists along a stylistic spectrum shared a common concern to avoid anything smacking of propaganda or mass manipulation, without at the same time endorsing an art that turned away from communication, producing surrealist conundra. In the process of navigating this charged terrain, artists in the war and postwar years redefined communication to incorporate the role of the viewer in a more active manner, unlike surrealism, in which the artist presumably held the key to meaning.[48] And unlike surrealism, it did so by avoiding the cultural mediations of language. The politicized terrain in which American artists defined their links to and differences from European art would eventually generate a paradigm shift that substantially directed American art away from the self-containment of the work toward a more intersubjective evolution of meaning.

Surrealism thus occupied a curiously bifurcated place in American culture of the 1930s. On the one hand it was the darling of sophisticated advertising and of the art world cognoscenti.[49] On the other hand it stood for an art in which imagination was directed at breaking the tyranny of the real and unsettling the reified nature of social relations under capitalism. By the late 1930s, surrealism carried a host of problems for artists who remained committed to the agency of art in the evolution of a more just society.

III

For a generation of critics and writers whose thinking was deeply informed by Marxism, dialectics offered a means of explaining how American artists both assimilated and transformed European sources. The nature of the transatlantic exchange was set forth in such terms by Jules Langsner, a West Coast critic, in 1935: "Surrealism, by exposing the plastic possibilities of the subjective, has occasioned the birth of Post-Surrealism; an art that affirms all that surrealism negates; impeccable aesthetic order rather than chaotic

confusion, conscious rather than unconscious manipulation of materials, the exploration of the normal functionings of the mind."[50] American artists would struggle to bring dream imagery into narrative and ideological focus. In doing so, however, they betrayed the very dialectical reasoning they had used to postulate a process of Americanization. For dialectics implies engagement, and I would argue that the American followers of surrealism never truly engaged the issue of the unconscious and of psychic drives in relation to social transformation. Instead, social surrealism redirected artistic energies from the exploration of psychic landscapes for their own inherent power in liberating the imagination, and toward an examination of the surreal landscapes of modernity, revealed in all their chaos and strangeness. The fragmentary and the monstrous became mannerisms used by social surrealists in their efforts to envision the social deformities of capitalism. Denying psychic processes any autonomy at all, social surrealism produced a social landscape heightened by surrealist gestures that were, in the end, somewhat incidental to its political critique. It made the psychic a function of the social rather than bringing the social into alignment with the powers of imagination. American artists' relationship to surrealism could, in this context, more accurately be described in terms of inversion rather than dialectical engagement.

One of the few American artists who did understand the surrealist poetics of the psyche on its own terms while placing it firmly within the context of social critique was photographer Berenice Abbott. As a medium, photography was well suited for exploring the surreality of the American landscape. In Abbott's hands, the straight, unmanipulated photographic image became a means of probing the surreal, socially charged dislocations of market capitalism. Abbott was responsible for bringing the work of Eugène Atget, much admired by the surrealists, to the American art world; in his work she responded to the very qualities that would also ignite her own passion for the strangely disjunctive landscape of New York. "Was not reality more fantastic by far than fiction? Perhaps the surrealists responded to this particular insight."[51] Abbott herself contributed to the Americanization of surrealism in her own practice, arguing in an essay for *Art Front* that photography was uniquely capable of catching the "fantastic unfamiliarity" and "the bizarre happenings of everyday existence. . . . "[52] Abbott eschewed the montage and multiple exposure used by surrealist photographers. She attempted to capture "the intangible and psychical aspects" of modernity, conveyed through visual coincidence, uncanny juxtapositions, and word-play and irony, introduced through signage. But Abbott's engagement with surrealist practice—unlike social surrealism—went beyond often superficial devices and mannerisms. In her fascination with the fragmented body—photographs of bodiless heads of female glamor queens and movie stars,

shown on magazine covers, and of headless torsos on shop window mannequins—Abbott reinterpreted the fetishized surrealist fragment. In New York in the depths of the Depression, the fragmented body assumed pointed social meanings, its focus shifting from the psychic process of fetishization to a comment on how market capitalism distorts and violates human desire.[53]

Abbott's work reveals an interest in what was elsewhere called the American macabre, a social landscape in the U.S radically at odds with official values and ideals. In the American macabre, surrealist dreams and nightmares, and repressed fears and projections, found substance in American history. American life *was* surreal. Surrealism was "in the American grain," not something plumbed from the depths of the private psyche but naturally produced by the American environment itself. Such a strategy paralleled a familiar American boast concerning cubism: that Americans did not need to invent it in the studio—it *was* a modern and American way of seeing. These arguments allowed American critics and artists to pit American modernity against European modernism. American artists and critics argued that their reality trumped art.

IV

While surrealism occupied a central place in discussions of the American left about the relationship between art and politics, it held a very different position in the gallery and museum world. Despite the scholarly emphasis on the 1930s as a time of national introspection and American Scene painting, gallery dealers such as Julien Levy, museum directors such as "Chick" Austin of the Wadsworth Atheneum and other modernist venues such as the Harvard Society for Contemporary Art enthusiastically promoted the European avant-garde, moving beyond the modernism of the School of Paris. In these prewar venues, a middle ground emerged on which French and American artists exchanged influences and established a shared language of cultural reference.

Interest in comics and animation linked Americans and Europeans.[54] Walter Quirt's "cartoon" style of exaggerated caricatural expression (figure 3.1) paralleled the Chilean surrealist Roberto Matta's direct borrowings from American cartoons such as Daffy Duck (figure 3.2).[55] American artists and critics, uneasy about Matta's borrowings from comics, evinced a conservative impulse to reaffirm the special status of the art object.

There were exceptions. "Chick" Austin identified an underlying linkage between American popular culture and surrealism: "[T]he artist seeks to create an effect of surprise and astonishment, made breath-taking by the juxtaposition of strange and disparate objects. Sensational, yes, but after all

Figure 3.1 Walter Quirt, *Tranquility of Previous Existence* (1941). Oil on canvas, 24 1/8 × 32". The Museum of Modern Art, New York. Digital image © The Museum of Modern Art / Licensed by SCALA / Art Resource, New York.

the paintings of our present day must compete with the movie thriller and the scandal sheet. . . . These pictures are chic. They are entertaining. They are of the moment. . . . Some of them are sinister and terrifying, but so are the tabloids."[56] Austin's light-handed disregard for art world hierarchies no doubt rubbed some American artists the wrong way. Even more striking is the manner in which Austin transformed Breton's politically charged concept of "convulsive beauty" into the pleasurable *frisson* of mass entertainments and the "shock" tactics of the adman.

With the arrival of the European émigrés beginning in 1939, further common ground emerged in the shared fascination with the American landscape. Ernst's *Eye of Silence* (1943–1944), with its strange geological formations, revealed the impact of his travels in the Southwest. André Masson saw his rural Connecticut landscape through the lens of Chateaubriand's New World. With its wildcats, rattlesnakes, and flaming autumnal colors, it was "très Fenimore Cooper."[57] The imprint of the western landscape is evident in the deep airless perspectives of Yves Tanguy, who traveled to Nevada in 1940, as well as in the twisted geological forms

Figure 3.2 Roberto Matta, *Untitled* (1945). Pencil and crayon, 14 1/2 × 20 1/8".
Mildred Lane Kemper Art Museum, Washington University in St. Louis. Gift of
Joseph Pulitzer, Jr., 1965. © 2006 Artists Rights Society (ARS), New York /
ADAGP, Paris.

of Seligmann's cyclonic landscapes, inspired by his journeys through
Arizona and New Mexico. The popular "Neo-Romantic" émigré artist
Eugene Berman painted vast windswept plains, punctuated by classical
ruins and false-fronted shacks that register a movie version of the American
West. Berman's art was described as "intensely romantic" in its themes of
"decay and despair" and existential isolation.[58] European travelers had long
been both drawn to and repelled by the desolate and disorienting quality
of the Plains and the American Southwest. Some of the émigrés saw the
landscape through the eyes of American nineteenth-century writers they
had already encountered in Europe, in particular Cooper, Herman
Melville, and Edgar Allen Poe. The latter two were associated with the
homeless quality of the American imagination, conditioned by the immen-
sity and lack of history and tradition embodied in the American landscape
itself. This quality resonated with the now homeless émigrés, who
responded to themes of metaphysical displacement.[59] The Greek Nicolas
Calas echoed a growing interest during the 1940s among both Americans
and European émigrés in America's native symbolist tradition. Calas

termed Poe, along with Melville, a "presurrealist."[60] A dawning European imagination of apocalypse—the voiding of culture—encountered a much older American tradition of "desert places" in the hybrid landscapes of the surrealist émigrés. This coincidence of motives and sources reinforced one another from both sides of the Atlantic, as Americans discovered the strangeness of their own landscape reflected back to them from the eyes of their European contemporaries.

V

When surrealist émigrés began arriving in the United States in 1939, the welcome they received was not always friendly. According to the New Dealer George Biddle, the surrealists were "thrown into high relief by the publicity methods of certain New York dealers, and also by the official stamp of the Museum of Modern Art. . . . There is no immediate danger to the republic from this band of weakened, sapless and occasionally loud-mouthed *homunculi*. Let them play with their melting watch-chains, their rubber snakes and other childish contraptions without much threat."[61] The kept quality of the surrealists—amusing patrons such as Peggy Guggenheim with their "psychoanalytic parlor games"—also disturbed them.[62] The Americans were not about to let themselves be annexed to a group of superannuated Europeans.

The cumulative impact of such negative criticism of surrealism was registered by the émigrés themselves, who withdrew from sustained contact with the Americans outside of their own circle.[63] Yves Tanguy claimed that "European artists seem to be utterly detested here, you only hear people speak about American art."[64] Peter Busa recalled in 1966 the "antagonism to Surrealism" common among younger abstract artists: "We were not attracted to the clichés of surrealism."[65] Clement Greenberg damned surrealism by associating it not only with the market but also with the rich, in their restless quest for fashion and "chic."

Such denials of influence, however, slight the historical give-and-take between surrealism and American art. There are ample countertestimonials concerning surrealism's impact. Breton wrote in 1939, "that almost all American painting and poetry derive more or less directly from surrealism," although he simultaneously acknowledged those "impatient gravediggers" who predicted the demise of the movement.[66] Susanna Perkins Hare reported that the émigrés "were 95% responsible for the appearance of the New York School."[67] Despite disavowals, the émigrés left a vital mark on American art in the 1940s. Surrealism in exile, in Peter Busa's words, was "a fuse which lit up the American scene,"[68] a force whose intellectual and artistic impact was widely felt throughout the art world.

The reasons for this range of opinion concerning the impact of surrealism may stem from the fact that, as with its first phase, assimilation and transformation occurred simultaneously. Even where the American debt to surrealism remains—in retrospect at least—largely undisputed, native resistance to the European movement was strong.[69] But unlike the first phase of encounter, which developed within a framework of opposition and ideological transformation, the second phase functioned as a catalyst, stimulating new forms of experimentation that pushed American abstraction in new directions. Those Americans most affected grasped instinctively what they needed from surrealism and made it their own, so much so that it is often difficult to identify precise influence. As Jimmy Ernst recalled years later, "We were not getting the last word from Europe, but rather the possibility for a further horizon that implied individualism."[70]

In addition to the presence of the émigrés themselves, significant new intellectual influences in the 1940s produced a cumulative paradigm shift in the procedures of artmaking.[71] The very nature of creativity was redefined by the new physics, Gestalt psychology, and pragmatist philosophy that collectively offered far more flexible intellectual models with which to engage cultural politics critically in a nonauthoritarian manner. The search for nonauthoritarian models of meaning occupied a central role in the ideological debates of the war and postwar years, and these debates in turn transformed the climate of reception for surrealism. At the same time, surrealism itself had also changed. No longer the same entity to which American artists had responded in the 1930s, surrealism in its exilic forms turned to a renewed interest in myth, thereby provoking a new phase of encounter and contestation.

By the early 1940s, Breton, who arrived in the United States in 1941, had subtly redirected the movement's emphasis from the uncensored and revelatory powers of the unconscious toward surrealism as a means through which to reconstruct the social imaginary. In 1942, Breton, addressing a group of Yale undergraduates, called for "an intervention into mythical life."[72] He saw the mythic imagination as a central necessity for human and social happiness; myth served a "hygienic" function by filling the void left by a rationalizing culture that ignored the power of the Freudian id. Ignored by culture, this id was the place "where myths swell beyond measure and where . . . wars are formented."[73] Elsewhere in the same year, he developed the idea of a new myth: "All that is needed . . . is a sudden convulsion of this globe, such as the one we are going through today, [to call] into question . . . the adequacy of the optional modes of knowledge and manipulation of reality" in operation throughout most of recent history. Citing a range of European writers and artists associated with surrealism, from Bataille to André Masson, Ernst, Calas, and Kurt Seligmann, Breton

identified an "anxious desire . . . to furnish a prompt reply to the question: 'What should one think of the postulate that 'there is no society without a social myth'? [and] 'in what measure can we choose or adopt, and *impose*, a myth fostering the society that we judge to be desirable?' " Referring to one such myth, namely "the search for the *Golden Fleece*," Breton called upon artists to risk everything in pursuit of a renewal of surrealism, brought perilously close to a dead conformism by "the innumerable followers of Chirico, of Picasso, of Ernst, of Masson, of Miró, of Tanguy."[74] Breton summoned a form of reenchantment, the renewal of the world organized around new forms of knowledge. Yet, clearly wary of the fascistic misuses of myth, his strategy was to attack fascism with its own instruments, through a collective countermyth.

Breton's call for a new myth entered—knowingly or otherwise—a charged field of discussion among American intellectuals and writers in the early 1940s. For it was around the subject of myth and its social functions that this wartime generation wrestled with the place of surrealism within American culture. The subject of myth revealed an internal struggle that intellectuals in both Europe and the United States carried on with themselves, as they debated how to balance the recognition of myth's central importance to the human psyche throughout history ("a basic need of the human psyche . . . that the age of rationalism refused to recognize,"[75] in Eric Kahler's words), with the simultaneous awareness of how easily served this need could be by reactionary forces seeking some secure foundation in the face of "[man's] ancient powerlessness to resolve the cosmos."[76] The artists and theorists of the early 1940s saw their task as the engagement with the renewing powers of the unconscious and irrational, while avoiding the pernicious mass delusion revealed by Hitler's Nuremberg rallies and the nationalistic misuses of myth in his tightly controlled aesthetic program.[77] In their search for new models of knowledge serving a postwar world, Breton and his American contemporaries also engaged the example of modern physics.[78] Yet modern science was equally double-edged in its promise; its normalizing and progressive discourses had produced the ultimate expression of banalized evil—the atom bomb. Despite its associations with instrumental reason, science offered many postwar intellectuals a new paradigm that replaced the Cartesian dualism of subject/object with a far more dynamic model of object relations. The war years—like the prewar period of the 1930s—required considerable agility in maneuvering through and avoiding opposing dangers as American writers and artists began their own tentative efforts to reengage new forms of imagination and fantasy.[79] Yet the 1940s negotiation with the promises and dangers of myth exposed a map of cultural anxieties. Klaus Mann and others had attacked surrealism for its "playful destructiveness" of all social and aesthetic values, which they

associated with the "murderous destructiveness of the Nazis." Indeed Mann went so far as to accuse surrealism of having "produced Hitlerism," while Motherwell, himself much involved with surrealist practices, associated it with the "right wing" in 1944.[80]

Shaping the repudiation of myth—surrealist or otherwise—was a post-Marxist existentialism that dismissed myths as a crutch for a humanity unwilling to face the universe without their protective cover.[81] Harold Rosenberg, in an imaginary dialogue among three "left-wing intellectuals," charted a spectrum of attitudes about myth in these years. At one extreme is "Hem," who voices a pragmatist position insisting upon the social necessity of myth: "Without beliefs man cannot act." Myths bonded the individual to the social; their absence threatened a form of social atomization leading to a Hobbesian state "more primitive than anything yet seen on earth." Myths should be judged not according to any absolute measure of truth: all knowledge systems, including science itself, contained elements of myth. The only measure of value was "their effect on behavior." Secular philosophies of history such as Marxism required binding myths and ceremonies of initiation "to seal the workers to one another."[82]

Rem—the second in this triad—speaks on behalf of a dialectical view, in which the liberation of the working class results in a transformation of consciousness that frees the worker from dependence upon "unrealities," a position that described Rosenberg's Marxist beliefs in the 1930s. The third voice, Shem (who most approximated Rosenberg's current position), condemned the revival of myth as a "reactionary" mystification of underlying social problems. Shem acknowledged new forms of ideological manipulation that drew on the older power of myth while using the mechanisms of mass media. The combination of myth and mass dissemination for Shem/Rosenberg would prove devastating to older ideologies such as Marxism, since these could no longer hold the attention of a public alike deluded by "Goebbels, Mussolini, and thousands of editors, advertising men, and information specialists."[83] Here the older authority of myth to organize and direct the power of the imagination was dangerously allied to the reifying force of modern media and technology. Rosenberg's experience with the antifascist left in the 1930s offered no ideological space for a reconsideration of the role of myth in engendering social health rather than mass pathologies. His solution was to repudiate myths—benevolent or otherwise—in favor of "practical politics" and democratic reform. He assumed a postideological position that registered the exhaustion of intellectuals with Marxism as with other totalizing philosophies of history.[84]

Rosenberg's retreat from myth was characteristic of many in these years who would come to view myth as the product of modern alienation—the deracinated individual, lacking anchors in social traditions, searching for

ways to fill the void in identity through a form of mystical participation in something larger than himself.[85] If Rosenberg's existentialism allowed no place for myth, then there were other positions from *within* surrealism that were equally skeptical of Breton's call for a new myth. Exponents of surrealism in the early 1940s struggled with internal contradictions surrounding the role of the irrational, forced to the surface by the historical encounter with fascism. Kenneth Burke warned of a tendency evident in Breton's revived call for myth toward a hardening of meaning, what he described as a "turn from liberal, individualistic 'philosophies of divorce,' of *loosing*, to collectivist philosophies of *binding*, 'philosophies of marriage,' " Burke made clear that surrealism in its originating form was "all for loosing," and in opposition to fascism and the "fixed" values of regionalisms or socialisms. Burke went on to criticize Calas, Breton's deputy, for imposing on surrealism "a pattern of monogamy" (continuing his marital metaphor), by which he meant a commitment to unitary meanings. He pointed by contrast to the freedom he admired in an older form of surrealism, which he defended as "the ultimate extreme of liberalism—'freedom' " projected into the aesthetic domain with an absoluteness, a squandering, that can only be found at a time when a "free" cultural trend is drawing to a close.[86]

Calas defended Breton to the end, setting out, in his Third Manifesto, to make good on Breton's unformed call for a new myth. Yet he could only do so in terms that avoided the social dangers this generation associated with myth, through a move that others would also make in these years: reinflecting myth through the concept of magic. Both the French surrealists and the New York painters hoped to find alternative forms of knowledge and experience beyond the logic and abstract reason so central to the postwar era. Magic took the form of the nonalienated shamanic powers of the artist, who was also granted interpretive power over the elements and meanings of myth. The artist emerged as a singular medium of connection with a universe of vital, mysterious, and dynamic agencies. The way was now open to a conception of the artist that reconciled individual agency with universal meanings.[87]

Richard Chase, in an essay for *Partisan Review* in 1946, reveals how this generation refocused their understanding of myth. Far from being based in delusion, myth issued from a new sense of connection, the world perceived, as it was to the savage mind, in "a blaze of reality."[88] Chase saw magic as the force binding world to self; without it, he wrote, quoting Yeats, "things fall apart," and chaos is unleashed upon a universe "no longer . . . enveloped in the tissue of human emotion." The force of magic lay in "the coercion of the objective world by the ego." The phrase beautifully expresses the inward turn of 1940s intellectuals, and the reinvestment in the power of imagination that was one of the most important lessons of surrealism for this

generation. For Chase, magic and myth were subsets of a broader impulse toward poetry, the act of reanimating the world that was instinctive to so-called primitive cultures, but that had been lost by modernity.[89] The influence of Jung's concept of "participation mystique" is apparent here; Jung, as we will see, was a major new defining influence in the 1940s.[90]

Breton's essays of the 1940s articulated a goal held in common by French and American intellectuals: to bridge what he called "the old antinomies" that artificially divided a world unified in imagination into the polarities of organic and mechanical, human and machine, reason and the irrational, mental representation and physical perception, and ultimately, the external and internal worlds.[91] The paradigm shift initiated by Einstein's relativity theory issued in a growing fascination with the fluid nature of human knowledge, newly relative to the position of the observer. Erich Kahler looked beyond the disciplinary distinctions between science and art toward a new epistemology, inspired by the model of quantum physics and by psychoanalytic approaches. In both, the boundaries between self and world, observer and the object observed, existed in "a perpetual interaction."[92] With the principle of epistemological uncertainty—indeed unknowability—inscribed into the very structure of things, the imperative to invent new myths was, for Kahler, a movement to establish certitude and stability by a modern society "helplessly ensnared in a chaotic skein" that could not be untangled by reason. Against the impulse toward permanence and finality, Kahler proposed an existential acceptance of unknowability: "We must become accustomed to living on that floating ground on which science has moved for so long."[93]

Burke, Kahler, and others were part of a broader call for skepticism in the face of the certainty, coherence, and reliance upon essences that myth promised. Running beneath the surface of these discussions is both a fascination and an anxiety over the authoritarian personality, the subject of a number of scholarly studies in the 1950s. In these cold war years, the memory of fascism shaped the response to the "totalitarian" forms associated with Soviet-style Communism. Arthur Schlesinger's influential effort to position American democracy between the extremes of right and left linked totalitarian cultural forms to the same intolerance for uncertainty that had previously been associated with fascism. Totalitarianism created a new social man "free from doubts or humility, capable of infallibility," a man without anxiety. "Totalitarianism sets out to liquidate the tragic insights which gave man a sense of his limitations."[94] The redefinition of myth and its uses in the 1940s increasingly took place on a terrain shaped by both existentialism and the concept of the liberal center.[95]

Central to the renewal of meaning through new forms of myth was the figure of Carl Gustav Jung.[96] Jung's ideas were first introduced to America

by the publications of Bollingen Press, established by Paul Mellon and his wife Mary, both patients of Jung.[97] Writers loosely affiliated with surrealism, such as the British art historian Herbert Read, turned to Jung in the early 1940s as a student of universal and cross-cultural myths.[98] The American "magus"—painter, theorist, and critic John Graham—introduced numerous artists to Jung's work, including Rothko, Gottlieb, and Pollock.[99] Jung seemed to offer a near ideal resolution to the balancing act that characterized Americans' attitude toward myth: a compelling universal language of meaning, yet one that also preserved the open-ended, creative, and nondeterministic nature of psychic process. The Freudian emphasis of earlier surrealism, which approached myth through dreams, was played down in preference to the Jungian interest in myths as remnants of the archaic childhood of the human.[100] Such myths, surviving into the present, could be accessed through the study and artistic engagement with legend, superstition, ritual, and—according to Whitney Chadwick—"all forms of magical, fantastic, legendary and totemic thought."[101] The Jungian unconscious differed in important respects from its Freudian version, a difference that would shape the postwar approach to myth. Psychoanalysis put great stock in the psychic significance of the accidental, in contrast to Jung, for whom culture and archetype were crucial mediating terms. Consistent with a cultural tradition that invested the artist with bardic powers, his creativity devoted to democratic enlightenment, American intellectuals preferred the idea of a shared, collective language of myth and memory over what they interpreted as the surrealist emphasis on the ungovernable idiosyncracies of the private psyche.[102]

Evolutionary transformation, cycles of life and death, destructive and creative forces—these were the focus of new forms of mythic narrative. Insisting on creative agency, American writers focused their interest on those transpersonal structures that gave shape to acts of individual creative will. The Chilean artist Roberto Matta who was active in New York, situated between European and American attitudes, articulated this shift in the relationship between the psyche and history: "I had some kind of trauma when I realized what the war was, and the concentration camps, and I went one step further in my understanding. I tried to use, not my personal psychic morphology, but a social morphology. . . . I tried to pass from the intimate imagery, forms of vertebrae, and unknown animals . . . to cultural expressions, totemic things, civilizations."[103]

VI

In the war and postwar years, Freud's model of the psyche continued to pose problems for American artists, as it had in the 1930s, though of a different

nature. Breton remained a true believer: "I discovered that someone all alone had just pierced the night of ideas in the region where it was thickest: I speak of Sigmund Freud."[104] However, many postwar American intellectuals and artists resisted the determinism implicit in Freudian models, as well as the therapeutic functions they served. Neo-Freudian psychotherapy came under fire in the American avant-garde during the 1950s for its role in a therapeutic culture that served a corporate liberal order with little tolerance for dissent or behavioral difference. Far from its liberating potential for the surrealists, Freud's ideas, in the hands of a therapeutic establishment, reinforced a repressive normativity, fostering "a psychology of non-revolutionary social adjustment that is precisely the political ideal . . . of the New Deal, . . . Stalinism, etc."[105] Among vanguard intellectuals—having grappled with surrealism—other psychological models acquired greater currency, considerably modifying Freud. Gestalt psychology in particular, as advanced by Paul Goodman and the German émigré Fritz Perls, proposed a model in which the psyche was continuously altered in a pattern of organic interaction with the environment; in which world and mind were in continual exchange, each altering the other. Cognition—the texture of the mind—shaped perception, which in turn shaped cognition in a continuous cycle.

Into this intellectual terrain, American artists working abstractly would fundamentally rethink the surrealist theory of psychic automatism to reflect a "field theory" approach to the dynamics of creativity. In the 1930s, automatism had been denounced in both theory and practice; in the war years, by contrast, it was one of a series of methods devised by American artists for generating new forms in a spirit of experimentation only indirectly linked to surrealism.[106] Automatism continued to challenge a deep-seated belief in the powers of conscious will and creative agency. Yet Americans had clearly absorbed from surrealism an understanding of the ways in which automatism might contribute to a renewal of visual languages, freed from the grip of learning and convention. Robert Motherwell's concept of plastic automatism accomplished this renewal without sacrificing creative agency. Plastic automatism differed from psychic automatism in that it was an artmaking procedure in which the process itself generates meaning, rather than serving merely to reveal the contents of the unconscious.[107] The concept of plasticity was widely used in the 1950s in a variety of contexts: to describe a healthy (meaning unfixed and fluid) relationship between psyche and environment,[108] and in connection with new theories of particle physics in which mass and energy were in a continuous process of exchange. "Plasticity" also defined new concepts of artistic creativity, in which the artist continuously reacted to his materials, in a creative give-and-take. As with the pragmatist tradition it resembled in many ways

(in particular the work of John Dewey), this plastic automatism remained free of any particular ends or preordained solutions, leaving the final product entirely open to the ever-changing process of creation.[109] Motherwell's theories of plastic automatism generated a version of the psyche that conformed far more closely to a gestalt than to a psychoanalytic model. In plastic automatism, the artist responds to the materials with which he works; the physical circumstances of the creative act provoke each new gesture and shape every decision. The artist, in other words, establishes a conversation with his own mind through the intermediary of the materials. These materials became more than a means to an end, as they had been for surrealist automatism. Fundamental constituents in the creative process, they actively shaped the results. Motherwell's ideas were strikingly close to Goodman's notion of a "plastic dialogue" between the artist and the sensory and tactile field in which he worked.[110] The materials of art established the determining conditions of this dialogue. Because these conditions existed outside the self, the concept of the "plastic dialogue" interrupted the solipsism of surrealist practice. In the context of Gestalt psychology, the very fluidity of the psyche, constantly evolving in relation to the intersubjective conditions of its existence in the world, meant that one could never deliver forth its contents in anything like a stable state. The very act of observing them would alter them. Surrealist automatism as a process was directed at the mind as a repository of repressed desires and memories, containing a fructifying power to renew self, language, and world. Once revealed, however, these memories and desires remained essentially unchanged; their force resided in their liberation into consciousness through automatism.[111] The surrealist approach to automatism differed in this fundamental respect from plastic automatism, whose power rested, in Goodman's words, "in the concentrated sensation and in the playful manipulation of the material medium."[112] In the process, both subject and object were transformed.

Nuclear physics—and more generally the shift from Euclidian (assuming a fixed observer) to Einsteinian models of the physical universe, in which the observer's position is always relational—also furnished a fundamental paradigm shift across a number of disciplines.[113] The mathematician Alfred North Whitehead transposed his insights into the terms of philosophy, in a series of influential writings.[114] Field paradigms shaped not only the content and practice of abstract expressionism, but also the impulse toward group definition itself. In 1947 Barnett Newman, in an exegesis of the emerging American "school," renounced any effort at systematic self-definition, doing so specifically in reference to the counterexample of surrealism: "I have never tried to speak à la Breton as a program-maker."[115] To do so would have gone against the very grain of the more processual approach of the Americans, in favor of an a priori, Procrustean definition into which

practice was forced to accommodate itself. Newman, by contrast, assumed the responsibility of explanation only following the appearance, around the country, of a spontaneous but untheorized practice, an "abstract idiom . . . unique" to the United States and of "historic importance."[116] At the heart of Newman's effort to distinguish the new American art from European sources was his claim that the Americans had at last broken entirely free from any lingering debt to nature. Unlike the "transcendental" nature of European art—a kind of ascending ladder from the material to the abstract world of the spirit, in which painting was still tethered to nature— the new American art was "metaphysical." No longer deriving from nature, it constituted a distinct reality in its own right. In explicating this idea, Newman referred to Einstein, whose cosmos broke free of referential logic altogether.[117]

American gestural abstraction differed from surrealism in practice as well as in theory. In the work of the most influential surrealist in New York in the 1940s, Roberto Matta, forms float in a void; objects retain a certain discrete relationship to the space around them (figure 3.3).[118] In varying degrees, this was true of all the surrealist émigrés to the United States.

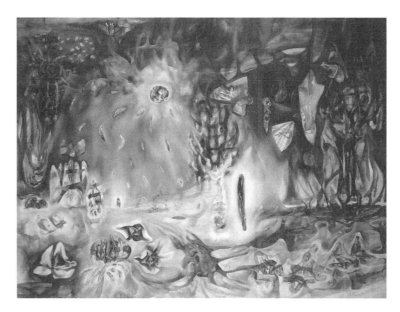

Figure 3.3 Roberto Matta, *The Earth Is a Man* (1942). Oil on canvas, 72 × 94". The Art Institute of Chicago. Gift of Mr. and Mrs. Joseph Randall Shapiro (after her death, dedicated to the memory of Jory Shapiro by her husband). © 2006 Artists Rights Society (ARS), New York / ADAGP, Paris.

Among the innovations of Pollock's drip style was to abolish the distinction between surface and depth within a unified field—a fine tracery of lines that frustrated the effort of vision to pick out or privilege particular shapes. Michael Leja has analyzed Pollock's all-over painting style in terms of the metaphor of the vortex, web, or labyrinth. The latter had a surrealist provenance in the myth of the Minotaur, but in the context of the 1950s, the labyrinth would come to be associated with a subjectivity no longer clearly bounded but absorbed into an energy field that redefined it.[119] Both the scale of painting and the image of space in Pollock's work draws in the spectator, who is now located within the image. Such an approach "violently rejected," in Dore Ashton's words, "established pictorial conventions for delimiting recessive space," pictorial conventions grounded in the Cartesian dualism of perceiving subject and static object.[120] By contrast, surrealist work generally preserved the intimacy and object quality of easel painting, as well as the distinction between figure and ground. The figure/ground analogy was used in Perls's and Goodman's *Gestalt Therapy* (1951) to characterize the relationship of the psychological subject to the surrounding environment, with which it was engaged in a continuous "interplay."[121] Gestural painting did not claim to transcribe a preexisting psychic landscape but instead to create this landscape through the encounter with materials in the "energy field" of the canvas.[122]

VI

In the years during and following the war, artists made numerous statements that suggest a shift away from the objective social processes that drove much social realism, and back toward inner realities. Ben Shahn wrote that he "became most conscious then that the emotional image is not necessarily of that event in the outside world which prompts our feeling; the emotional image is rather made up of the inner vestiges of many events."[123] This entailed an effort to define new forms of symbolism that linked subjective experience to a world beyond the hermetic self. The function of symbols, so critical in the Depression years, remained but underwent a transformation from allegories of social conflict to more open-ended metaphors of cultural renewal.[124] Historical experience itself was perhaps the greatest force in drawing Americans away from naturalism toward newer languages with which to explore the intersections of the personal with the historical. In this movement of artistic and cultural renewal, the American encounter with European surrealism proved a vital catalyst. Contact with European art and artists culminated in a renewed impulse within American art toward self-definition. In the end it was a growing sense of *difference* from European art and artists, rather than shared convictions

or similar ideological orientation, that drove the future outlines of American art in the decades that followed the European exchange. The native "triumph" of American painting in the postwar era was achieved through both the stimulus of and resistance to European painting, and to surrealism in particular.

Finally, the varied American response to surrealism was unified around a shared preoccupation with free will, imaginative agency, and personal freedom. Museum director René d'Harnoncourt expressed what would soon become a standard cold war defense of modernist experimentation in terms of the free agency of the individual: "To expect a diversified society to produce a uniform, universally understood art is a measure of our true fear of facing the results of our own advances . . . here we are with our hard-earned new freedom. Walls are crumbling all around us and we are terrified by the endless vistas and the responsibility of an infinite choice. It is this terror of the new freedom which removed the familiar signposts from the roads that makes many of us wish to turn the clock back and recover the security of yesterday's dogma." This existential challenge, d'Harnoncourt argued, was the testing ground of a new democratic society, a condition of the fullest development of individuality "for the sake of the whole." Modern art, with its absence of defining barriers and its "infinite variety and ceaseless exploration," was the very symbol of the new freedom.[125]

Freedom had, of course, been a catchword of the surrealist movement in Europe. But American critics were acutely aware of the paradoxical nature of the surrealists' assertion of imaginative freedom, on the one hand, and on the other its obsession with unconscious psychic process, over which the individual could exercise no control, and to whose laws one had little choice but to submit.[126] Coupled with the authoritarian personality of Breton, this psychic determinism seemed to contradict fundamental principles of the self-determining individual central to the emerging postwar modernism of New York City.

Yet—reacting against such rigid insistence on the power of the unconscious to shape individual destiny—American artists and intellectuals faced a different form of determinism in the postwar culture of the United States, the effect of an emerging mass society directed by corporate requirements. As thoughts and desires were increasingly colonized by mass media, advertising, and managerial insistence on behavioral conformism, the role of the imagination, poetry, and magic intensified as a stay against banality and an ever more straitened interior life.[127] The American encounter with surrealism left American artists and intellectuals a vital legacy of resistance and opposition.

Notes

I would like to thank Elizabeth Allen, Howard Brick, and my editors Sabine Eckmann and Lutz Koepnick, for invaluable assistance with this essay. Special thanks to Andrew Hemingway, whose important work on American artists and the left has furnished crucial guidance, and who has saved me from numerous interpretative errors.

1. "The Great Flight of Culture," *Fortune Magazine*, December 1941, 102.
2. The reception of surrealism among American writers constitutes a distinct and important episode that cannot be treated here. See, in particular, Malcolm Cowley, *Exile's Return: A Literary Odyssey of the 1920s* (New York: Viking Press, 1951); and Matthew Josephson, *Life among the Surrealists: A Memoir* (New York: Holt, Rinehart, and Winston, 1962).
3. Helena Lewis, *The Politics of Surrealism* (New York: Paragon House Publishers, 1988), 136, 173. See also Mari Jo Buhle, Paul Buhle, and Dan Georgakas, eds., *The Encyclopedia of the American Left* (New York: Oxford University Press, 1998), 808; Franklin Rosemont, ed., *What is Surrealism? Selected Writings of André Breton* (New York: Monad Press, 1978), 56; Dickran Tashjian, *A Boatload of Madmen: Surrealism and the American Avant-Garde, 1920–1950* (New York: Thames and Hudson, 1995), 118; and Susan Noyes Platt, *Art and Politics in the 1930s: Modernism, Marxism, Americanism* (New York: Midmarch Press, 1999), 209–213.
4. Martica Sawin notes that Breton, with one exception, was not translated until the mid-1940s. See Martica Sawin, *Surrealism in Exile and the Beginning of the New York School* (Cambridge, MA: MIT Press, 1995), 101. See also Tashjian, *Boatload of Madmen*, 188; and Dore Ashton, *The New York School: A Cultural Reckoning* (New York: Viking Press, 1972), 85–86.
5. André Breton, "Speech to the Congress of Writers," *Manifestoes of Surrealism*, trans. Richard Seaver and Helen R. Lane (Ann Arbor: University of Michigan Press, 1972), 241.
6. Wolfgang Paalen, Kurt Seligman, Roberto Matta, and Yves Tanguy arrived in New York in 1939; André Masson, André Breton, and Max Ernst in 1941. In 1942 both Salvador Dali and Joan Miró had major exhibitions at the Museum of Modern Art, while New York galleries held exhibitions of Masson, Ernst, Matta, and Tanguy, and the journal *VVV* was founded, bringing together American and European Surrealists. The Pierre Matisse Gallery held its "Artists in Exile" exhibition in March 1942. Marcel Duchamp returned to the United States in June of 1942; his presence was instrumental in the First Papers of Surrealism exhibition, which opened in October 1942. Peggy Guggenheim's *Art of this Century*, featuring the Surrealists, opened concurrently.
7. Keith Eggener, "'An Amusing Lack of Logic': Surrealism and Popular Entertainment," *American Art* (Fall 1993): 31–45.
8. Frank Getlein, *Peter Blume* (New York: Kennedy Galleries, 1968), n.p.
9. Virgil Barker, "A Trans-Atlantic Chronicle—III," *The Arts* (December 1925): 317–318.
10. On these two exhibitions, see Deborah Zlotsky, "'Pleasant Madness' in Hartford: The First Surrealist Exhibition in America," *Arts Magazine*, 60.6 (February 1986): 55–61.

11. Jeffrey Wechsler, *Surrealism and American Art, 1931–1947* (New Brunswick, NJ: Rutgers University Press, 1976), 29; and Gerald Durozoi, *History of the Surrealist Movement*, trans. Alison Anderson (Chicago: University of Chicago Press, 2002), 394. While Dali's influence on American artists waned in the 1940s, the American public continued to associate him with surrealism. See Sidney Simon, "Concerning the Beginnings of the New York School, 1939–1943," *Art International*, 11.6/7 (1967): 18; Sawin, *Surrealism in Exile*, 157; and Tashjian, *Boatload of Madmen*, 227–228.

12. Charmion Von Wiegand, "Expressionism and Social Change," *Art Front*, 2.10 (November 1936): 10–13.

13. Quoted in Alfred Barr, Jr., ed., *Fantastic Art, Dada, and Surrealism* (New York: Museum of Modern Art, 1936), 41.

14. On this point, see Charles Russell, *Poets, Prophets, and Revolutionaries: The Literary Avant-Garde from Rimbaud through Postmodernism* (New York: Oxford, 1985), 159.

15. See, e.g., Barnett Newman, "What About Isolationist Art?" quoted in James E. B. Breslin, *Mark Rothko: A Biography* (Chicago: University of Chicago Press, 1993), 198.

16. Meyer Shapiro, "Populist Realism," *Partisan Review* (January 1938): 56.

17. See Erika Doss, *Benton, Pollock, and the Politics of Modernism: From Regionalism to Abstract Expressionism* (Chicago: University of Chicago Press, 1991), 388–392.

18. With the arrival of "Los Tres Grandes" from Mexico, American artists had another model for extending the language of narrative art beyond naturalism. Orozco's mural cycle *Epic of American Civilization* at Dartmouth was of particular importance for the Social Surrealists, especially Quirt. See Andrew Hemingway, *Artists on the Left: American Artists and the Communist Movement, 1926–1956* (New Haven: Yale University Press, 2002), 27–28; and James Oles, *South of the Border: Mexico in the American Imagination, 1914–1947* (Washington, DC: Smithsonian Institution Press, 1993), 171 ff. In addition, Mexico offered an American version of the fantastic, attracting a number of Surrealists and their American compatriots in the 1940s, including Wolfgang Paalen and Robert Motherwell. Breton considered Mexico *the* surrealist country.

19. Quoted in *Walter Quirt: A Retrospective* (Minneapolis: University Gallery, University of Minnesota, 1980), 11.

20. Holger Cahill, "American Art Today," *Parnassus* (May 1939): 36.

21. Sawin, *Surrealism in Exile*, 91.

22. Jerome Klein, "Dada for Propaganda," *Art Front* (February 1935): 7.

23. Grace Clements, "New Content—New Form," *Art Front* (March 1936): 8.

24. Susan Ehrlich, ed., *Pacific Dreams: Currents of Surrealism and Fantasy in California Art, 1934–1957* (Los Angeles: UCLA, 1995), 22. On Surrealism's impact on art in California, see also Susan Landauer, *The San Francisco School of Abstract Expressionism* (Berkeley: University of California Press, 1996), 31.

25. Quoted in Ehrlich, *Pacific Dreams*, 106.

26. Tashjian, *Boatload of Madmen*, 132.

27. Clements, "New Content," 9.

28. Charmion Van (sic) Wiegand, "The Surrealists," *Art Front* (June 1937): 12–14.

29. Ibid., 12–14. On Wiegand, see Hemingway, *Artists on the Left*, 109–112; and Platt, *Art and Politics in the 1930s*, 109–121.
30. Margaret Duroc, "Critique from the Left," *Art Front* (January 1936): 7.
31. Patricia Hills and Roberta Tarbell, *The Figurative Tradition and the Whitney Museum of American Art* (New York: Whitney Museum of American Art, 1980), 86–89. On the early reception of Freud, see Sanford Gifford, "The American Reception of Psychoanalysis, 1908–1922," *1915: The Cultural Moment*, ed. Adele Heller and Lois Rudnick (New Brunswick, NJ: Rutgers University Press, 1991), 128–145; and Leslie Fishbein, *Rebels in Bohemia: The Radicals of the Masses, 1911–1917* (Chapel Hill: University of North Carolina Press, 1982), 83–93.
32. Quoted in Eggener, "An Amusing Lack of Logic," 33.
33. See, e.g., Wiegand, "The Surrealists," 13; and Clarence Weinstock, "A Letter on Salvador Dali," *Art Front* (February 1935): 8.
34. Simon, "Concerning the Beginnings of the New York School," 18.
35. Breslin, *Mark Rothko*, 184.
36. On the close association between Surrealism and advertising in the United States, see Eggener, "An Amusing Lack of Logic." The commercialization of surrealism seems to have taken off with the fantastic art, Dada, and surrealism exhibition at MoMA in 1936.
37. Frank Caspers, "Surrealism in Overalls," *Scribner's Magazine* (August 1938): 17–21.
38. Quoted in Stephen Polcari, "Ben Shahn and Postwar American Art: Shared Visions," *Common Man, Mythic Vision: The Paintings of Ben Shahn*, ed. Susan Chevlowe (Princeton: Princeton University Press, 1998), 71.
39. On social surrealism, see Cahill, "American Art Today," 35–36; Stanley Meltzoff, "David Smith and Social Surrealism," *American Magazine of Art* (March 1946): 98–101; Tashjian, *Boatload of Madmen*, 110–136; Susan Ilene Fort, "American Social Surrealism," *Archives of American Art Journal*, 22.3 (1982): 8–20; Wechsler, *Surrealism and American Art*, 39–43; and Hemingway, *Artists on the Left*, 43–44 (passim).
40. Robert Motherwell, "The Modern Painter's World," *Dyn*, 6 (November 1944): 13.
41. John O. Baker, *Louis Guglielmi: A Retrospective Exhibition* (New Brunswick, NJ: Rutgers University Art Gallery, 1980), 12; and Louis Guglielmi, "I Hope to Sing Again," *Magazine of Art*, 37.5 (May 1944): 177. On the Marxist underpinnings of art on the left, see Andrew Hemingway, "Meyer Schapiro and Marxism in the 1930s," *Oxford Art Journal*, 17 (1994): 13–29.
42. For an account of the Museum of Modern Art symposium, which included Quirt alongside Dali, see Anita Brenner, "Surrealism and Its Political Significance," *The Brooklyn Daily Eagle*, January 24, 1937, 82.
43. Elizabeth McCausland, "Living American Art," *Parnassus* (May 1939): 20.
44. Quoted in Cécile Whiting, *Antifascism in American Art* (New Haven: Yale University Press, 1989), 189.
45. Clements, "New Content," 9.
46. E. M. Benson, "Exhibition Reviews," *American Magazine of Art* (April 1936): 260. Quirt and Dali were also discussed in the *Art Digest* (March 1936): 16; and *Art News* (February 1936): 9.

47. Kenneth Burke, "Growth among the Ruins," *Philosophy of Literary Form: Studies in Symbolic Action* (Baton Rouge: Louisiana State University Press, 1941), 435.

48. See, e.g., Meyer Schapiro, "The Liberating Quality of Avant-Garde Art," *Art News* 56 (June 1957): 40–41, as an example of the shift in emphasis toward more difficult art requiring more from its audiences.

49. Margaret Breuning, "Seeing the Shows: The Whitney Annual," *American Magazine of Art* (December 1938): 709, refers to the role of the "modish European language of Surrealism (so actually outmoded in Europe itself)" in American art sales.

50. Quoted in Ehrlich, *Pacific Dreams*, 15.

51. Berenice Abbott, *World of Atget* (New York: Horizon Press, 1964), xxii. On photography and the "social fantastic," see Christopher Phillips, "Resurrecting Vision: The New Photography in Europe between the Wars," *The New Vision: Photography between the World Wars*, ed. Maria Morris Hambourg (New York: H. N. Abrams, 1989), 95–105.

52. Berenice Abbott, "Photography: 1839–1937," *Art Front* (May 1937): 25; and by the same author, "Photographer as Artist," *Art Front* (September 1936): 6. Quoted in Joe Fox, "Berenice Abbott's Surrealist Gaze," unpublished MA thesis, Art History and Archaeology Department, Washington University, 2002.

53. Thanks here to Elizabeth Childs's perceptive comments about Abbott's *Changing New York*.

54. See Peter Wollen, *Raiding the Icebox: Reflections on Twentieth-Century Culture* (Bloomington: Indiana University Press, 1993), 105; and Kirk Varnedoe and Adam Gopnick, *High and Low: Modern Art and Popular Culture* (New York: Museum of Modern Art, 1990), 64–179.

55. Quirt's early work included cartoons for radical publications in the 1930s. "Doing cartoons," according to Anton Refregier, muralist and friend of Quirt's, "was not a separate activity from our painting or from our lives" (quoted in *Walter Quirt*, 17). Clement Greenberg referred to Matta as "that little comic stripper" (Sawin, *Surrealism in Exile*, 374).

56. Quoted in Zlotsky, " 'Pleasant Madness' in Hartford," 59.

57. See Sawin, *Surrealism in Exile*, 173–174, 178.

58. City Art Museum of St. Louis, *Trends in American Painting Today. The Thirty-Sixth Annual Exhibition. Paintings by Émigrés* (St. Louis: City Art Museum, 1942), 32.

59. On the impact of the American landscape on the émigrés, see Anthony Heilbut, *Exiled in Paradise: German Refugee Artists and Intellectuals in America from the 1930s to the Present* (New York: Viking Press, 1983), 50–56.

60. "An Interview with Nicolas Calas," *New Directions in Prose and Poetry*, ed. Nicolas Calas (Norfolk, CT: New Directions, 1940), 394.

61. Quoted in Romy Golan, "On the Passage of a Few Persons through a Rather Brief Period of Time," *Exiles and Émigrés: The Flight of European Artists from Hitler*, ed. Stephanie Barron and Sabine Eckmann (Los Angeles: Los Angeles County Museum of Art, 1997), 132–133.

62. See Klaus Mann, quoted in Peyton Boswell, "Surrealist Circus," *Art Digest*, 17 (May 1943): 21.

63. Quoted in Breslin, *Mark Rothko*, 185.

64. Durozoi, *History of the Surrealist Movement*, 393. Irving Sandler, in *Triumph of American Painting: A History of Abstract Expressionism* (New York: Harper & Row, 1970), 32, states that only a handful of American artists—David Hare, Motherwell, Baziotes, and Gorky, among them—had any sustained contact with the Surrealists. For an intimate view of the relations between the émigrés and those artists who would later feed into abstract expressionism, see Simon "Concerning the Beginnings of the New York School."

65. Simon, "Concerning the Beginnings of the New York School," 18.

66. Quoted in Durozoi, *History of the Surrealist Movement*, 393; André Breton, "The Situation of Surrealism Between the Two Wars," *Yale French Studies*, 1.2 (1948): 67.

67. Quoted in Durozoi, *History of the Surrealist Movement*, 393.

68. Simon, "Concerning the Beginnings of the New York School," 17.

69. See Breslin, *Mark Rothko*, 183.

70. Jimmy Ernst, quoted in Sawin, *Surrealism in Exile*, 166.

71. Durozoi states that since Breton's *Second Manifesto* of 1930, the Surrealists had directed their interest "toward a collective myth, something that could be effective on a social level and no longer solely on the level of the individual psyche" (*History of the Surrealist Movement*, 399). On the social origins of this search for a new myth in the European exile experience of displacement, see Sawin, *Surrealism in Exile*, 150.

72. Breton, "Situation of Surrealism," 78. In 1941, Breton declared his intention of writing a Third Manifesto of Surrealism, but only got as far as a Prolegomena. See *View*, 7/8 (October/November 1941): 1.

73. Breton, "Situation of Surrealism," 77. See also Sawin, *Surrealism in Exile*, 215.

74. André Breton, "Prolegomena to a Third Surrealist Manifesto or Else," *Manifestoes of Surrealism* (Ann Arbor: University of Michigan Press, 1972), 287–289.

75. Eric Kahler, "The Persistence of Myth," *The Chimera*, 4.2–11 (Spring 1946): 9.

76. Ibid.

77. The mythic appeal of fascism was a commonplace by the late 1940s. See Andrea Caffi, "On Mythology," *Possibilities*, 1 (Winter 1947–1948): 91, which refers to the "*Ersatz* mythologies" of the Reich as well as of Stalinist Russia, Japan, and Italy. Whiting points out that in the 1940s, all forms of myth, including the archaic myth preferred by the Surrealists and the abstract artists in the early 1940s, had to establish their difference from Nazi uses of myth (Whiting, *Antifascism in American Art*, 188).

78. Breton, "Situation of Surrealism," 73. Gavin Parkinson's *Surrealism, Modern Physics, and Epistemology* (London: Yale University Press, forthcoming 2007) was unavailable for me to consult.

79. On the postwar quest for new myths, see Serge Guilbaut, *How New York Stole the Idea of Modern Art: Abstract Expressionism, Freedom, and the Cold War* (Chicago: University of Chicago Press, 1983), 110, 157.

80. Quoted in Boswell, "Surrealist Circus," 27; Motherwell, "The Modern Painter's World," 12 (passim).

81. On existentialism in the United States, see George Cotkin, *Existential America* (Baltimore: Johns Hopkins University Press, 2003), 104–133.

82. Harold Rosenberg, "Breton—A Dialogue," *View*, 3.2 (Summer 1942): n.p.

83. Ibid., n.p.

84. On Rosenberg's political development, see Fred Orton, "Action, Revolution, and Painting," *Oxford Art Journal*, 14.2 (1991): 3–7.

85. On this point, see Philippe Lacoue-Labarthe and Jean-Luc Nancy, "The Nazi Myth," *Critical Inquiry*, 16.2 (Winter 1990): 291–312.

86. Kenneth Burke, "Surrealism," *Prose and Poetry*, ed. Nicolas Calas (Norfolk, CT: New Directions, 1940), 572.

87. On this point, see Guilbaut, *How New York Stole the Idea of Modern Art*, 77–78.

88. Richard Chase, "Notes on the Study of Myth," *Partisan Review*, 13.3 (Summer 1946): 344.

89. Ibid., 345, 346. For a related expression of the same idea that myths are "made up of the residue of poetic illuminations," see Benjamin Peret, "Magic: The Flesh and Blood of Poetry," *View*, 2 (June 1943): 46; and Charles Henri Ford, "The Point of *View*," *View*, 1 (April 1943): 5.

90. A major vehicle for new ideas about myth among both European Surrealists and their American colleagues were the 'little magazines' that appeared beginning in 1941: *View, VVV*, and *Vertical* (ed. Eugène Jolas) which had only one issue. See Tashjian, *Boatload of Madmen*, 197–198.

91. Breton, "Situation of Surrealism," 76; and Peret, "Magic," 44.

92. Kahler, "Persistence of Myth," 10.

93. Ibid., 11. The image of the skein links this model of world and self to the drip techniques of Pollock, which would emerge in the next few years. See Michael Leja, *Reframing Abstract Expressionism: Subjectivity and Painting in the 1940s* (New Haven: Yale University Press, 1993), 308–319. Wolfgang Paalen, editor of *Dyn*, was also drawn to contemporary physics—in particular the Heisenberg uncertainty principle. See Sawin, *Surrealism in Exile*, 255–256, 266–271, 275, 284.

94. Quoted in Guilbaut, *How New York Stole the Idea of Modern Art*, 56.

95. On the role of existentialism in the early years of abstract expressionism, see Nancy Jachec, " 'The Space Between Art and Political Action': Abstract Expressionism and Ethical Choice in Postwar America, 1945–1950," *Oxford Art Journal*, 14.2 (1991): 18–29.

96. See Stephen Polcari, *Abstract Expressionism and the Modern Experience* (New York: Cambridge University Press, 1991), 29, 43–48.

97. See Heilbut, *Exiled in Paradise*, 220.

98. Breton, "Prolegomena to a Third Manifesto," 279–294; Whiting, *Antifascism in American Art*, 170–196; and Tashjian, *Boatload of Madmen*, 202–234. Herbert Read drew a distinction between different forms of irrational instinct: those he termed "phylocentric," or ego-centered and fascistic, and those antifascist instincts of "mutual aid and constructiveness." See Herbert Read, *The Politics of the Unpolitical* (London: Routledge, 1946), 89.

99. See Sandler, *Triumph of American Painting*, 23; and Polcari, *Abstract Expressionism*, 22.

100. The preference for Jung was widely recognized by the late 1950s. See Alfred Barr, "Introduction," *The New American Painting* (New York: Museum of Modern Art, 1959), 16.

101. Whitney Chadwick, *Myth in Surrealist Painting, 1929–1939* (Ann Arbor: UMI Research Press, 1980), p. 97.

102. On this point, see Charles E. Gauss, "The Theoretical Backgrounds of Surrealism," *Journal of Aesthetics and Art Criticism*, 2.8 (Fall 1943): 43; and Sawin, *Surrealism in Exile*, 161. Not everyone embraced Jung, however; his fascination with the occult and irrational aspects of human experience made Jung a double-edged sword for Americans in the wake of World War II, who weighed his overlaps with Nazi ideologies against the postwar search for mythic anchors in a time of psychic and social recuperation. Barnett Newman considered Jung a Nazi. See David Anfam, "The Extremes of Abstract Expressionism," *American Art in the 20th Century: Painting and Sculpture, 1913–1993*, ed. Christos M. Joachimides and Norman Rosenthal (Munich: Prestel, 1993), 87.

103. Quoted in Polcari, *Abstract Expressionism*, 28.

104. Breton, "Situation of Surrealism," 71.

105. Paul Goodman, "The Political Meaning of Some Recent Revisions of Freud," *Politics*, 2.7 (July 1945): 197.

106. On the independent experimentation of Kamrowski, Baziotes, and Pollock, both on their own and with Matta, see Martica Sawin, " 'The Third Man,' or Automatism American Style," *Art Journal*, 47.3 (Fall 1988): 181–86.

107. Sandler, *Triumph of American Painting*, 41; and Wechsler, *Surrealism and American Art*, 63.

108. See Daniel Belgrad, *The Culture of Spontaneity: Improvisation and the Arts in Postwar America* (Chicago: University of Chicago Press, 1998), 151.

109. On Dewey's influence on both Motherwell and Paalen, see Robert Saltonstall Mattison, *Robert Motherwell: The Formative Years* (Ann Arbor: UMI Research Press, 1987), 36.

110. See Belgrad, *The Culture of Spontaneity*, 153.

111. As Paul Rodgers argues, once liberated, images from the preconscious mind often assumed a conventional artistic form. See Paul Rodgers, "Towards a Theory/Practice of Painting: Abstract Expressionism and the Surrealist Discourse," *Artforum*, 18 (March 1980): 53.

112. Quoted in Belgrad, *The Culture of Spontaneity*, 155.

113. On the cultural impact of particle physics, see ibid., 120. For the contemporary application of the "field" model to the study of society, see Kurt Lewin, *Field Theory in Social Science: Selected Theoretical Papers* (New York: Harper & Row, 1951). Lewin's insistence that behavior be studied as the interaction of "the organism *and* its life space, in the group *and* its setting" (173), suggests strong parallels to emerging ways of thinking about artistic production.

114. See, e.g., Alfred North Whitehead, "Objects and Subjects," *Adventures of Ideas* (New York: MacMillan Company, 1933), 225–245.

115. Quoted in Ellen H. Johnson, *American Artists on Art from 1940 to 1980* (New York: Harper & Row, 1982), 16. On the American resistance to "fixed conceptual structures [that] truncated and falsified reality," see Belgrad, *The Culture of Spontaneity*, 107.

116. Quoted in Johnson, *American Artists on Art*, 16.

117. Newman, quoted in ibid., 19.

118. On the illusionism of Matta in relation to Motherwell, see Mattison, *Robert Motherwell*, 26.

119. See Leja, *Reframing Abstract Expressionism*, 313.

120. Quoted in ibid., 316.

121. See Belgrad, *The Culture of Spontaneity*, 150–151.

122. See, e.g., Motherwell's statement made in 1979, quoted in Stephanie Terenzio, *Robert Motherwell and Black* (Storrs: University of Connecticut Press, 1980), 130. Lawrence Alloway described the difference between American abstract painting and surrealism in similar terms: "[T]he picture became a field of running decisions rather than a spontaneous confession." Lawrence Alloway, *William Baziotes: A Memorial Exhibition* (New York: Solomon Guggenheim Museum, 1965), 13.

123. Quoted in Polcari, "Ben Shahn and Postwar American Art," 71.

124. On the interest among Shahn, Gottlieb, and others in the question of the origins of language, see ibid., 81.

125. René D'Harnoncourt, "Challenge and Promise: Modern Art and Modern Society," *American Magazine of Art* (July 1948): 252. The theme of an unsettled time yielding an unsettled art was sounded often in these years. See Piri Halasz, "Art Criticism (and Art History) in New York: The 1940s vs. the 1980s: Part Two: The Magazines," *Arts Magazine*, 57.7 (March 1983): 67.

126. On the Surrealist commitment to freedom, see Breton's *Second Manifesto* (1930) in Breton, *Manifestoes of Surrealism*, 187; Guilbaut, *How New York Stole the Idea of Modern Art*, 32–33.

127. Antoine de Saint Exupéry, another wartime New York exile (and an ardent critic of surrealism), passionately defended freedom from the oppressive conformism of mass democracy. See Jeffrey Mehlman, *Émigré New York: French Intellectuals in Wartime Manhattan, 1940–1944* (Baltimore: Johns Hopkins University Press, 2000), 151.

CHAPTER FOUR

GERMAN EXILE, MODERN ART, AND NATIONAL IDENTITY

Sabine Eckmann

I

Even today, more than sixty years after the German surrender in 1945, accounts of the transatlantic interchange between Germany and the United States about Hitler's artists in exile inaccurately dramatize them as representatives of all the victims of the Third Reich. Undoubtedly, the experience of exile and emigration changed the path of artists' lives significantly. Many encountered the geopolitical displacement as double loss: they felt exiled from Nazi Germany and as outsiders in the United States. Although their traumatic experiences unify them as a social group, their reasons for emigration and exile vary greatly. These include political and racial persecution, individual decisions to pursue life in a democracy and the simple fact of better career opportunities in the New World. Similarly, to follow their aesthetic endeavors means to follow individual creators rather than to identify collective goals and a unified artistic voice.[1]

For more than a decade, critical investigations in cultural studies in particular, and the humanities in general, have explored memory as a form of writing history, in order to embrace a broad variety of social, national, and cultural identities. These studies consider the ideological functions of memorial strategies such as forgetting mechanisms, subjectivized perceptions and constructions of the past and their use for present narratives.[2] Similar to discourses about the Holocaust, exile studies are more often than not subject of charged discussions and more indebted to political and moral schemes of assessment than to processes of historicization. A critical assessment of memory in lieu of a linear and progressive history appears as an appropriate tool for analyzing exile. In contrast to Holocaust studies, however, the history of German exile art has thus far rarely been explored in

theoretical frameworks that consider mnemonic activity as central to narratives of exile art history.

Historian Jörn Rüsen recently conceptualized a three-phase model of West German identity formation in relation to Holocaust memory. According to Rüsen, the first phase set in immediately after the war and is characterized by silence and exterritorialization, followed after 1968 by a second phase of moral distanciation, which was affected by the second generation of Germans born during or immediately after the war. The third phase begins after 1989 and is distinguished by historical distance and ideological uncertainties unleashed by the upheaval of political systems after the end of the cold war. With this somewhat simplified model Rüsen established an interpretive frame that reciprocally relates memory and identity to one other. Memory serves as a mediator between past, present, and future that forms identity conceived as a practice of differentiation.

Pierre Nora, however, claims past and memory as independent entities. Memory in his opinion historicizes or better gives meaning to the present rather than reinterpreting the past(s). The acceleration of history, he argues, cut us off from the past and led to an "autonomizing" of the present that is informed by a deep-rooted uncertainty about the future. While formerly past and future were mediated by the present, the rapid changes characterizing the latter twentieth century resulted in a detachment of these entities whereby the present itself is experienced as self-reflective of its ontology, thus being already historical.

In light of Nora's thesis, Rüsen's assessment of the changing historical patterns of Holocaust memory may then only reflect the shifts in postwar German identity constructions as opposed to new narrations of the past. The mythologizing and consistent inscriptions of exile artists as transcendent and symbolic figures of Germany's national past suggest from the very outset a limited engagement with the past. For Germany, the exile artists not only function as evidence of the victimization of Germany by Hitler but also give reason to mourn that past from the perspective of the victim. By contrast, in the United States Hitler exiles most often are seen to underscore a homogenous conception of the United States as a democratic haven for all victims of dictatorships. In both cases exile artists are used to institutionalize hegemonic cultural positions. To avoid the reification of such arresting narratives, this chapter will trace those moments of art history when exile memory surged in order to explore if and how these memories served to renew the imagination of a national identity. The institutions of art history as registered in art criticism, through museums, and through academe will be consulted in order to trace this trajectory.

With respect to exile art history statistics are often misleading: A recent study of German exile artists lists 369 German artists who either emigrated

from Nazi Germany between 1933 and 1945 or were active members within exile cultural groups. Seventy-two of these artists made their way to the United States, making the United States the third important destination for German exile artists after Great Britain (115) and France (96).[3] The list of names of German exile artists in the United States includes important Weimar modernists such as Joseph Albers, Max Beckmann, Max Ernst, Walter Gropius, George Grosz, and Mies van der Rohe, to name a few. Only a very small number of exile artists returned after the war to Germany, most often to the East Germany. Many decided instead to make their country of exile a home. These included Albers, Gropius, and Mies. Others, like Beckmann continued his itinerant life by emigrating from Amsterdam to the United States after the war. This inclusion of artists and architects who represent some of Weimar Germany's most important modernists prompted in the late 1960s the thesis that Germany was suffering a self-inflicted loss of its modern artistic elite, a thesis tied to the metaphor of the Third Reich as a wound. The artists' displacement served and continues to serve as a basis for responses of empathy that reflect the perception of a German national identity as fractured.

The statistics further imply that Hitler's exile artists are identical with those artists who were showcased in the 1937 Degenerate Art Exhibition in which Nazi Germany pilloried modern German art, in particular expressionism, Constructivism, and Dadaism. However, as Rosemunde Neugebauer has recently demonstrated, only 28 of the 109 German artists included in Degenerate Art emigrated from Nazi Germany. And not all of them left Germany due to their aesthetic persecution. More important reasons for emigration were racial and political discrimination or the allure of economic success elsewhere. Neugebauer further explicates that from the 300 artists listed in the *Biographisches Handbuch der deutschsprachigen Emigration* only 15 percent were included in either the Degenerate Art Exhibition or in similar defaming exhibitions organized by the Nazis.[4] Thus the majority of German exile artists never played a central role in art historical narratives that constructed the canon of early to mid-century modern German art. Nonetheless postwar accounts rely heavily on this identification between exile and modern art. Moreover, before and after 1945, not only exile but also modern art was subject to interpretations that formed national self-images. It is this triangular constellation between exile, modern art, and national identity that fashioned German and American art historical narratives concerned with the 1930s and 1940s.

Therefore, we have to ask which interpretations of modernism were tied to or detached from exile and how these in turn affect concepts of exile art. Only then will we be able to gain insights into how exile shapes and shaped certain ideas of modernism that through the politicization of art in the

1930s and 1940s contributed to notions that mold postwar Germany's national imaginary. The following discussion brings together German and American interpretations of modernism and exile art. The chapter will pay attention to both political and aesthetic aspects of these concepts to consider them as an intricate and inseparable part of the history and historiography of exile. These shifts in understandings of exile memory and their potential to ascribe new meaning to a traumatic past recast both narratives of modernism and exile art.

II

In the first three and a half decades after Nazi Germany's defeat, exile art as such was rarely addressed in the postwar German art world(s).[5] Immediately after, the war efforts focused on presenting modernist art defamed by the Nazis. Early exhibitions such as Erste Kunstausstellung nach dem Krieg (First Art Exhibition after the War, 1945) organized by the artist Hans Uhlmann, and the opening exhibition of the gallery Gerd Rosen (1945), Berlin's first postwar art gallery, included works by expressionists such as Ernst Ludwig Kirchner, Erich Heckel, and Ernst Barlach. None of these expressionist artists, however, had emigrated. Their work was showcased together with artworks by contemporary artists such as Hans Uhlmann and Heinz Trőkes. Similarly, the first Allgemeine deutsche Kunstausstellung[6] (General German Art Exhibition) in Dresden in 1946 exhibited prewar German expressionism side by side with contemporary practices. These exhibitions not only brought back into the public sphere the work of Nazi banned artists but also constructed a linkage between postwar German art and Wilheminian as well as Weimar modern art traditions. As in most other areas of postwar Germany, the art world omitted the productions created during the twelve years of Nazi rule and instead forced a straight continuation between prewar modernism and postwar art. Yet this absence of Germany's most recent past was not so much informed by the attempt to undo it but rather in order to "detraumatize" it through setting up relations to pre-1933 Germany. In this respect Dan Diner's famous thesis that after the singular experience of Auschwitz (conceived as the rupture of civilization) temporality came to a standstill and also contaminated pre-1933 history proves problematic. The newly established bond between German expressionism, representing modern German art, and contemporary aesthetic practices not only demonstrated a reconnection to an abandoned tradition but more importantly underscored recent artworks as inherently German, solidifying a national art just months after Nazi Germany's surrender.

Representative examples of German postwar modernism either in its figurative or abstract versions such as Karl Hofer's *Ruins by Night* (1947)

and Willi Baumeister's *Original Forms* (1946) are, in contrast to expressionism, aesthetically moderate in their modernist idiom—certainly a consequence of Nazi artistic practices with its emphasis on shifting combinations of modernist visuality and classicist realism. More important for postwar artists than inaugurating a modernism that was tied to or critical of postwar modernity was the yearning to create images that clearly verified a detachment from Third Reich art through means of style and subject matter. Instead of Nazi realism the imagery showed either figurative, archaic modes, or abstract styles, very similar to practices of German modernists who had remained in Nazi Germany where they worked in retreat, in a state of so-called inner emigration such as Fritz Winter. Postwar themes included mythic and antique subject matter, landscapes, cityscapes, and motives that mourned the bleak presence of a destroyed country and its damaged citizens through symbolic and metaphoric means. Yet in these images, the ritualized and collectivized life of Nazi society is still conveyed through preindividualized, that is, primitivist or archaic aesthetics. It was not until the early 1950s that artists in the East developed the Soviet heritage of socialist realism in order to build up a viable antifascist art and imagery that would at the same time encourage the building of the new socialist state. During the same years, the West German art world led among others by Franz Roh and Will Grohmann showed their commitment to embrace Western modernist traditions, especially abstraction, to visualize democratic individualism.

The connection between German pre-1933 modernism, West German contemporary art and international modernism was made explicit with the first *documenta* in Kassel organized by Arnold Bode in 1955. Omitting art from the Third Reich, the focus was on rehabilitating those strands of German modernism that were pilloried by Nazi cultural policies. The claim that Germany's pre- and postwar art is an important part within international modernism was conveyed by "liberating" modernism from any contextual frameworks. Modernism's autonomy was contrasted with the Nazi aestheticization of politics and conversely established as democratic art, an argument that had already been made in the United States in the early 1940s when it embraced the modernism of Hitler's exile artists.

Among the modernists included in *documenta 1* were also artists who had left Nazi Germany such as Beckmann, Paul Klee, and Oskar Kokoschka. The same artists were featured in many one-man exhibitions in East and West Germany over the next decades.[7] Yet their exilic practice never played an important part in such examinations as the issue at stake was to place Weimar modernist practices into the canon of international postwar modernism. It took art history until the late 1970s to consider exile art as a separate theme. Rather than focusing on modern art created outside of Germany in the 1930s and 1940s the immediate postwar discourse on

German modernism embraced the continuation of Weimar German modernism by postwar contemporary art in order to make up for the art executed during the twelve years of Nazi rule inside the Third Reich. This interpretation underscored German modernism as a democratic practice that had been interrupted by the Third Reich thereby stressing a version of Germany's special path (Sonderweg) during the twentieth century. The effort to institute a national democratic German art after 1945 also entailed positioning it within international Western contemporary art conventions that were dominated by abstraction. The concept of a universal language of abstraction envisioned as the art of the Western democracies was confirmed to the art world in 1955 at Kassel's first *documenta*. Nevertheless, occasional exhibitions that showcased Nazi art, as staged by the art dealer Everhardt in Krefeld in 1950, for example, not only illustrate the struggle about modern and specifically abstract art in postwar Germany, but also convey the continuing impact and effects of national socialist art education.[8]

Yet through the advancement of modernism, postwar Germany established a new democratic identity for itself that clearly defied Nazi art models. Ironically, however, much of late 1940s and 1950s imagery continued to display a moderate modernism as practiced, despite Nazi cultural policies by artists such as Werner Heldt or Ernst Wilhelm Nay. These younger artists as well as the older generation that included Otto Dix, Karl Schmidt-Rottluff, and Oskar Schlemmer were later claimed as "inner emigrants." The work of exile artists who had actually left the country were not of interest. Rather it was the already canonized pre-1933 German art that was recalled in order to legitimize postwar art practices not only as democratic but also as German. After the founding of both Germanies in 1949, the German Democratic Republic (GDR) embraced a realist style as a means to communicate the collectivist politics of socialism to the broadest audience possible, while the Federal Republic of Germany (FRG) was intent on associating its own modernism with American abstract expressionism to strengthen the notion of an individualized, universalized, and autonomous modernism that in turn was often mobilized to advocate an Americanized identity for West Germany.

III

East German art historian Erhard Frommhold's 1968 book *Kunst im Widerstand* (Art in Resistance) was the first comprehensive study to address antifascist art made during the 1930s and 1940s. In line with GDR politics he was devoted to an antifascist, politically engaged art that was to portray a "better Germany." His book included many artists conventionally placed on the margins of German modernism such as Carl Schwesig and Josef

Scharl. Frommhold's volume also laid the groundwork for West German exhibitions of the late 1970s and 1980s. The 1978 West-Berlin Academy exhibition Zwischen Widerstand und Anpassung: Kunst in Deutschland, 1933–1945 (Between Resistance and Accommodation: Art in Germany, 1933–1945) drew on Frommhold's research as did the 1980 exhibition organized by the West German institution Badischer Kunstverein, Widerstand statt Anpassung: Deutsche Kunst im Widerstand gegen den Faschismus (Resistance Instead of Accommodation: German Art Resisting Fascism). In contrast to Zwischen Widerstand und Anpassung, which explored artistic practices within Nazi Germany, Widerstand statt Anpassung embraced exiled artists with politically activist motivations. The provocative nature of Zwischen Widerstand und Anpassung was due to its organizers' approach to demonstrate for the first time how German modernists attempted to accommodate their aesthetics to fit Nazi art policies, and if rejected, worked in retreat, in the inner emigration. In this state, which was theorized in psychological terms, most artists such as Schlemmer and Dix continued working in a formalist yet moderate modernist idiom and repressed contemporary subject matter. In his introductory essay Frommhold brings up the issue that instead of framing accommodated modernist expression and Nazi art as an oppositional pair, one should seriously reconsider the validity of such antipodes since both forms of artistic articulation integrated affirmative ideological stances.

Widerstand statt Anpassung was the first art exhibition to survey Czechoslovakia, France, and Great Britain as centers of German exile activity. However, it only included works by exiled modernists who produced artwork with overt political ambition. This increasing interest in activist exile art was preceded by exhibitions such as the 1974 Frankfurt Kunst im Dritten Reich: Dokumente der Unterwerfung (Art in the Third Reich: Documents of Repression), and the 1977 exhibition Die Dreißiger Jahre: Schauplatz Deutschland (The 1930s: Arena Germany) presented in Munich, Essen, and Zurich. The interest in Nazi art found successors in the 1980s, with exhibitions such as Die Axt hat geblüht (The Axe has Blossomed, Kunsthalle Düsseldorf 1987), which placed German art of the 1930s in its international context, and Inszenierung der Macht / Ästhetische Faszination im Faschismus (Staging Power/Aesthetic Fascination during Fascsim, 1987), which analyzed the Nazi aestheticization of politics, organized by Berlin's left-oriented Gesellschaft für bildende Kunst. The 1980s witnessed additional exhibitions devoted to exile art. Among them was the 1983 Berlinische Galerie exhibition Aus Berlin emigriert: Werke Berliner Künstler, die nach 1933 Deutschland verlassen mußten (Emigrants from Berlin: Works of Berlin Artists Forced out of Germany after 1933), and the 1986 Kunst im Exil in Großbritannien, 1933–1945 (Art in Exile in Great

Britain, 1933–1945). While curiously the Berlinische Galerie exhibition focused on art that either pre- or postdated exile, the Kunst im Exil in Großbritannien exhibition was conceived in an encyclopedic manner, surveying the works of about 120 exile artists, many of them formerly unknown to the history of German art.

This sudden increase in interest to recall and analyze art of the 1930s and 1940s created within or outside Germany should be seen in relation to concurrent cultural and political agendas. In East Germany, after a decade of solidification of the new socialist regime (1949–1959), the focus expanded to strengthening the antifascist identity of the GDR, using art and culture to activate communist traditions that reached well back into the Third Reich. Some engaged antifascist artists such as John Heartfield and Hans Grundig had returned to the GDR after the war, but it took until the late 1960s for their exile work to receive recognition. Simultaneously, art history became a tool of differentiation, in that a socialist modern art history, with its emphasis on forms of realist politicized art, contributed to setting up an identity independent of West Germany's concept of autonomous and democratic modernism.

In West Germany, starting in the late 1950s and gaining momentum in the 1960s, with the first televised Holocaust trial (Adolf Eichmann, 1961), artists such as Wolf Vostell, Joseph Beuys, and Gerhard Richter began to thematize the Nazi past in their works. Moreover, later in this decade, the left orientation of the student movement instigated the politicization of the humanities, including art history. Instead of holding on to notions of modernism as an autonomous venture, a purely formalist effort, subject only to judgments of aesthetic quality as it had been foregrounded at *documenta I*, now the politicization of aesthetics took center stage. The former concept of autonomous modernism relied on universalizing notions of artistic creativity and utopian concepts of the transcendence of German modernism. The concentration on politicized artistic practices shifted attention away from the canonical figures of German modernism such as the expressionist Brücke artists to antifascist and politically active artists such as Heartfield to revise the history of modern German art. It also moved away from stressing individual artists' accomplishments to encompassing the institutional agendas of modernism.

However, Werner Haftmann's 1986 *Verfemte Kunst: Malerei der inneren und äußeren Emigration* (published in English under the title, *Banned and Persecuted: Dictatorship of Art under Hitler*), which he was asked to write by the CDU (Christlich Demokratische Union) government under the leadership of Chancellor Helmut Kohl, put a stop to these converging approaches and aggravated previous cold war polarizations in the cultural arena. His book bluntly reinforced old notions that all modernist artists were

anti-Nazi, art is an essentially apolitical endeavor, and modern art is autonomous from contemporary contexts. Quoting Klee's remark that "there is no anti-fascist art but only art" and Kurt Schwitters's opinion that "the responsibility of the artists only applies to art," Haftmann sustained his position that there is no connection between art and political responsibility.[9] By including artists exiled and those who stayed in Germany in the inner emigration, he managed to demonstrate that those artists who were included in the 1937 Degenerate Art Exhibition were indeed all émigrés. Leveling the differences between resistance, accommodation, and exile that had been the focus of the 1970s and 1980s exhibitions, he criticized Zwischen Widerstand und Anpassung, and Widerstand statt Anpassung for its emphasis on the politicization of art that, according to him, led to the inclusion of works of minor artistic quality and a lack of emphasis on the personal achievements of major artists.[10] He omitted all art from his volume that could have the taint of political investment. Haftmann's contribution underscored the ideological differences between GDR and FRG conceptions of modern art—antifascist and realistic art versus apolitical and highly individualistic expressions—thereby initiating a renewed flourishing of the differences between both German states that were to reflect their respective political systems, the Westernized liberal democracy on the one hand, and the Eastern socialist dictatorial regime on the other hand. Haftmann's endeavor to repress research that exposed artists' very different and not necessarily antifascist responses to national socialism, corresponded with Kohl's aspiration to "normalize" the memory of the Third Reich in order to strengthen West German national identity, an effort he demonstrated to the world during a visit to Bitburg in 1985. There Reagan and Kohl not only commemorated Nazi victims at the Bergen Belsen concentration camp but also perpetrators at the cemetery in Bitburg, where members of the Wehrmacht are buried. This relativization of Holocaust memory legitimized a resurgence of West German nationalism that reinforced the cold war division between East and West.

In addition to stressing exile art as an apolitical endeavor, Haftmann's main objective was, by including Nazi pilloried expressionist artworks, to plead for a return to the traditional canon of modern German art. Elaborating on the Degenerate Art Exhibition, he reinforced the concept that expressionism is truly representative of German modern art. Internationally this was a well-chosen moment: for the first time since the end of World War II German contemporary art had gained international acclaim in the art world, specifically in the United States. So-called neoexpressionist artworks by Markus Lüpertz, Georg Baselitz, and even Anselm Kiefer came to represent the revival of a national German art carrying on Weimar modernism and symbolically capable of putting to rest Germany's

Nazi past.[11] By the mid-1980s, historicizing approaches that examined exile, acquiesced, and antifascist art motivated by left antinational German sentiments were officially corrected by Haftmann's book. Yet in contrast to interpretations of the late 1940s, the 1950s, and most of the 1960s that often neglected exile art, Haftmann concentrated on establishing a link between exile art and German modernism through their independence from politics; his notion of artistic quality is inseparable from his view of the artwork as an autonomous entity. His book illuminates how assessments of exile art crystallized ideological struggles within West Germany and between the two Germanies.

Yet despite Haftmann's successful intervention, dominating the 1970s and 1980s reception of exile was a change in focus from canonized modernists most often related to the expressionist legacy to those on the margins who often employed art as a political tool. This notwithstanding, it was GDR art history that had a significant impact on West German art history at that time. Frommhold's notion of a "better Germany" embedded in the history of antifascist exile art and connoting art's ethical responsibility shaped an interpretation of exile art that is still being pursued. However, while the GDR wrote its own art history focusing on antifascist and communist artists who worked in a realist idiom and thus underscored current aesthetic practices in the GDR, leftist West German art historians were motivated to uncover taboos buried in the traumatic history of the Third Reich. Their interest in artistic activism and in artists whose positions on the margins enabled them to break open the canon of modernism aimed at establishing a history of German modernism that detached itself from constructions of national self-legitimization. The political rupture prompted by the student movement called for narrating an alternative past in order to establish a history that would open venues for negotiating an antinational German identity.

IV

From the very beginning the United States too brought national interests into play when it came to taking up the issue of German exile art and artists. Most of the artists, like many other exiles from Nazi Germany arrived on U.S. shores in the late 1930s. A 1939 opinion poll published in *Fortune* magazine demonstrates that 83 percent of the American population was opposed to welcoming Hitler's refugees on their shores.[12] Yet a *New York Times* article from the same year—with the unusually long and explanatory title "In the Realm of Art: Divers Matters of Importance. The Creative Life vs. Dictatorship. Works Exiled from Reich Collections and Now Acquired by the Museum of Modern Art—Freedom in Democracy," stressed U.S.

cultural policies that endorsed freedom in the arts and embraced the import of pilloried modern art and artists as cultural gain.[13] As early as 1937 the *New York Times* had celebrated the immigration of Bauhaus artists and architects with the headline "America Imports Genius." These early statements already precisely encapsulate the debate in the decades to come. Following the traditions of a national art history that tends to collapse artistic production with national superiority, the discussion focused on the role the arts ought to play in American democracy. What was at stake was not so much the accommodation of German exile artists, although these accomplished modernists were in the 1940s often seen as a rather inconvenient competition by American artists. More importantly, the issues discussed in relation to the relocation of European and in particular German modernist art to the United States shows that its reception of German exile art cannot be separated from the perception of the larger field of German modernism.

Preceding the 1937 Degenerate Art Exhibition, positive evaluations of German modernism in the United States were sparse. In this regard, matters of aesthetic preference played as important a role as politics. In the decade after Germany's loss of World War I, the foreign political relations between Germany and the United States were still informed by their status as enemies. Cultural exchange and mutual interest was limited. Once relations became warmer—due to the Dawes Plan (1923–1924), through which the U.S. government, among other nations, supported Germany's unstable economy—Weimar Germany had already prepared for the ascent of the Nazis to power. This certainly played a role when American modern art museums and galleries began to institutionalize the modern movement in the late 1920s and early 1930s. In an overall conservative and nationalistic cultural climate that favored accessible, beautiful, and figurative artworks, discussions about modern art were harsh, especially when the art of foreign nations was concerned. It was the art produced in Paris and not that made in Berlin that led influential art historians such as the Museum of Modern Art's Alfred Barr, Jr., to conceive narratives of the modern movement. Barr's vision of aesthetic modernism was developed in a Hegelian manner that foregrounded an evolutionary pattern that led progressively to the liberation of form, color, and line from subject matter and content. Abstraction was consequently the climax and teleology of twentieth-century artistic efforts. In accordance with this theory, Barr took an apolitical stance and defended an autonomous modern art symbolized in free artistic expression. Yet his writings also drew on national art historical narratives as remote as Vasari's. Barr, for example, claimed that "before the Nazi revolution the art of Germany stood second only to that of France among European nations."[14]

Although Barr favored constructivist and rational art, among it cubism and the works created at the Bauhaus, he had nevertheless presented German expressionism in his German Painting and Sculpture exhibition at the Museum of Modern Art (MoMA) in 1931. The exhibition was followed a year later by Philip Johnson's The International Style: Architecture Since 1922 that included Bauhaus modernism. Both strands of German modernism, expressionism and Bauhaus, were read in national terms. Yet while expressionism was seen as a distinctive German art, Bauhaus architecture was presented as international modernism, thereby preparing U.S. audiences for easy assimilation of it.

The overall reputation of German art finally increased as a result of the 1937 Degenerate Art Exhibition. German modernism in the United States was reevaluated not because of its aesthetic value but because of its politicization by the German dictatorship. As a visitor to the 1938 MoMA exhibition, Bauhaus 1919–1928, poignantly remarked, "I don't expect to enjoy it, exactly, but if Hitler has banned it I think we ought to look at it."[15] In addition to this widely publicized show and its traveling version (The Bauhaus: How it Worked), beginning in 1938 several exhibitions were mounted in the United States that featured banned German modernism, such as Contemporary German Art (1939) at Boston's Institute of Modern Art, Landmarks in Modern German Art (1940) at Curt Valentin's Bucholz Gallery in New York, and Forbidden Art of the Third Reich (1945) at Karl Nierendorf's New York gallery. With the exception of the MoMA show, these exhibitions featured predominantly German expressionism. Regarded as an expression of German national ingenuity, this art, however, was rarely met with admiration. In this respect, James Plaut, organizer of Contemporary German Art, warned his audience that "[f]or the American observer, contemporary German art has none of the gayety, charm, and technical brilliance readily associated with the spectacular school of Paris or the best of our own Americans. It seems almost overburdened in its sociological implications and guided by repressions or adversity."[16] Many visitors to the 1939 Boston exhibition are purported to have agreed with Hitler's purge.[17] It seems fitting then that Life magazine reproduced some of Hitler's watercolors in the fall of the same year. Despite these contradictory responses that side with German expressionism for political reasons but against it on grounds of aesthetic judgment, in the 1930s expressionism was scarcely a competition; it could be absorbed as something "typically German" and seen as a matter of the past.[18]

More important, and a more viable competition to the development of both an indigenous national or international American modern art (two concepts that were strongly debated in the United States in the 1930s and 1940s) was the Bauhaus. In contrast to the expressionists artists, many

members of the internationally composed German Bauhaus school—such as Gropius, Mies, Laszlo Moholy-Nagy, Ludwig Hilbersheimer, and Marcel Breuer—immigrated to the United States in the 1930s. In its interpretation of the famous art school, the 1938 MoMA exhibition excluded the Bauhaus years under communist director Hannes Meyer and under the modernist ideologue Mies. Only the traveling version included a section on the Bauhaus activities in the United States, thus preparing the ground for the marketing of the Bauhaus as successful cultural transfer that would shape the American discussion in the decades to come. The contemporary reception of this exhibition, however, included critical voices that conveyed American skepticism toward German "international" modernism. "In America we have our own tradition, and, we hope, our own future. In the field of design we must be continually watchful for valid ideas based on our own ecological and social needs and we must always beware of dated ideologies. The Bauhaus, having moved from Weimar to Dessau to Berlin to Chicago, and having failed through its own weakness to acclimatize itself, has shown a ghostlike nature."[19]

Even if Bauhaus modernism was contested during the 1930s and 1940s, after the war Barr's uncritical vision of Bauhaus modernism, in unity with advanced modernity, gained widespread credence. Specifically, Mies's concept took hold. Both Gropius's and Meyer's notions that tied the Bauhaus to social and political betterment were detached from Bauhaus modernism as it was depoliticized and promoted only for its aesthetic accomplishments. This development indeed was in keeping with the legacy of the Bauhaus in America. Bauhaus modernism, in particular the architecture of Mies van der Rohe, became symbolic for Western capitalist democracy originating in the United States and exerting from there its international impact. This narrative of Bauhaus transformation contributed significantly to the shaping of the United States as a world and cultural leader during the cold war.

The Bauhaus emigrants became fully integrated into American cultural life; they were no longer regarded as Hitler exiles, but as Americans. The same holds true for individual German exiles whether associated with the Bauhaus or not. Lyonel Feininger, for example, who had left the United States as an adolescent and had since gone on to establish himself as an important modernist in Weimar Germany was, after his forced return to America in the 1930s, celebrated as a U.S. artist by Barr.[20] And in 1948 George Grosz was lauded in *Look* magazine as one of the ten best living American painters.[21] Apart from biographically structured narratives such as Laura Fermi's *Illustrious Immigrants* that narrated how the European elite arrived on U.S. shores in the 1930s and 1940s, bringing with them high culture, accounts from the late 1960s through the 1980s consistently elaborate the transformation of German Bauhaus modernism in the United States and its subsequent American qualities.[22]

Even the enthusiastic reception of Hans Jürgen Syberberg's film *Hitler—Ein Film aus Deutschland* (Our Hitler) in the late 1970s, which increased interest in German fascism was of no consequence for new and differentiated examinations of exile art.[23] It was only in the 1990s, coinciding with the focus on memory and the allure of the overlooked, that exhibitions such as Exiles and Emigrants. A Lost Generation of Austrian Artists in America, Max Beckmann in Exile and Exiles and Emigrés, revised old accounts.

Just as Bauhaus modernism was turned into an American accomplishment during the cold war, expressionism was further relegated as a specifically German art. In the 1950s the United States witnessed the recuperation of the reception of German expressionism that was again interpreted as endemically German. This is not only true for the first postwar exhibition that German art historians Werner Haftmann and Alfred Hentzen organized at MoMA (German Art of the Twentieth Century, 1957), but also for later exhibitions such as the 1981 Guggenheim exhibition expressionism: A German Intuition. In their focus on expressionism rather than on exile art, these exhibitions associated German modernism with "degenerate art." The relocation of the Bauhaus to America was always perceived as a perfect import as it best matched America's image as the embodiment of advanced modernity that embraced all spheres, including the arts, thereby strengthening coveted superiority of U.S. culture. Bauhaus modernism's formal qualities furthermore lent themselves more readily to interpretations of autonomous art than Expressonist artworks. Bauhaus aesthetics could even be traced back to cubism, the early twentieth-century movement that Barr recognized as most important within the history of modern art. In contradistinction, expressionism was excluded from U.S. national aesthetic projections. It, however, occupied another important position in the discussion on modern art. In contrast to the censorship practiced in Nazi Germany, the public showing in the United States of expressionism confirmed the democratic acceptance of all types of artistic expression, even if these were not easily palatable. In the context of exile art, the contradiction of U.S. notions of modern art were illuminated unmistakably. On the one hand, modern art was conceived as an independent realm; on the other, it was instrumentalized for political purposes.

V

After the unification of the two Germanies in 1990, Ernst Loewy called for a paradigm shift within exile studies. He advocated the historicization of exile culture in order to liberate the engagement with exile from interests that would serve anew the construction of a now unified German national identity. He encouraged approaches that would explore the intersection of

different cultures, suggesting that processes of acculturation and intercultural identities would enable new approaches and insights. Exhibitions such as Exiles and Emigrants (1996) and Exiles and Emigrés (1997–1998) stressed concepts such as displacement, acculturation, and memory as complex components of exile identity. Yet the exhibitions also aimed to disentangle the complex nature of artists' reactions to the forced politicization of their versions of modernism. It appeared that German exiles to the United States, like those to West European democracies, produced no homogenous German art. Thus, in this respect, German exile art can be understood to exemplify what Homi Bhabha has called the crisis of the concept of a common culture. Valid questions, for example, of whether German exile art amounted to something transnational, hybrid, or intercultural, are still subject for future studies.

However, much of the recent reception of German exile art suggests that interest in exploring the effects of the politicization on modernism and the cultural ambivalence of German exile art still remains limited. Criticism in the United States and Germany continued to insist upon the ahistorical, aesthetic quality of the artwork and its high art status. For example, in 1998 Exiles and Emigrés was criticized by German reviewers for thematically interconnecting artworks with historical documents. "Above all the main room appears to be precarious: The central focus is a series of vitrines. . . . The archival materials, however, distract from the first-class sequence of paintings on the walls."[24] And Berlin-based critic Andres Lepik argued in the Neue Züricher Zeitung that "through the intended transparency . . . art is downgraded to illustration."[25] By contrast, former East German reviewers characterized the exhibition as an "intelligent historical didactic presentation."[26] This German East-West double vision illustrates that eight years after German unification two contrary positions lingered: on the one hand, aesthetic quality is favored; on the other, the examination of art within its political contexts is privileged.

In 1992 Andreas Huyssen argued that, after a decade of musealization and representation of German history, German identity is again up for discussion due to "the rebirth of history" unleashed by unification. Public discussions that negotiate a German national identity triggered only after 1989 associations with Germany's national socialist past and its aggressive ideology of Germanness and German nationhood. The unification of the two Germanies in 1990, the end of the cold war, and united Germany's accession of full political sovereignty in 1991—for the first time since 1945—brought about radical transformations for Germany including the return of the highly contested discourse on national identity. The contradictoriness and complexity of the discussion on present-day German national self-conceptions is particularly evident when the issue of German exile from

the Third Reich is addressed. This late 1990s reassessment motivated reflections on German national identity that underscore the importance of the German past for present self-understanding.

Critics in unified Germany claimed German exile art as cultural capital and elevated it to the realm of advanced culture. As was the case before 1989, all artists who left Germany during the Third Reich symbolize the victims of the national socialist regime.[27] At times this resulted in quite exaggerated statements. German art critic Klaus Hartung stated in the liberal-intellectual weekly *Die Zeit*: "Exile is actually a euphemism. It concerned the rescue from death, sole survival in a time when artistic production itself was life threatening."[28] Without minimizing the catastrophic effects of the national socialist ban upon modern art, there is no known case (before the incarceration in concentration camps) where an artist had to fear for his life because of his aesthetic program. Rather, it was their race and ethnicity, as in the case of Otto Freundlich and Felix Nussbaum, or their political activities, as in the case of Heartfield and Grosz that placed artists' lives in peril. In fact, exile artists' responses to Nazi ideology and the politicization of their art manifested themselves in a broad spectrum of visual images encompassing antifascist, apolitical, accommodated, and opportunist positions.

Heartfield executed the photomontage *Five Minutes to Twelve* (figure 4.1) based on a German proverb in exile in Great Britain, in order to participate in the didactic anti-Nazi exhibition Allies Inside Nazi-Germany organized by the Free German League of Culture. The exhibition was on view in London between July 3 and August 16, 1942. The twenty-seven didactic panels on display were intended to educate British audiences about Hitler's rise to power, the elimination of his enemies, and Nazi Germany's victories from 1938 to 1941. *Five Minutes to Twelve* was part of the sixth panel. It shows a miniature Goebbels with a huge clubfoot alongside Göring, and Hitler who try to stop a clock. A small label on the clock reads "Made in France." The three Nazi leaders, Hitler, Göring and Goebbels, feared a second front victory by France and Great Britain over Nazi Germany that Stalin demanded in 1942. Heartfield's image and text-based montage is politically activist in its intention and message and relies on avant-garde strategies that incorporate modern advertising tools into the realm of high art. Fragments of photographs are combined in such a way that the message is easily accessible, forming a powerful tool in the fight against Nazi Germany. In contrast to Nazi Germany's actual war successes in 1942, Heartfield's large clock visually evokes the collaborative strength of the Allies. Through the reproduction of miniature photographs of the Nazi leaders, their power appears diminished, anticipating the surrender of the Third Reich. Thus Heartfield's image served as an optimistic motivation in

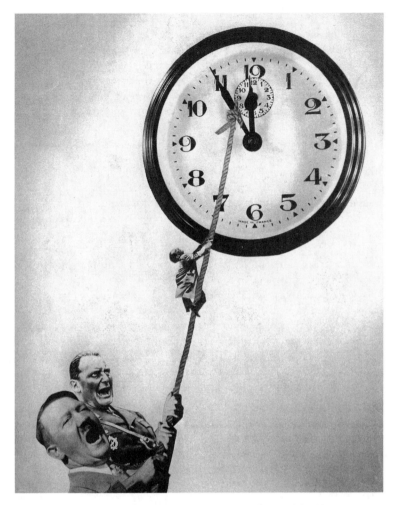

Figure 4.1 John Heartfield, *Five Minutes to Twelve* (1942). Photomontage, 19 1/4 × 15 3/4". Archive der Akademie der Künst, Berlin, Kunstsammlung. © 2006 Artists Rights Society (ARS), New York / VG Bild-Kunst, Bonn.

the war effort against Nazi Germany at a time when Allied war efforts were unsuccessful.

Other German exile artists, such as Grosz in exile in America, departed from such outright activist political art. In the second and third decades of the twentieth century, Grosz had executed caustic satires, often using the form of photomontage and collaborating with Heartfield. These works

were targeted at Germany's first democracy, the Weimar Republic. In exile, he switched back to creating predominantly figurative and metaphorical paintings. His 1945 *Cain or Hitler in Hell* (figure I.1) appropriates the Old Testament narrative of Cain and Abel, likening Nazism to the archetypal fratricide. But the biblical trope is refracted by the meticulous depiction of hundreds of skeletons that appear to haunt the seated figure, which resembles Adolf Hitler. Apart from artworks executed in concentration camps in Europe, this is the first work by a leading German exile artist to capture the Holocaust and address its afterimages. The ambiguity of the allegory, which on one hand points to Hitler as accountable for mass murder and on the other to Cain standing in for Hitler, as well as the collective German population, positions the artwork at the beginning of Germany's postwar attempts to come to terms with the traumatic Nazi past.

By contrast, Schwitters and Beckmann insisted on several occasions that, as artists, they were untouched by politics. Schwitters's *The Hitler Gang* (ca. 1944 [figure 4.2]) is one of the artist's few works that incorporates political references. In it an ad for John Farrow's 1944 anti-Nazi Hollywood movie *The Hitler Gang* is glued on top of a reproduction of a target and can thus be read as direct political comment. Schwitters' inclusion of a detail of chair caning references Picasso's first collage *Still Life with Chair Caning* (1912), and serves to demonstrate a connection between himself, the famous Weimar founder of Merz collages and marginalized exile in Great Britain, and Picasso, whose reputation had not decreased. But the chair caning in Schwitters's collage can also be read—as Barbara Buenger has pointed out—as an even line of shots that would, considering it together with the target, establish an interpretation of the artwork's intention as directed against the national socialists.[29] A consistent political interpretation of these three motifs, however, remains vague. Schwitters used so many other bits of paper, which he mixed with abstract and colorful forms, that the artwork ultimately resists a clear message. Similar to many other collages of Schwitters, these elements could suggest nothing more than an abstract interplay between form, color, and texture.

By comparison, Beckmann's *Les Artistes mit Gemüse* (1943 [figure 4.3]) appears at first sight as an unambiguous assertion that the artist's realm is the transcendental sphere. Following seventeenth-century Northern group portraiture traditions, a tribute to artistic traditions of Beckmann's host country Holland and a period of art history favored by Nazi leaders, Beckmann depicts four exiles: the abstract artist Herbert Fiedler, the constructivist Vordemberge Gildewart, the conservative philosopher Wolfgang Frommel, and himself. Beckmann clearly underscores his belief in art's autonomy by reflecting his own face in the mirror as a clown, a common modernist metaphor used to position the artist as an outcast from society.

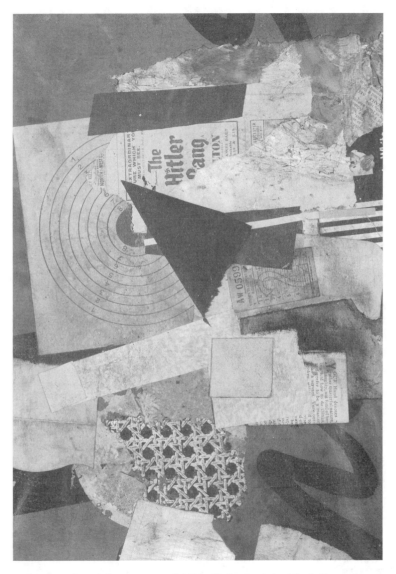

Figure 4.2 Kurt Schwitters, *Untitled* (*The Hitler Gang*) (1944). Collage, oil, canvas, cardboard, and paper on paper, 13 2/3 × 9 2/3". Kurt und Ernst Schwitters Stiftung, Hannover. Photo courtesy of Kurt Schwitters Archive at the Sprengel Museum Hannover. Photographer: Michael Herling/Aline Gwose. © 2006 Artists Rights Society (ARS), New York / VG Bild-Kunst, Bonn.

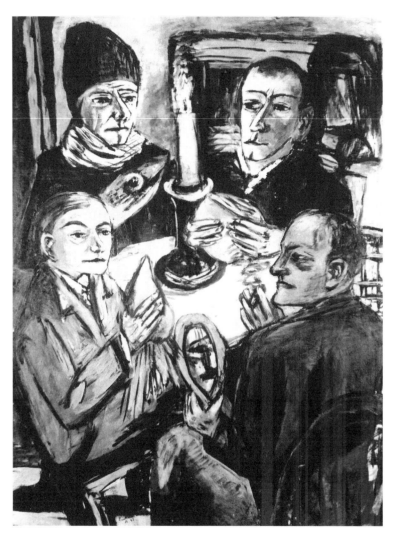

Figure 4.3 Max Beckmann, *Les Artistes mit Gemüse* (1943). Oil on canvas, 58 15/16 × 45 3/16". Mildred Lane Kemper Art Museum, Washington University in St. Louis. University purchase, Kende Sale Fund, 1946. © 2006 Artists Rights Society (ARS), New York / VG Bild-Kunst, Bonn.

With the painting Beckmann constructs a discourse that ambiguously vacillates between creating a fictitious narrative and representing independent German exiles. Aspects that certainly constitute a narrative about the collective experience of four exiles include the fact that all portrayed individuals are known to have lived in Holland as German exiles where they shared a common fate, and their appearance around a table is a probable situation. Moreover, the red background behind Frommel's head references the theater of war penetrating into the small interior. Other factors, however, suggest a composition that underscores a pointedly apolitical representation of individuals. Beckmann, for example, avoids any visible interaction between the individuals who would encourage a narrative line, thus emphasizing their independent status. In addition, the attribution character of the objects that the exiles hold in their hands, the white cover of the table, and the large candle in its center all establish a religious or at least pseudo-religious session, elevating the artists' meeting into a higher, transcendental realm. Beckmann's dual demand on narrative and representation, group and individual, and by extension collectivism and individualism, illuminates his perception of the unavoidable penetration of politics into the aesthetic realm. Yet he desired a utopian practice of modernism in which art is detached from politics and "is the mirror of God embodied by man."[30]

Other German exiles, such as Gropius and Mies, attempted to collaborate with the national socialist regime before deciding to emigrate for career reasons.[31] In 1934 Mies together with other German artists such as Wilhelm Furtwängler and Ernst Barlach signed a petition that supported Hitler. He also entered Nazi-sponsored competitions such as the Project for the German Pavilion at the Brussel's World Fair of 1934, demonstrating his belief that modernist architecture could serve the new German regime, a belief shared by MoMA curator Philip Johnson. Johnson argued in 1933 in the U.S. magazine *Hound and Horn* for Mies as a suitable architect for the new German regime: "Mies has always kept out of politics and has always taken a stand against functionalism. Two factors especially make Mies' acceptance as the new architect possible. First Mies is respected by conservatives. Even the Kampfbund für deutsche Kultur (the most aggressive association fighting for pure German racist art) has nothing against him. Second Mies has just won (with four others) a competition for the new building of the Reichsbank. A good modern Reichsbank would satisfy the new craving for monumentality."[32] However, Nazi Germany turned to classicist monumentalism seeing it as most suited to imagining the Third Reich. This left Mies with only a few commissions. Consequently, he accepted an appointment as professor at Chicago's Armour Institute for Technology in 1938. The other major German Bauhaus architect, Gropius, joined in 1933 the Reich Chamber of Culture, the Nazi-controlled arts

organization. He participated in the design of the exhibition Deutsches Volk—Deutsche Arbeit and entered several other Nazi architectural competitions, such as his entry for a House of Labor. The building was intended to propagate Nazi ideology of labor celebrating brotherhood, communal feelings and physical endurance while economically strengthening the German nation. It was with the permission of the German government that Gropius left Nazi Germany in 1935 for Great Britain to pursue his work there. Two years later he moved to Cambridge, Massachusetts, where he was appointed professor of Harvard's Graduate School of Architecture and Design. Upon his arrival, German newspapers published proud and friendly reviews. This brief sketch demonstrates that both Gropius's and Mies's political positions vacillated between accomodation and opportunism in order to carry on a formally uncompromised modernism.

These artists and architects answered the Nazi politicization of modernism, targeted as a collective phenomenon with individually, very different responses, bringing to the fore the complicated relation between aesthetic modernism and politics. The artistic practices of Heartfield, Mies, and Gropius remained unchanged. While Mies and Gropius pursued the ideology of modernist architecture, Heartfield's message-driven, realistic photomontages aimed to serve antifascist goals. Grosz equally engaged in realistic art, yet his fatalistic horror scene is contained in the aesthetic realm. Perceiving naturalism as too grim to penetrate politics; he chose metaphorical images to represent present conditions. In the 1920s and 1930s, Schwitters's collages that incorporated a fragmented reality illustrate how bits of the everyday may be appropriated for various abstract styles. In exile his interest in the forms of modernist art diminished somewhat; instead his collages bore ambiguous references to politics. Nevertheless, the penetration of reality into an independent aesthetic realm is most clearly negotiated against each other in Beckmann's painting.

The reluctance on the part of German critics of the 1990s to address these various political and aesthetic positions and to engage in a discourse that explores how these artists who were marginalized by Nazi Germany responded to the politicization of their art make obvious that within current discussions about the Nazi past exile art is still seen to symbolize the "other," or better, Germany—a concept that, as we have seen, was applied to exile art retrospectively by East German art historian Erhard Frommhold. The long-time leader of Germany's Social Democratic Party and former exile Willy Brandt asserted in 1980, "the need for a good tradition . . . [p]erhaps . . . a new generation had to grow up, in order to really be able to feel what exile had claimed: if not to be the genuine, then at least the better Germany."[33] Loosely following Brandt's model, criticism in the late 1990s still perceived exile in contrast to the art of the "inner" emigration "as a messenger of liberty."[34]

Since the late 1960s the concept of Germany's identity as "Kulturnation" advanced by Willy Brandt, Günther Grass, and other German left-wing intellectuals was to provide a surrogate for the lost German national unity. A federal German Kulturnation was desired as bridge between the two German states. Although the concept lost its political grounds after unification, it didn't lack its attraction for German critics who struggled in the 1990s with exile. In contrast to earlier conceptions such as Brandt's, Kulturnation was now detached from political realities. The term itself, which can be traced to nineteenth-century German identity debates, was also used by German exiles in order to compensate the loss of a national political identity with a cultural one. Within exile and exile studies, Kulturnation as the intellectual consciousness of Germany always functioned as symbolic expression of the opposition of *Geist* (spirit) to the politics of the Third Reich. Considering theories that emphasize historical progression, the catastrophe unleashed upon German history by the Third Reich is widely perceived as discontinuity within that history and often described as German Sonderweg or special path. Identification with Kulturnation replaces this discontinuity with a desired continuity or normalcy in the cultural arena. This normalcy that plays a considerable role in postwall German identity constructions relies on memory that idealizes exile art and artists in order to be able to locate Germany as Kulturnation within the Nazi past.

Conversely, yet in line with this notion, is the argumentation of the 1990s that detaches the production of exile art from historical contexts. For example, authors such as Manfred Flügge attributed a "universalistic impetus" to exile art.[35] Others, such as art historian Moritz Wullen and referencing system theoretician Niklas Luhmann, raised doubts "to which degree the situation of exile was determining the art. . . . It remains to be discussed . . . if the experience of exile indeed determined and formed art from the outside or if the art itself only determined an already existent self-determined creative potential."[36] Whether German critics in the late 1990s still link exile art to cold war arguments—presenting art as an autonomous, purely aesthetic, and individualistic product—or advocate a definition of art that frees the artwork from history and individual agents, in both cases they dissociate German exile art from Germany's Third Reich past.

In the evaluations of the effects and aftereffects of exile, the country of the perpetrators is still assuming the role of victim, as it continues to mourn the loss of its artistic elite. This loss is construed as still actively affecting the present. *Berliner Zeitung* critic Sebastian Preuss pointed out that "especially Germany . . . never recovered from the mass exodus of intellectuals and artists who were scattered under Nazi rule to all winds."[37] Others, however, claimed that postwar German art reachieved the status of advanced culture

through artistic exchange. In 1997 the Berlin National Gallery presented a collection-based exhibition of North American and European artworks of the past three decades.[38] According to the museum, "the works by Rauschenberg, Nauman or Keith Haring are supposed to elucidate that after the stimulation of the U.S.-culture by the progressiveness of the exiles, the United States of the post-war period steered the art of Europe into new progressive courses."[39] Similarly, it was asserted that the history of modern art "is foremost a history of continued impulses from Europe to America and back to Europe."[40] Less subtle is the opinion that "behind much which counts as endemic American, one discovers the forced transfer of the mid-century."[41] Nationally framed stereotypical tropes of New and Old World, Self and Other remain prevalent by reestablishing the location of high culture in Europe. It is no surprise then that some critics could not resist voicing stereotypical prejudices about the United States as a nation without culture: "Before 1933 the intellectual landscape of America yawned like a broad, flat desert. . . . In the midst of the most barbarian war and confusion, an unprecedented process of intellectual stimulation came about. . . . Artists, driven by Hitler's insanity . . . , challenged to their best performance, revolutionized the art world."[42]

In the 1990s dominating assessments of exile art rely on a variety of older concepts. In order to engage with a positive national identity, German critics identified exile art with Kulturnation. Therefore, exile artists symbolize the "better" Germany tradition, and exile art is seen as capable of connoting a positive national identity, establishing continuity from the founding of the German nation in 1871 through the Nazi era to the present. To underscore their arguments, critics insisted that German exile art was disengaged from controversial entanglement in Germany's national socialist past. Thus the experience of exile, as much as the artworks produced there, are seen as universal expressions. Conservative models that conceive of modern art as depoliticized and timeless, thereby capable of transgressing German national socialism, gained momentum again. However, in contrast to cold war assessments, critics in the 1990s separated those exiles that actually left Germany from the "inner" emigrant artists. Yet the history of artistic exchange between Germany and the United States is written as a history of national accomplishments establishing cultural hegemonies. But the canon of modernism no longer plays a role; exile art is a valid equivalent to modernism.

VI

American art critics also adhered to the trope of the West as the locus of modern high culture. Emphasizing "extraordinary works of art,"[43] formalist and conservative critic Hilton Kramer stated, "It wasn't until the age of the

émigrés in the Thirties and Forties that American cultural life was brought into alignment with the imperatives of the kind of intellectual modernity that had dominated the high culture of Europe since the turn of the century."[44] To account for the accommodating reception of German modernism in the United States,[45] Kramer alluded to the status of national socialist Germany as a political enemy, all the more obvious after the outbreak of World War II. The collective narrative of democratic America's resistance to national socialist Germany and rescue of its "better" culture is reinforced in this context. The title of Robert Hughes's *Time* magazine review, "A Cultural Gift from Hitler," implies in an ironic way this narrative of the democratic country of immigration, which, even before the end of World War II, had bested the Third Reich in the cultural arena.

This narrative of course conceals that by far not all German artists could immigrate to the United States. Schwitters and Heartfield, for example, tried unsuccessfully to obtain visas. It also valorizes those influential artists and architects who left Germany for economic rather than political reasons, such as Mies and Gropius. These facts went unnoticed by American critics, who repeatedly stressed the extraordinary impact of the German Bauhaus.[46] Likewise neglected were strong American antimodernist sentiments of the time, as voiced by H. W. Janson in 1946. "It is difficult to suppress the feeling that a vast majority of the American public, given a choice in the matter, would agree with the policies of the Reichskulturkammer. Here as in Germany, the man in the street regards the modern artist as a 'crazy, morbid charlatan'; and who would blame him, since his opinion seems to be shared by no less an authority than the present director of the hallowed Metropolitan Museum of Art."[47]

Instead American critics in the late 1990s recuperated the national imagining of the once popular narrative of the United States as cultural world leader. Serge Guilbaut's 1983 book, *How New York Stole the Idea of Modern Art*, in which he launched a widely influential ideological critique of America's nationalistic ambitions toward world leadership in the 1940s, was dismissed. In particular Kramer made this unambiguously apparent: "A new sense of historical possibility proved to be an even greater consequence of the émigré influence. For the first time, it looked as if American art might become, instead of a dependency of the modernist movement, its principal heir."[48]

Moreover, Kramer also used exile art to legitimate the practice of autonomous and apolitical art. "Emigration was not only a reprieve from a death sentence but a release from having to bear responsibility for anything but their art. . . . Membership in the avant-garde had always been a form of internal emigration from the societies that had produced them."[49] He appealed to a definition of the avant-garde, as it has been elaborated by Peter

Bürger[50] and Martin Warnke,[51] that establishes the production of avant-garde art outside or at the margins of society, in a space that Warnke labeled "internal" or "inner" emigration, a place where avant-garde art can retreat to better regain its critical and political potential. Kramer borrowed this concept but inverted it to relegate apolitical art to the antisocial space of "internal" emigration. According to Kramer, American art achieved the status of high art only after detaching itself from the ideological and political disputes that had dominated the American art world in the 1930s and 1940s. Paradoxically, in Kramer's formulation, American art owes this shift to exile art and exile artists in its midst. Many other critics engaged in aesthetic devaluations of artworks because of their political content, thereby conforming to Kramer's line. For example, the point was made that "Kokoschka allied himself with expatriate artists' groups in London and painted historical subjects. His 'Anschluss— Alice in Wonderland' . . . is a regrettable product of that decision."[52] In keeping with this approach, emphasis was given to the high aesthetic quality of paintings such as Beckmann's *Self-Portrait with Horn* (1938) and Feininger's *Manhattan II* (1940) that are assessed as apolitical examples of exile art.[53] The modernist canon, which favors works from the 1910s and 1920s, the ostensible heyday of modernism, is another criterion used to buttress negative aesthetic judgments. "Other artists . . . were already a little past their prime, Ernst's paintings in America . . . hardly compare with his work in the 1920s."[54] These claims, hiding under the cloak of subjective judgments of quality or the validity of the modernist canon, contribute to notions that value modern art for its detachment from the political world.

Although the arguments made by U.S. critics appear pragmatic and clear in their goal to underscore cultural superiority, they still make up a narrative loaded with contradictions. They conceptualize exile and Nazi-banned German modernism as the historical moment through which American civilization was transformed into culture and could produce not only its own endemic high art but also pull off world cultural leadership. Yet although exile productions are seen to exemplify outstanding examples of high art, they are nevertheless also considered moderate in their aesthetic value, as they were either executed after the climax of modernism in the 1910s and 1920s or showed signs of politicization. The ideological and contradictory struggle about modernism is conveyed most poignantly in the assertion that modernism must be an apolitical venture while U.S. democracy is valorized for saving modernism from the hand of the German dictatorship.

VII

Finally, in both German and American criticism, a reevaluation of the modernist concept of exile art as artistic gain is evident, a trope given extensive analysis in literature by literary feminist theorist Karen Caplan.[55]

The binary model of assimilation and isolation underpins this modernist discourse, but in contrast to earlier estimations, assimilation in the 1990s was equated with "good" art, while isolation supposedly produced "bad" art.[56] German critics described the forces of conflict, rootlessness, alienation, and isolation, on one hand, and assimilation and acculturation, on the other, in terms of a Darwinian fight for survival, which inevitably ended in failure or success.[57] Paradigmatic of these contrasting poles is the Bauhaus standing in for assimilation and success, while Weimar modernists such as George Grosz exemplify cultural isolation. Added to that, critics in the 1990s often evaluated Grosz' art as "bad."[58] The sociologist Richard Sennett critically observed the postmodern ideology of (short-term) capitalism's demand for flexibility. He showed that social adaptability to a constantly changing environment is required for the individual to be competitive and successful. In terms of exile, late capitalism's demand for social adaptability and flexibility is complemented by a call for assimilation and acculturation.[59] Contrary to modernist and elitist concepts, such as the notion that art has to be isolated on the margins of society to effectively unfold its critical potential, or the idea that exile art guarantees artistic gain because of the artist's isolating situation, German and American art criticism in the 1990s evaluated exile art's success and high aesthetic quality by the degree of the artist's successful assimilation and acculturation to the new culture. Within the current discourse on exile art, this discussion stands out as being informed by notions of globalization and transnationalism, leaving behind issues of national identity.

The reception of exile art exposes interpretative strategies that draw upon memory as a flexible and indiscriminate tool. The scholarship illuminates many and often contradictory notions of exile art in its contingent relation to modernism and constructions of national identity. Implicit is a concept of the past that has the limited task of shaping the present. Exile art is seen as a prime example for illuminating various postwar and postwall ideologies of modernism, highlighting the debate over the political versus apolitical function of modern art. Rather than historicizing, deconstructing, or questioning the role exile played in national narratives, critics often put it to service to validate hegemonic agendas. Notions of modern art that at times intentionally exclude or, by contrast, stress exile art are most often tied to homogenous national self-perceptions and narratives of national superiority.

In the early postwar years a renewed national identity was fashioned by means of reviving prewar modern German art traditions and their relation to artworks executed in the inner emigration. Exilic aesthetic practices, however, were excluded. In the decades following the 1960s, exile art served to endorse Eastern and Western modern art conceptions, the realist and politicized art of German postwar communism, and the abstract and

individualized forms of the democracy that shaped two German modernisms and provided foundational narratives of the two political systems. Despite strong antinational tendencies in West Germany that coincided with the 1968 upheavals driven by the goal to break open the taboo of the Nazi past and to explore a politicized art, in West Germany exile was repeatedly employed to fabricate a "normalized" national history that considers the Third Reich dictatorship as exceptional. Exile art in these accounts communicates an autonomous and modern German high art, easing the ground for a homogenous national identity that entangles modernism and democracy. Similar in its effects was East Germany's emphasis on political activist exile art that supported strengthening its antifascist identity. During the cold war the attempt to stress certain conceptions of modernism and national identity revealed willful interpretations of the past as necessary to heighten present-day ideological needs. For example, exile art was excluded from modern German art narratives, or, if not, the focus was exclusively on the exiles' depoliticized aesthetics; vice versa, important modernists who had remained within Germany were declared exiles.

In the postunification period, these older and conflicting concepts are not only revived but also fused to underscore exile as part of a German history to proudly look back to. Although the memory of exile art always served to construct a positive German national identity, it was only in the 1990s, with the establishment of German political sovereignty, that it could make a decisive impact in the political sphere. The renewal of the German nation brought about a resurgence of national imagining. Taking the hybrid and often contradictory combinations of these most recent exile interpretations into account—in which the exiles are seen as representatives of the "better Germany," as furnishers of national superiority and as creators of art that is universalist and detached from politics—it appears that the discourse on exile still cuts Germany off from differentiated notions of the past. Hitler's exiles indeed mark an inassimilable historical moment used for unifying national projections similar to a Lacanian mirror.

Notes

1. Sibyl Milton, "Is there an Exile Art or only Exiled Artists," *Exil: Literatur und die Künste nach 1933* (Bonn: Bouvier, 1990), 83–89.
2. See Jan Assmann and Tonio Hölscher, eds., *Kultur und Gedächtnis* (Frankfurt a. M.: Suhrkamp, 1988); Mieke Bal, Jonathan Crewe, and Leo Spitzer, eds., *Acts of Memory: Cultural Recall in the Present* (Hanover: University Press of New England, 1999); Harald Welzer, ed., *Das soziale Gedächtnis. Geschichte, Erinnerung und Tradierung* (Hamburg: Hamburger Edition, 2001); and Etienne Francois and Hagen Schulze, eds., *Deutsche Erinnerungsorte*, 3 vols. (Munich: Beck, 2001).

3. Martin Papenbrock, "Die Emigration bildender Künstler aus Deutschland 1933–1945. Eine Statistik," *Kunst + Politik: Jahrbuch der Guernica-Gesellschaft*, ed. Jutta Held (Osnabrück: Rasch Publisher, 1999), 91–118.

4. Rosamunde Neugebauer, "Avantgarde im Exil? Anmerkungen zum Schicksal der bildkünstlerischen Avantgarde Deutschlands nach 1933 und zum Exilwerk Richard Lindners," *Exil und Avantgarden*, ed. Claus-Dieter Krohn (Munich: Edition Text und Kritik, 1998), 35; and Christoph Zuschlag, "*Entartete Kunst.*" *Ausstellungsstrategien im Nazi-Deutschland* (Worms: Wernersche Verlagsgesellschaft, 1995).

5. An early exception is the exhibition Ausgewanderte Maler organized by the Museum Morsbroich in Leverkusen in 1955. It included among others Kurt Schwitters, Max Beckmann, Max Ernst, and Paul Klee.

6. In the GDR these annual exhibitions were held until the fall of the Berlin wall in 1989.

7. For example the Kunstverein in Hamburg devoted a one-man show to Max Beckmann in 1947; Oskar Kokoschka was featured in an exhibition at the Mannheim Kunsthalle in 1951; that same year the city of Brühl presented its famous son, Max Ernst, in an exhibition; and in 1954 the Haus der Kunst in Munich organized a Paul Klee exhibition.

8. *1945–1985. Kunst in der Bundesrepublik Deutschland*, exhibition catalogue, Nationalgalerie Berlin (Berlin: Staatliche Museen Preußischer Kulturbesitz, 1985), 472.

9. Werner Haftmann, *Verfemte Kunst: Malerei der inneren und äußeren Emigration* (Cologne: DuMont, 1986), 17.

10. Ibid., 80–81.

11. Donald Kuspit, "Flak from the 'Radicals': The American Case against Current German Painting," *Art after Modernism: Rethinking Representation*, ed. Brian Wallis (New York: New Museum of Contemporary Art, 1984), 137–151.

12. *Fortune Magazine*, April 1939, 102–103.

13. Edward Alden Jewell in *New York Times*, August 13, 1939.

14. *New York Times*, August 8, 1939.

15. Leslie Topp, "Moments in the Reception of Early Twentieth-Century German and Austrian Decorative Arts in the United States," *New Worlds: German and Austrian Art 1890–1940*, ed. Renée Price (New York: Neue Galerie, 2001), 579.

16. *Contemporary German Art*, exhibition catalogue (Boston: Institute of Modern Art, 1939), 5–8.

17. "[W]e heard several of the spectators agreeing wholeheartedly with him (i.e. Hitler) . . ." *Boston Herald*, November 2, 1939.

18. Vivian Endicott Barnett, "Banned German Art: Reception and Institutional Support of Modern German Art in the United States, 1933–1945," *Exiles and Émigrés: The Flight of European Artists from Hitler*, ed. Stephanie Barron and Sabine Eckmann (New York: Los Angeles County Museum of Art and Harry N. Abrams, 1997), 273–284; and Pamela Kort, "The Myths of German Expressionism in America," *New Worlds: German and Austrian Art 1890–1940*, ed. Renée Price (New York: Neue Galerie, 2001), 260–294.

19. Topp, "Moments in the Reception," 579–580.

20. Sabine Eckmann, "The Loss of Homeland and Cultural Identity: George Grosz and Lyonel Feininger," *Exiles and Emigrés: The Flight of European Artists from*

Hitler, ed. Stephanie Barron and Sabine Eckmann (New York: Los Angeles County Museum of Art and Harry N. Abrams, 1997), 296–303.

21. Barbara McCloskey, "George Grosz," *New Worlds: German and Austrian Art 1890–1940*, ed. Renée Price (New York: Neue Galerie, 2001), 331.

22. William H. Jordy, "The Aftermath of the Bauhaus in America: Gropius, Mies and Breuer," *The Intellectual Migration: Europe and America, 1930–60*, ed. Donald Fleming and Bernard Bailyn (Cambridge, MA: Harvard University Press, 1969), 485–543; and Cynthia McCabe Jaffe, ed., *The Golden Door: Artist-Immigrants of America, 1876–1976* (Washington, DC: Smithsonian Institution Press, 1976).

23. Susan Sontag, "Fascinating Fascism," *Under the Sign of the Saturn* (New York: Farrar, Straus and Giroux, 1980), 71–105.

24. Sebastian Preuss, "Flucht aus der Vogelhölle," *Berliner Zeitung*, October 10, 1997.

25. Andres Lepik, "Exil und Emigration," *Neue Züricher Zeitung*, April 10, 1997.

26. Thomas Irmer, "Sinnliche Zeugnisse von der Vertreibung des Geistes," *Leipziger Volkszeitung*, October 23, 1997.

27. Katrin Bettina Müller, "Verlorene Perspektiven," *Die Tageszeitung*, October 11, 1997; and Annette Lettau, "Produktiv im Exil," *Focus*, 6 (October 1997): 181.

28. Klaus Hartung, "Kunst Überleben," *Die Zeit*, October 31, 1997, 65.

29. Barbara Copeland Buenger, "Antifascism or Autonomous Art: Kurt Schwitter," *Exiles and Émigrés: The Flight of European Artists from Hitler*, ed. Stephanie Barron and Sabine Eckmann (New York: Los Angeles County Museum of Art and Harry N. Abrams, 1997), 84.

30. Barbara Copeland Buenger, ed., *Max Beckmann: Self-Portrait in Words* (Chicago: University of Chicago Press, 1997), 288.

31. Peter Hahn, "Bauhaus and Exile: Bauhaus Architects and Designers between the Old World and the New," *Exiles and Émigrés: The Flight of European Artists from Hitler*, ed. Stephanie Barron and Sabine Eckmann (New York: Los Angeles County Museum of Art and Harry N. Abrams, 1997), 211–25.

32. Philip Johnson, "Architecture in the Third Reich," *Hound and Horn*, 7 (1933): 138–139.

33. Willy Brandt, "Literatur und Politik im Exil," *Literatur des Exils. Eine Dokumentation über die P.E.N.-Jahrestagung in Bremen vom 18. bis 20. September 1980*, ed. Bernt Engelmann (Munich: Edition Text und Kritik, 1981), 170–171.

34. Hartung, "Kunst Überleben," 65.

35. Manfred Flügge, "Landlose Kunst westlich von Chicago," *Berliner Zeitung*, March 17, 1997.

36. Moritz Wullen, "Exil—Flucht und Emigration europäischer Künstler," *Museumsjournal*, 4 (Fall 1997): 20.

37. Preuss, "Flucht aus der Vogelhölle," 12.

38. On the occasion of the exhibition, "Exil—Flucht und Emigration europäischer Künstler," the Neue Nationalgalerie in Berlin presented a selection of postwar artworks that was supposed to demonstrate how American art returned to its origins in Germany.

39. Press Release, Neue Nationalgalerie, Berlin.

40. Thomas Irmer, "Exil: Flucht und Emigration europäischer Künstler," *Neue Bildende Kunst* (June 1997).
41. Ibid.
42. Harald Kretschmar, "Kunsternte partieller Ausländerfreundlichkeit," *Neues Deutschland*, October 10, 1997.
43. Hilton Kramer, "Refugees from the Nazis in Historic Exhibition," *New York Observer*, October 3, 1997.
44. Hilton Kramer, "The Age of the Émigrés," *The New Criterion*, 16 (April 1997): 17.
45. Kramer, "Refugees from the Nazis in Historic Exhibition," 17.
46. Ibid., 17; and Robert Hughes, "A Cultural Gift from Hitler," *Time*, March 24, 1997.
47. H. W. Janson, "Benton and Wood, Champions of Regionalism," *Magazine of Art*, 39 (1946): 184.
48. Kramer, "The Age of the Emigrés," 17–18.
49. Ibid., 19.
50. Peter Bürger, *Theory of the Avant-Garde*, trans. Michael Shaw (Minneapolis: University of Minnesota Press, 1984).
51. Martin Warnke, "Einführung," *Künstlerischer Austausch/Artistic Exchange. Akten des XXVIII. Internationalen Kongresses für Kunstgeschichte*, ed. Thomas W. Gaethgens (Berlin: Akademie Verlag, 1993), 161–175.
52. Francine Prose, "The Art Hitler Loved to Hate," *The Wall Street Journal*, August 19, 1997, A17.
53. Julian Freeman, "Exiles and Emigrés," *Apollo* (August 1997): 60.
54. Hughes, "A Cultural Gift from Hitler."
55. Karen Caplan, *Questions of Travel: Postmodern Discourses of Displacement* (Durham: Duke University Press, 1996), 27–65.
56. It is generally doubted that the isolating situation of exile produces art of high quality: Hughes, "A Cultural Gift from Hitler."
57. Gerald Felber, "Karriere oder Resignation," *Kölnische Rundschau*, October 25, 1997; and Roland H. Wiegenstein, "Ein schwarzer Kasten voll Geschichte," *Frankfurter Rundschau*, October 18, 1997.
58. Marianne Heuwagen, "Vom Bauhaus zum Kehraus," *Süddeutsche Zeitung*, October 22, 1997, 14; Nicola Kuhn, "Endstation: Gelobtes Land," *Der Tagesspiegel*, October 9, 1997; and David Bonetti, "The Indelible Imprint of Exile," *San Francisco Examiner*, October 9, 1997.
59. Richard Sennett, *The Corrosion of Character: The Personal Consequences of Work in the New Capitalism* (New York: W. W. Norton, 1998).

PART II
A GUIDE FOR EMIGRANTS

CHAPTER FIVE
"YOU KNOW, THIS ISN'T BAD ADVICE!!"

Renata Stih and Frieder Schnock

The newcomer should try to understand first and criticize either never or very late.

Let yourself be carried away by the optimistic ground swell of the country. Then you will retain a happy outlook on life and things will start coming your way.

The American projection of a psychiatrist and psychoanalyst as a foreign-looking man with a beard and an accent of like Thickness helps the refugee neurologist and analyst.

Americans have a special way
to soften social contacts. Germans
frequently mistake a friendly reception
of themselves and their projects for
genuine interest. It is likely to be an
indifferent position or an elegant negation.

A professor in a German university is a man
of research rather than a teacher. He will find
it difficult to understand that it is the student
who is at the center of the American system
and not the professors.

Remember that Europe is the cradle of
American culture. Do not exchange it for
what is inferior in American thinking.
Remember the culture you bring to America.

America has not waited for you.
The newcomer has to adapt –
not the Americans – his ways.

Women tend to adopt "The American look"
in dress much more rapidly than men. They
acquire greater language facility and the
outward manner of American society sooner.

You can dress casually. Be aware
that denims, regardless of kind or color,
are not permitted in some places.

Americans are born collectivists.
They constantly live in groups,
and participate in group activities
to an extent unknown anywhere
else in the world.

Don't isolate yourself in little foreign
language communities. Do everything
possible to speed up the process of
Americanization and integration.

In America one never says "no"
if it's possible to avoid it.
In almost every case there
is an indirect approach.

Forget what you have been, concentrate
on what you can become. Don't Think
anything under your dignity as long as
it is an honest way of making a living.

Germans and especially Berliners
are accustomed to a rude directness.
Typical in America is a very cautious
way of dealing with people, using a
very "diplomatic" language.

Find in all the different nationalities
with whom you have to live the
spirit which made America great.

Americans are polite listeners.
Don't take their comments on
The beautiful way you speak
English too seriously.

Be wholly absorbed by the American
community. Become an active member
of a religious group – no matter whether
it be Catholic, Protestant n Jewish.

often the employment of the wife made
possible the retraining of her husband.
while The emigrant went to school
she earned the money for the family.

Part III
Popular Modernism and the Legacy of the Avant-Garde in Exile

CHAPTER SIX

PETERS AND SCHNEIDER: THE
DRAWING BOARD AS HOME

Iain Boyd Whyte

The émigré or exile experience vacillates, necessarily, between the extremes of pessimism and optimism. The former is admirably represented by Theodor W. Adorno's assertion, made in *Minima Moralia*, that the émigré intellectual "lives in an environment that must remain incomprehensible to him, however flawless his knowledge of trade-union organizations or the automobile industry may be; he is always astray. . . . The share of the social product that falls to aliens is insufficient, and forces them into a hopeless second struggle with the general competition. All this leaves no individual unmarked."[1] An extreme opposite reading, in which strangeness is equated with novelty, positive challenge, and rebirth is offered by Vilém Flusser, who urges that the arrival of the exile "allows the natives to discover that they can only 'identify' themselves in relationship to him. At the point when the exile arrives, a splitting open of the 'self' takes place and an opening up towards others. A form of companionship. This dialogical disposition, which marks the state of exile, is not necessarily a sign of mutual respect, but is rather a polemical (not to say murderous) condition. For the exile threatens the 'particularity' of the native and questions it in his alienness. Yet even this polemical dialogue is creative, as it leads to the synthesis of new information. Exile, in whatever form, is the breeding ground for creative action, for the new."[2]

Émigrés and exiles, like everyone else, are diverse in their characters, intelligence, and skills, even before the departure from their native land. They leave for a wide variety of motives, ranging from free choice at one extreme to compulsion at the other. A capricious joy may well mark the former option, abject terror the latter. Far from homogenizing or negating these variables, the act of leaving or of expulsion magnifies and exaggerates them. Once on foreign soil, the experience of the émigré is conditioned by

countless other parameters, the majority of which are beyond his or her control or, indeed, consciousness. The list would include the site of relocation, be it carefully chosen or arbitrary; the openness of the host society to the nomad or outsider; the buoyancy of the host economy; the nature of the host bureaucracy, or the existence of émigré networks. Such parameters vary wildly not only between nation and nation but also between city and city. Beyond the quantifiable coordinates that might help explain success or failure hover the much more important and infinitely less tangible elements of chance, fortune, and simple luck.

The fascinating yet brief careers of the German architects Jakob Detlef Peters and Karl Schneider offer a modest test case through which to approach broader-ranging questions about the émigré and exile experience. After parallel career trajectories and a brief period of collaboration in the same office in Hamburg immediately after World War I, Peters moved to the United States of America in 1922, with Schneider following in 1938. Peters was an émigré, Schneider an exile: Peters moved to Los Angeles, Schneider to Chicago. The similarities and disparities in their two careers invite certain questions: apart from the obvious difference that one cannot return home, is the experience of the exile essentially different to that of the émigré within the host culture? Are both experiences inevitably negative? Is exile a historical category that offers insights that go beyond comparative biography? Can comparative biography add up to anything more than its component parts? Beyond such general musings about the condition of exile or displacement, the biographies of both Peters and Schneider invite more specific questions about the relationship between European high modernism and American mass culture.

Both Jakob Detlef Peters and Karl Schneider came from craft backgrounds, and both worked briefly in the studio of Peter Behrens, the epicenter of modernist architecture at that time. Born in 1889 in Jarranenwisch in Schleswig Holstein, near the Danish border, Peters was apprenticed to a stonemason in Hamburg at the age of fourteen, before embarking on the study of technical drawing at the Baugewerkeschule in Hamburg. He was an autodidact as an architect, learning his professional skills in Düsseldorf—where he worked briefly in the office of Wilhelm Kreis in 1912—and in Hamburg, where he worked in 1913 in the office of C. G. Bensel. Later in the same year, he moved on to the Behrens atelier in Neu-Babelsberg on the outskirts of Berlin. Schneider was born in Mainz. He was the son of a carpenter and learned his architecture at the Kunstgewerbeschule in his home city, where the courses were strongly inclined toward craft skills rather than academic learning. Following his first employment as an architect with the well-known firm of William Lossow & Max Hans Kühne in Dresden, he worked from 1912 to 1914 in

the newly established practice of Walter Gropius and Adolf Meyer, both graduates of the Behrens atelier.

Located in Neu-Babelsberg in the far western suburbs of Berlin, the studio of Peter Behrens was the most exciting location anywhere in the Western world for ambitious young architects in the early years of the twentieth century. So much so that a list of Behrens's assistants reads like a *Who's Who?* of modernist architecture. Adolf Meyer arrived in November 1907 and stayed until September 1908; Walter Gropius joined him slightly later (June 1908–March 1910); Mies van der Rohe followed late in 1907 and stayed until 1910; and Le Corbusier did his turn at the cutting edge for five months, starting on November 1, 1910. Peters worked with Behrens in 1913 and 1914, although the exact dates of his sojourn in Neu-Babelsberg have not been recorded. Karl Schneider arrived in 1915 and stayed until he was conscripted into the army in November 1916.

Behrens's fame was grounded on his pioneering design work for the electrical giant AEG, for whom he had been appointed artistic director in 1907. On an incrementally expanding basis, Behrens was commissioned to redesign the company's buildings, products, and publicity material, ranging from enormous factories to tiny publicity seals. His most celebrated work for AEG was the Turbine Factory that he built in Berlin-Moabit in 1909: one of the canonical statements of a new architecture that derived its rationale and techniques not from academic precedents but from the new world of high technology. The driving force for this reappraisal of the processes and forms of industrial production was the founder of the company Emil Rathenau who saw the future of the AEG in the production of standardized products, rather than in fulfilling one-off commissions. The model here was America. As Rathenau recalled in 1908: "The study of the American methods had deepened my understanding of modern manufacturing processes and served as a pointer to the direction which I was to pursue."[3] In his design work for the company, Behrens combined the consciously American demand for standardization and repetition with an architectural sensibility nurtured on the austere Prussian classicism of Karl Friedrich Schinkel. In fusing classicism and technology, Behrens gave formal expression to the universalism of the machine imperative, the fundamental tenet of the new architecture.

Gropius's arrival at Neu-Babelsberg coincided almost exactly with the design phase of the AEG Turbine Factory, which started in the autumn of 1908. Although both he and Adolf Meyer were entirely committed to the vision of a high, industrial culture, they felt that the Behrens version was still burdened with vestiges of late nineteenth-century aestheticism. Looking back on the major triumphs of the AEG factory-building program, Gropius subsequently wrote, "Neither the front of the Turbine Factory nor

the facade on Volta Straße [of] the Small Motor Factory were structurally 'true' but seemed instead [to be] aesthetically manipulated."[4] The response of Gropius and Meyer to this manipulation was the radical design for a shoe-last factory that was to become the ultimate canonical building of the early modern movement in architecture, the Fagus Factory at Alfeld an der Leine, completed in 1914. This celebration of the industrial process in steel and glass rapidly gained iconic status and became a standard point of reference in the early histories of modern architecture.

Karl Schneider worked for Gropius and Meyer while the Fagus Factory was designed and constructed. He not only learned the gospel of lightness and transparency from his new employers but was also introduced to a new source of inspiration for the European avant-garde: North America. Besides the Fagus Factory, Gropius's most lasting contribution to the prewar discussion on the future of the architecture was his inclusion in the 1913 *Jahrbuch des Deutschen Werkbundes*, of a celebrated set of images of American industrial buildings, commenting, "With their monumental expressive power, the grain elevators of Canada and South America, the coal silos of the great railway companies, and the modern factory halls of the North American industrial trust can be compared to the buildings of ancient Egypt."[5] In spite of his critique of Behrens, Gropius was continuing his master's work in admitting the industrial architecture of America into the discussion of modernist architecture. Just as Behrens linked the classicism of Schinkel to the machine, so also Gropius saw parallels between the Egyptian pyramids and the grain silos of North America. This typically avant-garde linkage of the ancient and archetypical with the new and ultramodern doubtless led Gropius and Meyer to introduce pylon-like features, derived from Egyptian models, on the façade of the model factory they were commissioned to design for the 1914 Werkbund Exhibition in Cologne. These monumental, inclined planes repeat a key motif from Behrens's Turbine Factory, and rather throw into doubt the post factum critique of the Behrens design as "aesthetically manipulated."

In 1914, when Schneider was working with Gropius and Meyer, Peters was already in the Behrens studio. By this time, Behrens's major works for the AEG were already behind him, although Peters may well have been involved in some of the late works, such as extensions to the locomotive factory in Hennigsdorf near Berlin or the design of an AEG factory in Riga. Closer to home, the flair for display design may well have commended him to Behrens as an assistant on the 1913 *Exposition universelle et internationale* in Ghent, in which a whole exhibition was given over to the work of Peter Behrens. The lessons of the AEG factories that Peters had learned from Behrens stood him in good stead when he returned to Hamburg in 1914 to work in partnership once again with Carl Georg Bensel. Among the several

projects that he worked on at this time was a prize-winning competition scheme for the Tiefstack power station in Hamburg, which was clearly indebted to the AEG heritage, and was actually realized in 1917.

Presumably with the support of Gropius and Meyer, Schneider moved to the still-functioning Behrens studio in 1915, and stayed until he was called to serve in the army. While the wartime economics precluded large-scale architecture, Behrens was occupied at this time on the design of workers' housing for the AEG on the outskirts of Berlin. Indeed, during his stay at the Behrens studio, Walter Gropius had proposed a system of industrialized housing for the AEG, and it may well be that Schneider moved from the Gropius office to Behrens to pursue the interest in affordable mass housing that was to become the dominant interest of the postwar architectural avant-garde and a major part of Schneider's own practice in Hamburg in the later 1920s.

Even in the realm of housing, however, as in that of industrial architecture, one of the strongest voices in the German discussion came from America: the voice of Frank Lloyd Wright. Wright had published his first great portfolio of works not in English but in German, when his *Ausgeführte Bauten* (Completed Buildings) was published in Berlin by Ernst Wasmuth in 1911 and won for Wright an instant following among the European avant-garde. As Winfried Nerdinger has noted, this publication was the "office bible" for Gropius and Meyer.[6] The biblical text found a strong exegesis in the Sommerfeld House, built by Gropius and Meyer in Berlin-Steglitz in 1920–1921, with the very active collaboration of Gropius's associates at the Weimar Bauhaus, who designed the interior. Indeed, as one of their assistants Fred Forbat recalled, "I'll never forget how Gropius and Meyer, in the initial stage of designing [the Sommerfeld House], pored over the large folios published by Wasmuth: Frank Lloyd Wright: Bauten und Entwürfe."[7] This powerful influence of Wright can also be seen very clearly in a series of studies for country houses produced by Peters during the war years, which are laden with Wrightian devices: low horizontal profiles with marked overhangs, glazed corners, the superimposition of diagonal geometries on the orthogonal plan, and the conscious integration of building and surrounding nature.

The American dream of handsome, light-filled houses set on the broad plains had a strong hold on the villa designs that Peters produced during the war years, releasing the architect, if only momentarily and on the drawing pad, from the horrors of the Western Front. Drafted into the army, Peters was detailed to work in munitions repair plants and foundries in Lille and Charleroi. The intellectual frustration of life at the front can be sensed strongly in the letters that Peters wrote at this time to his wife. "Only with peace," he wrote in December 1917, "will we be able to return to a

consciousness of ourselves. Only with peace may we expect the sun which will bring to life again all that we have put aside during this time. Then we will be able to enjoy again the work of our hands, to create freely, and to act in accordance with morals and customs. It is this association with people in the military straight-jacket that makes one feel cast out from all culture. . . . When, when will I stand by your side again and piece by piece bring together all that the war has torn asunder. I hope it will be soon because it is dawning brightly in the east and from there I imagine the peace will soon surprise us."[8] The lasting physical effect of Peters's war experience was tuberculosis, which he contracted in 1918, and which robbed him of the use of one lung. Permanently weakened by this, he returned to Hamburg after the cessation of hostilities.

The horrors of the war and the trauma of defeat fed the expressionist impulse in German architecture, which flourished briefly but influentially from 1914 to 1922. While it took on many incarnations and is enormously difficult to define, some defining traits can be discerned, such as a fixation on gothic architecture as a model, a formal investment in glass, transparency, and crystalline imagery, and a powerful intellectual commitment to a more harmonious and equitable society, for which the architect would play the role of midwife or social engineer.[9] A recurring building symbol and discursive theme was the *Stadtkrone* or city crown, derived from the gothic cathedral, which would spread its benign influence across the city of the future. As described by its most eloquent exponent Bruno Taut in his eponymous book, the city crown would be a radiant work of architecture, which would act as both the visual focus and the summation of the social idealism of the people. As Taut explained,

> It is impossible to transform a mere thought into architecture without positive action and engagement, which is the reason why all attempts to build modern monuments are doomed to fruitlessness. They cause nothing to happen and are intentionally based on the surface imitation of misunderstood works from the past. The religious ritual in the temple, the sacrifice, the mass, and the like were essential to the creation of the majestic buildings. . . . It is our world's will to build. We have the idea for a new city, yet it is a city without a crown. Now, however, we know the form its head, its crown must take.[10]

Peters made his own contribution to the *Stadtkrone* discussion with his project for a tower that would serve both as an exhibition space and as a memorial to the war. It evolved out of an earlier scheme for an exhibition building, which Peters had initially drawn up in 1913 for a site at the Ferdinandstor in Hamburg, and intended to act both as a multilevel exhibition hall and as a war memorial (figure 6.1). Its villa-like plinth derives

both from Behrens's neoclassical villas of the immediate prewar years, like the Villa Cuno at Eppenhausen, and from Wright's Winslow House of 1893, an early work that sat easily as a model beside Behrens's neoclassicism. The brick tower, in contrast, talks the language of the AEG and the powerful forms and strong silhouettes of the power station, a gesture dissipated at its upper conclusion by a whimsical row of equestrian figures, launching themselves suicidally, it would seem, off the roof. The intentions behind the project were profoundly influenced by the expressionist spirit of the moment, with art seen as a force for social hope and redemption. A text from the period in a manifesto that has survived in the Peters papers, entitled *Die gelbe Posaune der Sieben* (The Yellow Trumpet of the Seven, a title referring to the seven muses), perfectly captures the mood of desperate optimism: "The ennobling of German labor, the penetration of every expression of life with the spirit of the arts is the ultimate goal. The Hamburg exhibition halls should be a demonstration of this volition. Art will stand at the centre . . . the art exhibition building will be the meaningful point of crystallization for the entire creation."[11] As another commentator asked at the time, referring specifically to the culmination of the Peters tower as it emerges out of the vertical shaft: "Who would not like to see this crowning decoration, radiating in the blue ether, awakening in us the eternally strong desire to be released from the pull of the earth."[12] The deadly, earthbound reality of a lost war and financial ruin condemned this and the many similar visionary schemes produced by the avant-garde in the immediate postwar years to remain as unbuildable, paper fantasies.

Karl Schneider's war had followed a more exotic course. Called up in 1916 into the railroad engineering corps (Eisenbahn-Betriebskompanie), his military career ended in a prisoner of war camp in Belgrade. After his return to Germany, he found work initially in Berlin in the office of Heinrich Straumer, before moving in the spring of 1920 to the office of the leading Hamburg architect of the period, Fritz Höger: here he worked together for the first time with Peters, who had joined Höger in December 1918. In partnership with Höger, Schneider submitted a design in 1920 to a competition for a temporary chapel on the Ohlsdorfer cemetery in Hamburg. More subdued in both scale and language, it nevertheless echoed the Peters tower in its nods to both Wright and to crystalline expressionism. Höger's own lasting claim to fame is his design for the Chilehaus in Hamburg, built 1922–1924, a massive office block that marks the pinnacle of North German brick expressionism, and evokes images of a modern ocean liner detailed by a gothic master mason, as it sails majestically through the Hamburg cityscape.

Installed in Hamburg in the same office, with postwar inflation raging and few building starts, both Peters and Schneider doubtless had time to

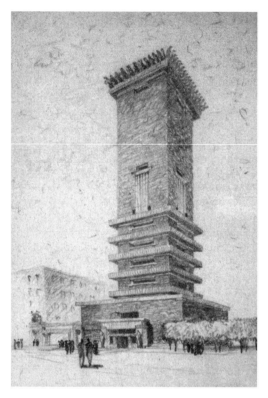

Figure 6.1 Jock [Jakob] Peters, project for the Schiller Memorial Art Exhibition Building, Hamburg (1913, revised 1919). Charcoal and crayon on board, 14 × 9 3/4". Jock (Jakob) D. Peters Collection, Architecture and Design Collection, University Art Museum, University of California, Santa Barbara.

ponder on their careers so far. Three principal components, as suggested by the biographies above, can be observed to a greater or lesser extent in the work of both men. From Behrens they inherited the double imperative of a design language that is able to express the industrial future while at the same time endorsing the calm, neoclassicism of Schinkel and the Berlin Building Academy as it evolved in the mid-nineteenth century. The inevitable resolution of these two demands was the suggestion that the machine and the industrial process, based as they are on the laws of physics and the natural sciences, pointed the way to a design language as universal and immutable as that of Greek antiquity. It was not mere chance that led another Behrens assistant, Le Corbusier, from the Neu-Babelsberg studio in 1910 to Athens in 1911, where he saw in the "supreme mathematics" of the Parthenon the

essential antecedent to a modernism that was universal rather than local, a manifestation of global civilization rather than local culture.

In contrast to this calm and Apollonian worldview, German architecture during and immediately after World War I was caught up in its own Dionysian frenzy, as political revolution and the abdication of the Kaiser marked the end of the stable, imperial order and heralded a new uncertainty that was exacerbated by galloping inflation. The crystalline and neogothic fantasies of the expressionist generation, their faith in a hyper-technology that bordered on science fiction, and the conviction that architecture had redemptive social powers did not leave either the generation of Peters and Schneider or, indeed, their immediate predecessors unmarked. Having urged the virtues of a rationalist and materialist modernism in his prewar practice, the Bauhaus that Gropius established in Weimar in April 1919 was, in its early years, an epicenter of expressionist mysticism.[13]

Resonating with both the rationalist and the mystical poles in the German discussion, Frank Lloyd Wright offered a beguiling third alternative that combined pragmatic design and construction principles, a poetic attachment to nature, and a profoundly modernist understanding of the architect's role as the harbinger of the future and as the social engineer. The key text from Wright that the English architect C. R. Ashbee quoted in his introduction to *Ausgeführte Bauten* helps explain the enormous fascination and attraction that Wright in particular and North American architecture in general exercised on a European building culture exhausted by war and material shortages.

> In a suggestive and interesting monograph which he contributed in 1908 to the *Architectural Record* of New York, entitled "In the Cause of Architecture," Frank Lloyd Wright laid down the principles that inspired his work. From among them I am tempted to extract the following because it is so significant of the work and what it stands for:
> "Buildings, like people, must first be sincere, must be true and then withal as gracious and lovable as may be."
> "Above all integrity. The machine is the normal tool of our civilization; give it work that it can do well—nothing is of greater importance. To do this will be to formulate the new industrial ideals we need if Architecture is to be a living art."
> Here we are brought face to face with the problem of our civilization, the solution of which will determine the future of the Arts themselves. It is significant that from Chicago, quite independently of England, of France, of Germany or elsewhere, here is a voice calling, offering a solution.
> "An artist's limitations are his best friends. The machine is here to stay. It is the forerunner of the Democracy that is our dearest hope."[14]

Here was a great vision of redemptive universalism: the reconciliation of democracy and the machine, painted with a broad brush for a vast

continent. Its appeal to the war-weary European radical echoed Goethe's famous line from 1827, "Amerika, du hast es besser."[15]

Defeat on the battlefield in November 1918 led to the abdication of the Kaiser and extreme political, constitutional, and social upheaval in Germany. In signing the Treaty of Versailles in June 1919, Germany lost three-quarters of its iron-ore deposits and a quarter of its coal. In addition, most of the merchant fleet was confiscated and enormous cash payments were imposed, which could only be honored by buying foreign currency against the steadily depreciating German Reichsmark. The inflationary spiral that dominated the immediate postwar period was thus preprogrammed. These economic miseries were widely seen in Germany as the direct result of British and French vindictiveness. The Americans, in contrast, acted with considerable compassion throughout, leading ultimately to the Dawes Agreement, signed in August 1924, which promoted the revival of the German economy. America was now regarded in Germany as the rightful leader of the industrial world, having taken over the mantle from the tired and embittered European powers, from France and Britain. As the great sociologist Max Weber insisted at the time, "America's domination of the world was as inevitable as Rome's after the Punic War."[16] It is not surprising, therefore, that so many Germans looked to America in the early 1920s for a beneficent guidance that was not offered by the European powers.

Superficially, but persuasively, "Amerikanismus" brought the Shimmy, the Charleston, the Tiller Girls, and jazz to German audiences. In the realm of architecture, the skyscraper tower was introduced into the urban discussion immediately after the war, and promoted a vigorous and polarized debate. The catalyst for this debate was the competition held in 1921–1922 for a skyscraper on a triangular block between the Friedrichstraße railroad station and the River Spree in the center of Berlin. This celebrated competition, which led Mies van der Rohe to design his first glass skyscraper, also saw a rather hapless entry by Karl Schneider, which was weak in terms of its orientation on the site and undeveloped in its details. The clearly modernist ambitions of the Friedrichstraße scheme were given much vigorous expression, however, in another sketch for an office tower from 1922, in which Schneider sets up powerful relationships between the vertical core of the tower and its horizontal divisions. As the sketch confirms, there is no ambition here to insert a city crown into the dense European cityscape, but rather to drop a solitary tower in a broad, undeveloped urban context, on the American model. Significantly, Schneider's library, as listed after his death, contained a book in German on the American skyscraper: Karl F. Stöhr, *Amerikanische Turmbauten*, published in 1921.[17]

The next major tower competition that excited the German avant-garde was located not in Berlin or Hamburg, but in the birthplace of the

steel-framed skyscraper—Chicago. This international competition for a new office tower for the *Chicago Tribune* was announced in July 1922. As inflation was running amok in Germany at this time, it is not surprising that the generous prize money offered in Chicago caught the imagination of the German architectural profession. *Die Baugilde*, for example, the journal of the Bund deutscher Architekten (German Architects' Federation), gave the competition a banner headline, announcing "100,000 dollar prizes for architects." In addition to the explicitly modernist projects entered for the official competition by such European architects as Max Taut, Bijvoet and Duiker, and Gropius and Meyer, there were also several projects that were not entered in the competition but which, nevertheless, were widely reviewed and commented on at the time. One of these was by the Danish architect Knut Lönberg-Holm, designed in collaboration with Jakob Peters.[18] As Roland Jaeger has noted, the experience of the *Chicago Tribune* competition led Lönberg-Holm to emigrate to the United States of America in the fall of 1922.[19] Peters followed in November 1922, initially leaving his wife, Herta, and five children behind in Hamburg to follow on at a later date.

It is difficult to comprehend the combination of hope and despair that must have led Jakob Peters to this decision. Distinguishing between exile and expatriation or emigration in an essay published in the late 1990s, Bharati Mukherjee suggests that "[e]xile lacks the grandeur, the majesty of expatriation. The expatriate, at least, is validated by a host culture which extends the hospitality, and he often returns it in civic dutifulness. But the exile is a petitioner. He brings with him the guilty reminders of suffering, his stay is provisional and easily revoked. . . . If expatriation is the route of cool detachment, exile is for some that of furious engagement."[20] Cool detachment, however, would barely describe the complex emotions that led Jakob Peters to abandon a promising design career in Hamburg, a secure position as director of the Gewerbeschule (School of Applied Arts) in Altona for which Behrens had recommended him,[21] and the editorship of the local architectural journal *Bau-Rundschau*. This apparent security was chimerical, however, as the inflationary pressures in the German economy were already reaching extraordinary heights in the winter of 1922, precluding any prospect of building, or, indeed, of any sustained economic activity, for the foreseeable future. Prices that had doubled between 1914 and 1919 doubled again during the first five months of 1922, launching the hyperinflationary madness that peaked in November 1923, when inflation had reached a staggering 300 million percent, with the exchange rate at 4.2 trillion (4,200,000,000) marks to the U.S. dollar. This was a recipe for a life of madness, desperation, and chaos, as life savings were reduced to worthless banknotes, and the price of an egg was reckoned in millions of marks.

Beyond the general misery of inflation, Peters himself was also suffering in the damp, cold Hamburg climate from the effects of his war injuries and the loss of a lung. With no economic security and the prospect of a possible fatal illness were he to remain in Hamburg, Peters decided on expatriation. It would be difficult to see him, however, as a willing expatriate, or to find in his experience much of the "grandeur" or "majesty" of which Mukherjee writes.

With a certain deft symbolism, Peters arrived in California on Thanksgiving Day 1922, and stayed initially with his brother George who had been in California since 1913. The first letters home from this period perfectly catch the polarized response of the émigré to the new land, which vacillates between blind, ecstatic optimism at the new prospects and bleak despair at what has been left behind and lost. There is no middle ground. "My dear ones!" his first letter home begins, "Now I sit here in paradise and am supposed to write a Christmas letter while the oranges are still hanging on the trees, and roses and all sorts of lovely flowers bloom in profusion." Although keen, as he writes, to build a family house in a nice area and to own a car, Peters's initial reaction to the strangeness of paradise and the shock of a new language was very telling. "I want to lead a quiet insular life with you here," he wrote to his wife in the same letter, "and shall try to avoid ambition and fame. . . . George will see to it that I do not overwork because he likes to work in order to live but not to live in order to work."[22]

Within a couple of weeks, however, Peters was running around Los Angeles with his drawings under his arm looking for work. He was turned away by a film company that was hiring architects, not because of his design ability but because of his weak English. This led him back to a German architect, Otto Neher, who ran a practice with a Viennese partner, who in turn had studied in Vienna with Josef Hoffmann and who was well disposed toward European modernism. As Peters explained in a letter home, dated December 6, 1922: "He and his partner are both married and they are both doing well; the latter very well. This city is a good field for architecture. I expect to learn a great deal in this office since there are only three of us and we do all the work. At the moment we have to do a big skyscraper; I am designing the façade, Neher is doing the floorplan. My work was favorably received by both the partners and the client. I have no fear that I will make progress here. Maybe I will try the movies in a few weeks because one earns good money there."[23] The same letter continues in characteristic émigré vein, swinging between optimism and loss. On the one hand, Peters explains how well he is eating, much better, he is sure, than his wife.[24] Even though the foreigners are initially exploited, there is work to be had and good salaries; $100,000 a year, he assures his wife, for an independent architect with plenty of work. On the darker side, however, Peters finds it

impossible to buy German books. Worried, one assumes, about losing his language, he urges Herta to buy as many good books as possible—specifying the complete works of Goethe and Kleist—for future transportation to California. Together with the linguistic rupture, Peters's reading of the German political scene is very prescient: "Evidently a right-wing putsch is to be expected; then things will really go downhill!! And when those men are at the oars, I will certainly never go back."[25] In a subsequent letter penned on Christmas eve, he concludes, "I have decided for sure to stay here. I shall try to forget, for the present, about all the cultural things that exist over there. Looking around here, I've experienced many disappointments, but after a while one finds other things; little by little one does not compare so much. Here it will be possible to live simply and contentedly, and to give form to inward things. One does not vegetate here. People who are spiritually rich do not need the whole ballast of art and ideas in order to feel complete and to be happy."[26]

The transformation of Jakob into Jock Peters reveals both the problematical and benign sides of the émigré experience. Although at no point compelled to leave Hamburg on political or racial grounds, severe ill health compounded by the food shortages and financial chaos of the early Weimar years may well have combined in his particular case to create a life-threatening condition. Once in the United States, Peters was immediately caught by the expatriate safety net. On the domestic front, brother George paid for Peter's steamship passage and his transcontinental journey to California, and had a bed awaiting his arrival. Professionally, the same modernist instincts that may well have inhibited Peters's progress within the German architectural profession were precisely those that commended his work to the Neher practice in Los Angeles and to the film industry toward which his ambitions were clearly aimed. As Roland Jaeger has noted in this context, "It was to his advantage, that there was a particular readiness to admit German emigrants in this industry. This was particularly true in the case of the studio Famous Players-Lasky, subsequently Paramount, whose art division was led by a German, Hans Dreier, who had worked in Berlin from 1919 to 1923 for UFA, and had come to Paramount on the invitation of Ernst Lubitsch. Under his supervision, the Paramount art division developed a particular openness to modern architecture, initially in the sense of Art Deco, and then in the 1930s with interiors in the International Style."[27] Modernism, in this instance, did indeed work as a universal language, unburdened by the habits and expectations of local, regional, or even national practice. In the Paramount Studios, however, the modernist language was delivered in markedly German or Austrian accents.

Back home in Germany itself, Karl Schneider's career was also taking off at this point. Although he and Peters had left the Höger office in May 1921

to establish their own practice in Spaldingstraße, Hamburg, little collaborative work came out of it, as each followed his own commissions. Both moved, however, in the same artistic circles, and the Schneider family moved in 1920 into an apartment in the house of the sculptor August Henneberger, who also helped Herta Peters's family financially, when she was left on her own in Hamburg in the winter of 1922–1923.[28] Via Henneberger, Schneider met Ite Michaelson, wife of the Hamburg industrialist Hermann Michaelson, for whom Schneider designed the villa in the exclusive suburb of Blankenese, which was to make his reputation in Hamburg. As Ruth Asseyer has noted, "They were artistically talented women, or women open to the new artistic tendencies, who chose Schneider as their architect, and whose husbands were responsible to a greater or lesser degree only for the business side of the building project. Schneider's private clients—and this now includes the men—were predominantly representatives of an unconventional, liberal, optimistic bourgeoisie: industrialists, business people, artists, academics, who were favorably disposed towards the new technical and cultural developments of the age."[29] Predictably enough, his commissions for large-scale housing projects came from mutual aid groups such as trade unions, and private or cooperative building associations.

This is not the place for a detailed account of Schneider's enormously productive career in Hamburg between 1921 and 1936, which resulted in some ninety built projects, ranging from villas, shops, and showrooms to subway stations, commercial premises, the Emelka-Palast cinema, and several large-scale housing estates.[30] As Winfried Nerdinger has pointedly noted, "In contrast to Gropius, Mies, Scharoun, Häring, or Taut, a freestanding monograph on Schneider by Heinrich de Fries already appeared in the 1920s, in the important series 'Neue Werkkunst.' "[31] One project, however, is particularly interesting in that it reveals very clearly the conditions of muted hostility under which Schneider was working in the early 1930s as a committed modernist in Germany. The opening of the *Kunstausstellungsgebäude* (art exhibition building) in May 1930 marked the end of a long and complicated saga that had run in Hamburg ever since the home of the local *Kunstverein* had been demolished in 1914 (figure 6.2). After many proposals and counterproposals the final decision to convert a late nineteenth-century villa into a gallery building was made in 1929. A closed competition was announced, which Schneider won with his proposal to bring light into the villa through a central light well, add a large exhibition hall to the rear on the site of the garden, and replace the stucco, Gründerzeit street front with an uncompromisingly modernist façade framed by glass and metal. Not only did Schneider win the competition and design and oversee the remodeling of the *Kunstausstellungsgebäude*, he did

Figure 6.2 Karl Schneider, remodeling of the Kunstverein, Hamburg (1929–1930), entrance facade, from Robert Koch and Eberhard Pook, *Karl Schneider: Leben und Werk, 1892–1945.* Hamburg: Dölling and Galitz, 1992.

this substantially at his own cost by not submitting his professional fees to the Hamburger Kunstverein. His thanks were a very aggressive response from both the popular press and from the circle of more conservative art lovers in Hamburg. As Heinrich de Fries wrote at the time in *Moderne Bauformen*,

> To say it straight away: a section of the Hamburg public is not totally happy. It sees building in brick as the sacred expression of Hanseatic-Hamburg-National values. (Like the national legends of every nation—for example the Wilhelm Tell saga in Switzerland—this is by no means true.) . . . Karl Schneider set a calm, entirely white, stucco building beside the green sward of the Moorweide, and look—it worked. Even more, it was beautiful! But it was against the supposed Hamburg tradition, which appears to be an important criterion (and not only in Hamburg). In short, the building's architectural standpoint aroused some very strong hostility. People were grievously offended, and many otherwise energetic supporters of the Kunstverein would have much preferred it if the building had, at least externally, retained its old form, or, more exactly, its old appearance.[32]

Two years earlier in his monograph, Heinrich de Fries had already written of Schneider's "years of isolation, of the especially talented person's dangerous position as an outsider."[33] To see his work attacked for its lack of local reference or respect for the regional building traditions was, sadly, nothing new for Schneider. Indeed, an extension to the boathouse of the Hansa rowing club that he had built in the mid-1920s had already been pulled down in response to disapproving public reaction.

This negative response to his work was compounded in 1932 by a concerted attack in the press on the structural defects that were appearing in his Harburg housing estate, defects ultimately traceable to poor construction rather than bad design. The conservative press, however, pointed its accusing fingers exclusively at the architect. "There were no lack of warnings at the beginning of the building phase," raged one of the daily papers on August 29, 1932, "but who did not want to hear? The creator of this disgraceful housing project, Herr Professor Karl Schneider, deep red by conviction and a social democrat by trade, who in the meantime has moved out of Harburg in order not to become a witness to the inglorious dilapidation of his own work. At the sight of these buildings, painted in all manner of screaming, parrot colors, the unsuspecting visitor is overcome by the enormous horror of the so-called 'new direction' of the Marxists."[34] Consistent with the tradition of avant-garde agonism, one might see Schneider's uncompromisingly modernist position as a form of internal emigration, or as a conscious withdrawal into an architectural language and habitus only accessible to fellow-believers. In this sense, Schneider's position as a

modernist in a frightened and disorientated society that was moving progressively to the political right and toward artistic conservatism was already preparing him for the exile that was awaiting him. With the National Socialist accession to power in 1933, Schneider's already difficult position became evermore precarious. Although admitted to the Reichskulturkammer in December 1933, his file carried a note that he should not be granted building permissions (*Baugenehmigungen*), thus reducing scope of his practice to small-scale commissions and alterations. He was also dismissed from the professorship at the Landeskunstschule in Hamburg, which he had taken up in November 1930, when his design practice was hard hit by the economic recession. This dismissal went ahead in spite of protests from his students, some of whom proclaimed themselves as Nazi supporters,[35] and Schneider was formally dismissed as of September 30, 1933, on the basis, as the dismissal letter explained, of "paragraphs 6 and 15 of the law for the reestablishment of the Civil Service of 7 March 1933."[36]

Professionally stamped as a "cultural Bolshevik," Schneider's personal life also came under scrutiny at this time, and his marriage to Emma (née Leon) was annulled in July 1935 on the grounds—according to the court papers—of his adultery with Mrs. Klara Wagner, Mrs. Maria Darboven, and the divorcee Mrs. Menke.[37] None of these, however, was the true love of his life, a role filled at this time by the Berlin-born photographer Ursula Wolff, daughter of the celebrated Sanskrit scholar Dr. Fritz Wolff. She had established her own studio in 1922 at the age of twenty-eight, and worked as a photojournalist for publications like the *Hamburger Illustrierte, Die Zeit im Bild*, and the *Hamburger Fremdenblatt*. Although her principle subject was working-class life in Hamburg, she was also drawn to architectural photography, and traveled through Greece in the early 1930s with the architect Richard Tüngel, photographing classical architecture and sculpture.[38] Indeed, Tüngel may have been the initial point of contact between Karl Schneider and Ursula Wolff, in his position as the director of Construction (*Baudirektor*) in the Hamburg City Council.[39]

Ursula Wolff was Jewish and, according to one account, a scorned and jealous admirer of Schneider's—one of the mesdames Wagner, Darboven, or Menke, perhaps—denounced the couple to the Gestapo on grounds of *Rassenschande*, the National Socialists' offence of mixed-race relations between Aryans and Jews.[40] Their initial response was to go into hiding in Richard Tüngel's apartment in Berlin, but the intensification of anti-Semitism in the National Socialist state and the absence of any professional prospects resolved the couple to leave Germany. As Ursula Wolff subsequently recalled, Schneider saw exile as their only option: "I cannot live in this land any longer, it is too dreadful."[41] In November 1937, Ursula Wolff

left Germany and settled in Chicago, close to her brother Dr. Emmanuel Wolff. Schneider followed, leaving Berlin on January 15, 1938.

Paradoxically, precisely the modernist convictions that had doomed Schneider's career in National Socialist Hamburg had opened doors to Jock Peters in Los Angeles. After his initial employment with Otto Neher, Peters, now calling himself Jock rather than Jakob, rapidly found employment in film design, and from 1925 to 1927 and again after 1932 he was employed by Paramount as an art director. Several of the films on which he worked allowed him the opportunity to design fantasy architecture, returning him to the world of German expressionism and to a mode of design in which architecture was the bearer of a political or social narrative, and practicality was of no consequence. The sketches he made in 1924 for a film entitled *City of the Future* (figure 6.3) reveal a potent mix of expressionist and corporate American architecture. On the one hand, they are entirely in spirit of the Berlin architect Otto Kohtz, who had published a series of monumental architectural fantasies in 1909 as *Gedanken über Architektur*, and whose polemics from the early 1920s on the need to build skyscrapers in Berlin would assuredly have been known to Peters.[42] On the other, they depict the dynamic, multilevel city beloved by the European avant-garde, which had already become reality in New York and Chicago. Ironically, Paramount abandoned its plans for *City of the Future* when it got wind of Fritz Lang's UFA film *Metropolis*, which finally opened in 1927. This potent German-American linkage can also be seen in the most important commission entrusted to Jock Peters in Los Angeles, the interiors of the Bullocks Wilshire Department Store.

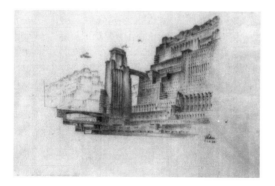

Figure 6.3 Jock [Jakob] Peters, studio set design for the film *City of the Future* (1924). Graphite on wove paper, 10 × 15 1/2". Jock (Jakob) D. Peters Collection, Architecture and Design Collection, University Art Museum, University of California, Santa Barbara.

When it opened in 1929, Bullocks Wilshire (figure 6.4) was uniquely glamorous among department stores. It was designed by the father and son architectural partnership John and Donald B. Parkinson, which was responsible for several of the landmark buildings of the city, including the Memorial Coliseum (1923), City Hall (1928), and Union Station (1939). John Parkinson was also an émigré, who had fled to California from the parochial and introspective building culture of late Victorian England. The client was the Bullock Corporation, led by John Bullock and P. G. Winnett, who had cut their teeth with Bullocks first Los Angeles store, opened in 1907 on the corner of Seventh Street and Broadway. The new venture, however, on the prestigious Wilshire Boulevard, was utterly different in scale and ambition from anything seen before in California and was the

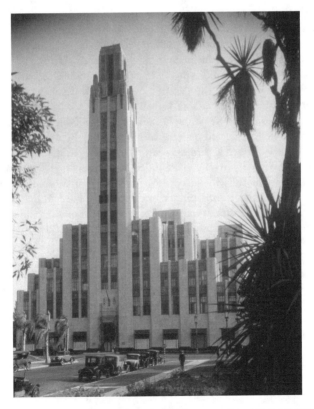

Figure 6.4 Jock [Jakob] Peters, Bullocks Wilshire store, Los Angeles (1929), exterior view. Jock (Jakob) D. Peters Collection, Architecture and Design Collection, University Art Museum, University of California, Santa Barbara.

built expression of John Bullock's credo: "Every activity of the store should be directed towards efficient selling. It pays to spend money for art in business when the expenditure follows this basic rule."[43] Art, in this context, meant predominantly interior design, the creation of interesting and elegant backdrops that would enhance the pleasure of purchase and ease the pain of payment. Jock Peters, then working as a draftsman for a firm of shop fitters, was entrusted with the task. Exactly why he was chosen is unclear, but an unsigned typescript in the Peters Collection at UC Santa Barbara offers a clue: "His executed work in America to that date consisted of motion picture and stage sets, furniture, and two small commercial buildings. There was little in his portfolio to recommend him for so grand a job, and the history of his receiving it is only informed conjecture. He was working at the time as draftsman for Feil and Paradise, store planners whose credits included work for Desmond's and Silverwood's. They were commissioned to design the interiors of the new Bullocks, and when their initial proposals failed to excite, the job seemingly fell to Peters."[44]

A seminal influence at the planning stage was the visit made by Winnett and the younger Parkinson to the 1925 "Exposition internationale des arts décoratifs et industrielles modernes" in Paris. The result was a marked preference toward Art Deco as a formal language, nowhere more striking than in the porte-cochère, where customers—on leaving their cars to be valet-parked—were greeted by a fresco-secco ceiling by the artist Herman Sachs, entitled *The Spirit of Transportation*. The composition is centered on the figure of Mercury, who is surrounded by stirring representations of an ocean liner, a Union Pacific locomotive, an airship, and assorted airplanes. Paradoxically for the first store in the world to be designed around the needs of the car driver, the automobile was not represented on the ceiling. It was, of course, already present in the space in real life, but was also irrelevant to a narrative in which transportation had exclusively intercontinental associations. The shoppers at Bullocks Wilshire were not being transported to Chicago, St. Louis, or even New York, but to London, Berlin, and Paris. This simple fact may have been enough to commend an émigré European as the designer of the interiors, while Peters's experience in creating the dream worlds and the fantasies of desire for the movies would also have appealed, slightly paradoxically, to the pragmatic businessmen running Bullocks.

While the external decorative motifs of Bullocks and much of the interior detailing were in the art deco manner that had triumphed in Paris, a closer inspection of the interiors reveals a subtly differentiating sensibility, in which many styles were recruited to create an atmosphere conducive to shopping. In contrast to the bazaar-like nature of the early department stores, in which the goods for sale were piled high, Bullocks Wilshire

displayed little merchandise, and individual items would be shown on request, one at a time. In the first instance, therefore, the customer was buying an ambiance of luxury and exclusivity, for which the actual goods purchased acted as mnemonic. To support the particularity of this illusion, Peters designed a series of glamorous interiors in a range of modernist styles. The sportswear department (figure 6.5), for example, was a clubbish, wooden clad space with more than a hint of the Sommerfeld House, which, as already noted, Gropius and Meyer had built in Berlin in 1920–1921, employing Gropius's Bauhaus colleagues on the internal decorations. Particularly striking is the close similarity between the mural at Bullocks by Gjura Stojano entitled *The Spirit of Sports*, and the wooden paneling, reliefs, and doors made by Joost Schmidt for the Sommerfeld House. A more austere modernism, closer to the ideals of the mature Dessau Bauhaus, was to be found in the Tea Room and the Salle Moderne restaurant on the fifth floor, while the pared-down classicism learned in the Behrens studio lurked behind the Fur Atelier. Closer to home, the menswear department was a homage to the concrete blockhouses that Frank Lloyd Wright had built in Los Angeles.

The proposition that Peters's interiors for a Los Angeles store owed much to his experience and knowledge of contemporary European design is

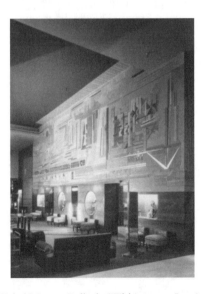

Figure 6.5 Jock [Jakob] Peters, Bullocks Wilshire store, Los Angeles (1929), interior view. Jock (Jakob) D. Peters Collection, Architecture and Design Collection, University Art Museum, University of California, Santa Barbara.

confirmed by the survival in the Peters Collection at UC Santa Barbara of a copy of the German interior design journal *Innen-Dekoration*, dating from July 1928. This issue was given over to a long and heavily illustrated account of the Deutsche Kunst (German Art) exhibition held in Düsseldorf in 1928. The undoubted star of the show was Fritz August Breuhaus, whose café—furnished with chrome steel chairs and tables—and elegantly minimalist boudoir for a "Dame der Welt" (cosmopolitan lady) (figure 6.6) both resonate in the interiors designed by Peters for Bullocks. In the same issue of *Innen-Dekoration* there is a quotation from Count Hermann Keyserling, entitled "The Laboratory of the World." It purportedly describes the German way of looking at the world but perfectly explicates the qualities that make Peters's work at Bullocks so powerful: "Germany," writes Keyserling, "is the laboratory of the world. Most of the those characteristics that in other directions so often have a destructive influence predestine it to fulfill this role. Ideas and the conceptions of the imagination mean more to the Germans than reality, but are essentially pursued without tangible goal or purpose. Ultimately the process, which is to say the experience, is the most important aspect. All this makes for the ideal experimenter."[45] Transplanted to America, the German predilection for the fantastic and poetic, for designing *Luftschlösser*—castles in the sky—was linked in the case of the Peters interiors at Bullocks, with very hard-headed business acumen. Lurking behind the bottom line of the account book, however, one can still detect the visionary spirit of the early century German avant-garde. So clear was this relationship that it even appeared in contemporary press reports. George Douglas, for example, writing in the *Los Angeles Times*, characterizes Bullocks as a "symphony": "Symphony is the fitting word. It best describes the triumph in exterior and interior harmony. One feels that the architect has been working inside as well as outside, and working in

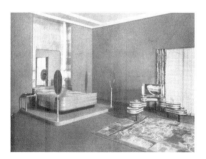

Figure 6.6 Fritz August Breuhaus, "Bedroom for a lady of the world" (Schlafraum einer Dame von Welt), exhibited at *Deutsche Kunst* exhibition, Düsseldorf (1928), from *Innendekoration* 39 (July 1928), p. 286.

perfect accord with the colorists and other decorations. The result is that here is art that is decoration and decoration that is art. . . . On the main floor the eye is immediately arrested by something entirely new even in modern art. . . . As here employed, it is the very dynamics of form and color. One may not know just what Stojana meant by those strange Kandinsky-like straight lines, sharp angles and speeding colors, but one gets the sense of movement, and movement is the dominant note in all the designs, save those inside the rooms where the visitor is invited to linger."[46]

The subheading to this *Los Angeles Times* review called Bullocks a "temple of trade"; several other commentators hailed it as a "cathedral of commerce." As one unnamed critic wrote at the time of the opening, "It is almost sacrilege to call it a store, it is a temple to many things, this new magnificent edifice erected by John G. Bullock out on Wilshire Boulevard at Westmoreland Avenue."[47] Another, with a hint more erudition, wrote that "Greece built temples. The middle ages built cathedrals. But we, whose life lies not in worship, but in producing and buying and selling, build great stores."[48] In orchestrating the collaboration of architects, artists, and craftsmen, working together on the same great building project, John Bullock gave reality to the expressionist dream that found its first formulation in a text penned in 1914 by the Berlin architect, Bruno Taut, and entitled "Eine Notwendigkeit" (A Necessity): "Let us work together," said Taut, "on a magnificent building! On a building which will not simply be architecture, but in which everything—painting, sculpture—will combine to create a great architecture, and in which architecture will once again fuse with the other arts. The architecture here will be simultaneously both frame and content. . . . The building should contain rooms that embody the characteristic manifestations of the new art: in the great glass windows the light compositions of Delaunay, on the walls the cubistic painting of a Franz Marc and the art of Kandinsky."[49] In the German expressionist context, which also informed the early Bauhaus, the great, secular temple expressly avoided any functional purpose beyond instilling higher ambitions in mankind and promoting the ideals of social and political harmony and brotherhood in place of the strife of World War I. Even if the ambition of Bullocks was much more explicitly focused on selling consumer goods, it still resonated with the spirit of the *Stadtkrone*. Rather than simply inspire by its presence, the store would ennoble the civil society by selling well-designed goods in well-designed spaces.[50] In the words of its most recent chronicler, Margaret Leslie Davis, "The store's tower, the outstanding crescendo to the building's architecture, was once crowned by a mercury beacon that formed a striking silhouette against the California sunset. The spectacular 241-foot spire with its majestic blue-green light was intended to lure customers to the store, but it became Bullocks Wilshire's most singular

trademark. Illuminated by 88 floodlights and four neon mercury vapor tubes and powered by 39,000 watts of electricity, the copper-crusted tower with its blue-hued light could be seen in the Los Angeles skyline from miles away."[51]

The new Bullocks store opened on September 26, 1929. In addition to the building itself and its lavish interiors, a further attraction in the opening month was an exhibition staged in the Palm Court of the past and present work of Jock Peters. One of the exhibits of which Peters was most proud was a series of drawings for an art education center, which sits squarely in a genealogy of utopian projects in which a center for the arts would act as the regenerator of the broader society, with the artist given a messianic role as leader.[52] Peters described his intentions in a letter written on October 22, 1929, to Arthur Hiller at the *Los Angeles Times*, which merits citation in full, in spite of the infelicities of its language:

Dear Mr. Hillier,

You possibly have already learned about an exhibition, of some of my old and new work, now open in the Palm Court of Bullocks Wilshire.

Among my studies is one which would certainly draw your interest. Allow me to explain this study to you. There are six sketches showing the preliminary idea of an art education center, not intended for beginners in art, but thought of being a recreation center for recognized reputed artists and masters of the different lines of Art. I will now take you on a trip through the different courts.

No. 1—The court for Botany where the growing of plant life can be observed.

No. 2—The court for Body Culture where form and movement on the track and in the swimming pool can be studied.

No. 3—This court would contain studies for Architects, Painters and Sculptors.

No. 4—The court intended to house a dormitory.

No. 5—The court for Philosophy which is the only one to have an entrance to the Tower in which are located Auditoriums, Laboratories for Natural History, Physics, Chemistry, and Astronomy.

(Figure 6.7) The entire, block, you see, is intended to enclose all lines of art that are liable to give an artist a widened atmosphere, a rounding off and strengthening of his personality.

The basic idea of this layout is that masters of all the arts can communicate here freely, can exchange ideas and take a stand to the different problems. Philosophers, Authors, Engineers, Mathematicians, etc., can be invited for lectures.

The artists should stay not more than three months and should work in their line during this time and give at least one personal creation of their art to the institute so artists coming after them have an opportunity to study their work. In this way there should be created

1. A Museum of contemporary art that would not have its equal in all the world and would in time become a museum of such valuation that no other museum in the world could buy equal masterpieces to such an extent.

2. Periodical publications of these masters would have unlimited educational value and no doubt also give financial value.

3. This Art Education Center could and will be the outstanding scientific and artistic institute of America.

This project was studied and taken with enthusiasm in 1921 by none less than the Senator of Education of the German Reich but financial conditions prevented even giving its execution a thought.

I don't believe that anybody in America so far knows this program and I give it in your hands that you might use your knowledge of American conditions to think about what probably can be done with it.

Sincerely, Jock D. Peters.[53]

This vision of a core institution with redemptive powers for the broader society belongs in a rich, idealist sequence whose high points would include Richard Wagner's Festspielhaus at Bayreuth, the Artists' Colony at Darmstadt, and the Bauhaus at Weimar.

Whereas Peters still nurtured this expressionistic and redemptive view of architecture in his California emigration, Karl Schneider's architecture had already taken a completely different course in the Hamburg years, favoring a much more reductive formal language and a more pragmatic and

Figure 6.7 Jock [Jakob] Peters, project for an art education center (1921), court 5, philosophy. Photograph of a lost original drawing. Jock (Jakob) D. Peters Collection, Architecture and Design Collection, University Art Museum, University of California, Santa Barbara.

politically informed position that saw the future of architecture in public housing rather than in glass temples. In Nietzschean terminology, if Peters favored the Dionysian, Schneider represented the Apollonian aspect of German modernism, the world of uncompromising *Sachlichkeit* (functionalism). And for precisely this rigor and control, he won many admirers beyond the boundaries of Germany. The distinguished British modernist Raymond McGrath, for example, asked in 1933 for material to be included in a book on "The Contemporary House." The even better known Hungarian émigré Ernö Goldfinger also wrote from London for information on the housing at Hamburg-Haselhorst, while the Royal Institution of British Architects asked for images of Schneider's designs for gas-filling stations for the transport section of the International Architecture exhibition held in November 1934 to mark the centenary of the RIBA. Schneider's surviving papers also include a postcard of the Tecton-designed Highpoint flats at Highgate—one of the earliest modernist housing blocks in Britain—with a note on the verso: "Where uncle Ernst Ofeffer lived."[54] Given a different personal constellation, Schneider may well have chosen England as the first stop in his exile, as did his master Walter Gropius.[55] But his relationship with Ursula Wolff suggested other directions, and he sailed from Hamburg on January 15, 1938 on the SS Manhattan of the US Line, and arrived in New York City on 25 January. Four days later, he was in Chicago.

Karl Schneider was by no means without influential admirers. Photographs and plans of both the Kunstverein in Hamburg and the 1930 Werner House were featured in the enormously influential survey *International Modernism: Architecture since 1922*, published by Henry-Russell Hitchcock and Philip Johnson in conjunction with the exhibition of the same name at the Museum of Modern Art, New York. After he had installed himself in Chicago, no lesser figure than Lewis Mumford wrote a reference for him in May 1938 for Sears, Roebuck and Company, placing him first among his contemporaries: "Every architectural movement," said Mumford,

> produces two types of leader. One is the theoretical exponent of new forms, the critic and the rationalizer. The other is the artist who transforms the principles and the technical means into living forms, warmed by the creative imagination. When the two types are combined in a single personality, the result is a high order of design: clearly conceived, boldly outlined, coherently organized and imaginatively shaped.
>
> Karl Schneider, of Hamburg, is such an architect. In his work, the principles that form the foundations of the new architecture are clearly defined: the understanding of the possibilities of new types of construction, the readiness to employ the machine and the forms derived from the machine, the rational organization of the whole structure in terms of its functions. . . .

Schneider's work in Hamburg was many-sided. It included some of the finest housing that Germany could show in the municipal or cooperative housing estates that were designed in the nineteen-twenties. But his designs reached an imaginative peak in his country houses. Such architectural ability, such humanized forms, belong to America, and we do well to welcome Karl Schneider; for he can demonstrate to us how to translate the structure of modern living into truly living structures: buildings that will embody the spirit, the purpose, and the functions of our own day.[56]

Less poetically, and doubtless in response to the same request for a reference, Gropius noted that Schneider "has done some outstanding work, particularly in Hamburg. He is an excellent designer and, in addition to this, a perfect draughtsman. I am sure he would do a very good piece of work for Sears, Roebuck and Company."[57] With one referee a professor at Harvard, and another a professor at Penn, Schneider was well recommended indeed and started work immediately with the Chicago-based company.

From its original roots in mail order delivery to the rural population, Sears, Roebuck and Company expanded in the 1920s into the urban market. With a massive increase in car ownership and the urbanization and suburbanization of the United States, the majority of potential customers were no longer limited to buying from a catalogue, but instead preferred the direct experience of shopping in a store. Responding to these changes in demography and transportation, Sears opened its first retail store in Chicago in 1925. Thereafter, the speed of expansion was remarkable, with 192 stores in 1928, 319 stores in 1929, and 400 in 1933. The nature of the merchandise also changed. As the company history explains, "The principle of Sears buying began to change in the late 1920s. Some mail-order merchandise already was being sold under Sears own trade names. And with the opening of more and more retail stores, volume in these and other lines grew rapidly. With this growth, Sears buyers were able to develop exclusively different items to be sold under Sears brand names. This was the beginning of such names as Craftsman, Kenmore and DieHard."[58]

Beyond the vast scale of the operation, the true novelty of the Sears retail stores was the way in which the relationship between the store building and the goods on sale was radically reconsidered. The conventional city store was a heavy, representational building—like Bullocks Wilshire—which created the appropriately grand framework or coulisse for the retail business. Sears, in contrast, developed the store around the merchandise, starting with the selling floor plan, which determined where the various goods for sale were placed within the store, and only then moving outward toward the building envelope. This, of course, is the paradigmatic sequence proposed by heroic European modernism, from Loos to Gropius to Le Corbusier,

whereby the outer skin, fenestration, entry sequence are determined by the functional demands expressed by the interior. Like Jock Peters, but for quite different reasons, Karl Schneider found a home-from-home in this manner of designing for retail.

Just as Behrens had put an enormously expressive skin around the industrial shed that the structural engineer Karl Bernhard designed for the AEG Turbine Factory, so also Schneider was giving the prosaic Sears retail sheds a self-consciously artistic cladding. Were one to theorize this process in depth, the inevitable starting point would be the theories of *Bekleidung* (dressing or cladding) proposed in the mid-nineteenth century by the German architect Gottfried Semper. Following Semper, the primeval wall, composed of woven fabric, was both the "purely symbolic indication of the spatial enclosure,"[59] and also the element—in contrast to the purely functional structure—that enabled the building to carry artistic motifs, thus transcending shelter and becoming architecture. Semper's argument, that the origins of the art of architecture lay in weaving, conflated architecture and the applied arts. At the historical moment in the 1890s, when this proposal was at its most potent, there is a marked conflation of architectural design and product design: one thinks, for example, of the Viennese Secession or its progeny the Wiener Werkstätte, where the talents of designers like Otto Wagner, Josef Hoffmann, or Joseph Maria Olbrich were directed not only at architecture but also at the domestic interior, at furniture, and prosaic objects like cutlery, tableware, and lamps. The Sears doctrine of an independently expressive skin or *Bekleidung* for their stores, brought Karl Schneider back to a similar position.

To this essentially handcrafting position of 1900, however, Schneider added the industrial sensibility that Walther Rathenau and his protégé Behrens had learned from American industry. This sensibility embraced not only the serial production of a wide range of electrical and mechanical goods but also their marketing. As Paul Jordan, the AEG director responsible for the firm's lighting factory insisted around 1910, "Don't believe that even an engineer takes an engine apart for inspection before buying it. Even as an expert, he also buys according to the external impression. A motor must look like a birthday present."[60] And just as the motor should be gift-wrapped, so should the store within which it is sold.

It is not surprising, therefore, that the idea of a unified, corporate design language, which Behrens invented with such brilliance for the AEG, informed Schneider's work for Sears, Roebuck and Company. This work falls into two distinct fields: product design, and store planning and design. For the AEG, Behrens had designed electric kettles, available in three basic designs, in three different metals, in three finishes, and in three sizes. The various permutations of these options produced a range of thirty-five

different kettles. Schneider took on for Sears where Behrens had left off with AEG, with the seventy or so sketches for kettles produced sometime between 1938 and 1944. Not only the volume but also the range of Schneider's product designs is impressive. Produced over the relatively short period of seven years, they range from cutlery, domestic furniture, and electrical appliances, to claw hammer heads, drill presses, and wood turning lathes. In the case of the motorized tools and appliances, Schneider was not designing the machines themselves, but, true to the spirit of AEG, was setting them in modern, streamform casings; transforming the confusion of the moving parts into a smooth-contoured and highly desirable "birthday present."

Precisely the same ambition informed the second main area of his work for Sears, namely design of standardized store plans and elevations (figure 6.8). In a well-developed series of studies, Schneider proposed ten different store configurations, designed around varying conditions of location, site access, and parking. Although widely differing in plan, all share the same design premises: they are thin-skinned, with few punctuations in the skin beyond the entrances and display windows; they beckon to the passing motorist by stressing horizontal circulation and viewing patterns—driving into Sears is no more complex than driving along the road outside; the vertical elevations are dominated by giant letters, running two and three stories high, spelling out the simple word "SEARS" in elongated capitals. In spite of the obvious differences in scale, the design skills exercised by Schneider in cladding a drilling machine or the selling spaces of a store were very similar, and used the same

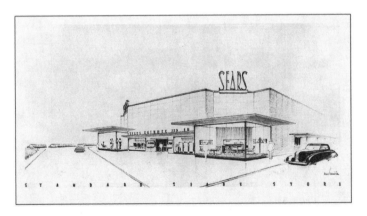

Figure 6.8 Karl Schneider, project for a standard store for the Sears Company, perspective (undated). From Robert Koch and Eberhard Pook, *Karl Schneider: Leben und Werk, 1892–1945*. Hamburg: Dölling and Galitz, 1992.

formal vocabulary. Both accentuate the horizontal contours, both use diagonals to express movement, and both are topped by streamform signs, proclaiming "Craftsman" (figure 6.9) or "Sears," respectively.

Peters died in 1934 at the age of forty-five of the tuberculosis that he had initially contracted during the war. Following a heart attack in 1943, Karl Schneider died in December 1945 aged fifty-three, only weeks after his application for membership of the American Institute of Architects had been accepted. While their work for Bullocks and for Sears can only hint at what might have followed, it allows some general conclusions to be drawn about the nature of the émigré and exile experience in the realm of architecture.

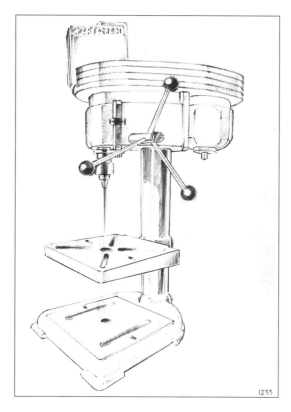

Figure 6.9 Karl Schneider, design for a "Craftsman" upright drill (undated). Karl Schneider papers, Special Collections and Visual Resources, Getty Research Institute, Los Angeles.

In the cases of Jock Peters and Karl Schneider, the practical differences between the émigré and the exile experience would appear to have been relatively slight, once the two men had landed on American soil. Clearly, Schneider had been exposed to vastly more psychological abuse toward the end of his stay in Germany than had Peters. Peters, however, was driven away not by anticommunism or anti-Semitism, but by the illness he had contracted during World War I and the economic hardships of the early Weimar inflation. It is hard to argue that one departure was more imperative than the other, as both may well have ended in death. On arrival in America, both were immediately protected and provided for by family members and friends, and both found work immediately. According to the ever-pessimistic Adorno, "The past life of émigrés is, as we know, annulled. Earlier it was the warrant of arrest, today it is the intellectual experience, that is declared non-transferable and unnaturalizable."[61] This conclusion, however, was drawn in the context of literary and textual scholarship, a model that does not transfer easily to the architectural profession. In the particular cases of Peters and Schneider, for example, it was precisely their professional past and their training and skill as architects that provided their strongest support. The practice of architecture and design offered a sense of stability and continuity that offset the negative affects of physical, social, and intellectual relocation. For Peters, the Bullocks store became the reincarnation of the expressionist city crown. For Schneider, the training in the Behrens studio and the development of his own design manner toward geometric reduction made him eminently qualified to produce standardized and repeatable designs for Sears. The continuity of their architectural personalities would seem, therefore, to have been much stronger and assertive than any loss of identity brought on by a change of country or location. It would be unwise, however, to regard either their work or their experiences in America as in any way representative of a broader category that might be dubbed "German exile architecture." Research into emigration and exile must, necessarily, be conducted at the level of the individual.

Notes

1. Theodor W. Adorno, *Minima Moralia: Reflections from Damaged Life*, trans. E. F. N. Jephcott (London: New Left Books, 1951), 33.
2. Vilém Flusser, *Von der Freiheit des Migranten: Einsprüche gegen Nationalismus* (Bensheim: Bollmann Verlag, 1994), 109.
3. Emil Rathenau, speech at banquet held to celebrate his 70th birthday, rept. in *AEG-Zeitung*, 11–12 (1908): 14.
4. Walter Gropius, letter to G. Hoeltje of June 5, 1958, quoted in Annemarie Jaeggi, *Fagus: Industrial Culture from Werkbund to Bauhaus* (New York: Princeton Architectural Press, 2000), 43.

5. Walter Gropius, "Die Entwicklung moderner Industriebaukunst," *Jahrbuch des deutschen Werkbundes*, 2 (1913): 17–22.
6. Winfried Nerdinger, *The Architect Walter Gropius* (Berlin: Gebr. Mann, 1985), 48.
7. Quoted in Nerdinger, *The Architect Walter Gropius*, 44.
8. Jakob Detlef Peters, letter to Herta (Boegie) Peters of December 28, 1917. Jock Peters Collection, Architecture and Design Collection, University Art Museum, University of California, Santa Barbara.
9. On the theoretical assumptions that informed expressionist architecture, see Iain Boyd Whyte, *Bruno Taut and the Architecture of Activism* (Cambridge: Cambridge University Press, 1982).
10. Bruno Taut, *Die Stadtkrone* (Jena: Diederichs, 1919), 61–62.
11. Hugo Koch, "Hamburger Ausstellungshallen-Gesellschaft," *Die gelbe Posaune der Sieben* (Hamburg: publisher unidentified, 1919), 4.
12. Anon. newspaper report on the "Hamburg Sezessions-Ausstellung" (1919). Jock Peters Collection, Santa Barbara.
13. See Marcel Franciscono, *Walter Gropius and the Creation of the Bauhaus in Weimar* (Urbana: University of Illinois Press, 1971).
14. C. R. Ashbee, "Frank Lloyd Wright: Eine Studie zu seiner Würdigung," *Ausgeführte Bauten*, by Frank Lloyd Wright (Berlin: Wasmuth, 1911), 4–5. Original text in English, "Frank Lloyd Wright, A Study and an Appreciation," *Frank Lloyd Wright—The Early Work*, by Frank Lloyd Wright (New York: Bramhall House, 1968), 4.
15. Johann Wolfgang von Goethe, "Den Vereinigten Staaten" (1827):

> Amerika, du hast es besser
> als unser Kontinent, der alte,
> hast keine verfallenen Schlösser
> und keine Basalte.

> (America, you're better off
> Than our continent that's old.
> At tumbled-down castles you scoff,
> You lack basalt, I'm told.)

16. Quoted in Golo Mann, *The History of Germany since 1789* (Harmondsworth: Penguin, 1985), 561.
17. Karl F. Stöhr, *Amerikanische Turmbauten* (Munich: R. Oldenbourg, 1921).
18. See J. J. P. Oud, "Bij een Densch ontwerp voor de 'Chicago Tribune'," *Bouwkundig Weekblad* (1923): 456–458; Walter Gropius, *Internationale Architektur* (Munich: Albert Langen Verlag, 1925), 48; and Adolf Behne, *Der moderne Zweckbau* (Munich: Drei Masken Verlag, 1926) pl. #34. Information from Roland Jaeger, "Von Altona nach Los Angeles: Jakob Detlef Peters (1889–1934)," *Architektur in Hamburg. Jahrbuch 1993*, ed. Hamburgische Architektenkammer (Hamburg: Junius Verlag 1993), 138–149.
19. Lönberg-Holm went via New York and Detroit to Ann Arbor, where he taught architectural design at the University of Michigan in 1924–1925. He then went into architectural publicity, and was responsible for many of the photographs in Erich Mendelsohn's celebrated book, *Amerika: Bilderbuch eines Architekten* (Berlin: Rudolf Mosse Verlag, 1926). See Jaeger, "Von Altona nach Los Angeles" 145.

20. Bharati Mukherjee, "Imagining Homelands," *Letters of Transit: Reflections on Exile, Identity, Language, and Loss*, ed. André Aciman (New York: New Press, 1999), 74.

21. See letter from Peter Behrens to the Gewerbeschule-Verwaltung, Altona, July 17, 1920: "In response to your esteemed letter of 14 July, I respectfully respond that Herr Jacob Detlev [*sic*] Peters worked in my studio as an assistant a few years ago. Herr Peters is a strong artistic personality, has mature technical skills at his disposal, and makes an entirely reliable and sympathetic impression as a person. For these reasons, I would regard him as entirely qualified for the position in question." Jock Peters Collection, Santa Barbara.

22. Jakob Detlef Peters, undated letter to his wife Herta (Boegie), December 1922. Jock Peters Collection, Santa Barbara.

23. Peters, letter to his wife, December 6, 1922. Jock Peters Collection, Santa Barbara.

24. Peters's wife Herta wrote to him at this time, saying that she needed 15,000 to 20,000 Marks a week to feed the family, with a loaf of bread costing 800 Marks. Herta (Boegie) Peters, letter to Jock Peters, January 12, 1923. Jock Peters Collection, Santa Barbara.

25. Ibid.

26. Peters, letter to his wife, December 24, 1922. Jock Peters Collection, Santa Barbara.

27. Jaeger, "Von Altona nach Los Angeles" 145. On the Paramount Studio, see Donald Albrecht, *Designing Dreams* (New York: Harper Row, 1986), 79–84.

28. See Jock Peters, letter to Herta (Boegie) Peters, December 24, 1922: "I'm happy that you were able to give everything back to Henneberger." Jock Peters Collection, Santa Barbara. This passage is omitted from the English translations of the letters held in the Peters Collection.

29. Ruth Asseyer, "Karl Schneider," *Karl Schneider: Leben und Werk*, ed. Robert Koch and Eberhard Pook (Hamburg: Dölling and Galitz, 1992), 10.

30. For a complete list of Schneider's built and unbuilt projects in Germany, see Koch and Pook, *Karl Schneider* 276–281.

31. Winfried Nerdinger, "Karl Schneider und die Moderne," *Karl Schneider*, ed. Koch and Pook, 51.

32. Heinrich de Fries, "Eine Kunstausstellung von Karl Schneider, Hamburg," *Moderne Bauformen*, 30.2 (February 1931): 81.

33. Heinrich de Fries, *Karl Schneider: Bauten* (Berlin: Hübsch, 1929), iv.

34. Unidentified newspaper article, August 29, 1932, quoted in Asseyer, "Karl Schneider" 13.

35. Letter from Karl Schneider's students at the Landeskunstschule, Hamburg, to the Herr Bürgermeister Krogmann (major of Hamburg), May 18, 1933. Karl Schneider Papers, Getty Research Institute, Special Collections and Visual Resources, file 850129-1, f. 5: "With this letter, the undersigned students of Professor Karl Schneider at the Landeskunstschule, Hamburg, request most respectfully that the grounds for the suspension of their esteemed teacher be reviewed. We have decided on this course, as there is a rumour that Herr Professor Schneider was suspended because he did not possess the necessary attributes of a teacher, and in particular because he could not instill enthusiasm for their work among his students. As such an assertion bears no relation to the

facts, we feel ourselves obliged to commend our position to your esteemed consideration.

We assure you, hereby, that *all* of Professor Schneider's students—regardless of their political and cultural views, and in spite of the fact that a considerable number are enthusiastic supporters of the self-critical spiritual and political reform of the German people—fail to understand the grounds for his suspension. We all admire Professer Schneider as a German of absolutely impeccable character, and as a teacher who has educated our artistic perceptions, and has enthused us for the tasks and goals of architecture" (signed by 14 students).

36. See memo from President of *Landesschulbehörde* to Karl Schneider, May 31, 1933. Karl Schneider Papers, Getty Research Institute, file 850129-1, f. 5.

37. See documents relating to Schneider's divorce, Hamburg, 1935. Karl Schneider Papers, Getty Research Institute, file 850129-1, f. 5.

38. One of Wolff's Greek photographs was used on the dustjacket of a book by a fellow exile, the architect Bernard Rudofsky, *Are Clothes Modern? An Essay on Contemporary Apparel* (Chicago: Theobald, 1947).

39. He was removed from this position, however, by the National Socialists in 1933, and moved to Berlin, where he launched a new career as writer and translator. In addition to his translation into German of Igor Stravinsky's autobiography, Richard Tüngel wrote on Goya and on the history of the Prado in Madrid, and was a cofounder of the German weekly newspaper *Die Zeit*.

40. Ruth Asseyer, "Zwischen Erfolg und Exil," *Bauwelt*, 25 (1988): 1078.

41. Sworn testimony of Ursula Schneider, born Wolff, September 6, 1955, qtd, in Asseyer, "Karl Schneider" 17.

42. Otto Kohtz, *Gedanken über Architektur* (Berlin: Baumgärtel, 1909); and *Büroturmhaüser in Berlin* (Berlin: Zirkel, 1921).

43. Quoted in Davis, *Bullocks Wilshire* 15.

44. Unsigned and unpaginated typescript. Jock Peters Collection, Santa Barbara. This pasage in the typescript is footnoted: "I am indebted to Raymond Dexter, on whose recollections this account is based."

45. Graf Hermann Keyserling, extract from *Das Spektrum Europas* (1928), quoted in *Innen-Dekoration* 34.7 (July 1928): 302.

46. George Douglas, "Bullock's Wilshire Store Delights City's Art Critics," *Los Angeles Times* September 26, 1929.

47. Quoted in Davis, *Bullocks Wilshire* 11.

48. Quoted in Davis, *Bullocks Wilshire* 13.

49. Bruno Taut, "Eine Notwendigkeit," *Der Sturm* (February 1914): 174–175.

50. This proposition finds a precedent not only in the pre-1914 debates of the Deutscher Werkbund, but also in a long text penned by Peters in 1920 entitled "Chaos," which urged the socially redemptive qualities of good design and hand production. See "Chaos," article in three parts, published in unidentified newspaper, 1920. Jock Peters Collection, Santa Barbara

51. Davis, *Bullocks Wilshire* 64.

52. For more on this theme, see Iain Boyd Whyte, *Modernism and the Spirit of the City* (London: Routledge, 2003), 1–31.

53. Jock Peters, letter to Arthur Hillier, October 22, 1929. Jock Peters Collection, Santa Barbara.

54. Correspondence in Karl Schneider Papers, Getty Research Institute, file 850129-1, f. 5.

55. Had he done so, he would probably have suffered the same, rather indifferent reception accorded by the British to Gropius. On architectural exile in Britain, see Charlotte Benton, "Continuity and Change: The Work of Exiled Architects in Britain, 1933–39," *Architektur und Exil: Kulturtransfer und architektonische Emigration von 1930 bis 1950*, ed. Bernd Nicolai (Trier: Porta Alba Verlag, 2003), 75–85. More generally, one might also ponder Susan Sontag's comment, penned in the context of the writer Elias Canetti: "The artist who is also a polymath (or vice versa), and whose vocation is wisdom, is not a tradition which has a home in English, for all the numbers of bookish exiles from this century's more implacable tyrannies who have lugged their peerless learning, their unabashed projects of greatness, to the more modestly nourished English-speaking islands, large and small, offshore of the European catastrophe." Susan Sontag, *Under the Sign of Saturn* (New York: Farrar, Straus and Giroux, 1972), 185.

56. Lewis Mumford, "Memorandum on Karl Schneider," May 20, 1938. Karl Schneider Papers, Getty Research Institute, file 850129-1, f.8.

57. Walter Gropius, reference for Karl Schneider to A. J. Snow, Sears, Roebuck & Co., Chicago, May 1938. Karl Schneider Papers, Getty Research Institute, file 850129-1, f.8.

58. "Sears History, 1925," in "About Sears, News and History," <http://www.sears.com/>.

59. Gottfried Semper, *Der Stil in den technischen und tektonischen Künsten* (Frankfurt a. M.: Verlag für Kunst und Wissenschaft, 1860–1863), I: 279.

60. Quoted in Peter Behrens, "Zur Ästhetik des Fabrikbaus," *Gewerbefleiss* 108.7–9 (July–September, 1929): 125–130.

61. Adorno, *Minima Moralia*, 46.

CHAPTER SEVEN

PERMANENT VACATION: HOME AND HOMELESSNESS IN THE LIFE AND WORK OF EDGAR G. ULMER

Noah Isenberg

Dwelling, in the proper sense, is now impossible. The traditional residences we grew up in have grown intolerable; each trait of comfort in them is paid for with a betrayal of knowledge, each vestige of shelter with the musty pact of family interests.

—Theodor W. Adorno, *Minima Moralia*

All I need is a brief glimpse, an opening in the midst of an incongruous landscape, a glint of lights in the fog, the dialogue of two passersby meeting in a crowd, and I think that, setting out from there, I will put together, piece by piece, the perfect city, made of fragments mixed with the rest, of instants separated by intervals . . . discontinuous in space and time, now scattered, now more condensed.

—Italo Calvino, *Invisible Cities*

I

In her preface to the catalogue published in conjunction with the Edgar G. Ulmer retrospective, held at the 1997 Edinburgh Film Festival, curator Lizzie Francke observes how the Austrian-born director and so-called wandering émigré once tellingly remarked, "there are no nationalities, the only home you have is the motion picture set."[1] For Ulmer, who was born in 1904 in Olmütz, in the provinces of the Austro-Hungarian Empire, a multinational amalgamation that no longer existed by the time he was in his teens, the question of home and nationality remained an elusive one throughout his adult life. He personally experienced the mass migrations prompted by two World Wars—the first landing him in foster care in Uppsala, Sweden, after his father's death in Austrian uniform in 1916, and

the second sealing his fate to remain, at least temporarily, among the many refugees from Hitler's Europe who decamped from Berlin and Vienna for Southern California in the 1930s and 1940s—and in his some thirty-five year career as a director, he returned to the basic theme of displacement with near obsessive frequency. The lack of permanence or firm footing that might link his subjects to a stable location—a city, a community, a nation—is something Ulmer explores in his best-known work, including *The Black Cat* (1934), *Detour* (1945), and *Ruthless* (1948), as well as in his lesser-known films: in his ethnic pictures directed in and around New York City during the mid- to late 1930s; in his eleven-film cycle of B-movies shot at Producers Releasing Corporation (PRC), the poverty row studio where, from 1942 to 1946, Ulmer earned a reputation as one of the pioneers of low-budget independent filmmaking; and in his later films, many of which were shot in Europe in the 1950s and 1960s and all of which were made outside the industry norms and standards of Hollywood.

Unlike the more illustrious career paths of his professional cohort Billy Wilder, Robert Siodmak, or Fred Zinnemann (all three of whom collaborated with Ulmer on their legendary 1929 production of *Menschen am Sonntag* [People on Sunday]), the trajectory of Ulmer's film career never quite brought him the recognition he undoubtedly sought. Instead, he often took on unconventional projects—both out of necessity and by choice—that kept him from the spotlight of American and European fame. As John Belton has argued, "Ulmer occupies an unknown, uncharted, and apparently invisible space on the margins of cinema history."[2] In the following, I wish to examine the life and career path of Ulmer in an effort to widen the scope of analysis in the research on exiled artists and filmmakers. Despite Ulmer's enigmatic career, the story that emerges is one that may shed further light onto some of the received wisdom concerning German exiles and that may, in turn, complicate our understanding not only of Ulmer but also of the vicissitudes of exile and émigré culture in general. Attempting to combine biographical sources with formal film analysis, my examination will follow several of the key detours that Ulmer's life and career took.[3] It will thus move among the cities and sites, real and imagined, that he inhabited and reflected in his work.

II

Although Ulmer was born in the provinces, his family moved back to Vienna soon after his birth. Like many artists before and after him, he felt the need to claim Vienna as his true birthplace; in doing so, he declared a profound attachment—emotional, cultural, and otherwise—to the imperial city. By the eve of the Great War, just as Ulmer was approaching his tenth

birthday, a catchy tune entitled "Wien, du Stadt meiner Träume" ("Vienna, You are the City of My Dreams"), written by Rudolf Sieczynski, was making the rounds in the Hapsburg capital and becoming a worldwide hit. Its refrain goes as follows:

> Wien, Wien, nur Du allein
> Sollst stets die Stadt meiner Träume sein
> Dort wo die alten Häuser stehn,
> Dort wo die lieblichen Mädchen gehn.
>
> [Vienna, Vienna, none but you,
> Can be the city of my dreams come true
> Here, where the dear old houses loom,
> Where I for lovely young girls swoon.][4]

As Ulmer's first metropolitan experience, Vienna certainly attained the status of "city of dreams," and he continued to treat it as such long after he left it behind, first for Sweden, then for Berlin to work on Max Reinhardt's stage productions and still later on to New York, Hollywood, and eventually back to Europe once more. For Ulmer, the memories and fantasies of Vienna were always recalled in a musical and aesthetic register. Consider, for instance, the opening paragraphs of his fragmentary, unpublished novel *Beyond the Boundary*—an elliptical, highly introspective, and blatantly autobiographical work—which he signed and dated "Hollywood, 1935":

> It is quiet in the large dark room. The dawn hasn't broken yet. The presence of sleeping humans is obvious. The window is open and past the snow-covered ledge, streams in the cold winter air. It gets quite cold in Vienna in the winter.
> The window looks out upon a back yard. Fore-shortened in perspective, one feels the back wall of the other house alongside. And opposite that bleak back wall, in "L" form runs a wing, housing the servant- and kitchen-quarters. Beyond that . . . the skyline of Vienna.
> It's futile to describe it. Listen to Schubert, Johann Strauss, to Mozart and Haydn, and you will feel the strange substance of sentimentality, charm . . . the Spanish court-ceremonial and the Wienerwald . . . The Danube.[5]

The novel follows its protagonist George (Ulmer's middle name) through the streets of the war-torn capital, from the breadlines to the brothels, and chronicles George's coming of age—the traumatic death of his father (the work is dedicated to Siegfried Ulmer, "one of many thousands who died in the First World War"), his sexual awakening in adolescence at the hands of a local prostitute, and the final departure from his maternal home. Although the work is hardly first rate in terms of its overall literary quality, it does offer something in the way of substance concerning Ulmer's cultural

sensibility, a sensibility that would be translated—never completely, often only in traces—in his cinematic output. Indeed the sounds of Vienna, not to mention the "ghost-like" figures and "shadows" that populate Ulmer's novel, cropped up repeatedly in his aural and visual lexicon. As the late German film critic Frieda Grafe once put it in her reevaluation of Austrian film history, "Vienna was a reservoir of dreams"; or, as she remarks further in the same essay, "Austrian film history is a phantasm, because it is not tied to a fixed place; its cinema is a kind of film without a specific space."[6]

From the very beginning, film in Austria was necessarily international, with well-trodden paths leading to Berlin, Paris, and, sometime later, also to Hollywood.[7] It should perhaps come as no surprise, then, that the Viennese-born, or in Ulmer's case Viennese-trained, film directors were particularly adroit fabulists when it came to dreaming up their pasts in the film world of Hollywood, the factory of dreams. Erich von Stroheim would take on the a self-avowed air of Prussian aristocracy, Billy Wilder the identity of a former gigolo, and Ulmer (the persona, that is) a wunderkind from Reinhardt's renowned drama school. Each of these roles, and there were of course many more, provided a new identity to the displaced émigré in need of a quick makeover, specifically one that might bring more work. "The secret affinity that existed between Hollywood on one side and Vienna or Paris on the other," writes Thomas Elsaesser, "was that they were societies of the spectacle, cities of make-believe and of the show. The decadence of the Hapsburg monarchy was in some ways the pervasive sense of impersonation, of pretending to be in possession of values and status that relied for credibility not on substance but on convincing performance, on persuading others to take an appearance for reality."[8]

As was the case with most German and Austrian filmmakers of his generation, Ulmer learned much of his trade in the theater. And like these other directors (F. W. Murnau, Otto Preminger, William Dieterle, etc.), he eventually made his way to Max Reinhardt. Even if his only official credit working with the Reinhardt stage was as a set designer, together with Rochus Gliese, on the acclaimed 1928 Berlin production of Ferdinand Bruckner's *Die Verbrecher* (The Criminals), he clearly identified himself, both professionally and aesthetically, with the theater and he asserted his deep-seated ties to the great impresario.[9] A calling card from the 1920s makes this assertion most apparent: it lists Ulmer's title as *Regisseur* (director) and *Ausstattungschef* (head of design) for the Reinhardt stage, and then gives Vienna, Berlin, and New York as his cities of operation, an early gesture toward the cosmopolitan identity he embraced until his death. When Ulmer set sail for New York, in spring of 1924, the staging of Reinhardt's *Das Mirakel* (The Miracle) at New York's Century Theatre was well underway. Ulmer himself claimed to have been involved in the stage design, and

he described his first trip to New York, at the age of nineteen, as one that had been arranged by the Schildkrauts, the father-and-son acting duo Rudolf and Joseph, with whom Ulmer had spent a formative phase of his late youth in Vienna. Indeed, Rudolf Schildkraut, like Fritz Feld, was part of the original cast of *The Miracle* that traveled to New York with the show. Yet, Ulmer's record from Ellis Island indicates that he traveled on the *SS President Roosevelt* and arrived in New York Harbor on April 12, 1924, almost four months after the play's premiere.[10] It is, however, fully conceivable that he had a hand, perhaps as one of the many designers or simply one of the some 700 people said to have been enlisted in the play's highly successful ten-month run.[11]

In his extensive interview with Peter Bogdanovich, Ulmer comments on his initial experiences in New York City: "When I came to New York the first time, Reinhardt hired Schildkraut, who had worked for him in Europe, to play in *The Miracle*. And I was taken down to Second Avenue, and met the Jewish Art Theatre, which had some tremendous actors—Muni Weisenfreund [Paul Muni], Jacob Adler, Maurice Schwartz—it was something which didn't exist elsewhere in all of New York. . . . It was a second Broadway down there."[12] This early contact to the thriving Yiddish stage on New York's Lower East Side may have inspired Ulmer, over a decade later, to direct the Yiddish films he completed in the late 1930s. His childhood friend Joseph Schildkraut, who originally arrived in New York in August 1920, writes in his memoir, *My Father and I*: "My first impression of New York was mixed, more confusing than exhilarating. The skyline, the harbor, the piers, the crowd—all these were exactly as I had seen them in paintings and photographs. Reality was merely copying art."[13] It is rather ironic that Schildkraut should find this relationship between art and reality in the New World, when in numerous cases émigrés found themselves engaged in the process of imitating reality—or what, in the New World, was taken for reality—in their art, even an imagined reality of the Old World left behind. Perhaps for Ulmer the main attraction of New York was the fact that there were so many fellow émigrés in his midst, many of them artists, actors, directors, and crew members, who drew on their pasts as a means of communicating with their new audience. In Ulmer's case, it was often his European training, the true extent of which he occasionally embellished, that linked him to other émigrés working in the United States.

In 1926–1927, Ulmer joined forces with German-born Rochus Gliese in set design at Fox Studios, assisting F. W. Murnau, also a former Reinhardt pupil, on his Hollywood debut *Sunrise*. Ulmer, who was already in Hollywood working in the Art Department at Universal and churning out two-reel Westerns on the side, considered Gliese as "[a] partner, a fantastic designer and camera builder."[14] Gliese, whose set design for *Sunrise* earned

him an Oscar nomination, had worked on several early German film productions, including the second Golem film *Der Golem und die Tänzerin* (The Golem and the Dancer, 1917), which he directed. For Ulmer, the significance of *Sunrise*, one of the greatest pictures Murnau ever made and, in Ulmer's words, "the *only* picture Murnau himself counted,"[15] cannot be underestimated. The film, which blends European and American styles from the *Straßenfilm* to the early Hollywood melodrama, pits traditional life in the provinces against the big city. The blissful harmony—or dreadful tedium—of family life between the nameless Man (George O'Brian) and Woman (Janet Gaynor) in the country is interrupted, much as in a classical horror film, by the intrusion of an outsider, the Woman from the City (Margaret Livingston). Murnau casts these two worlds in stark opposition, opening the film with a brilliant montage (à la Ruttmann's *Berlin: Die Sinfonie der Großstadt*) and having the city woman lure away the man of the country, indulging him in fantasies of urban decadence. In such scenes as the man and city woman imagining the city, or the man and wife having their photo taken during their later visit to the city, the film can be viewed, as Lucy Fischer asserts, "as a self-reflexive text which, provisionally, identifies the cinema with the metropolitan."[16] One might add to this equation the European city that seems to symbolize the cosmopolitan sensibility par excellence, a sensibility Murnau—and later, Ulmer—frequently incorporated into his work.

In order to achieve this most effectively, Murnau had to rely on high-quality production design, much of it pioneered in Weimar Germany, as a means of depicting the separate worlds. As Lotte Eisner remarks, "Gliese [and, by extension, Ulmer working with him] had created every kind of landscape, from fields and meadows, through an industrial area and the sparse gardens of the suburbs to the city itself."[17] The ostensible lessons that Ulmer learned while working with Murnau—not merely in terms of design but also in terms of handling his characters and themes—would stick. One can indeed see shades of Murnau in several of Ulmer's subsequent films. As late as 1955, in his Mexican Western shot in Technicolor, *The Naked Dawn*, the rural-urban dialectic is played out again in a new light. The film is, according to the trenchant interpretation by John Belton, "a reworking of Murnau's *Sunrise*—Santiago, with the lure of money for the husband and tales of exotic Vera Cruz for the wife, taking the part of Murnau's Woman from the City"[18] (figure 7.1). Not only does the film present a plausible "reworking," but it also picks up on several of Ulmer's own stock themes: the false promise of material wealth; the romantic wanderings of a lonely hero; and the struggle to remain loyal to a more noble, if less profitable, calling. In a critical moment in the film, the husband (Eugene Iglesias) falls prey to the venal impulses of a modern man, a man who is willing to forsake

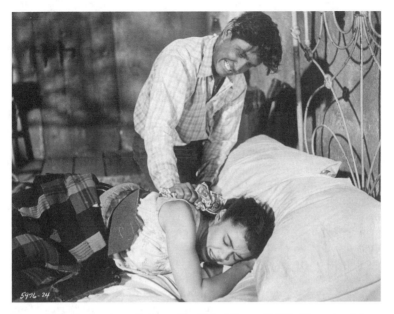

Figure 7.1 Production still from *The Naked Dawn* (1955). Courtesy of Jerry Ohlinger's Movie Material Store, Inc.

his seemingly perfect home—and his beautiful wife (Betta St. John)—for financial gain, contrasting him in striking terms with the homeless renegade Santiago (Arthur Kennedy), who has no deeper connection to the money he acquires and therefore does not allow himself to be alienated by its material worth. Just as Ulmer saw himself as belonging to the "Romantic" and "art-possessed" directors, as opposed to the "group [for] whom theatre and film was a business,"[19] so too his characters often confront the clash between higher pursuits—be they aesthetic, philosophical, or even theological—and base material concerns, between art and commerce. From the beginning of his American career to his final pictures made in Europe, this dialectical tension remained palpable both on and off the set.

III

Ulmer's American directorial debut, or, more precisely, his big studio debut, would take place a good two decades before *The Naked Dawn*. The 1934 production of *The Black Cat* lies at the heart of the famed Universal Horror cycle, which starts with *Dracula* and *Frankenstein*, both from 1931, and ends with *Son of Frankenstein* (1939). The film offers a fascinating glimpse

into the world of an émigré filmmaker negotiating American financial and aesthetic constraints. With Bela Lugosi and Boris Karloff in leading roles—the first of seven pictures in which they would star opposite each other—it is a film that represents the rich interplay between European art cinema and the Hollywood blockbuster, between reflections of exile and those of home. The film opens with images of transit: a European railway station, packages and luggage, train officials and passengers. Aboard the Orient Express is a newlywed, patently American couple, the mystery thriller writer Peter Alison (David Manners) and his young bride Joan (Jacqueline Wells), bound for a luxury resort in the Carpathian mountains (a familiar destination for viewers of early German horror as the home of Murnau's *Nosferatu*). The honeymooners, shown affectionately in their cheery, brightly lit compartment, soon face an intruder Dr. Vitus Werdegast (Lugosi), who in fact does become a guest, as his name—in German, literally "I shall be a guest"—tells us. His jarring screen presence disrupts the harmonious moment shared by the Alisons. Werdegast immediately finds himself enraptured by the sight of Joan, which Ulmer captures in several revealing point-of-view shots—a foreboding sign of what's to come (Lugosi's role in the *Black Cat* was very much colored by his recent memorable performance in *Dracula*). The remainder of the film develops on two levels: the tale of the European returnee (Werdegast), who accompanies his American visitors to the original site of his wartime trauma, where former general and engineer Hjalmar Poelzig (Boris Karloff) has constructed his spectacular compound; and the face-off between Werdegast and Poelzig, which includes a few notable flourishes of gruesome sadism, bondage, and revenge along with the requisite American happy ending.

In keeping with the American horror genre, *The Black Cat* adheres to the boilerplate plotlines of murder and deception. Unlike its counterparts, however, it introduces two important elements to the genre: a score that showcases European, largely German and Austrian, classical music (Brahms, Schubert, Beethoven) and a high modernist aesthetic that informs the overall design of the film. The clean lines, luminous interiors, and sleek, minimalist decor all replicate the taste of 1920s Berlin, Vienna, Paris, and Amsterdam. As Ulmer claimed, somewhat boastfully, the film was "very much out of my Bauhaus period."[20] Another effort to have his name associated with some of the most venerable artistic figures, movements, and institutions, Ulmer's grandiose appraisal should be considered a bold indicator of his highly self-conscious approach to making a film that would deliberately evoke the style of a period in which Ulmer admittedly had little part. Jim Hoberman's memorable appraisal, riffing on the famous title of Siegfried Kracauer's history of Weimar cinema, still rings true: "From Caligari to Hitler in one lurid package."[21]

On the set, Ulmer worked with British-born designer Charles Hall, producing what Donald Albrecht has pronounced an "architectural tour de force."[22] Albrecht credits Ulmer with envisioning Hjalmar Poelzig's elaborate compound, the space in which Ulmer's implicit nod to his former home, that is, to the European high modernist aesthetic cultivated in his choice of design, comes into direct conflict with the homeless characters who languish within it: Werdegast, the Allisons, even the ghoulishly preserved bodies of former inhabitants. Despite the fact that the film's supposed location is far removed from an urban world, the highly stylized interiors suggest something more out of the European metropolis than out of the provincial hinterland (figure 7.2).

Ulmer's playful adaptation of early German cinematic style in *The Black Cat* manifests itself in a variety of ways. His dramatic use of light and shadow throughout the film evokes a hallmark, by now nearly clichéd, of German expressionism. There are also narrative strategies that appear to be holdovers from the silent era: for example, when Poelzig lies down in bed, he reads the *Rites of Lucifer* (like the *Book of Vampires* in *Nosferatu*— indeed, the affinities with *Nosferatu*, and, more broadly, with Murnau proliferate throughout). However, some of Ulmer's references to Weimar cinema

Figure 7.2 Production still from *The Black Cat* (1934). Courtesy of Jerry Ohlinger's Movie Material Store, Inc.

resemble more of an inside joke among German and Austrian émigrés than a genuine homage: in using a name like Poelzig, and making him an engineer at that, it is impossible to miss the allusion to renowned German architect Hans Poelzig, who designed the sets for Paul Wegener's 1920 *Golem* film and who also built one of Berlin's most celebrated theaters, the Großes Schauspielhaus. As for the sadistic personality of Poelzig, Paul Mandell has argued that the figure was based on Fritz Lang, who was widely considered to be a tyrannical director.[23] The sets, Ulmer suggested to Bogdanovitch, were inspired by conversations with Gustav Meyrink, the Prague novelist who wrote his own rendition of *The Golem*, on which Paul Wegener's film of 1920 was based, and who had allegedly considered writing a play set in a French military fortress from World War I.[24]

Although *The Black Cat* was by all counts a commercial success, ending the year as Universal's top-grossing picture of 1934, Ulmer's days as a Hollywood studio director were numbered. While working on the film, he met his wife-to-be Shirley Castle (neé Kassler), a script supervisor and screenwriter, who at the time was still married to studio boss Carl Laemmle's nephew Max Alexander. Their liaison immediately branded Ulmer persona non grata in Laemmle's powerful domain, a stronghold that reached far into other studio dynasties. In the words of Bill Krohn, Ulmer was "blackballed not for politics, but for love."[25] The rejection made Ulmer a different kind of "exile" in Hollywood; unlike one by national policy, it was a banishment from a new home and from the world in which he once saw great potential to flourish. Ulmer and his wife became, in Shirley's words, "Hollywood outcasts," or, as she puts it more plainly in the same interview, "we were told that we'd never work in Hollywood again."[26] They were thus forced to look elsewhere, in peripheral markets outside of Southern California.

IV

After completing a B-class Western, *Thunder over Texas* (1934), and shooting a cheap thriller in Montreal, *From Nine to Nine* (1936), Ulmer set up shop in New York, where he would direct, among other projects, four feature-length Yiddish pictures, ranging from the pastoral *Grine Felder* (Green Fields, 1937) and the gloomy *Fishke der Krumer* (*The Light Ahead*, 1939) to his startlingly urbane *Americaner Schadchen* (*American Matchmaker*, 1940). Almost a sequel to *The Light Ahead*, which chronicles the dilemmas faced by Fishke and Hodl, two social pariahs who flee the world of the shtetl in search of a better life in the city, *American Matchmaker* brings us directly to the world of the metropolis—not Odessa, as in *The Light Ahead*, but New York—and introduces us to the different

roles that Yiddish-speaking Jews occupy there. As Bill Krohn has suggested, *American Matchmaker* might indeed be viewed as a "comedy in which we see what became of Fishke and Hodl's descendents in the city."[27] The film's protagonist Leo Fuchs, regarded at the time as the "Yiddish Fred Astaire," plays the upwardly mobile, highly successful, assimilated businessman Nat Silver, who in the process of continuing to climb the social ladder of New York City in the late 1930s, effects a career makeover ("human relations" or what is sardonically called "human relishes") and changes his name from Silver to Gold.[28] The film opens inside a sumptuously designed apartment on Central Park West—an address where Ulmer himself once lived with his wife—where Nat Silver's bachelor party is underway.

The elegant setting, lavish design, mannerism, and style of the opening sequence conjure a milieu that is anything but specifically Jewish. The only thing that marks the film as Jewish, as critics have observed, is the fact that Yiddish is spoken; and even that is highly Americanized and urbanized with continuous references to contemporary idiomatic phrases and expressions evocative of street-savvy sophistication.[29] "The big city, as it's portrayed," asserts Stefan Grissemann, "is still more of a village than a jungle, a very manageable small world in which the Jewish community, almost as if there were no other religions or social groups in New York City, effortlessly sticks together."[30] There are, however, running gags within the story line of the film that explicitly address the vexed issue of assimilation, for example, the faux-English butler (Yudel Dubinsky) who insists on speaking a Yiddishized British English, or the constant use among the other actors of American slang, which peppers their speech. Moreover, the transformation of the film's protagonist entails a complete embrace of secular, bourgeois American culture. Hoberman calls attention to the fact that among the four Yiddish pictures that Ulmer directed this was the only one in which he was also partly responsible for the script, cowritten with his wife and his Viennese cousin Gustav Heimo (née Horowitz). As a result, the film might be seen as a personal response to the dilemmas of Jewish assimilation in an urban setting, a dilemma with which Ulmer undoubtedly had some familiarity, having grown up in Vienna during the first decades of the twentieth century. For Hoberman, the character of Nat Gold represents the "bridge between the hapless Menakhem Mendl [the famed *luftmentsh* of Sholem Aleichem's stories] and the neurotic heroes of Woody Allen."[31]

In terms of Ulmer's career development, the film fits into an extended phase of directing pictures aimed at minority audiences. Around the same time that he shot his Yiddish pictures, Ulmer was at work on a series of shorts commissioned by the Brooklyn-based National Tuberculosis and Health Association, among them *Let My People Live* (1939), a plea for disease prevention among African-Americans filmed at the all-black Tuskegee

Institute in Alabama. During that year Ulmer and Shirley also teamed up again with Gustav Heimo, along with Shirley's brother Fred, as assistant director, and her father Peter, as associate producer, to make the all-black musical drama *Moon Over Harlem* (1939). Catering to a target audience of African-American cinema-goers, the film takes the viewer inside the world of the famed neighborhood, "black Manhattan," as the film's hero Bob (Carl Gough) calls it: a world of gangsters and mob control—characters from rival gangs with names like Dollar Bill and Wall Street—but also one of an aspiring middle class represented by Bob and his like-minded girl-friend Sue (Ozinetta Wilcox), both of whom seek to overcome adversity and triumph in the city just as Nat Silver does in *American Matchmaker*. For them, it is less cultural assimilation than class assimilation—certainly a fraught issue in Nat Silver's quest as well—which stands in the way of their dreams of success. They must invent a new home in a hostile urban world beset by violence, poverty, and other social maladies, a collective pursuit in which countless characters from Ulmer's film repertoire engage themselves. Finally, there is, on a less overt level, a shared plight or an analogous state of exile from the dominant culture that links the black characters on the screen to the displaced émigrés on the set.[32] This may indeed help to explain Ulmer's choice of direction as well as his input on the story. And it may give further meaning, albeit merely symbolic in nature, to the general experience of homelessness, or estrangement from one's birthplace, as treated in Ulmer's films.

V

Another narrative thread in which Ulmer seems to play out a kind of European-American dialogue is the recurrent battle between art and con-sumerist mass culture in his films. Never quite striking a preachy, didactic, or doctrinaire tone, he frequently pits aesthetic compromise against mate-rial or professional payoff. For instance, in his low-budget melodrama, *Jive Junction* (1943), he draws on the musical talent of émigré composer Leo Erdody—with whom he collaborated on many occasions during his years at PRC—to tell the story of young Peter Crane (Dickie Moore), a classically-trained pianist and a self-proclaimed lover of music, who finds himself drawn into the big band jazz scene at Clinton High School. Early on in the film, Ulmer allows the viewer to catch precious glimpses of Peter listening to his father's favorite composers (strictly of the European variety, from Brahms to Schubert)—as we quickly learn, Peter's father, like Ulmer's own father, has died on the battlefront—before he heads down the path toward mainstream pop music played at juke joints like Jive Junction. The under-lying conflict of the film, then, is not merely musical, but generational,

especially when Peter has to turn to his former mentor at the conservatory, the "Maestro" (played by Viennese-born Frederick Feher), to help procure instruments for the school band's big performance broadcast on live radio. The Maestro's final words, as he accompanies Peter to the performance, express both the ambivalence of the film's story line and that of its director: "It's noisy . . . but beautiful . . . maybe."

Ulmer's preoccupation with jazz culture and a kind of urban social anxiety carried on throughout the 1940s. Arguably his most famous film *Detour* (1945) is filtered through the pained, edgy noir voice-over of downtrodden nightclub pianist Al Roberts (Tom Neal), a man whose dreams, musical and otherwise, are ultimately shattered. Toward the beginning of the film, as Al remembers his past while seated in a roadside diner somewhere in Nevada, we witness him dismissing the encouragement of his singer girlfriend Sue (Claudia Drake) who tells Al that he will make it to Carnegie Hall someday. We soon discover that Sue is leaving behind her job, Al, and the New York nightclub in which they work, to try her luck in Hollywood; she travels alone. But when Al gets an unexpected tip of $10, after playing a classical jazz medley (from Brahms to boogie-woogie), he immediately calls Sue and announces his plans to join her in Los Angeles.

The path from New York to Los Angeles is depicted in a series of stock shots of telephone operators, a rush of traveling shots of phone lines, and finally the itinerary's points on a map fuse with the melody of "I Can't Believe You're in Love With Me," the same song that first summons up Al's memory at the diner and that links him and Sue. Al's desperation to get to Los Angeles (by "train, plane, bus, magic carpet. . . . I'll get there if I have to crawl, if I have to travel by pogo stick") may mirror in unexpected ways Ulmer's own desire to make it in Hollywood, a desire he expressed rather passionately in several letters from the early 1940s, after having held out in New York and elsewhere for so long. However, the fact that Sue is working as a "hash slinger," and has not broken into the trade, does not bode well. As Ulmer once remarked, in his interview with Bogdanovich, "I did not want to be ground up in the Hollywood hash machine."[33] In this case, then, the big city (Los Angeles) possesses at least two very different symbolic functions: it is a place of flight for those who are left homeless, where Al— after he becomes implicated in a murder on his fateful trek to the West Coast—believes he will be able to find anonymity ("In a small town I might be noticed, but in a city I should be safe enough"); it is, however, also a place that can, and will, eventually drive people into the ground. Nearly the entire film explores Al's restless wanderings, his total lack of refuge, and the frenetic pace that propels him through a hostile world.[34]

Just as Bill Krohn claims that we might understand *American Matchmaker* as a kind of postscript to *The Light Ahead*, so too we may

consider *Carnegie Hall* (1947)—or at least the schmaltzy story line of the film—a happy-end sequel to *Detour*. In other words, this is the story of what could have happened to Al Roberts, had he made it to the big leagues. In the film, Tony Salerno, Jr. (William Prince) pursues a similar path to Al, moving freely in the world of urban musical culture from classical to jazz, but he, unlike Al, suceeds in the end. He makes it in spite of the fact that his mother, who works her way up from janitor of Carnegie Hall (which, after all, is what Al, in his self-deprecating fit in *Detour*, tells Sue should be his proper role) to a high-level office worker, castigates the turn from high to low art. As the American musicologist Erik Ulman has recently noted, "it is tempting to read Ulmer's own situation into these films, as an artist who descended from Murnau and Reinhardt to the depths of PRC, with Tony as a kind of wish fulfillment of finding artistic validity . . . in commercial culture."[35] Ulmer, for his part, was rather dismissive of the story line of the film, and would have preferred to have made a documentary, "to have the Hall speak," featuring the same virtuoso performances (Artur Rubinstein, Jascha Heifitz, Bruno Walter, Fritz Reiner, and Artur Rodzinski) without the canned narrative. As he put it, "What are you going to do after Rubinstein plays Chopin?"[36]

To Ulmer, whose first passion—even before theater and cinema—was music, Carnegie Hall represented a mythical place, a sacred shrine or Golden Temple that embodied the best that an advanced metropolitan culture could offer (he makes a passing reference to it as the quintessential marker of success not only in *Detour* but also in *Her Sister's Secret* [1946], when the toddler Billy is banging the keys on his toy piano and Bill Sr., quips, "Skipper, we have a long way before Carnegie Hall"). Like the name Max Reinhardt, Carnegie Hall possessed household recognition; it was a name to be venerated, one that carried enormous cultural cachet, and a name with which Ulmer was all too happy to be associated. As he had done half a decade before, in his *Jive Junction*, Ulmer fashions the maestro as something of a savior, a figure who transcends the prosaic concerns of everyday life and deals with things on a higher plane. At numerous junctures in the film, Ulmer shoots the conductor from an extreme low angle, thereby endowing his character with a larger-than-life aura. Perhaps even more significant, in terms of Ulmer's career trajectory, *Carnegie Hall* represents another film in which he, as director, is able to revisit a lost world—complete with the resonant chords of Old Vienna and the luminaries who, not unlike Ulmer, had similarly migrated to the New World.

VI

Ulmer's fellow Austrian émigré and screenwriter Salka Viertel notes in her memoirs how she and presumably many others in her shoes hoped for the

opportunity to retrace their steps to the world they had left behind. "In those first years in California [in the early 1930s]," she writes, "I don't think I met anyone who had been born or raised there. The actors and writers, especially those from the East, were transitory, having come to make money and to get out as soon as possible. I also was counting the days till our return to Europe."[37] After struggling to keep afloat in Hollywood throughout much of the 1940s, Ulmer finally severed ties to the American B-studios—his four-year, eleven-film stint at PRC, having come to an unceremonious end in 1946—and made his way across the Atlantic, where he eventually became involved in a string of eclectic productions: starting with *I Pirati di Capri* (Pirates of Capri, 1949), his Italian swashbuckler starring Luis Hayward (a regular in Ulmer's ensemble), and leading up to the Danziger Brothers' Spanish production of *Muchachas de Bagdad* (Babes in Baghdad, 1951), Ulmer's garish Italian Technicolor fantasy film *L'Atlantide* (Journey Beneath the Desert, 1961) and his final picture, the gripping wartime drama shot in the mountains of Italy and Yugoslavia, *Sette contro la morte* (The Cavern, 1965). These churned-out movies have been largely forgotten—some for good reason—by film history.

Stefan Grissemann has recently suggested that Ulmer's career reached its "official" apex in the years 1947–1948, after the release of *Carnegie Hall*, and that essentially, with few exceptions, from that moment onward went downhill. "Assignments become ever more irregular," Grissemann avers, "and he had to consider working outside of the country, overseas."[38] He attributes this development to Ulmer's reputation as a "cheap" director, a filmmaker who plumbed the depths of poverty row, and to the fact that he had not worked at A-list studios since his first (and only) picture for Universal, *The Black Cat*, in 1934. After his relatively stable and successful run at PRC in the early to mid-1940s, Ulmer was essentially left unmoored, stripped of any residual ties to a studio, independent or otherwise. As Grissemann puts it in his pithy summation, "Independence can hurt."[39]

After pursuing several untenable ideas, including a remake of Leni Riefenstahl's *Das blaue Licht* (The Blue Light, 1932), and after the American B-picture industry had lost its steam, Ulmer found himself committed to producer Victor Pahlen, in late summer 1948, on an Italian coproduction *Pirates of Capri*. He initially hoped to thrive in a nascent industry away from Hollywood, but his stint in Italy also made him even more aware of his lack of success on the other side of the Atlantic and heightened his increasing alienation from that world. As he writes, on October 13, 1948, from Rome, "I am of course very lonesome, they tell me life is very beautiful in Rome; I'd rather be home in Kings Road [i.e., just above Sunset Boulevard, in West Hollywood, where the Ulmers had a house at the time]."[40] Ulmer's conception of home becomes complicated during

his years abroad; he may, at times, have thought of himself as a citizen of the world, but he also encountered an acute and recurrent sense of homelessness while living in Europe, signing a postcard mailed from Belgrade in 1956: the "Wandering Minstrel."[41]

Ironic as it may seem, Ulmer, who never managed to lay roots in Hollywood, yearned even more for a second calling there after he returned to Europe. During the early 1940s, before he began his stint at PRC, he had expressed similar hopes of landing work at one of the big studios. In 1941, in a letter to his wife Shirley dated July 1 on Hollywood Plaza Hotel stationary, Ulmer wrote, "The prayer has worked. Sweetest I am so excited I hardly can hold the pen in my hand. I just returned from Paramount. Sherle, they have not forgotten. Sherle, I am as good as signed with Paramount. Producer—director—good God! Sweets we are home again and on the way." He then proceeds to assert, repeating what the studio bosses have presumably told him, "Well, Ulmer, I am sold on you 1,000% . . . You are going to be one of the big men on the lot. Dearest, I hardly could keep from crying out. So seven years [i.e., 1934–1941] I had to suffer and starve. I nearly sold you out, you, [the] picture business, my family, myself. Oh, I am so excited I hardly can think."[42] In the last lines of the letter, Ulmer announces the two pictures he hopes to shoot for Paramount: first, an idea called *Beggar on Horseback*, based on the Broadway comedy, a parody of German expressionist drama, written by George S. Kaufman; and second, a remake of *The Blue Angel*, starring Veronica Lake. Neither of the two pictures ever panned out, and Ulmer's fantasy of becoming a redeemed and celebrated studio director at Paramount remained just that: a fantasy.

After his return to Europe, several years later, these unfulfilled desires resurfaced. As much as he tried to reinvent himself abroad—even taking on the respectful and entirely fabricated title of Dr. Ulmer during his brief tenure as a producer at the Munich-based Eichberg Film Company in the 1950s—he often looked back to Hollywood. For example, following the shoot of *Pirates of Capri*, Ulmer writes from Rome that he keeps humming Cole Porter's "Just biding my time." And, not long after, in a letter to Shirley from May 4, 1951, he spells out his predicament, "In plain English, I need a job in Hollywood pronto. . . . I need a job quick at home in Hollywood."[43] During this period of intense disenchantment, Ulmer wrote frequently to his agent, the Viennese-born Ilse Lahn of the Paul Kohner Agency (known for representing a host of more successful émigré filmmakers, from Billy Wilder to Erich von Stroheim), urging her to assist him in securing work in America. In a letter of August 25, 1951, he writes to Lahn from Barcelona, "I cannot tell you how lonesome I am for Hollywood, and if it would not be for Shirley and Arianne [Ulmer's daughter] I surely would

have chucked the whole think [*sic*] and be on my way home. I can only repeat again and again 'You can only make pictures in Hollywood and nowhere else.' By that I mean make them and don't work yourself into a state where everything borders on heart failure. Undoubtedly we are spoiled. A sun ark [*sic*] becomes something awfully precious when you leave the shores of the U.S.A."[44] Unlike the 1930s émigré directors in Hollywood (e.g., Walter Reisch), who conjured up an "imaginary homeland" in their work, Ulmer's personal writings from the 1950s and 1960s seem to rely instead on the notion of a fantasy Hollywood, a world that, when regarded from his stilted, desperate vantage point, is stripped of all the imperfections he knew so well.[45]

As several critics have remarked, Ulmer's films often feature characters without a fixed abode, who are given to unexpected and frequent movement and who experience a similar kind of transience to what Ulmer himself experienced both in his early and later years. French filmmaker Bertrand Tavernier has said of Ulmer's characters: "They are always wandering."[46] This is true of his figures from the ethnic films of the 1930s, and of Al Roberts from *Detour*, as well as of characters from his later work, including various kinds of uprooted and estranged figures. As for Ulmer's personal predicament during the 1950s, he went so far as to liken himself to "a dog in search of a place to find peace," and his own restlessness elicits deeper reflection both on and off the screen. In a letter of October 5, 1953, following yet another ill-fated project (this time *Loves of Three Queens* [1954] starring Hedy Lamarr) he writes to Ilse Lahn from Rome, "Just a quick note with real news. Sad! But news. Hedy unfortunately is completely out of hand and I am unable to cope with her. She refuses direction. Therefore to avoid another 'Babes in Baghdad' I have resigned from the picture. I have finished 'Genevieve,' but 'Helene' and 'Josephine' must be done by somebody else. The little self-respect I still have I cannot and will not lose. . . . So I am at liberty and willing to make a picture from the first of November on. But only in Hollywood. I've got my free of wandering."[47]

Even though Ulmer's wife Shirley may have felt, as she formulated it in a letter to her husband on February 4, 1961, "Home is where you are and where we are working,"[48] Ulmer himself did not seem, ultimately, to have shared this view. The constant movement, the near nomadism of his later years in Europe, left him distraught and eager for just one final return— even if, in the end, it meant that his filmmaking career would come to a close. Writing to his agent from Paris in autumn 1961, he noted in a wistful key, "Shirley and I are desperately lonely and very, very homesick. It has been a long haul in Europe for both of us."[49] The romance of a wandering hero, while perhaps seductive in film and in fiction, lost its allure over time.

That is perhaps the true point at which exile (the idea) and exile (the reality) part ways for good.

Notes

1. Lizzie Francke, "Edgar G. Ulmer," *Retrospective* (Edinburgh: Edinburgh Film Festival, 1997), 148.
2. John Belton, "Cinema Maudit," *Retrospective*, 150.
3. For a more thorough exploration of this line of inquiry, see my "Perennial Detour: The Cinema of Edgar G. Ulmer and the Experience of Exile," *Cinema Journal*, 43.2 (Winter 2004): 3–25.
4. Quoted in Frederic Morton, *Thunder at Twilight: Vienna 1913/14* (New York: DaCapo, 2001), 185–186.
5. Edgar G. Ulmer, "Beyond the Boundary," unpublished manuscript, 1–2, The Edgar G. Ulmer Collection, Margaret Herrick Library, Academy of Motion Picture Arts and Sciences, Beverly Hills, California.
6. Frieda Grafe, "Wiener Beiträge zu einer wahren Geschichte des Kinos," *Aufbruch ins Ungewisse: Österreichische Filmschaffende in der Emigration vor 1945*, ed. Christian Cargnelli and Michael Omasta (Vienna: Wespennest, 1993), 227.
7. See Daniela Sannwald, "Metropolis: Die Wien-Berlin-Achse im deutschen Film der 10er und 20er Jahre," *Elektrische Schatten: Beiträge zur Österreichischen Stummfilmgeschichte*, ed. Francesco Bono et al. (Vienna: Filmarchiv Austria, 1999), 139–148.
8. Thomas Elsaesser, "Ethnicity, Authenticity, and Exile: A Counterfeit Trade? German Filmmakers in Hollywood," *Home, Exile, Homeland: Film, Media, and the Politics of Place*, ed. Hamid Naficy (New York: Routledge, 1999), 112.
9. See Heinrich Huesmann, *Welttheater Reinhardt* (Munich: Prestel 1983); and Otto Preminger, "An Interview," *Max Reinhardt 1873–1973*, ed. George Wellwarth and Alfred Brooks (Binghampton: Max Reinhardt Archive, 1973), 109–111.
10. The database available at www.ellisisland.org contains Ulmer's passenger record from April 12, 1924, his place of residence given as "Wein [*sic*], Austria" and his ethnicity as "Austria Hebrew."
11. See Stark Young, "The Miracle," *The New York Times*, November 9, 1924; and Fritz Feld, "In Memoriam of Edgar Ulmer," unpublished manuscript, October 3, 1972, The Edgar G. Ulmer Collection, Beverly Hills, California.
12. Peter Bogdanovich, "Edgar G. Ulmer: An Interview," *Film Culture*, 58–60 (1974); rept. in Bogdanovich, *Who the Devil Made It: Conversations with Legendary Film Directors* (New York: Ballantine, 1998), 557–558.
13. Joseph Schildkraut, *My Father and I* (New York: Viking, 1959), 114.
14. Bogdanovich, "Edgar G. Ulmer," 568.
15. Ibid., 565.
16. Lucy Fischer, *Sunrise* (London: British Film Institute, 1998), 40.
17. Lotte Eisner, *Murnau* (Berkeley: University of California Press, 1973), 180.
18. John Belton, "Edgar G. Ulmer (1900 [*sic*]-1972)," *American Directors*, ed. Jean-Pierre Coursodon with Pierre Sauvage, 2 vols. (New York: McGraw-Hill, 1983), I: 342.

19. Bogdanovich, "Edgar G. Ulmer," 566.
20. Ibid., 576.
21. J. Hoberman, "Low and Behold," *Village Voice*, November 17, 1998, 135.
22. Donald Albrecht, *Designing Dreams: Modern Architecture and the Movies* (New York: Harper & Row, 1986), 100–101.
23. Paul Mandell, "Edgar Ulmer and the Black Cat," *American Cinematographer* (October 1984): 36.
24. Bogdanovich, "Edgar G. Ulmer," 576.
25. Bill Krohn, "King of the B's," *Film Comment*, 19.4 (July/August 1983): 61.
26. Tom Weaver, "Shirley Ulmer," *Cult Movies*, 25 (1998): 64.
27. Krohn, "King of the B's," 64.
28. J. Hoberman, *Bridge of Light: Yiddish Film Between Two Worlds* (New York: Museum of Modern Art/Schocken, 1991), 317.
29. See, e.g., Betty Yetta Forman, "From *The American Shadchan* [*sic*] to *Annie Hall*: The Life and Legacy of Yiddish Film in America," *The National Jewish Monthly* (November 1977): 4–13; and Judith N. Goldberg, *Laughter Through Tears: The Yiddish Cinema* (Madison, NJ: Farleigh Dickinson University Press, 1982).
30. Stefan Grissemann, *Mann im Schatten: Der Filmemacher Edgar G. Ulmer* (Vienna: Szolnay, 2003), 143.
31. Hoberman, *Bridge of Light*, 321.
32. See Anton Kaes, "A Stranger in the House: Fritz Lang's *Fury* and the Cinema of Exile," *New German Critique*, 89 (Spring/Summer 2003): 35–58.
33. Bogdanovich, "Edgar G. Ulmer," 592.
34. One can, indeed, read the film as a compelling allegory of exile. For further analysis along these same lines, see my "Perennial Detour," 15–19.
35. Erik Ulman, "Edgar G. Ulmer," http://www.sensesofcinema.com/contents/directors/03/ulmer.html (accessed January 2003).
36. Bogdanovich, "Edgar G. Ulmer," 599.
37. Salka Viertel, *The Kindness of Strangers: A Theatrical Life. Vienna, Berlin, Hollywood* (New York: Holt, Rinehart and Winston, 1969), 143.
38. Grissemann, *Mann im Schatten*, 253–254.
39. Ibid., 254.
40. Unpublished letter of October 13, 1948, Edgar G. Ulmer to Ilse Lahn, Paul Kohner Archive, box 4.3–88/14–6 (EGU to PK 1948–1955), Filmmuseum Berlin, Germany.
41. Unpublished postcard of 1956, Edgar G. Ulmer to Shirley Ulmer, The Edgar G. Ulmer Collection, Margaret Herrick Library, Academy of Motion Picture Arts and Sciences, Beverly Hills, California.
42. Unpublished letter of July 1, 1941, Edgar G. Ulmer to Shirley Ulmer, The Edgar G. Ulmer Collection, Margaret Herrick Library, Academy of Motion Picture Arts and Sciences, Beverly Hills, California.
43. Unpublished letter of May 4, 1951, Edgar G. Ulmer to Shirley Ulmer, The Edgar G. Ulmer Collection, Margaret Herrick Library, Academy of Motion Picture Arts and Sciences, Beverly Hills, California.
44. Unpublished letter of August 25, 1951, Edgar G. Ulmer to Ilse Lahn, Paul Kohner Archive, box 4.3–88/14–6 (EGU to PK 1948–1955), Filmmuseum Berlin, Germany.

45. See Thomas Elsaesser, *Weimar Cinema and After: Germany's Historical Imaginary* (New York: Routledge, 2000); and Salman Rushdie, *Imaginary Homelands* (London: Granta Books, 1991).

46. Bertrand Tavernier, unpublished interview with Michael Henry Wilson, November 7, 1997, 62, The Edgar G. Ulmer Collection, Margaret Herrick Library, Academy of Motion Picture Arts and Sciences, Beverly Hills, California.

47. Unpublished letter of October 5, 1953, Edgar G. Ulmer to Ilse Lahn, Paul Kohner Archive, box 4.3–88/14–6 (EGU to PK 1948–1955), Filmmuseum Berlin, Germany.

48. Unpublished letter of February 4, 1961, Shirley Ulmer to Edgar G. Ulmer, The Edgar G. Ulmer Collection, Margaret Herrick Library, Academy of Motion Picture Arts and Sciences, Beverly Hills, California.

49. Unpublished letter of October 5, 1961, Edgar G. Ulmer to Ilse Lahn, Paul Kohner Archive, box 4.3–88/14–6 (EGU to PK 1948–1955), Filmmuseum Berlin, Berlin, Germany.

CHAPTER EIGHT

MAD LOVE: RE-MEMBERING BERLIN IN HOLLYWOOD EXILE

Lutz Koepnick

In his book *An Accented Cinema*, Hamid Naficy has offered the most rigorous attempt to date to understand certain cinematic practices as expressions of exile and cultural displacement. According to Naficy, accented films—films that are produced under the condition of forced or voluntary dislocation—"are interstitial because they are created astride and in the interstices of social formations and cinematic practices. Consequently, they are simultaneously local and global, and they resonate against the prevailing cinematic production practices, at the same time that they benefit from them."[1] Exilic filmmaking, in Naficy's view, cannot but operate in critical distance to mainstream cinema. Exile cinemas explore their own smallness and imperfection, their lack of shine, their artisanal status, as a source of creative authenticity and critical meaning. They defy genre formulas and cinematic realism in order to utilize the filmic medium as a mouthpiece for personal narratives of loss, nostalgia, transition, and reconfiguration. In conflict with mass cultural norms of narrative closure and resolution, exile filmmakers tell ruptured and often highly subjective stories. Their films are film-letters and letter-films, addressed to often very narrowly defined audiences. These films' narrative energies and formal designs communicate a sense of claustrophobia and shattered temporality, of contorted space and warped time. And in traversing multiple times and discontinuous spaces, these films feature journeys of identity in which old and new appear in uneasy proximity: "In the best of the accented films, identity is not a fixed essence but a process of becoming, even a perform-ance of identity. Indeed, each accented film may be thought of as a performance of its author's identity."[2]

Naficy's analysis of exilic and diasporic filmmaking is no doubt useful. It provides helpful categories to examine how experiences of dislocation can

shape the narrative forms, audiovisual shapes, and institutional positions of films produced by exiles. However, one of the central shortcomings of Naficy's approach is that it relies on rather conventional conceptions of film authorship whose valorization of authenticity and intentionality cannot but favor art cinema over any form of mass cultural practice. To be sure, weary about the denunciation of authorship and agency in postmodern criticism, Naficy is quite right in emphasizing that we cannot properly understand the specificity of exilic experiences if we categorically deny the possibility of autonomous subjects and willful acts of cinematic expression. But in resuscitating concepts of cinematic authorship of the 1950s, Naficy not only underestimates one of the central paradoxes of cultural production under the condition of exile, namely that it encodes the experiences of people who have lost authorship over their life paths in the first place. As important, due to his emphasis on art cinematic practice, Naficy leaves no room at all to better understand the contribution of exiles and diasporic subjects to mainstream film industries and popular forms of entertainment.

It therefore should come as no surprise that Naficy's book has little to say about how Hitler refugees after 1933 tried to find a reasonable working base in Hollywood and market their professional skills to the demands of a highly rationalized and genre-bound studio system. Nor is it an exaggeration to say that Naficy's model is not really helpful in developing operative distinctions between on the one hand the work of German film practitioners who joined the American film industry already prior to Hitler because Hollywood seemed to provide more promising professional opportunities (e.g., Eric Pommer, William Dieterle, Marlene Dietrich, and Karl Freund), and on the other hand the work of film exiles who arrived and thrived in Hollywood after 1933. Because, for Naficy, exilic filmmaking per se challenges the codes and operations of industrial filmmaking from the outside (rather than modifying them from the inside), his theoretical template is too narrow to map the presence of "Berlin in Hollywood" in the 1930s and 1940s, that is, to account for the differences between forced and voluntary transfers to Hollywood, between political and economic dislocation.

The concept of cinematic authorship, as used by Naficy to define the formal and institutional features of exile filmmaking, was first developed during the rise of European art cinemas in the 1950s and 1960s. In this context, it served critics as a polemical device to isolate formal, narrative, and thematic strategies that could be seen as a virtual trademark of a filmmaker's entire career.[3] Although some critics applied this concept to the work of outstanding Hollywood directors and actors as well, there is little evidence for an understanding of most studio directors—including successful Hitler refugees such as Fritz Lang, Robert Siodmak, Otto Preminger, Edgar Ulmer, and Billy Wilder—as sole creators of individual films,

endowed with the authority to weave various narrative perspectives and aesthetic strategies into one unified fabric. For the vast majority of German film practitioners during the 1930s and 1940s, Hollywood exile signified a multiplied loss of authorship: a dramatic loss of control over the narrative of one's own life, and a certain loss of control over the means of professional creativity. Though questions of personal self-expression indeed matter to the study of exile filmmaking, German exile film studies therefore does well to avoid Naficy's reifying and romantic notions of filmic authorship. If we want to account for the contribution of Hitler refugees to American cinema, we cannot limit our focus solely to quasi-artisanal niches in which certain individuals were able directly to articulate their sense of displacement and despair. Instead, we need to develop reading strategies that allow us to understand certain filmic features as allegories, symptoms, and signs of exilic experiences. The question of "authorship" in exile film studies, in other words, is less a question of material practices of creative self-realization than it is a question of reading narratives, mise-en-scènes, acting patterns, and sound tracks against the grain of mainstream interpretations in order to make them speak about the exile's experience of rupture. Exile film studies, rather than categorically valorizing art cinema over mass cultural film production, approaches the role of Hitler refugees in the classical studio system with a double gaze,[4] one that is fully aware of the limitations of self-expressions in industrial filmmaking, but that at the same time hopes to make certain texts speak about the exilic condition of some of its makers *as if* these films indeed could be seen as symbolic structures articulating personal agendas and sensibilities. The task of exile film studies is to establish meaningful constellations and imaginary relays that allow us to read that which has never been written. Its aim is to explore what I would like to call with Fredric Jameson exile filmmaking's "political unconscious," understood as a set of "absent" causes and concerns that became engines of formal, figurative, and narrative development, of textualization and visualization.

This chapter probes the possibilities of reading and reconstructing the tale of Hitler exiles in Hollywood by analyzing both the accented performance of Peter Lorre and the iconography of hands in Karl Freund's 1935 MGM horror film *Mad Love*. As I will argue in a series of analytical and theoretical moves, Lorre's acting style as well as the film's images of manual dexterity shed light on the subject position of Hitler exiles in the classical Hollywood studio system. While Freund and Lorre on the one hand invite us to think through the exile's loss of authorship and self-determination, they on the other hand also allow us to reconsider historical debates about the relation between autonomous art and popular diversion, between European high culture and the American culture industry. Far from simply encoding exile as a state of spiritual dismemberment and inauthenticity,

Lorre's performance as a mad scientist in *Mad Love* permits us to read the story of Berlin in Hollywood as a story of creative transformations, unexpected fusions, ironic slippages, and startling departures. Unlike many of his fellow exiles, Lorre understood how to articulate something foreign within the conventional operations of American genre filmmaking as much as to use the resources of the studio system to illuminate what he had left behind.

I

Our story, like so many other stories, begins before its actual beginning, owing to the fact that one of the most striking images of exile and displacement was conjured by a German filmmaker already two years before the Nazi regime began to force thousands of film practitioners to leave Germany for uncertain futures. What we see in this image is a graphic drawing of a hand reaching toward the viewer, its palm exposed like a flat screen. This is clearly no ordinary hand. It appears charged with the power to impart life to inanimate matter and shape amorphous materials into compelling shapes. Nothing, we assume when first looking at its dynamic shape, could ever stop this hand from doing what it sets out to do. Nothing could ever prevent its will from triumphing over the banality of matter. For in spite of all its iconographic simplicity, this hand seems to allegorize the aesthetic genius who produces meaning by grafting his or her personal signature onto the objects of the world. Form here emerges as a pure expression of power, while power reflects humanity's resolute will to self-realization.

Or so it seems at least at first.

The drawing's style evokes the exaggerated shapes of German expressionist painting, but due to its linear abstraction and dynamic simplification the hand's image is also reminiscent of 1920s techno-culture: of new objectivity's cold and detached modernism and of futurism's celebration of speed, energy, and prosthetic body machines. Its vigor and demiurgic gesture notwithstanding, this hand in fact borders the nonorganic. It strikes the viewer as an artificial limb taking on the uncanny function of the living, or conversely, as a human extremity curiously charged with the strength of a robotic apparatus. In his famous chapter on the uncanny, Sigmund Freud argued that images of separated body parts can signify fearful states of emasculation and castration, of identity loss and contingency.[5] Our hand on display—strangely dissected from any integrated human body, though fully operational and potent—clearly reveals some traces of the uncanny. It is as if it were out there on its own, haunting the viewer with a mere semblance of human authority and corporeal integrity. Whoever will be touched by this hand must experience a sensation of unsettling loss and disorientation,

a dislocating shock triggered by the recognition of something that should have remained hidden.

Chalk marks cover the palm of this phantom hand. They announce the name of the film whose narrative is to unreel in a moment: *M*, Fritz Lang's 1931 masterpiece on urban paranoia, sexual perversion, despotic surveillance, and mass mobilization. Later in the film, these chalk marks will be imprinted onto the coat of Hans Beckert, a serial killer played by Peter Lorre in the first, yet most memorable performance of his career. Transferred to his body, the written letter will not only identify Beckert as a foreign object and dangerous other but will also impart identity to Beckert's decentered personality in the first place. Throughout most of the film, Lang will picture Beckert as abstract and insubstantial. The film's child murderer is not an autonomous author of his own life. When he enters the frame for the first time, he does so as a disembodied voice and spectral shadow. Later on we see him making faces in front of a mirror as if to probe who he could be and how his appearance could affect the gaze of his audiences. Though we at some point will view the interior of his rented apartment, we cannot think of Beckert as someone inhabiting an ordinary dwelling and home, understood as a compass guiding his steps through the modern city. Instead, whatever we could call his identity is an effect of various acts of external inscription and projection of which the letter "M" is the most fateful one. As Tom Gunning has put it, "The mark, then, is the sign of singularity, of guilt, of being picked out from the crowd. But the hand that is inscribed with the M is, therefore, not the murderer's hand, but rather that of the man who marks him. As an emblem for the film, the image of the hand serves as a transfer between the marker and the marked, a common bond between murderer and pursuer, as much as a differentiation."[6]

It remains one of the principle challenges of viewing *M* that Lang's film does not grant the viewer the comfort of a conventional protagonist. Neither Beckert nor the mob leader Schränker (Gustaf Gründgens), neither Beckert's victims nor the police investigator can be seen as reliable points of spectatorial identification. The graphic drawing of the credit scene provides a preview of this sense of instability and disorientation. The hand might at first sight symbolize conventional notions of authorship and self-expression, yet upon closer inspection it evades bourgeois visions of identity and agency. What this hand signifies is neither a figure nor a setting of the film, but the abstract process of mediation and signification that—in Lang's often gloomy view of modernity—defines the modern relations of identity, space, and time to begin with. Authorship here seems to do without authors, subjectivities emerge without subjects, writing does not serve the purpose of expressing inner thoughts and emotions but of qualifying unstable selves from the outside and defining their identities as that of outsiders. Under the

sign of this hand, traditional ideas of existential origin and goal-oriented action, of home and belonging, have become obsolete. Experiences of exile and dislocation, in turn, have become the order of the day—that which makes and marks modern existence.

II

Two years after the premiere of *M*, both Fritz Lang and Peter Lorre were to experience this peculiarly modern sense of exile in much more concrete terms. Both lost their working base in Germany after the Nazi takeover, and both were eventually stranded in Hollywood to resume their careers. The exile of German film practitioners like Lang and Lorre was fraught with many challenges, paradoxes, and ironies. Though it would be cynical to deny the hardship that exile brought for the majority of Jewish-German film workers, it is equally important to keep in mind that for some film practitioners, Hollywood became a springboard for celebrity and upward mobility. The condition of exile produced many moments of blockage and silence, but it also opened the door for a good number of professional triumphs.

Edward Said has pointed out that in the modern world being exiled often means being coerced into disturbing positions of suspension and into in-between situations. According to Said, the exile "exists in a median state, neither completely at one with the new setting nor fully disencumbered of the old, beset with half-involvements and half-detachments, nostalgic and sentimental on one level, an adept mimic or a secret outcast on another."[7] The exile of German film practitioners in Hollywood largely followed this description. While Nazi film officials were eager to build up a German Hollywood, Hitler refugees in Southern California were often contracted to mimic the very past they had left behind. Hollywood studios hired refugee actors to play Nazi soldiers, immigrant composers to bring German musical traditions to Hollywood screens, émigré directors to imitate Weimar expressionism or reference exoticized notions of European high culture. When considering the ways in which exile film workers imported Weimar sensibilities to Hollywood, we will thus find that acts of performative repetition and unforeseen redress clearly outnumbered instances of direct or intended transfer. The success of German film practitioners in Hollywood relied not on *what* they had done before, but on *how* they had done it—on their professional skills in navigating the unsteady terrain of industrial filmmaking, on their ability to replay "Weimar" as masquerade in order to fulfill industry expectations and secure a working base in the studio system. As a result, their work was rarely able to address Nazi politics head-on. Rather, it allegorized what had turned them into exiles by offering fictions of doubling,

misidentification, cultural camouflage, and imaginary displacement. As Thomas Elsaesser notes, "The extent and kind of involvement the émigrés had with the political realities of their time were . . . refracted via the politics of make-believe, so that the stylization of film noir, the double-entendres or sight gags of sophisticated comedy, and the 'imitations of life' of melodrama might turn out to be just as politically engaged as the anti-Nazi films."[8] The films of German exiles in Hollywood became exile films whenever they succeeded in translating the exile's constitutive experience of suspension into cinematic forms that represented identity not as something fixed and essential but as a process and performance, as fluid and contested.

III

Consider the 1935 horror classic *Mad Love*, a remake of the German expressionist film *Orlocs Hände* (1924), bringing together the talents of émigré filmmaker Karl Freund and exile actor Peter Lorre. Freund had been one of the leading cinematographers of Weimar cinema. He had been essential in shaping the visual aesthetics of expressionist and social realist landmark films such as *The Last Laugh*, *Metropolis*, and *Berlin—Symphony of a Great City*. In the late 1920s, Freund had moved to the United States, first in order to carry out color experiments for Eastman Kodak and then to emerge as a highly inventive cinematographer in Hollywood whose career reached well into the 1950s and whose work would include films such as *The Seventh Cross* (1944) and *Key Largo* (1948) as much as countless episodes for the early television classic *I Love Lucy* (1951–1957). During his early tenure in Hollywood, Freund also served as director for a handful of horror films, the most noteworthy of which was *The Mummy* (1932) with Boris Karloff. At the time, the horror genre rested safely in the hands of Universal Studios. MGM contracted Freund as a director for *Mad Love* not simply with the intention to beat Universal at its own game, but to make use of his proficiency in order to elevate the genre to a more respectable level (figure 8.1).

For Peter Lorre, on the other hand, *Mad Love* was the first professional engagement in the United States. After starring in *M*, he had played in ten more German films prior to the Nazi takeover, worked in 1933 with G. W. Pabst in France on *Du haut en bas*, in 1934 with Alfred Hitchcock in England on the first version of *The Man Who Knew Too Much*, and then had sailed to the United States in July 1934. Lorre's entry into the American industry turned out to be more difficult than Freund's due to the fact that Columbia executives did not quite know what to do with their new acquisition and hence were looking for opportunities to trade him off to other studios. *Mad Love* was the first of these opportunities. In spite of Lorre's considerable acting talents, it was not until 1936 that he was able to secure

Figure 8.1 Production still from *Mad Love* (1935). Courtesy of Filmmuseum Berlin—Deutsche Kinemathek.

a more permanent contract with Twentieth Century Fox—even though it meant to being typecast as and becoming the infamous Mr. Moto.

Based upon Maurice Renard's novel *Les Mains d'Orlac, Mad Love* tells the story of Dr. Gogol (Lorre), an eccentric doctor whose desire is obsessively fixated on Yvonne Orlac (Frances Drake), an actress in a show at the Theatre des Horreurs in Paris. When Dr. Gogol—watching Yvonne's performance night after night from a private box—finally tries to admit his obsession to Yvonne, he learns that the actress is about to quit her career and be reunited with her husband, the famous concert pianist Stephen Orlac (Colin Clive). Utterly devastated, Dr. Gogol nevertheless seizes the opportunity and harrasses Yvonne backstage with a prolonged kiss. Next, we witness Stephen as he travels on a passenger train to Paris. A convicted criminal en route to his execution in Paris, the circus knife performer Rollo shares Stephen's wagon. Another passenger borrows a fountain pen from Stephen in order to get Rollo's autograph. Rollo snatches the pen and hurls it skillfully through the air like a knife, not without attracting Stephen's attention. Minutes later, the train will derail. Yvonne hurries to the site of the disaster. She learns that Stephen is still alive, but also that his hands were damaged so badly that they must be amputated instantly. Deeply tormented by this

vision, Yvonne turns to one of the most famous authorities in matters of reconstructive surgery—none other than Dr. Gogol. First, Dr. Gogol has not much hope to give, but during the operation he decides secretly not simply to amputate Stephen's hands, but to replace them with Rollo's, as the knife thrower has to face the guillotine anyway.

Though the surgery is successful, Stephen Orlac's recovery turns out to be more difficult than the pianist and his wife expected. Unaware of the true origin of his new hands, Orlac seeks to resume his career unsuccessfully in spite of different therapeutic treatments. Instead of playing the piano himself, we see him listening to shellac recordings of his own former performances. Things get even worse. First threatened by a creditor and later unable to garner financial support from his stingy stepfather, Stephen no longer can control his emotions—and his manual extremities. Twice, we become witness to how the former piano genius flings objects—a pen, a knife—at other people with the dexterity of an experienced knife performer. The putative crudeness of Rollo's mass cultural past here seems to prevail over Stephen's artistic elitism and aesthetic refinement, a process causing horror and self-loathing in Stephen while pushing his marriage to the brink of implosion. In the meantime, Dr. Gogol transfers some of his desire to a fetish: a wax replica of Yvonne that the doctor entertains with poetry and organ music. But he has clearly not yet given up on the real Yvonne. After another session with Stephen, Dr. Gogol urges Yvonne to leave her husband in order to save her own life from Stephen's dangerous behavior. In a rather campy scene, he masquerades as Rollo and kills Stephen's stepfather, not only in order to further drive the pianist into insanity but also to have Stephen arrested and accused of homicide. Desperate to rescue her husband from both the police and himself, Yvonne slips into Dr. Gogol's house, discovers the wax figure, takes on its role, and then witnesses Dr. Gogol as he triumphantly admits all his doings to what he thinks is a mere replica, his Galatea. Enraged about this, Yvonne comes to life indeed while crazed Dr. Gogol—believing to be a new Pygmalion—makes violent advances in his locked study. In the interim, Stephen has somehow convinced the police to pay Dr. Gogol a visit. In a last minute effort, Stephen makes use of his unwanted skills and flings a knife at Dr. Gogol through the bars of an observation window, thus rescuing his wife from the horror of a mad doctor's obsession and clearing his name. The End.

The end?

"Even a cursory viewing of *Mad Love*," writes Steven Thornton, "makes evident the sexual symbolism evident in the film's story line. Using his surgical skills to attach the limbs of a dead killer onto his romantic rival, Dr. Gogol figuratively castrates Stephen Orlac, corrupting his musical proficiency and driving an emotional wedge between the musician and his

frustrated wife."[9] Similar to the vast majority of horror movies, *Mad Love* abounds with ciphers of sexuality, desire, Oedipal struggle, and "perverse" displacement. It trades in the repressed and allows the viewer unexpected pleasures that exceed what psychoanalytic film theory has discussed as the dominance of sadistic voyeurism in mainstream filmmaking.[10] Clad in fur, the Lorre character is marked from the film's very first images as a first-rank masochist. Unlike Rollo and Orlac, he seems to reject narcissistic identifications with any given father figure and instead directs his desires at highly aestheticized scenarios of suffering, scenarios in which both sexuality and gender appear diffused, masquerades delay consummation, fetishistic objects provide rituals of disappointment, and fantasy displaces the real.[11] It is precisely the film's indulgence into the ambivalent territories of the masochistic which in the end distracts first time viewers from realizing that *Mad Love*'s ending, at least according to classical Hollywood standards, is no end at all. Even though Orlac of course rescues his wife from the grasp of the mad doctor, the genius pianist in the end is still stuck with the killer's hands, the stigma of the common, coarse, and uncivilized. For even though Orlac in the film's last scene turns Dr. Gogol's "art" against Dr. Gogol himself, he cannot but remain haunted by Dr. Gogol's earlier act of castration. Dr. Gogol might be dead, but how can we talk of narrative closure once we recognize that Orloc will never be able to recoup his former grandeur as both a highbrow artist, heterosexual husband, and Oedipal authority?

When seen against classical Hollywood norms of gender, sexuality, narrative development, psychological causality, and dramatic resolution, the open ending of *Mad Love* certainly remains puzzling. The horror genre's predilection for perverse identification and the masochistic might surely be one way to account for the film's quirky finale. As I would like to suggest in the following, however, it would mean missing some of the film's most interesting aspects if we simply considered masochism as "causing" this rupture of mainstream narrative causation. What I would like to argue instead is that *Mad Love*'s masochist aesthetic itself is merely a symptom, an overdetermined cipher deeply involved in the cinematic barter between Hollywood and Berlin around 1935. Both Dr. Gogol's operatic masochism and Orloc's unresolved symbolic castration—the film's unsettling images of manual dexterity, genius, and trauma—are much more indicative of Hollywood's struggle between the Old and New World, between the exile's imaginary position in between high and mass culture, than of horror's challenge of gender identity and heterosexual identification. What in the end prohibits formal closure and reconciliation is brought about, not by the decentering logic of masochistic identification, but by the unsettling accents of cultural dislocation and exile, understood as a crossroads of imaginary and physical acts of cultural mingling.

IV

From the film's very first shots, *Mad Love* abounds with reified signs of Old Worldliness. Exterior settings not only recall the claustrophobic spaces of German expressionist cinema, they are marked as back-lot configurations: man-made artifice solely designed for the eye of Hollywood cameras. Whether we witness cobblestone streets, narrow archways, or convoluted housing arrangements, the film's Paris is displayed as a cinematic dream of first rank. It is presented as an exotic imaginary reflecting the New World's ambivalent desire for Europe: for the material textures of history, for cultural distinction and differentiation, for premodern forms of urbanity and metaphysical significance. In *Mad Love*'s Europe, public spaces emerge as landscapes of the mind, haunted by desire, diffuse anxiety, and the return of the repressed. Though far from resembling the eccentric designs of Robert Wiene's *The Cabinet of Dr. Caligari* (1919), *Mad Love*'s images of urban space convey inner visions rather than duplicate the real; they privilege shapes, forms, and patterns over realistic imitation. Like cinema itself, *Mad Love*'s Paris understands how to put on a good show and bathe the viewer in melodramatic intensities, in primal emotions and archaic longings, in images of radical evil and unconditional good.

No one in *Mad Love*, at first, seems to embody a more involuntary wanderer between Old and New World—and hence a more apposite allegorical cipher of exile and dislocation—than Stephen Orlac. The pianist's physical dismemberment stands in for what both he and his wife Yvonne experience as a larger process of forced dislodgment and cultural transformation. Dr. Gogol's surgical procedure imposes the vulgar mass culture of knife throwing onto Orlac's passion for high art; it results in a traumatic dominance of mechanical reproduction over the possibility of auratic solo performance; and it infuses Orlac's scenes of European cultural refinement with American sensationalism. Alienated from the here and now of high art production, Orlac suffers the loss of his status as an autonomous, sovereign, and self-producing subject, a privileged individual graced by the creative, original, and ahistorical bliss of aesthetic genius. He might not leave his physical home, but what modern civilization and technology seem to do to him mirrors the kind of narratives often told about the fate of German artists and filmmakers stranded in the United States in the course of the 1930s. Similar to the self-perception of many a German intellectual in American exile, Orlac experiences unwanted forms of modernization and cultural commodification forced upon him. As he has to assimilate to commercial mandates and the dictates of mundane self-expression, Orlac feels deprived of the resources of artistic production as much as of the possibilities of authoring his own life.

There might be good reasons, then, to understand Orlac as a projection screen for the exile's experience of traumatic displacement and creative blockage. Interestingly enough, however, the film foretells Orlac's road into exilic conditions already prior to the pianist's train accident and ill-fated encounter with Dr. Gogol. Orlac first enters the narrative not in the form of an arresting image and unified body but as a distant and technologically mediated sound—as a strangely disembodied effect of modern radio transmission. Even though we will eventually see him on stage playing one of his own compositions, the film makes great efforts to underscore the fact that Orlac's performance caters to the new mass medium. Moreover, though poised to listen to her fiancée's performance from afar, Yvonne will miss almost all of it—including the double cough, Orlac's secret sign of love—because of her own career obligations. The radio, rather than bringing people together across space, in this opening scene establishes distance and fails to connect people's itineraries. It not only marks what surreptitiously separates Orlac and Yvonne, but also serves as a sign of the pianist's emasculation. Orlac's musical genius and cult of personality is thus shown as a product of, rather than an antidote to, modernity's culture of distraction, commercialism, and technological mediation. Deeply associated with the arsenal of modern mass entertainment, Orlac might still think of himself as a sovereign representative of aesthetic refinement, but his time an autonomous artist is up long before he enters the train and ends up in Dr. Gogol's hands.

Like the life of many exiles, Orlac's existence after his accident is marked by nostalgia and claustrophobic inertness. Driven away from his career and creativity, he encounters his new present as a liminal space overshadowed by memories of the sounds, sights, and plenitudes of a more originary life in the past. Whatever he does in this new life is defined in relationship to how it once was. Whatever he may think, feel, and envision is colored by his intense hope to recuperate his time and place of origin. And yet, as we have just seen, Orlac's agonistic rejection of his present is energized by fundamental delusions about the role of cultural production under the sign of mass cultural diversion. What once made him a star pianist was not his elite resistance to, but rather his deliberate endorsement of, commercial entertainment and modern cultural transmission. While Orlac thus, in some sense, might indeed embody what many German exile film workers in Hollywood experienced as their personal narratives of trauma, rupture, and involuntary displacement, neither his nostalgia nor his pathos of suffering have much to offer in order to complicate dominant stories of exile and dislocation. Moreover, solely animated by his desire for the past, the Orlac character has little to offer to occupy a prominent position in the film's overall narrative economy. Orlac's role is too much caught in binary

structures of thinking and feeling in order to affect the story's drive and bring something unexpected to Freund's genre film. In spite of his rather creepy ordeal, Clive's Orlac cannot but remain marginal, pale, and—with all due respect—boring. His role is completely overshadowed by Lorre's Dr. Gogol, and it is in the perverse figure of Dr. Gogol, and in Peter Lorre's unique way of bringing him to life, that we can identify ciphers of the exilic far more complex than Orlac's—a performative rhetoric of displacement transcending worn-out binarisms and revealing what is both collective and political about the exile's personal experience of dislocation.

V

The film introduces Dr. Gogol indulging in perverse spectatorial pleasures at the Theatre des Horreurs. Halfway hidden in his box, he casts his eyes on the body of Yvonne as she is being tortured on stage in a scene of stylized violence and melodramatic suffering. Recalling Laura Mulvey's famous analysis,[12] Dr. Gogol's gaze in this first sequence oscillates between voyeuristic distance and narcissistic identification. Dr. Gogol not only immerses himself in the illusion of gazing at a seemingly private world; he identifies with what we can see on stage in the hope of losing and reconstituting the contours of his identity. Sadistic fantasies of visual control thus go hand in hand with masochistic desires for loss, self-punishment, and sexual de-differentiation. Though installed at a point of privileged distance, Dr. Gogol's gaze unites bliss and pain into one single mechanism. It draws scopophilic delight from highly performative, ritualistic, and cold enactments of cruelty as much as it functions as a mechanism temporarily to repress the doctor's own exhibitionist desires.

It is tempting to elaborate in further detail on Dr. Gogol's masochistic gaze. However, what makes Dr. Gogol most interesting for our inquiry here is not so much his initial role as a spectator, but his ensuing transformation into a master showman and cunning shape shifter. Before long, in what is perhaps the film's most visually stunning and emblematic series of shots, we witness Dr. Gogol summoning all kinds of techniques and technologies to animate Orlac's new hands and naturalize their relation to the pianist's body. Tightly framed and rapidly cut, this montage sequence presents close-ups of Orlac's hands as they are being subjected to massaging, x-raying, hot towel kneading, vibrator manipulation, ultraviolet treatment, electrical shock therapy, heat exposure, and rhythm exercises in front of a metronome. Because Orlac's hands throughout this series of shots remain rather static, our attention is mostly directed at the panoply of high-tech gadgets used by Dr. Gogol in order to turn the prosthetic into the organic. Modern machines here are meant to produce impressions of immediacy and

corporeal integration; their task is to reconstitute Orlac's body as unified, as a site of imaginary plenitude. That Dr. Gogol's ultraviolet gun closely resembles the look of a camera might therefore be no coincidence. For what Dr. Gogol is doing in this scene emulates what film directors and camera operators do both to the profilmic event and to their audiences in classical narrative cinema, namely to conjure a Lacanian imaginary that renders the artificial natural and converts feelings of fragmentation into sights of unity and totality. Like a film director, Dr. Gogol uses a whole array of special effects in order to overcome disbelief and orchestrate experiences of closure and continuity. Like a cinematographer and editor, he sutures disparate materials and make-believe into self-sustaining visions of wholeness and unquestioned autonomy.

In a later scene, Dr. Gogol masquerades as Rollo in order to drive Orlac over the brink of sanity and incite him to criminal action. Dr. Gogol's hands are masked by metallic, robot-like gloves, reminiscent of Rotwang's prosthetic extremity in Fritz Lang's *Metropolis* (1927). Additionally, Dr. Gogol wears a fantastic neck collar trying to persuade Orlac of the fact that Dr. Gogol secretly reconnected Rollo's head after the knife thrower's execution. The scene takes place in a shady part of town whose choreography of light and shadow directly recalls the urban scenes of the Weimar street film genre. Lit from a dramatic angle, Dr. Gogol's face and bodily appearance surely produce the desired effects in Orlac: terror and fear. The very possibility of prosthetic bodies and interchangeable identities, in the perspective of Orlac, violates the cult of authenticity, originality, and uniqueness that had marked the center of Orlac's former artistic practice. While in *Metropolis* Rotwang's artificial hand served as a sign for the mad scientist's fear of castration, in this particular scene of *Mad Love* the mad doctor parades his body as mutilated, hybrid, and void of organic integrity to emasculate his spectator Orlac. By performing as Rollo, Dr. Gogol succeeds in revealing something terrifying to Orlac that, in the pianist's eyes, should have remained hidden. If in the earlier series of montage images Dr. Gogol assumed the pose of a film director naturalizing the constructedness of Orlac's damaged body, in this later scene he poses as a proficient actor stirring hysteria by staging an uncanny return of the repressed. Whereas during the therapy session the special effects of Dr. Gogol's machines were meant to transform the fragmentary into an imaginary site of corporeal identity, in this second scene Dr. Gogol's play-acting exhibits a seemingly dismembered and prosthetic body as a spectacular source of horror and anxiety.

Prosthetic limbs, corporeal metamorphoses, mutilated body parts, and mask-like make-believe were to become the hallmark of Pete Lorre's exile career in Hollywood, a career jam-packed with excessive gestures of drag and masquerade, mimicry and imitation, posing and posturing, parodying and

deceipt.[13] In his best films, Lorre was not only to perform different identities, but to use the exile's experience of dislocation in order to perform the very performativity of identity. In Robert Florey's 1941 *The Face Behind the Mask*, Lorre for instance played Janos Szabo, a kind immigrant from Europe whose face has been disfigured in a fire right after his arrival in New York. A skillful watchmaker, he is unable to find appropriate employment due to his hideous facial features. He therefore turns to crime, soon accumulating enough wealth in order to buy a facial mask and cover the scars left by his accident. In the film, Szabo's facial prosthesis is represented by nothing other than Peter Lorre's own face. Lorre's face, in other words, becomes Szabo's mask, the prosthetic being embodied by what is one of the most undistorted appearances of Lorre's countenance during his long and often agonizing Hollywood career. Harun Farocki's essay film, *Das doppelte Gesicht: Peter Lorre* (*The Double Face: Peter Lorre*, 1984), comments on Lorre's role in *The Face Behind the Mask*: "One doesn't quite know: does he use his expression-less face as a mask or does he endow the mask with expression in order to use it as a face. The result is an equivocal correspondence between mask and face. The actor Peter Lorre made his living from this kind of equivocality."

At first, we might think that scenes such as the one in which Dr. Gogol enacts Rollo remain free of such moments of equivocality. Freund's film here seems to draw distinct lines between the organic and the prosthetic. It displays the use of artificial limbs and prosthetic identities as a diegetic event and performance, not as something making us wonder about the limits of the world of the story and the cinematic image. Freund's use of man-made hands and facial masks simply tries to symbolize Dr. Gogol's perverse imagination; it does not intend to establish ambiguous correspondences between mask and face, role-play and the real, artifice and nature. And yet, once we consider the extent to which the figure of Dr. Gogol in general is associated with cinematic techniques of cutting, editing, projection, and performance; once we recognize Dr. Gogol's ambitions to be a skillful author of deceptive images and moving imaginaries; and once we take a closer look at how the actor Peter Lorre himself performs Dr. Gogol's diegetic performances as master showman and directorial stand-in—it becomes difficult to overlook how the diegetic process of *Mad Love* here and elsewhere runs up against and transcends its own boundaries, and how Lorre thus sets up something foreign in this film that accents dominant conventions from within and decenters any sense of narrative closure.

VI

It is warranted at this point to pause for a moment and discuss in greater detail how we can theorize accent as a cipher of the exilic in mainstream

filmmaking. In linguistics, the notion of accent refers primarily to the area of pronunciation. Understood as auditory effects, accents serve as powerful markers of group identity and belonging; they articulate different regional backgrounds, social origins, and educational levels whose sounds deviate from what is considered to be the "official" language, that is, the standard, neutral, and value-free idiom of expression. By contrast, in what Naficy calls accented cinema—that is, the cinema of exile and diasporic displacement—the category of accent is meant to describe much more than merely a film's particular modulation of sound effects. "If in linguistics accent pertains to pronunciation, leaving grammar and vocabulary intact, exilic and diasporic accent permeates the film's deep structure: its narrative, visual style, characters, subject matter, theme, and plot."[14] Accented films, according to Naficy, challenge the dominant production mode at almost all fronts. They signify the condition of exile by embracing artisinal strategies of production and by subverting mainstream conventions. Because accented films, in Naficy's understanding, necessarily subscribe to an aesthetic of smallness and imperfection, they disrupt the very language of commercialized genre filmmaking.

Naficy's theory of accent intends to develop a universal matrix able to classify the multifaceted particularity of exile and diasporic filmmaking. Due to its one-sided valorization of noncommercial, auteur-centered filmmaking, however, this theory turns out to be too broad in order to explore the specificity of exilic articulations. In the final analysis, the style of Naficy's accented cinema does not really differ from what we tend to encounter under the rubric of independent filmmaking today or have considered as Art Cinema or Third Cinema some forty years ago. Let me therefore turn to what I consider a more narrowly defined and hence more focused theory of accent, namely Gilles Deleuze and Félix Guattari's notion of minor language as developed in their study of Franz Kafka. Though designed with regard to literary materials, Deleuze and Guattari's concept of minor language not only helps specify Naficy's understanding of cinematic accents, but—as I shall argue in a moment—sheds light on Peter Lorre's peculiar mode of performative enunciation.

Kafka's idiosyncratic use of Prague German, Deleuze and Guattari suggest, did not derive from his desire to mobilize a minor language from an extraneous speaking position against the official language. Instead, Kafka's language attempted to set up a new and different idiom within the bounds of the major and dominant language. Kafka was a nomad, a gypsy, in relation to his own language. He opted for the strangely impoverished and insulated idiom of Prague German in the hope of pushing its sobriety, its dryness and artificiality, beyond its own limits toward a point where it could vibrate with a new kind of intensity.

How?

Kafka's language, Deleuze and Guattari argue, is a language torn from the imperatives of sense and signification. In Kafka's prose, words no longer designate things directly; nor do they metaphorically apply to other things: "Kafka deliberately kills all metaphor, all symbolism, all signification, no less than all designation. . . . There is no longer any proper sense or figurative sense, but only a distribution of states that is part of the range of the word. The thing and other things are no longer anything but intensities overrun by deterritorialized sound or words that are following their line of escape."[15] In Kafka's texts, language stops being referential and representative. It moves toward its extremes, transcends the limits of expression and communication, and in this way exposes what is violent about the dominant language of commerce, bureaucracy, government, and ordinary interaction. Inasmuch as Kafka uses prepositions incorrectly, abuses the pronominal, arranges adverbs in prolonged series, and inserts terms that directly connote pain, he turns the alleged poverty of Prague German into something creative, into something in which words jar up against each other and open a new kind of expressivity—into something that allows Kafka to stay a stranger within his own language: "He will turn syntax into a cry that will embrace the rigid syntax of this dried-up German. He will push it toward a deterritorialization that will no longer be saved by culture or by myth, that will be absolute deterritorialization, even if it is slow, sticky, coagulated. To bring language slowly and progressively to the desert. To use syntax in order to cry, to give a syntax to the cry."[16]

VII

To be sure, Lorre never spoke Prague German like Kafka, nor did studio executives ever allow him to make use of and experiment with his native language in any of his Hollywood films. And yet, it is difficult to think of any other actor more prone to bring language, as well as the language of film acting, to the desert than Peter Lorre. Born as Laszlo Loewenstein in Rózsahegy (Hungary) in 1904, Lorre's vocal registers, even prior to his Hollywood exile, extended a sense of incommensurability and deterritorialization. As important as his odd looks and self-reflexive acting style, it was the strangeness of Lorre's Austrian-Hungarian accent that fascinated Fritz Lang when choosing Lorre for the role of Hans Beckert in *M* in 1931. Lorre had moved to Berlin in the course of the 1920s, promoted by Bertolt Brecht in order to demonstrate the playwright's concept of epic theater. Performing in Brecht's *A Man's a Man* and Marielusie Fleisser's *Pioneers in Ingolstadt* in the late 1920s and early 1930s, Lorre developed an acting style that drew awareness both to the actor's role-play on stage as well as the destructive power—the

hysteria and hypocrisy—that lurked beneath the operative veneers of bourgeois culture. Lorre's acting on stage depsychologized the roles he was meant to play. In accord with Brecht's theory of distanciation, the stage actor Lorre prioritized the presentational over the representational; he shifted emphasis from "psychology to sociology, from empathy to critical distance, from organic growth to montage, from suggestion to argument."[17] For Lang, Lorre's accent and intensity worked perfectly in order to accomplish the goals of his first sound film *M*: to portray a society haunted by the alienating logic of urban modernity, by mass mobilization and the cold gaze of surveillance.[18] Lorre's strangeness, rather than marking Beckert as an unassailable outsider, exposed to view what was strange and extraterrestrial about the film's vicious metropolis itself.

Lorre's bravura in *M* did not prevent him from being typecast as an essential oddball, as an actor representing the uncanny, eerie, hysteric, animalistic, and sinister. Lorre's exile career in Hollywood in fact became a history of agonizing deployments and spectacular misrecognitions. He was summoned to embody characters of all possible cultural backgrounds; his mere physical appearance was considered by filmmakers and audiences alike as a marketable sign of universal otherness. No one, in the course of the 1930s and 1940s, perhaps made more of a living in Hollywood by presenting himself in ethnic drag than Peter Lorre. And no one's acting ability during this time was perhaps more thoroughly misconstrued than Lorre's.

Having become cynical and sour about the commodification of his acting talents, Lorre once remarked,

> Me act? Why, I just make faces! Really, that's all I do, I make lots of faces and they pay me for it. The director says: "You're mad, Peter. Make like you're mad." Then pretty soon someone calls out "one hour for lunch"! I follow the others to the commissary and later return to the set. "Make like you did before lunch, Peter," says he director. "Make like you're mad." So I make like I'm mad again and before long someone says, "wrap 'em up. That's all for today." So I go home, have dinner, go to bed, get up, report for work again and the director says: "Make like you're mad again, Peter. Make like you did yesterday." I find it so easy. I just look mad and like old man river I keep rolling along doing devilish things in motion pictures.[19]

Lorre's reflections indicate the extent to which his body, his gestural and vocal accents, served the classical Hollywood studio system as marks of consumable alterity. They allowed viewers to take delight in highly generic figurations of difference without experiencing any possible blurring of the boundaries between self and other. Lorre made faces, but he did not make his audiences rethink what a face on screen was or meant in the first place (figure 8.2).

Figure 8.2 Peter Lorre in *The Face Behind the Mask* (1941), dir. Robert Florey. Courtesy of Filmmuseum Berlin—Deutsche Kinemathek.

But then, again, shall we really allow studio bosses and mainstream audiences of the past to speak the last word about the intricate and multivalent dimensions of Lorre's performative style? Isn't it the task of exile film studies to read dominant film history and reception against the grain, unearth suppressed and obscured legacies, and rearticulate what in its historical moment may have spoken in distorted, stammering, or unintelligible ways? Isn't our task *to look and hear again* so as to reclaim what was once overlooked or silenced in the process of cultural transfer and transaction?

VIII

Consider a scene in *Mad Love* in which Lorre plays Dr. Gogol play-acting a Freudian psychoanalyst. Orlac storms into Dr. Gogol's office, rightly

unnerved about his new hands and their uncanny ability to throw knives. Dr. Gogol takes Orlac to the side and involves his patient in what, in the eyes of the viewer, quickly turns out to be a parodic performance of psychoanalytic discourse: a deliberately vulgarized showcasing of European culture and science well prior to the popularization of Freudian psychoanalysis in the United States in the late 1930s and 1940s. What is remarkable about this scene is that Lorre's performance within the performance produces something that, rather than playfully heightening the film's illusionism, draws our awareness to the performativity of all identity and subject positions. Similar to many innerdiegetic performances of Marlene Dietrich, converting visible artifice into confusing signs of authenticity,[20] Lorre's doubled performance here challenges our ability to judge his acting because it dismantles ontological conventions and collapses governing distinctions between realist and comic codes of dramatization. First, Dr. Gogol's eyebrows undergo a number of asymmetrical, albeit strangely self-sufficient movements, thus generating a disproportionate frown that we can neither understand as a theatrical response to Orlac's hysteria nor as a covert communication of mischievous intentions to the camera across Orlac's own perception. Next, Dr. Gogol will turn his face away from Orlac focusing for a brief moment on a point outside the frame. When he returns his attention to Orlac, he overwhelms Orlac with pseudo-analytical jargon, trying to persuade his patient that his sudden expertise in throwing knives might reflect some kind of belated wish fulfillment; that Orlac's new skill might reenact childhood traumas and desires; and that his patient might be haunted by forgotten memories that festered deep in his subconscious and that should be brought to consciousness in order to provide instant cure.

Lorre's therapeutic monologue in this scene has trademark quality. Lorre speaks as if no one was intended to listen, as if the materiality of words and vocal sounds would always block any hope for possible communication. His intonation of individual words and whole sentences violates phonetic conventions and expectations. He speaks nonexpressively when meanings might call for heightened vocal intensity; he stresses words and phrases that do not really have any importance for his overall argument. Lorre's language here is anti-language: it seeks to escape from ordinary signification and representation. In fact, Lorre treats language like musical material, concerned not with meaning and conceptual truth but solely with the peculiar accenting of individual phonetic units, with the nonreferential sounds of his intonation. Barely opening his lips in order to utter his sentences, Lorre's vocal pitch, timbre, and modulation thus surreptitiously renounce the semantic and pragmatic intentions of Dr. Gogol's speech. Though meant to persuade Orlac of his sickness, Lorre performs Dr. Gogol as if he were trying to neutralize the telos of language, namely self-expression and mutual

understanding. Instead, Lorre's sounds—his arbitrary and idiosyncratic inflections—position Dr. Gogol as a stranger in his own language as much as they make language strange to us. What we hear here is no longer a sovereign subject of enunciation utilizing language in order to achieve personal goals and manipulate other's emotions. What we hear here is language itself speaking through Dr. Gogol. What we hear is Lorre transforming his voice into a deterritorialized machine of sound production—a transsubjective assemblage of enunciation. What we hear is "a language that moves head over heals and away."[21]

After a brief interlude, we see Dr. Gogol together with his assistant in the operating room. Both wear surgical robes, their heads masked, their hands wrapped in sterilization towels. We start with a medium shot. Once again Lorre is staring beyond the frame, while Dr. Gogol's assistant is turning to the doctor to ask him about the meeting with Orlac. Dr. Gogol answers first without looking at the assistant: "I told him a lot of nonsense I don't believe myself." We cut to a close-up of Lorre's face, his lips hidden behind the mask, the eyes doing all the actor's work: "I didn't dare to tell him his hands are those of a murderer." We now see Lorre hide his eyes under his heavy eyelids as he slowly turns his head to his assistant and says: "That would probably drive him . . ." Dr. Gogol stops in the middle of his sentence, visibly intrigued by a new strategy to eliminate Orlac and clear his path to his love object, Yvonne. What is startling about this part of the scene, however, is not that Lorre once again plays with the internal tensions of linguistic expressions, or that his use of accent and intonation moves language toward or even beyond its limits. Instead, what makes this final segment of the "therapy" scene remarkable is the fact that Lorre here succeeds in displaying Dr. Gogol's thoughts and strategies as effects rather than engines of verbalization. Instead of simply explaining or illustrating intentions, Lorre here reveals the extent to which Dr. Gogol's thoughts and actions perform and trail the uncontainable sounds of linguistic signs, sounds that are freed from conventional separations of signifier and signified. Though at this point in the film we have come to think of Dr. Gogol as a man of uncompromising stratagems, as an auteur director in disguise, Lorre here reveals that language, far from embodying a mere means of intentional expression and communication, subjects Dr. Gogol to its own arbitrary laws and movements. Dr. Gogol, as played by Lorre, here partakes of modernist literatures' most terrifying experiences: the "discovery that it speaks, that one is being spoken, that one's life is being lived."[22] Like a Brechtian actor on the Weimar stage, Lorre steps out of his role and portrays Dr. Gogol as a ventriloquist's dummy. A would-be showman and dexterous master over the imaginary, Lorre's Dr. Gogol thus turns out to be as much of a nomad, an exile, a stranger in the house of language and self-expression as all the other

European artists and intellectuals who were on the run from Hitler's politics in the course of the 1930s. Lorre's eerie sobriety, the willed poverty of his Brechtian style, here pushes deterritorialization to such an extreme that nothing remains but words without subjects of enunciation, intensities without meanings, inflections without referents, expressions without intentions.

IX

The career of Peter Lorre suggests that neither his vocal intonation nor his gestural accents were seen as something transcending Lorre's odd star personality. Lorre was seen as a freak, an ogre, a natural outsider, as a one-of-a-kind actor whose idiosyncratic looks and skills qualified him for very narrowly defined role. But Lorre's unsettling performance in films such as *Mad Love* urges us to rethink this view of Lorre as the essential and universal oddball. The accents of minor languages, as Deleuze and Guattari have shown, are never simply and solely eccentric, individual, and idiosyncratic. Accents are intimate signs of difference as much as they designate group identities and maintain certain forms of solidarity. Minor languages echo larger collective experiences and hence are, in and of themselves, always political. In Lorre's acting, idiosyncratic expressions, peculiar qualities, and odd enunciations became prominent and necessary, not in spite of Lorre's history of cross-cultural mimicry and migration, but precisely because—following Deleuze and Guattari's analysis of Kafka's minor literature—"a whole other story [was] vibrating within it."[23] Lorre's odd and scarce talents did not simply belong to him; he was not a sovereign "master" over his style. In Lorre's acting in films such as *Mad Love*, the exile's experience of ruptured and prosthetic identity formation, became a site of creative experimentation and enunciation. Mingling different cultural codes and styles of acting, Lorre did not only create selves on screen that deferred and dispersed traditional notions of creativity, authorship, and selfhood. As importantly, his hybrid and accented style allowed the viewer to think of the exile's self-expression as a necessarily common action, as something collective and political. What made Lorre into the typecast image Hollywood studios and audiences expected him to be was not his alleged innate weirdness, but how this extremely talented actor used his professional skills in order to resound shared stories of displacement and deterritorialization.

No wonder, then, that *Mad Love* ends the way it ends. In his very first appearance in a Hollywood film, Lorre not only introduced something strange into the horror craze of the mid-1930s; he in fact succeeded in making Hollywood codes of narrative and illusionism themselves strange to the viewer. Entirely centered around the haunting figure of Lorre's Dr. Gogol,

the film was thus simply unable to achieve any conventional sense of generic closure. Dr. Gogol might be dead, but his ghost—his story of irrevocable rupture and dispersal—prevails and looms large over the narratives of the living. Stephen Orlac might live, but his pathos of aesthetic genius and self-expressionism, of uninhibited authorship and identity formation, is irredeemably lost.

X

Lorre's cinematic discoverer and fellow exile, Fritz Lang, was known to have included insert shots of his own hands into almost all of his films in order to display the auteur's directorial control and creative imagination. Though himself a genius-like engineer of powerful illusions and manual wonders, Lorre's Dr. Gogol in the end refutes the common symbolism of artistic authority and charismatic ingenuity commonly invested into the image of the hand. In an exilic age of artificial limbs, prosthetic identities, and accented voices no one can claim to be the master of his own house and the creator of his own life anymore. Nothing here in fact turns out to be more fallacious than to think that we could manage our own life stories akin to the ways in which God-like artists or film directors model their material and assign meanings to their aesthetic structures.

Time and again we find Lorre playing roles in Hollywood after *Mad Love* that, by exploring the mechanics or metaphoricity of the human hand, question high-flying notions of individual sovereignty, demiurgic self-creation, and aesthetic autonomy. In Michael Curtiz's *Casablanca* (1942)— "everyone's favorite émigré film"[24]—Lorre embodies Ugarte, a shadowy underground figure whose hands end up passing on those very letters of transit that allow Victor and Ilsa Laszlo (played by fellow émigrés Paul Henreid and Ingrid Bergman) to escape Nazi persecution.[25] In Robert Florey's 1946 *The Beast with Five Fingers* (written by Hitler refugee Curt Siodmak), we see Lorre in the role of Hilary Cummins as he encounters the disembodied hand of former concert pianist Bruce Conrad (Robert Alda). Similar to the emblematic extremity in Lang's *M*, Lorre's Hollywood hands here and elsewhere served as relay stations between the marker and the marked. They established common bonds between the criminal and the innocent, between the eccentric and the normal, between murderer and victim. Rather than stimulating fantasies of autotelic closure and control, Lorre's hands blurred categorical distinctions between good and evil, feeling and action. They made use of the arsenal of commercial genre filmmaking in order to show how in modern industrial culture traditional aesthetic categories such as creativity and genius, originality and closure, serve as seductive ideologies whose uncontrolled application might lead to devastating ends.

What makes the hands of Lorres film deeply political becomes perhaps the clearest when seen against the backdrop of the Nazi cult of aesthetic creativity and manual labor. "Art is an expression of feeling," Joseph Goebbels wrote in his expressionist novel *Michael* in the mid- 1920s, "The artist differs from the non-artist in his ability to express what he feels. In some form or other. One artist does it in painting, another in clay, a third in words, and a forth in marble—or even in historical forms. The statesman is also an artist. For him, the nation is exactly what the stone is for the sculptor. Führer and masses, that is as little of a problem as, say, painter and color."[26] National socialism was driven by the belief that political action and leadership should be understood in likeness to the process of artistic creation. Hitler's hands were seen as those of a genius artist originating the very norms and standards according to which his works—the new state and community of the folk—were supposed to be evaluated. Though Nazi politics utilized effectively the means of modern mass communication and mechanical reproduction—film, radio, and photography in particular—it often resorted to the vocabulary of high art and the image of the heroic artist's masculine hands in order to present the figure of Hitler as an unquestionable presence.

A 1932 cartoon in the satirical journal *Simplicissimus* still tried to poke fun at this aesthetic approach to politics. We see Hitler positioning himself in front of a modernist sculpture, modeled by what is shown as an academic and emasculated artist. Next, Hitler's fist resolutely squashes the sculpture to pulp, to the utter consternation of the artist. Finally, Hitler's hands take command over the chunk of raw clay, shaping a sculpture whose muscular masculinity resembles Arno Breker's and Joseph Thorak's monumental statues. In the final image, we see Hitler looking at the work of his hands like a demiurge who created a New World from scratch. The last drawing, however, is ambivalent: Did Hitler's hands shape this new man in order to have someone to bear witness to his own greatness? Or did he model this figure in order to cast into material form his desired self-image? In either case, the image of Hitler's artistic ambitions in this cartoon not only allegorized the Nazi's quest for totalitarian power, it also sought to debunk the resolution and dexterity of Hitler's hands—that is, the Nazi's attempt to render politics aesthetic—as highly narcissistic, as skills and structures of feeling producing kitsch rather than art.

Needless to say, cartoonists such as the one working for *Simplicissimus* had not much left to laugh about once Hitler had come to power. National socialism turned out to be the first full-fledged media dictatorship in world history. It employed the entire spectrum of modern tools of communication and dissemination, not only to mobilize minds and engineer emotions but also to glorify totalitarian power as an auratic presence. Simultaneously

made by movies and mad for movies,[27] the national socialist regime employed the modalities of modern industrial culture with the intention of giving twentieth-century politics the appearance of unified and resolute action. It recycled romantic notions of artistic genius to refashion the political as a self-referential space of authenticity and existential self-assertion. Entertainment films such as Hans Schweikart's *Befreite Hände* (*Liberated Hands*, 1939) provided powerful allegories for this aesthetic remaking of the political. Premiering on December 20, 1939, in Munich, the film narrates the story of a rural sculptress who, after first throwing away her talents by mass-producing statuettes for the culture industry, in the end discovers her true calling: to be the inspired creator of monumental designs. In the final scene, we see her chiseling a massive stone statue, oblivious to anything around her and solely focused on selecting the right hammer to get her work done. The final shot zooms in on her "liberated hand" as it, briefly interrupting its vocation, shakes the hand of her teacher. This final handshake is meant to express the alleged triumph of true heroic art over the strictures of gender, class, and regional identity. It celebrates the desexualized communion of autonomous artists whose sole passion is to shape amorphous materials into distinct forms and in so doing—like the Hitler of the *Simplicissimus* drawing—to render art as a practical expression of power, stripped of any commitments to uninhibited sensuality, free play, and spontaneous communication.

In contrast to the Nazis' transformation of power into a highly choreographed spectacle of self-expression and heroic resolution, Peter Lorre's accented style of performance insisted on forms of aesthetic experience and creatvity that did not discipline the body and hit people over the head. Lorre's Dr. Gogol might be a mad scientist and a masochist psychopath, but in the final analysis his insanity brings to light what is mad about any modern attempt to tie the image of the hand to discourses of artistic genius and resolute power. Lorre's hands revealed that the logic of modern industrial culture had invalidated the very categories used by Goebbels, Hitler, and Schweikert in order to justify unlimited authority as a seductive and sublime site of aesthetic values. These hands sought to undercut whatever had driven Nazi politicians to transform the political into an aesthetic spectacle of first rank.

It is perhaps for this reason that Lorre was never considered to play the role of Frank Marlow in Robert Siodmak's 1943 *Phantom Lady*, a film exploring the location of aesthetic genius in modern industrial culture and clearly allegorizing Nazi constellations. *Phantom Lady* revolves around the deadly obsessions of a monumentalist, New York-based sculptor, Frank Marlow, who despises the triviality of mass cultural expressions as much as the work of modern engineering. Preoccupied with his own hands, Marlow lectures his victims about the power and authenticity of manual labor.

Recalling Goebbels's comments on modern art and power, Marlow considers his hands as instruments to organize the chaos of existence into meaningful structures no matter whether they seek to preserve or to annul life. Hands can "mold beauty out of clay," "trick melody out of a piano keyboard," or bring "life back to a dying child," but "the same pair of hands can do inconceivable evil," it can torture, whip, "even kill." Marlow, in the gesture of an avant-gardist in Peter Bürger's sense, hopes to burst the boundaries of the aesthetic in order to reintegrate art into everyday life.[28] Yet as he radically privileges form over norm and content, Marlow comes to venerate death as the telos of all human creativity. For it is only in death that the world adheres to the structure and order Marlow's hands desire to impose onto the messy gestalt of modern life.[29]

Phantom Lady's Marlow is played by Franchot Tone, who in the course of the 1930s, due to his upper-class poise, could be seen in sophisticated, elite, highbrow, and cosmopolitan roles in numerous MGM comedies and dramas. His stardom descending in the 1940s, Tone embodies Marlow's insanity with his trademark aloofness, reserve, and rigidity. Worlds lie between his acting style and Peter Lorre's accented presentations. Worlds also lie between Marlow's fascistic philosophy of manual productivity and armor-plated identity on the one hand, and on the other Dr. Gogol's deconstruction of the image of the hand as allegory of sovereign subjectivity and self-expression. In spite of all his thespian flexibility, Lorre would have been unthinkable as Marlow. Lorre's careers, masks, and performance styles as an exile reflected what hands such as Marlow's had done to the lives of German-Jewish and Austro-Hungarian-Jewish film practioners in Nazi Germany. An insider embodying the outsider, Lorre at his best understood how to use and embrace industrial genre filmmaking in order to articulate the exile's loss of voice and articulation.[30] His contribution to Hollywood was to allow us to recall and recognize Marlow's victims. His accented style and minor language unsettled the perverse blending of art and power that had forced Lorre—to refer to the title of his own 1951 film *Der Verlorene*—to enact the role and life of a "lost one."[31]

Notes

1. Hamid Naficy, *An Accented Cinema: Exilic and Diasporic Filmmaking* (Princeton: Princeton University Press, 2001), 4.
2. Ibid., 6.
3. David Bordwell, "Art-Cinema Narration," *Narration in the Fiction Film* (Madison: University of Wisconsin Press, 1985), 205–233.
4. For more on the stakes of German exile film studies and its double gaze, see also the various essays in *New German Critique*, 89 (Spring/Summer 2003), Special Issue on Film and Exile, ed. Gerd Gemünden and Anton Kaes.

5. Sigmund Freud, "The Uncanny," *The Standard Edition of the Complete Psychological Works of Sigmund Freud*, ed. and trans. James Strachey, 24 vols. (London: Hogarth, 1953), XVII: 219–252.

6. Tom Gunning, *The Films of Fritz Lang: Allegories of Vision and Modernity* (London: British Film Institute, 2000), 2.

7. Edward W. Said, *Representations of the Intellectual* (New York: Vintage Books, 1996), 49.

8. Thomas Elsaesser, *Weimar Cinema and After: Germany's Historical Imaginary* (London: Routledge, 2000), 380.

9. Steven Thornton, "*Mad Love*, 1935," *Peter Lorre*, ed. Gary J. Svehla and Susan Svehla (Baltimore: Midnight Marquee Press, 1999), 51.

10. For a persuasive rethinking of horror's sexual politics, see Carol J. Clover, *Men, Women, and Chain Saws: Gender in the Modern Horror Film* (Princeton: Princeton University Press, 1992).

11. For more on the masochistic aesthetic, see Gilles Deleuze, *Masochism: An Interpretation of Coldness and Cruelty* (New York: George Braziller, 1971); and Gaylyn Studlar, *In the Realm of Pleasure: Von Sternberg, Dietrich, and the Masochistic Aesthetic* (New York: Columbia University Press, 1988).

12. Laura Mulvey, "Visual Pleasure and Narrative Cinema," *Visual and Other Pleasures* (Bloomington: Indiana University Press, 1989), 14–26.

13. See the various contributions to Michael Omasta, Brigitte Mayr, and Elisabeth Streit, eds., *Peter Lorre: Ein Fremder im Paradies* (Vienna: Zsolnay/Kino, 2004).

14. Naficy, *An Accented Cinema*, 23.

15. Gilles Deleuze and Félix Guattari, *Kafka: Toward a Minor Literature*, trans. Dana Polan (Minneapolis: University of Minnesota Press, 1986), 22.

16. Ibid., 26.

17. Anton Kaes, *M* (London: BFI, 2000), 24.

18. Anton Kaes, "The Cold Gaze: Notes on Mobilization and Modernity," *New German Critique*, 59 (Spring/Summer 1993): 105–117.

19. Quoted in Claudia Kaiser, "Peter Lorre alias Mr. Murder. Ein Doppelgänger zwischen Europa und Amerika," *Der Verlorene*, ed. Michael Farin and Hans Schmid (Munich: Belleville, 1996), 271.

20. James Naremore, *Acting in Cinema* (Berkeley: University of California Press, 1988), 131.

21. Deleuze and Guattari, *Kafka*, 26.

22. Andreas Huyssen, "Fortifying the Heart-Totally: Ernst Jünger's Armored Texts," *New German Critique*, 59 (Spring/Summer 1993): 11.

23. Deleuze and Guattari, *Kafka*, 17.

24. Thomas Elsaesser, "Ethnicity, Authenticity, and Exile: A Counterfeit Trade? German Filmmakers in Hollywood," *Home, Exile, Homeland: Film, Media, and the Politics of Place*, ed. Hamid Naficy (New York: Routledge, 1999), 100.

25. For more on Henreid's exile, see Peter Nau, "Vor Sonnenuntergang. Paul Henreid in Hollywood," *Schatten.Exil: Europäische Emigranten im Film Noir*, ed. Christian Cargnelli and Michael Omasta (Vienna: PVS Verleger, 1997), 89–104.

26. Joseph Goebbels, *Michael: A Novel*, trans. Joachim Neugroschel (New York: Amok Press, 1987), 14.

27. Eric Rentschler, *The Ministry of Illusion: Nazi Cinema and Its Afterlife* (Cambridge, MA: Harvard University Press, 1996).

28. Peter Bürger, *Theory of the Avant-Garde*, trans. Michael Shaw (Minneapolis: University of Minnesota Press, 1984).

29. For a more detailed reading of *Phantom Lady*, see Lutz Koepnick, *The Dark Mirror: German Cinema between Hitler and Hollywood* (Berkeley: University of California Press, 2002), 164–200.

30. Stephen D. Younkin, "Der Insider als Outsider: Die Emigration des Peter Lorre," *Peter Lorre: Portrait des Schauspielers auf der Flucht*, ed. Felix Hofmann and Stephen D. Younkin (Munich: Belleville, 1998), 107–161.

31. For an astute analysis of Lorre's 1951 film, see Jennifer M. Kapczynski, "Peter Lorre's *The Lost Man* and the End of Exile," *New German Critique*, 89 (Spring/Summer 2003): 145–172.

CHAPTER NINE

HANS RICHTER IN EXILE: TRANSLATING THE AVANT-GARDE

Nora M. Alter

Driven out of my country, now I must see how to find a new store, a bar, where I can sell what I think.

—Bertolt Brecht, "Sonnett in der Emigration"

I

A large number of European abstract films premiered in the United States in a 1940 festival at the Museum of Modern Art in New York. The program featured, along with the work of Man Ray, Fernand Léger, and Marcel Duchamp, one of the earliest abstract films, Hans Richter's 1921 study, *Rhythmus 21.* At the time, Richter was head of film production at the Frobenius Film Studios in Basel, Switzerland. But Swiss officials had just announced their intention to deport him back to Germany. Richter, one step ahead of the Swiss, had filed with the U.S. consulate for immigration papers, and was awaiting his official documents. MoMA's screening therefore provided a timely introduction of the artist's work into the New York art scene. Less than a year later, in 1941, Richter immigrated to the United States and took up residence in Manhattan where he would continue to reside on a part-time basis until his death in 1976. Although identified as a German artist, for the past quarter of a century before he arrived in the United States, Richter had a peripatetic lifestyle and he counted Zurich, Munich, Berlin, Moscow, Eindhoven, Basel, and Paris, amongst other cities, as his residences. Thus, to varying degrees, one might be tempted to conclude that most of Richter's life was spent in exile. However, the term exile, as Hamid Naficy reminds us, is traditionally taken to mean "banishment for a particular offense, with a prohibition to return,"[1] and many of

Richter's earlier departures were voluntary and he always returned to Germany. Further, it is important to stress that the condition of exile is more than a physically lived reality and can be both internal and external. More than temporarily moving to a new setting, it bespeaks an attitude, a state of mind, a condition of desire, and it is accompanied by a yearning for a return to the place that has been left behind, and a feeling of displacement in the new environment. Exiles often "memorialize the homeland by fetishizing it in the forms of cathected sounds, images, and chronotopes that are circulated intertextually."[2] In examining Richter's life course, it is evident that although he did to a certain extent experience the condition of being an external exile during his early years, for reasons that will become clear, that physical state was not paralleled by a corresponding psychological and interior one until he immigrated to North America. And, I argue, this convergence of exterior and interior states of exile profoundly effects his filmic production: both formally and thematically.

Whereas the psychological condition of internal exile certainly marks Richter's life in the United States, it is not evident during the first half of his career. This is in part due to his political allegiance to the historical avant-garde and its disavowal of national identity and patriotism in favor of a broader internationalism. Often for the external exile there is a longing for an abandoned "homeland" (Heimat) that has a distinct geographical location, and internal exiles yearn or exhibit nostalgia for a condition of being, an abstract philosophical mindset rather than a concrete or material territory. Thus, while in Europe, Richter was less of an exile (internal or external) since he was still part of a community that transcended national borders and that existed regardless of where he was located: be it Berlin, Moscow, or Zurich. His allegiance was not to a national identity constructed as "German" but rather to a specific group of avant-garde artists whose own geographical and national identifications were certainly as labile and fluid as Richter's. In his moves to France, the Soviet Union, and Switzerland, Richter was operating within a comfortable and well-known network of like-minded European cultural workers. By contrast, his departure for New York constituted a departure into the unknown and was immediately characterized by a form of exilic anxiety. Furthermore, his leave from the continent, due to Hitler's successes, was marked by a sense of finality that had been absent in his previous moves. As he remarked in retrospect, "When I left Lisbon, on the eve of my fifty-third birthday, I felt sure I would never see Europe again. My heart felt heavy, looking at the vanishing lines of Portugal; it was no lighter when I landed in New York, the city terrified me—Sodom and Gomorrah."[3] More than just an ocean was crossed by Richter's journeying to New York. The implications of the continental shift from Europe to North America had profound implications for

Richter's type of artistic practice. For although fascist Europe was certainly the explicit enemy, in terms of filmic production, the thoroughly commodified entertainment culture of the United States also represented an implicit threat to avant-garde work. Unlike in Europe, North America did not have a highly developed experimental cinematographic practice. During the 1930s and early 1940s, Hollywood was in its "Golden Age," leaving little space for alternative modes of production and reception. Indeed, such narrative filmmaking as epitomized by big studio productions, was precisely what Richter was committed to combating with his cinematic activities. Already in a short essay "Film—A Ware" of 1931 he had argued vehemently against the complete transformation by the capitalist film industry of films into manufactured goods or wares without any redeeming qualities.[4] Film is produced according to the same principles as boots, stamped out to conform to set models and sizes with little or no variations. Further, he proclaimed, the film industry is controlled by monopolies operating on similar principles as those of oil or steel,[5] which led Richter to conclude that these contributing factors make it almost impossible to conceive of an "art film."

Of course the condition that Richter is describing finds its hyperbolic realization in the United States thus explaining in part his profound dismay at finding himself en route into the belly of the beast, as it were. Unlike other immigrants such as Oskar Fischinger who migrated to the West Coast and tried to integrate themselves into the industry, Richter had always been adamant about maintaining a degree of autonomy and not compromising his artistic ideals by working for and producing mainstream cinema.[6] Thus, Richter's immigration to New York constituted more than a condition of external exile marked by geographical displacement, linguistic and cultural alienation; it was also characterized by a deep internal exile produced in the confrontation with a system of audiovisual production and a conception of art that was radically at odds with everything that Richter had been striving to achieve previously. Richter was heavily invested in the historical avant-garde until 1930, after which time there is a gap or interruption that is figured both temporally and spatially. From Richter's *Alles dreht sich, Alles bewegt sich* (Everything Revolves, Everything Moves) of 1929, to his next production, *Dreams That Money Can Buy* of 1947, there is a break of eighteen years, and a geographical dislocation of 4,000 miles (figure 9.1). And the cultural project that began for Richter with Dada in Zurich in 1916 during World War I is only resumed thirty years later in New York City in the aftermath of the Second World War. In this chapter, I will examine how Richter's move to the United States can be viewed as a significant rupture in his career and correspondingly enacted a profound transformation on his filmic theory and production.

Figure 9.1 Hans Richter in *Dreams that Money Can Buy* (1947). Courtesy of Filmmuseum Berlin—Deutsche Kinemathek.

II

Richter was one of the key players in German Dada. He worked closely with other central figures in this movement, including Richard Huelsenbeck, Kurt Schwitters, Hans Arp, Viking Eggeling, Tristan Tzara, Marcel Duchamp, and Sophie Taeuber. As early as 1913, he became acquainted with two modernist avant-garde movements that challenged prevailing notions of art: the Dresden-based Die Brücke, and the Munich-based Der Blaue Reiter. Both were comprised primarily of painters who sought to push beyond figuration and representation toward abstraction. The following year he joined an expressionist group centered around the journal *Die Aktion*, which featured his work. Richter enlisted in World War I in 1915, but was soon seriously wounded, and while on medical leave in 1916 he traveled to Zurich where he became involved in the formation of Dadaism.

Richter returned to Germany at the end of the war and played an active part in the left-wing revolutionary politics raging in Munich and Berlin. Drawing on connections made while in Zurich, he figured prominently in

the historical avant-garde of the immediate postwar period, and partici-
pated in the Congress for International Progressive Artists in 1922 as well as
in the Constructivist International of the same year. Moreover, whereas he
had worked primarily as a painter and engraver until the end of World War I,
his association with constructivist filmmakers—Sergei Eisenstein and
especially Viking Eggeling—pushed him toward the filmic medium.
Beginning in the 1920s he began to make films, and in 1926 he founded
the Gesellschaft für Neuen Film with Karl Freund and Guido Bagier in
order to promote experimental film, and in 1929 he wrote his first book
Filmgegner von heute—Filmfreunde von morgen (Film Enemies Today and
Film Friends Tomorrow). Both projects sought to alter significantly the
manner in which films were produced and received, and to move away from
the narrative feature film structure. During the early 1930s, Richter found
himself increasingly under censorship and attack—intellectually, institu-
tionally, and even physically—leading to his relocation to Basel and
subsequent emigration from Europe in 1941. Once in New York, he
became director of City College's Institute of Film Technique, a post he
would hold until he retired in 1957.

In 1920 Richter collaborated with Eggeling to produce a pamphlet,
"Universelle Sprache" (Universal Language), in which, Richter recalls in
1965, they tried to elaborate the thesis "that the abstract form offers the
possibility of a language above and beyond national frontiers."[7] As is evi-
dent, an art that is based on national or cultural identification should be
avoided in favor of productions that achieve transcendent or nonculturally
specific communication. He continues that "the basis for such a language
would lie in the identical form of perception in all human beings and would
offer the promise of a universal art as it had never existed before. With care-
ful analysis of the elements, one should be able to rebuild men's vision into
a spiritual language in which the simplest as well as the most complicated,
emotions as well as thoughts, objects as well as ideas, would find a form."[8]
The following year, in 1921, Richter made his first film, *Rhythmus 21*. The
latter is a black-and-white study of suprematist squares and rectangles that
change in size and depth through a series of rhythmic evolutions. ("Twenty-
one" merely refers to the year it was made.)

Rhythmus 21 was followed by three subsequent abstract studies:
Rhythmus 23 (1923), *Rhythmus 25* (1925), and *Fuge in Rot und Grün*
(Fugue in Red and Green, 1923). In the latter two works, Richter hand-
painted colors in the geometrical shapes directly on the celluloid, thereby
adding yet one more dimension to his light and motion explorations. The
role of varying intensities and registers of light in producing an image were
crucial in Richter's filmic constructions. As he had theorized already in
1923, "The space is neither architectonic nor graphic, rather it is

time-based. That is to say that light constructs through changes in quality and quantity (light, dark, color) a lightspace, that is created not through volume but is rather a space composed out of the progression of planes, lines, and points."[9] Thus the overriding structure of these productions was determined more by the motion of the filmed objects in time and space rather than by any physical or referential materiality. As Richter said on more than one occasion in the early years of his film career, "The only reality you have in the movie theater is the screen." In addition, Richter further experimented with the possibility of adding sound, and while the structure of *Rhythmus 21* was relatively random, *Rhythmus 23, 25,* and *Fugue in Red and Green* set into motion a complex interplay of forms arranged according to the musical composition of a fugue in which several motifs of the polyphonic composition are repeated voices and parts that enter and exit in succession.[10]

At this stage in his filmic career, Richter was concentrating on seeing just how far he could develop or translate the abstract form into celluloid. In sharp contrast to the developmental leaps in narrative film during the 1920s, Richter pushes in the opposite direction completely away from diegesis and mimetic representation. As he stresses, "[T]he abstract form offers film unusual possibilities because: 1) it allows for the possibility that the artistic expression can be realized free of all associations and coincidences, 2) nonrepresentational, abstract 'signs' are, for us, the most persuasive and strongest means for expression."[11] However, despite Richter's commitment to abstract form one can detect a gradual evolution of his films into more representational forms and finally into sociocritical shorts in the late 1920s and early 1930s. Interestingly, whereas Richter's painting moves from representation to abstraction, the opposite movement takes places cinematically. From his first writings about film, it is clear that one question remained central to Richter: "What social purpose does cinema serve?" For only if one continuously poses such a question can cinema's "artistic development as a whole and the development of each individual sector in every one of its forms" be properly understood.[12] Richter considered film to be an art form, with the more prevalent narrative cinema representing a continuation of nineteenth-century realist art. His early cinematic experimentations sought to translate avant-garde painting directly into the medium of film. Hence the purely abstract nature of his rhythm films, and especially his use of the form of the suprematist square in *Rhythmus 21*. However, Richter soon realized that "abstract form in films does not mean the same as in painting where it is the ultimate expression of a long tradition of thousands and thousands of years. Film has to be discovered in its own property."[13] It was this attentiveness to the specificity of the filmic medium that led Richter to dramatically alter his filmic style in favor of representational

forms and human figures such as one finds beginning with his 1928 *Filmstudie* (Film Study).

Filmstudie is a transitional work that opens with a medley of geometrical shapes including circles and spheres that gradually metamorphize into free floating eyeballs and finally a face. What follows is an interplay between abstract forms and representational ones appearing at rhythmic intervals creating a complex medley. Any thematic link is impossible to discern and the impetus behind the images is rather one of a confluence and representation of forms than one of content. Representational images thus function in the same manner as the abstract shapes of his earlier studies. *Filmstudie* was followed by the surrealistic and highly experimental *Vormittagsspuk* (Ghosts Before Breakfast) of 1927, in which Richter mobilized what at the time were very sophisticated camera tricks in order to produce a spectacular film filled with amazing stunts in the tradition of Georges Melies. Although heralded for its formal properly cinematographic properties and despite its playful nature and seemingly disassociated series of images, *Ghost Before Breakfast* also was read retrospectively as containing a critical message that alluded to the rise of fascism. For example, the opening shot of a clock about to strike midnight was seen as indicating that Germany was in its "eleventh hour" and the final shots of the image of a rotating revolver was viewed auspiciously as pointing toward a bleak future. In the next few years Richter's filmmaking practice continued to move away from abstraction and he produced more overtly sociocritical shorts such as *Inflation* (1928), *Rennsymphonie* (Race Symphony, 1928–1929), *Zweigroschenzauber* (Two Pence A Commercial Pictue in Rhymes, 1928–1929), and the 1929 *Everything Revolves, Everything Moves*—the latter that led to Richter being labeled a "Kulturbolschewist."

Yet it should be stressed that even though Richter moves away from abstract geometrical forms in the 1920s, the fundamental driving force is still not one based on narrative, but on rhythm and movement. The function of the human figures is not significantly different from that of the earlier geometric forms. An anecdote that Richter liked to recall is highly revealing in this context. The anecdote is about a Jewish acquaintance of Richter's who immigrated to Palestine and set up a movie theater where he always projected the same film. One day the reels were mixed up and much to his surprise he noticed that it did not affect the appeal of the film since the spectators were not as much interested in the plot as in the spectacle of a "world in motion."[14] A basic fascination with moving images therefore precedes sophisticated plot developments and Richter concentrated his efforts in utilizing movement to achieve the maximum impact on the audience.[15] Not only is the effect of motion achieved through plays with light and rhythm but it is enhanced by what Richter termed "visual rhyming."

The concept of visual rhyming is fully developed in his *Zweigroschenzauber* (Two Pence: A Commercial in Picture Rhymes, 1928). For instance, when an image of a moon dissolves into a man's bald head that then turns into mirror reflection of a human figure, or when the legs of an infant kicking are immediately followed by the legs of bicyclists pedaling, the result is akin to a visual rhyme.

And yet, as indicated earlier these later films produced in the late 1920s are not as playful as they appear to be. Indeed, Richter's works increasingly are imbued with elements of critique that reside not merely in formal properties but also in the choice of images and representations thereby corresponding to the ever-growing atmosphere of political crisis in which the artist found himself. As the pressure increased, so did Richter's probing into the ontological nature of film and his attempt to conceive of a different type of cinema that was neither distracting narrative, nor documentary, nor purely abstract. Thus, in 1929 he observes that "[t]he path of theatre-freed film follows two directions: one in the pursuit of so-called unstaged shots, which are the technical basis of weekly recordings of reality, the main proponent and director of this type of cinema is Dsiga Werthoff [*sic*]; the other type of film is that without plot, theme or narrative—the so-called 'absolute film.' "[16] Although both of these paths—documentary and abstract— provided viable alternatives to dominant narrative cinema, Richter still found both of them inadequate. By the time he left Germany for Switzerland in the early 1930s, having witnessed both the death of the avant-garde (in some cases literally) as well as the complete co-option of commodification of feature film, he was committed to advancing a new mode of filmic production, one that would somehow constitute a fusing of art and entertainment film.[17]

III

Richter's first decade of filmmaking prior to his exile in the United States can be divided into two distinct styles: abstract films, which include the *Rhythm* trilogy and *Fugue in Red and Green*; and experimental shorts including *Ghosts Before Breakfast* and *Inflation*. The impact of all these early works on avant-garde filmmakers and artists cannot be underestimated. Already in 1929 after a trip to Germany Kasimir Malevich composed a script storybook on Richter after viewing his films, and a future generation of filmmakers such as Stan Brakhage, Kenneth Anger, Michael Snow, Peter Kubelka, Jonas Mekas, and Maya Deren freely acknowledged the importance of Richter for their development.[18] Histories and anthologies on art film still consider these abstract and avant-garde productions as seminal to the development of experimental film.[19] Indeed, testifying to the

importance and success of this early work was the fact that during the 1960s the influential contemporary art journal/*Aspen* distributed copies of *Rhythm 21* in one of its box-set editions along with films by Robert Rauschenberg and Laszlo Moholy-Nagy.

However, beginning with Richter's exile a new period emerges and his filmic oeuvre reveals a third genre: what I call his history or essay films. These include three films made during the postwar period while he was in the United States: *Dreams That Money Can Buy* (1947), *8×8: Chess Sonata* (1957), and the two-part *Dadascope* completed in 1963. In addition, to these completed projects Richter had several planning sketches and scenarios for films that were never realized due to political or economic circumstances. Amongst these are *Keine Zeit für Tränen* (No Time for Tears, 1933–1934) about the discrimination directed against professional women; *Daily Life* (1934); *Baron Munchhausen* (1937), for which Méliès was supposed to make the sets; *The Role of Women in America* (1941–1942); *The Accident* (1945–1956), about race discrimination; *The Story of the Unicorn* (1945); and *The Minotaur* (1948), based on the Greek myth of Theseus and the Minotaur. What is immediately striking about these projects is that for the most part (*Munchhausen* is an exception), those planned before the war's end have an overt immediate sociopolitical agenda whereas those conceptualized from 1945 onward reference "timeless" Western myths. This recourse to more traditional, universal (albeit Western) genres can be linked conceptually to Richter's earlier belief that abstract forms provided a "universal" visual language for film. In addition, the adaptation of a story that has endured through the millennia attests to a degree of stability that serves to counter the otherwise extreme precariousness of the condition of exile.

While in exile, Richter published a number of books, the most prominent being *Dada Profile* (1961), *Dada, Kunst and Anti-Kunst* (Art and Anti-Art 1964), *Begegnungen von Dada bis Heute* (Encounters from Dada to the Present, 1973), *Kampf um den Film* (The Struggle for Film, 1976), and the autobiographical *Hans Richter by Hans Richter* in 1971. During his later years in the United States, he divided his time between his home in Southbury, Connecticut, and Locarno, Switzerland. Both of these had firmly established communities of artists, many of whom were also exiles. Connecticut was even described at the time as a "Surrealist outpost," and Richter's neighbors included Yves Tanguy, Alexander Calder, the Gorkys, and a constant influx of long-term and repeat visitors such as André Breton and Duchamp.[20] To a certain extent, this community paralleled the equally infamous émigré community on the West Coast of the United States, in the Hollywood hills, during World War II. Indeed, the community of exiles in California will serve as an important point of anti-identification for Richter and his cohorts on the East Coast.

Despite his productivity, Richter's post-World War II films are barely mentioned in film history, and when they are it is to dismiss them as "baroque indulgences."[21] His impact on the filmic avant-garde is thus seen to rest entirely on his early production, and his later works are treated merely as archival curiosities. This perspective is all the more striking when one recalls that in 1947 *Dreams That Money can Buy*, which had been financed by Peggy Guggenheim and Kenneth McPherson, won the Special Award at the Venice Biennale for "the best original contribution to the progress of cinematography."[22] Critic Siegfried Kracauer proclaimed that "[h]e [Richter] transfers for the first time essential forms of modern art to the projection screen. . . . *Dreams that Money Can Buy* confirms the secret dream-life of drawings, paintings, and sculpture. With this film a future collaboration between art and film can begin."[23] And yet, in film and art history it is only the abstract experiments that are recalled and not the later figurative, representational, and narrative-based films. However, to ignore the breadth of Richter's filmic production is to underestimate the artist's keen awareness of the possibilities and limits of the filmic medium, for as we have seen, Richter was also a highly sophisticated film theoretician who wrote several books and essays on the medium.[24] And though perhaps on a superficial level Richter's later films are easier for the audience to receive, they are as "experimental," "avant-garde," and ambitious as their precursors in their attempt to push the medium of film to another dimension.

Richter's early films are marked by a conspicuous absence of recognizable characters or actors on screen. In sharp contrast, however, all three films made in the United States rely heavily on easily identifiable personalities and stars. *Dreams That Money Can Buy*, for instance, is divided into seven parts, each scripted by an important artist in the New York exile community. Part one, "Desire" by Max Ernst, is based on the surrealist artist's 1934 novel in the collage, *Une Semaine de Bonté*. The second segment, "The Girl With the Prefabricated Heart," is by Fernand Léger and features references not only to his works in film, such as *Ballet Mechnique* (1924), but also to paintings such as *La Grande Julie* (1945) made by the artist immediately after the war in 1945 in France. Part three, "Ruth, Roses and Revolvers" by Man Ray, is essentially a self-portrait of the artist, and the fourth part, *The Street Without Law*, is by Duchamp. The latter restages Duchamp's infamous *Nude Descending a Staircase* (1913), as well as extended camera shots of his "Chinese Lantern" and "Goldfish" *Rotoreliefs* (1926). Duchamp appears in the film in the character of a New York City policeman.[25] Episodes five and six are by Calder and revolve around his signature mobiles. It is interesting to note in this context that of those contributing artists both Léger and Ray had attracted Richter's attention in the 1920s as exemplary in their attempts to advance film in innovative directions. This

construction of an artist collective—many of them exiles themselves—is a significant feature of exilic cinema in which the condition of displacement and alienation serves to bring individuals together united by their relationship to the new host country.[26] Richter thereby relinquishes his individual authorship in favor of a position that would be more akin to that of an editor (figure 9.2).

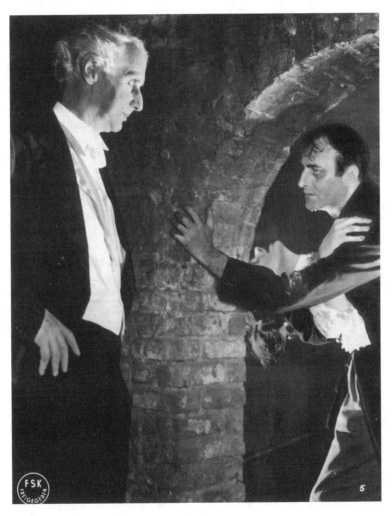

Figure 9.2 Hans Richter, *Dreams that Money Can Buy* (1947). Note fellow émigré Max Ernst on the left. Courtesy of Filmmuseum Berlin—Deutsche Kinemathek.

Richter's role in the highly collaborative *Dreams That Money Can Buy* involved scripting the overarching narrative structure and frame story, which references not only the latter's filmic works but earlier paintings by him such as *Blue Man* of 1917. The ostensible narrative concerns a business venture in which the protagonist "Joe" sets up a pseudo-psychoanalytic practice that allows its patients/clients, for a price, to have their dreams and desires realized. Thus, in the New World even the unconscious can be bought and sold. What unfolds are a series of episodes, each corresponding to the secret fantasies of prospective customers. The role of the unconscious in surrealism is of course central, and on a meta-level *Dreams That Money Can Buy* comments on what happened to that art movement when it comes to the United States as discussed in Angela Miller's contribution to this volume. On another level, the recourse to the unconscious and the realm of dreams as a structuring principle harkens back to Richter's earlier attempts to find a "universal film language"—with the unconscious replacing abstract geometric principles. Further the labile space of the dream world, like that of the myth, and its "universal appeal" serves as a site for identification and a focus around which to gather the disparate group of exile artists for whom stabile concepts of culture, practice, or nation have been eradicated. The transition from the world of the office to that of fantasies and dreams becomes a metaphorical journey or crossing that many of these artists had undergone in actuality.

The frame story also directly references Richter's personal current exile status. Joe, who propels the narrative, is a GI who finds himself treated as a foreigner upon his return from the war and as such, he stands in for Richter. Joe asks in the film, "Why do you look at me as if I was a foreigner who spoke a strange language and refuses to assimilate?" And later in an ambiguous statement that could easily refer as well to Richter leaving Europe for exile, Joe proclaims, "the invasion of Holland, May 10, 1940—I had to go and so I did." As Richter muses in his autobiography, "To leave Europe became more and more urgent and this task absorbed all my energies. My patience daily snapping and breaking, daily restored and redressed again, I felt like I was climbing a ladder leading to the sky, rungs disappearing one after the other. Five years later, I filmed such a scene in the last episode of *Dreams That Money Can Buy* without realizing that I was recounting my earlier experiences when leaving Europe."[27] Such paranoid scenarios replete with claustrophobic scenes, situations imbued with panic, fear, entrapment, pursuit and escape are all typical of exile cinema.[28] Further, the self-reflexive, fragmented, and episodic nature of the film stands in radical opposition to standard Hollywood fare of the time and exists as yet another marker of the displaced status of its various contributors.[29] In short, *Dreams That Money Can Buy* tells the story of the dislocated European intelligentsia's perception

of the United States as a place where everything, including the unconscious, had been commodified. It also relates the experiences of a very specific group of avant-garde artists who, having earlier decried the increasing instrumentalization of art, now find themselves geographically located deep within that system.[30]

IV

Richter gathers a similar cast of Dada and surrealist celebrities ten years later for *8×8 Chess Sonata*, which is divided into eight parts. Former Dadaist Huelsenbeck reminisces in his autobiography, *Memoirs of a Dada Drummer* (1969), that Richter cast him as a knight in Connecticut: "[Richter] said, 'I've got a great part for you. You'll be a knight, and—now you'll be amazed—you're going to lift Matisse's daughter or rather, granddaughter from a tree."[31] Indeed, Huelsenbeck goes on to recall that he agreed to participate in Richter's film precisely because of the number of art "stars" involved. Richter's last film, *Dadascope* also brings together a similar cast of characters. According to Richter, "*Dadascope* is not conceived of at all as chaos, but as freewheeling poetry; and as such it is in my opinion the best film-making I have done."[32] Described by Richter as an "anti-film," *Dadascope* is comprised of a collage of performances by Duchamp, Arp, Tanguy, and Huelsenbeck reading Dada texts—it is above all an anthology of Dada sounds and Dada poems. But there is more to *Dadascope* than verbal poetry, for Richter was also striving to make a visual poetry with images carefully chosen to correspond to the rhythm of the verbal text recalling his earlier visual explorations in *Two Pence: A Commercial in Picture Rhymes*. *Dadascope* replays and restages, as it were, an event nearly half a century in the past—that of Dadaism of the late 1910s. Thus, Richter and his collaborators recreate a historical moment for the camera—this journey into the past and performance of a previous identity is a typical feature of exile cinema. To that extent both *Dreams That Money Can Buy* and *Dadascope* each provide individual vignettes, "capturing" an identity that the artists in question have chosen to represent themselves with for the public. Richter's postimmigration films, in this way, illustrate Naficy's claim that accented films are often a "performance of the author's identity."[33] In this instance, "accent" is taken to its extreme with each grain of the voice producing the Dadaist sounds.

The importance of bringing back-to-life visually and audially a certain moment in history cannot be underestimated, for the significance of the prewar European avant-garde was rapidly being forgotten in the New World. While names such as Man Ray, Duchamp, Arp, Léger, Cocteau, and Ernst resonate with significance today, their art was marginalized in the

United States during the immediate postwar period. Both Dadaism and surrealism had been dismissed as minor art movements by modernist critics such as Clement Greenberg and other supporters of the New York School, who instead championed abstract expressionists such as Jackson Pollock and Willem de Kooning. As Richter notes retrospectively in an interview, the historical avant-garde of the interwar period had all but been forgotten until 1953. Indeed, 1953 marks the advent of what immediately came to be labeled Neo-Dada, practiced by a new generation of artists including Jasper Johns, Rauschenberg, Cy Twombly, and a number of others who were all in one way or another associated with Duchamp's friend, the American composer John Cage. From this perspective, Richter's postwar productions featuring a coterie of Dada and surrealist artists can be seen as attempts to redeem and revitalize crucial moments of the historical avant-garde in the cultural context of what Peter Bürger has termed the "neo-avant-garde."[34] The figures mobilized by Richter for these films do not so much self-consciously play roles as they in many ways appear self-referentially as themselves. As Richter explains his choice of cast for 8×8 Chess Sonata, "I love to work with my old crowd of friends. . . . I prefer to work with people I know rather than professional actors, people to whom I can adapt a role. I work with them in a kind of documentary way."[35] Although their works were mostly treated as curiosity pieces, the artists who starred in these films were often featured on the guest lists of prominent New York art world functions, which attest to the considerable cultural capital they commanded. Richter strategically features these characters in his films as documentary material to attract an audience that, once brought into the cinema, would then be encouraged to focus on the meaning of the films.

Needless to say, Richter is not unique in his efforts to construct a history of a period that he witnessed as an active participant. His mining of cultural memory is a characteristic trait of the exile. What is unusual, however, is the number of efforts by former Dadaists to produce a written record of the brief movement. Indeed, already in 1920 Huelsenbeck published "En avant Dada: Eine Geschichte des Dadaismus." The following year in Zurich, Tristan Tzara wrote up a chronology of Dadaism, and in France Louis Aragon outlined the basic principles of the movement. These early memoirs were succeeded by more written histories, penned by Arp, Emmy Ball-Hennings, Ernst, Germaine Everling, George Grosz, and Raoul Hausmann, to mention but a few. Richter contributed to this extensive body of literature with his 1961 *Dada Profile*, which featured portraits made between 1916 and 1920 of former Dadaists together with his accompanying notes and observations. This was followed by his well-known studies, *Dada: Art and Anti-Art* (1964), *Köpfe und Hinterköpfe* (Heads and Foreheads, 1967), *Hans Richter by Hans Richter* (1971), and *Begegnungen von Dada bis Heute.*

Briefe, Dokumente, Erinnerungen (Encounters from Dada to the Presentday: Letters, Documents, Memories, 1973). Two important points should be stressed here, for they are highly revealing of Richter's exilic condition: first, that Richter's historicizing writings all appear in the 1960s after he stops making films, and second, that they were all initially written in German, Richter's native tongue. While these texts are informative and together contribute to our general understanding of Dadaism, their substance or form does not set them apart in any significant way from the vast corpus of writings on the subject. Indeed, Richter's historical reconstruction of Dada and his own identification with it are typical of the condition of exile where identity becomes frozen in a past life and seems to stop in its development and evolution. As Thomas Elsaesser has noted the following in regard to another German émigré and filmmaker, Ernst Lubitsch: "Once arrived in the United States, Lubitsch, along with other 'name' émigrés who came to Hollywood with an international reputation, realized that for the New World, they were representative of the Old World. They found Hollywood hungering for images of a Europe fashioned out of nostalgia, class difference, and romantic fantasy . . . , [and felt] obliged to recreate and imitate a version of the world they had left behind."[36] Richter was clearly subject to this pressure to deal with his identity as part of the Old World. But he also faced the additional burden of having to distance himself from other German filmmakers in the United States such as Oskar Fischinger, Fritz Lang, Ernst Lubitsch Otto Preminger, Robert Siodmak, and Billy Wilder, and for whom commercial success was a central issue. Thus, it was Richter's overdetermined significance as a Dadaist that governed the nature of his cultural production after the war. This in part is what led him to his exceptional project of narrating and actually performing cinematographically a history of the avant-garde, and to producing films that radically departed from those being made on the West Coast.

Equally important to Richter's project of reconstituting or at least restaging the European avant-garde was his commitment to exploring the medium of film and devising new strategies of cinematic representation that would challenge the genre of feature narrative. The genre of documentary film becomes particularly significant for Richter during this period. In his seminal 1951 essay *The Film as an Original Art Form* he cites documentary as one of two genres—the other being experimental or art film—capable of challenging dominant commercial cinema.[37] However, neither form, by Richter's estimation, goes far enough. Indeed, Richter's postwar film production strives to expand the latter two genres and can best be understood as fusions of these two forms. For though they bear some affinities to the growing body of nonfiction films that focus on art and artists, the form and structure of Richter's later films cannot be said to fall either completely into

the objective truth-based documentary category or into that of the abstract art film.[38] Instead, they creatively mix fact and fiction, and blur the distinction between documentary, narrative, and experimental genres. Recall the opening credits of *Dreams That Money Can Buy*: "This is a story of dreams mixed with reality." For Richter, it was this particular brand of filmmaking that seemed most appropriate for the condition of exile that he and others of the Dada and surrealist avant-garde found themselves in during the 1940s. The external, material, physical, and geographical condition of their displacement—the "facts" as it were combined with a highly emotional subjective response that might be marked by paranoias, fantasies, and illusions as well as memories both real and imagined. The genre of the essay that encourages such free play between the poles of representation and does not operate under the pretext of producing either truth or fiction is in many ways the ideal form to be translated into exile film.[39]

In his study of the cultural production of history, Michel-Rolph Trouillot isolates four important components of the process of historical construction: "1) the moment of fact creation (the making of sources); 2) the moment of fact assembly (the making of *archives*); 3) the moment of fact retrieval (the making of narratives); and 4) the moment of retrospective significance (the making of *history* in the final instance)."[40] Richter's exile postwar films feature an archival process of this sort, as they attempt to produce a record of a historical avant-garde of an earlier era. Richter's record, however, is performed filmically rather than textually. Indeed, at one point he explicitly observes that film is inherently predisposed to the act of historical preservation: "Even to the sincere lover of the film in its present form it must seem that the film is overwhelmingly used for keeping *records* of creative achievements: of plays, actors, novels, or just plain nature."[41] And just as fictional narratives, memoirs, and autobiographies of the diaspora or migrant often lead writing in new directions and into novel forms, so too Richter pushes nonfiction film toward a new genre—the essay film—in order to produce history.[42]

In her recent study, *Writing Outside the Nation*, Azade Seyhan observes that "[t]he work of commemoration is often the only means of releasing our (hi)stories from subjugation to official or institutional regimes of forgetting. Remembering is an act of lending coherence and integrity to a history interrupted, divided, or compromised by instances of loss. We engage in history not only as agents and actors but also as narrators and storytellers."[43] What needs to be stressed then is the creative act involved in producing and remembering history with subjective interpretations that have conventionally been judged as anathema to the official historical or documentary project. It is important to recall that the German language essay emerges historically during those periods marked by crisis, rupture, and uncertainty, when representation is called into

question. Moreover, Richter's essay films in turn develops during a time of both personal and public crisis functioning as a means by which to commemorate, restore, and re-present a "history interrupted." Both the art film and the documentary would fall short of fulfilling such a mission.

Already in Basel in April 1940, when it was clear that he would have to go into exile from Europe, Richter wrote a short text, "Der Filmessay: Eine neue Form des Dokumentarfilms" (The Film Essay: A New Form of Documentary Film).[44] In this pioneering article, Richter proposes a new genre of film capable of enabling the filmmaker to make the "invisible" world of thoughts and ideas visible on the screen. Unlike the genre of documentary film that presents facts and information, the essay film produces complex thought that at times is not grounded in *reality* but can be contradictory, irrational, and fantastic. The essay film, according to Richter, no longer binds the filmmaker to the rules and parameters of the traditional documentary practice. Rather, the imagination with all of its artistic potentiality is now to be given free reign. Moreover, Richter explains that he is employing the term "essay" because it signifies a genre in between genres, one that combines documentary with experimental or artistic film. And it is precisely this formal resistance to binary categories and oppositions that is solidified by the process of exile because, according to Naficy, "border consciousness, like exilic liminality, is theoretically against binarism and duality and for a third optique, which is multiperspectival and tolerant of ambiguity, ambivalence, and chaos."[45] The third optique in this instance becomes a triple fusion of three genres: narrative, documentary, and art, thereby confirming Naficy's theory that "accented films in general derive their power not from purity and refusal but from impurity and refusion."[46]

Richter retrospectively cites his own film *Inflation* (1928) as an early example of what an essay film might look like and several sketches for cinematic projects in the 1930s and early 1940s, such as his *Super Essay Films* (1941), indicate that he has thoroughly conceptualized the genre. However, I argue, he only actualizes the genre with films such as *Dreams That Money Can Buy*, *8×8: Chess Sonata*, and *Dadascope*. For these three works endeavor both to provide a documentary record of an artistic movement and to present a new mode of aesthetic production for these artists. Each is as strongly marked by an attempt to chart the dream world of the unconscious as it is by the exilic condition. Furthermore, they all seek to organize a historical account of the aims and aspirations of Dada and surrealism. Each thereby transforms the conventional notion of the historical document, or of the archive, moving away from the written form into an audiovisual essay. For as Richter notes, "The history of the cinema, like that of society, is split into two divergent lines. As a result, the progressive cinema can no longer be identified simply with the artistic cinema . . . the history

of the progressive cinema is rather that of the European spirit trying to obtain some kind of self-consciousness and hence a tradition of its own in this art too."[47] Hence, Richter pushes artists such as Duchamp, Léger, and Ernst to think about how to realize their aesthetic production in the medium of film. His later films thus involve not only a geopolitical translation—from a European to an American context—but also the translation of media: from painting and sculpture to film. As such, these films, like his earlier abstract productions, constitute important artistic precedents for the audiovisual essays that have become prevalent in the past decade. Ironically, it took just about as long for this cultural form to enter into dominant practice as it did for Richter's abstract films to have an impact on structuralist avant-garde film of the 1950s and 1960s. As Peter Wollen has put it, "history in the arts" is achieved through "knight's moves."[48] And it is precisely this type of diagonaling, not just spatially across oceans and continents, but temporally as well, that culminates in the contemporary essay film.

Although Richter continued to paint until the end of his life, it was in his capacity as a *filmmaker* that he had the greatest impact and influence. This is particularly apparent in his development of the genres of both artistic experimental filmmaking and nonfiction film essays. Moreover, the trajectory of his films provides a glimpse of how the condition of exile fixes and solidifies a carefully and highly self-consciously constructed identity. Yet, in exile his identity was inextricably linked to his prewar career, a form of aesthetic production—Dadaism and surrealism—that was rendered quaint, "minor," by the proponents of the paradigm of modern art championed in the United States at the time. Richter, like other members of the historical avant-garde who escaped to the United States during the rise of fascism in the 1930s and early 1940s, found himself treated as European curiosities whose art was less interesting than his character and personality. As such, his highly innovative work of the postwar period was largely ignored, and his attempt to develop a new mode of filmic production—that of the essay—one that was neither feature, documentary, nor pure art, would not receive its well-deserved recognition until years after his death. It is no small irony that today many experimental filmmakers and visual artists who work in film and video proclaim themselves to be "essayists" leading it to be one of the most popular current genres in contemporary audiovisual production.

Notes

1. Hamid Naficy, *An Accented Cinema: Exilic and Diasporic Filmmaking* (Princeton: Princeton University Press, 2001), 11.
2. Ibid., 12.
3. Cleve Gray, ed., *Hans Richter by Hans Richter* (New York: Holt, Rinehart and Winston, 1971), 48.

4. Richter proclaims, "Today's capitalist film industry produces wares, protects wares and consumes wares. One can demand wares from them but not products with a true worth." He continues, "Film is therefore a commodity good, like boots or beer. As a ware then it must fall under the same production regulations as other wares. Naturally, by characterizing film as a ware or good effects its mode of production. When a boot is made, it is not worth finding a new form for each boot, rather the production can only be worthwhile if it can be produced on a mass scale with variations: yellow, black, green boots with or without buckles or buttons. The same principles apply for film. . . . As a result, film has developed in the direction that minimizes risk to the industry. One calculates according to how the instincts of the masses can be most easily satisfied, with the preconception that the majority of the public has an undeveloped sense of taste and is not ideologically aware. The result then is the excuse that 'the public wants it this way' " (Hans Richter, "Der Film—eine Ware," *Arbeiterbühne und Film*, 4 [April 1931]; rept. in *Hans Richter Film ist Rhythmus*, ed. Ulrich Gregor, special issue of *Kinemathek*, 95 [July 2003]: 69; unless otherwise noted, all translations from the original German are my own).

5. "With sound film, the commodity production of film reaches its zenith. Film is not only standardized according to national and international copyrights, it is monopolized. . . . The development of the film industry as a monopoly parallels the monopolizing developments in all industrial production. Just as oil, steel, and matches control and set prices, so too sound film corporations control and determine the taste and the standard of film consumption" (Richter, "Der Film—eine Ware," 70).

6. "If we do not want to be assimilated into the industry and do not have the intention of being satisfied with the infection of normal films with pretty pictures, then we have nothing to do with usual film production" (Hans Richter, "Der moderne Film," *Filmliga*, 6 [March 1930]; rept. in *Hans Richter Film ist Rhythmus*, 63).

7. Viking Eggeling and Hans Richter, *Universelle Sprache* (Fort in der Lausitz: Eigenverlag, 1920), n.p.

8. Ibid.

9. Hans Richter, "Film . . . ," *De Stijl*, 5 (June 1923); rept. in *Hans Richter Film ist Rhythmus*, 22.

10. For an insightful discussion of the theoretical and serial implications of Richter's work, see Brian O'Doherty, *Hans Richter* (New York: Byron Gallery, 1968).

11. "Der Gegenstand in Bewegung"; rept. in *Hans Richter Film ist Rhythmus*, 43.

12. Hans Richter, *The Struggle for the Film: Towards a Socially Responsible Cinema*, trans. Ben Brewster, ed. Jürgen Römhild (New York: St. Martin's Press, 1986), 24.

13. *Richter on Film*, a filmed interview with Cecile Starr, conducted in Southsbury, Connecticut, 1972.

14. Richter, *The Struggle for the Film*, 41.

15. Similarly, in *Ghosts Before Noon*, the objects and the people played equally significant roles as projected forms in motion. In the film's most famous sequence, Richter playfully has four bowler hats take on an uncanny life of their own.

16. Hans Richter, "Film von morgen"; rept. in *Hans Richter Film ist Rhythmus*, 56.

17. Richter, *The Struggle for the Film*, 41.
18. It should be noted that as recently as 2003 Jonas Mekas paid tribute to Richter with his nine-minute *A Visit to Hans Richter*.
19. See Peter Wollen, "The Two Avant-Gardes," *Readings and Writings: Semiotic Counter-Strategies* (New York: Verso, 1982), 92–104.
20. For a discussion of this community, see Martica Sawin, *Surrealism in Exile and the Beginning of the New York School* (Cambridge, MA: MIT Press, 1995), 176.
21. As A. L. Rees notes, Richter's later films, "such as *Dreams that Money can Buy* (1944–7)—were long undervalued as baroque indulgences . . . by contrast to the more 'materialist' abstract films of the twenties" (*The Oxford History of World Cinema: The Definitive History of Cinema Worldwide*, ed. Geoffrey Nowell-Smith [Oxford: Oxford University Press, 1996], 104).
22. For a historical overview of the film, see Stephanie Casal and Pia Lanziger, "Dreams That Money Can Buy," *Hans Richter: Malerei und Film*, ed. Hilmar Hoffman and Walter Schobert (Frankfurt A. M.: Pippert & Koch, 1989), 104–111.
23. Siegfried Kracauer, "Kunst und Film. Zu Hans Richter: Träume für Geld," *Neue Züricher Zeitung*, January 25, 1948; rept. in *Hans Richter Film ist Rhythmus*, 126.
24. Including *The Struggle for Film* in 1939, first published in 1976.
25. It is important here to recall the MoMA screening of 1941 in which Richter's *Rhythmus 21* was shown with films by Man Ray, Léger, and Duchamp.
26. As Naficy observes, these groups "signify and signify upon exile and diaspora by expressing, allegorizing, commenting upon, and critiquing the home and host societies and cultures and the deterritorialized conditions of the filmmakers. They signify and signify upon cinematic traditions by means of their artisinal and collective production modes, their aesthetics and politics of smallness and imperfection, and their narrative strategies that cross generic boundaries and undermine cinematic realism" (Naficy, *An Accented Cinema*, 4–5).
27. *Hans Richter by Hans Richter*, 48.
28. According to Naficy, "[T]he spatial aspects of the closed form in the mis-en scène consist of interior locations and closed settings, such as prisons and tight living quarters, a dark lighting scheme that creates a mood of constriction and claustrophobia, and characters who are restricted in their movements and perspective by spatial, bodily or other barriers. . . . The closed temporal form is driven by panic and fear narratives, in essence, a form of temporal claustrophobia, in which the plot centers on pursuit, entrapment, and escape" (Naficy, *An Accented Cinema*, 153).
29. Overall Naficy concludes that films produced in exile are "fragmented, multilingual, epistolary, self-reflexive, and critically juxtaposed narrative structure; amphibolic, doubled, crossed, and lost characters; subject matter and themes that involve journeying, historicity, identity, and displacement; dysphoric, euphoric, nostalgic, synaesthetic, liminal, and politicized structures of feeling; interstitial and collective modes of production; and inscription of the biographical, social, and cinematic (dis)location of the filmmakers" (Naficy, *An Accented Cinema*, 4).

30. A never fully realized semiautobiographical film project (1948–1952) immediately following *Dreams* was based on the myth of Theseus trapped in the maze with the Minotaur.
31. Richard Huelsenbeck, *Memoirs of a Dada Drummer*, trans. Joachim Neugroschel, ed. Hans J. Kleinschmidt (Berkeley: University of California Press, 1991), 109.
32. *Hans Richter by Hans Richter*, 148.
33. Naficy, *An Accented Cinema*, 6.
34. See Peter Bürger, *Theory of the Avant-Garde*, trans. Michael Shaw (Minneapolis: University of Minnesota Press, 1984).
35. *Hans Richter by Hans Richter*, 54.
36. Thomas Elsaesser, *Weimar Cinema and After: Germany's Historical Imaginary* (New York: Routledge, 2000), 372.
37. "The fact is that there are at least two film forms besides the fictional film that, less spectacular than Hollywood, are more cinematographic in the proper sense of the word," the documentary form and the experimental or art film (Hans Richter, "The Film as an Original Art Form," *Film Culture Reader*, ed. P. Adams Sitney [New York: Praeger Publishers, 1970], 17).
38. For an overview of these films, see Richard M. Barsam, *Nonfiction Film: A Critical History* (Bloomington: Indiana University, 1992), especially chapter 6.
39. Indeed, many of the filmmakers that Naficy has grouped together under the term "accented cinema" are film essayists.
40. Michel-Rolph Trouillet, *Silencing the Past: Power and the Production of History* (Boston: Beacon Press, 1995), 27.
41. Richter, "Film as an Original Art Form," 16.
42. As Azade Seyhan astutely observes, "Writers of diasporas often employ linguistic forms of loss or dislocation, such as fragments or elliptical recollections of ancestral languages, cross-lingual idioms, and mixed codes to create new definitions of community and community memory in exile" (Azade Seyhan, *Writing Outside the Nation* [Princeton: Princeton University Press, 2001], 17).
43. Ibid., 4.
44. Hans Richter, "Der Filmessay: Eine neue Form des Dokumentarfilms," *Schreiben Bilder Sprechen: Texte zum essayistischen Film*, ed. Christa Blümlinger and Constantin Wulff (Vienna: Sonderzahl, 1992), 195–198.
45. Ibid., 31.
46. Naficy, *An Accented Cinema*, 6.
47. Richter, *The Struggle for Film*, 29.
48. Wollen, "Two Avant-Gardes," 104.

SELECTED BIBLIOGRAPHY

1945–1985. Kunst in der Bundesrepublik Deutschland. Berlin: Staatliche Museen Preußischer Kulturbesitz, 1985.

Aciman, André. Ed. *Letters of Transit: Reflections on Exile, Identity, Language, and Loss.* New York: New Press, 1999.

Adorno, Theodor W. *Minima Moralia: Reflections from Damaged Life.* Trans. E. F. N. Jephcott. London: New Left Books, 1951.

Albrecht, Donald. *Designing Dreams: Modern Architecture and the Movies.* New York: Harper & Row, 1986.

Anfam, David. "The Extremes of Abstract Expressionism." *American Art in the 20th Century: Painting and Sculpture, 1913–1993.* Ed. Christos M. Joachimides and Norman Rosenthal. Munich: Prestel, 1993.

Ashton, Dore. *The New York School: A Cultural Reckoning.* New York: Viking Press, 1972.

Assmann, Jan, and Tonio Hölscher. Eds. *Kultur und Gedächtnis.* Frankfurt a. M.: Suhrkamp, 1988.

Bal, Mieke, Jonathan Crewe, and Leo Spitzer. Eds. *Acts of Memory: Cultural Recall in the Present.* Hanover: University Press of New England, 1999.

Barron, Stephanie, and Sabine Eckmann. Eds. *Exiles and Emigrés: The Flight of European Artists from Hitler.* New York: Los Angeles County Museum of Art and Harry N. Abrams, 1997.

Barsam, Richard M. *Nonfiction Film: A Critical History.* Bloomington: Indiana University, 1992.

Beckmann, Mathilde Q. *Mein Leben mit Max Beckmann.* Trans. Doris Schmidt. 2nd ed. Munich: Piper 2000.

Beckmann, Max. *Briefe.* Ed. Klaus Gallwitz, Uwe M. Schneede, and Stephan von Wiese, with Barbara Golz. 3 vols. Munich: Piper, 1993–1996.

———. *Tagebücher, 1940–1950.* Comp. Mathilde Q. Beckmann. Ed. Erhard Göpel. Munich: Albert Langen-Georg Müller, 1955.

Beckmann, Peter. *Max Beckmann: Leben und Werk.* Stuttgart: Belser, 1982.

Belgrad, Daniel. *The Culture of Spontaneity: Improvisation and the Arts in Postwar America.* Chicago: University of Chicago Press, 1998.

Belton, John. "Edgar G. Ulmer (1900 [sic]–1972)." *American Directors.* Ed. Jean-Pierre Coursodon with Pierre Sauvage. New York: McGraw-Hill, 1983. I: 339–347.

Bhabha, Homi, "Frontlines/Borderposts." *Displacements: Cultural Identities in Question.* Ed. Angelika Bammer. Bloomington: Indiana University Press, 1994. 273–275.

Bogdanovich, Peter. "Edgar G. Ulmer: An Interview." *Film Culture* 58–60 (1974). Rpt. in *Who the Devil Made It: Conversations with Legendary Film Directors*. New York: Ballantine, 1998. 558–604.

Breslin, James E. B. *Mark Rothko: A Biography*. Chicago: University of Chicago Press, 1993.

Breton, André. *Manifestoes of Surrealism*. Ann Arbor: University of Michigan Press, 1972.

Buenger, Barbara Copeland. Ed. *Max Beckmann: Self-Portrait in Words*. Chicago: University of Chicago Press, 1997.

Buhle, Mari Jo and Paul, and Dan Georgakas. Eds. *The Encyclopedia of the American Left*. New York: Oxford University Press, 1998.

Bürger, Peter. *Theory of the Avant-Garde*. Trans. Michael Shaw. Minneapolis: University of Minnesota Press, 1984. Trans. from *Die Theorie der Avantgarde*. Frankfurt a. M.: Suhrkamp, 1974.

Bywaters, Jerry. *Seventy-Five Years of Art in Dallas: The History of the Dallas Art Association and the Dallas Museum of Fine Arts*. Dallas: Dallas Museum of Fine Arts, 1978.

Caplan, Karen. *Questions of Travel: Postmodern Discourses of Displacement*. Durham: Duke University Press, 1996.

Clark, T. J. *Farewell to an Idea: Episodes from a History of Modernism*. New Haven: Yale University Press, 1999.

Cotkin, George. *Existential America*. Baltimore: Johns Hopkins University Press, 2003.

Cowley, Malcolm. *Exile's Return: A Literary Odyssey of the 1920s*. New York: Viking Press, 1951.

Czaplicka, John. Ed. *Exiles and Emigrants: A Lost Generation of Austrian Artists in America, 1920–1950*. Vienna: Österreichische Galerie, 1996.

Davis, Margaret Leslie. *Bullocks Wilshire*. Los Angeles: Balcony Press, 1996.

de Fries, Heinrich. *Karl Schneider: Bauten*. Berlin: Hübsch, 1929.

Deleuze, Gilles and Félix Guattari. *Kafka: Toward a Minor Literature*. Trans. Dana Polan. Minneapolis: University of Minnesota Press, 1986.

Denning, Michael. *The Cultural Front: The Laboring of American Culture in the Twentieth Century*. London: Verso, 1997.

Derenthal, Ludger. "Hans Richter—der Künstler als Kunsthistoriker." *Hans Richter: Malerei und Film*. Frankfurt a. M.: Pippert & Koch, 1989. 146–154.

Dervaux, Isabelle. *Surrealism USA*. Ostfildern-Ruit: Hatje Cantz, 2005.

Durozoi, Gerald. *History of the Surrealist Movement*. Trans. Alison Anderson. Chicago: University of Chicago Press, 2002.

Doss, Erika. *Benton, Pollock, and the Politics of Modernism: From Regionalism to Abstract Expressionism*. Chicago: University of Chicago Press, 1991.

———. "Catering to Consumerism: Associated American Artists and the Marketing of Modern Art, 1934–1958." *Winterthur Portfolio* 26.2/3 (Summer/Autumn 1991): 143–167.

Eggeling, Viking and Hans Richter. *Universelle Sprache*. Fort in der Lausitz: Eigenverlag, 1920.

Eggener, Keith. " 'An Amusing Lack of Logic': Surrealism and Popular Entertainment." *American Art* (Fall 1993): 30–45.

Ehrlich, Susan. Ed. *Pacific Dreams: Currents of Surrealism and Fantasy in California Art, 1934–1957*. Los Angeles: UCLA, 1995.

Elsaesser, Thomas. *Weimar Cinema and After: Germany's Historical Imaginary.* London: Routledge, 2000.

———. "Ethnicity, Authenticity, and Exile: A Counterfeit Trade? German Filmmakers in Hollywood." *Home, Exile, Homeland: Film, Media, and the Politics of Place*. Ed. Hamid Naficy. New York: Routledge, 1999. 97–124.

Ernst, Max. *Une Semaine de Bonté*. New York: Dover, 1976.

Fantastic Art, Dada, and Surrealism. New York: Museum of Modern Art, 1936.

Fermi, Laura. *Illustrious Immigrants: The Intellectual Migration from Europe, 1930–1941*. Chicago: University of Chicago Press, 1968.

Fischer, Friedrich Wilhelm. *Max Beckmann: Symbol und Weltbild. Grundriss zu einer Deutung des Gesamtwerkes*. Munich: Wilhelm Fink, 1972.

Fischer, Lucy. *Sunrise*. London: BFI, 1998.

Fishbein, Leslie. *Rebels in Bohemia: The Radicals of the Masses, 1911–1917*. Chapel Hill: University of North Carolina Press, 1982.

Flavell, M. Kay. *George Grosz: A Biography*. New Haven: Yale University Press, 1988.

———. "Barbed Encounter: A Study of the Relationship between George Grosz and Thomas Mann." *German Life and Letters* 38 (1984): 110–124.

Flusser, Vilém. *Von der Freiheit des Migranten: Einsprüche gegen Nationalismus*. Bensheim: Bollmann Verlag, 1994.

Forman, Betty Yetta. "From *The American Shadchan* [*sic*] to *Annie Hall*: The Life and Legacy of Yiddish Film in America." *The National Jewish Monthly* (November 1977): 4–13.

Forster-Hahn, Françoise. "The Ambiguous Duality between Hero and Devil: Max Beckmann Reinvents Goethe's *Faust* in His Amsterdam Exile." *Memory & Oblivion: Proceedings of the XXIXth International Congress of the History of Art held in Amsterdam, 1–7 September 1996*. Ed. Wessel Reinink and Jeroen Stumpel. Dordrecht: Kluwer Academic Publishers, 1999. 949–958.

Fort, Susan Ilene. "American Social Surrealism." *Archives of American Art Journal* 22.3 (1982): 8–20.

Franciscono, Marcel. *Walter Gropius and the Creation of the Bauhaus in Weimar*. Urbana: University of Illinois Press, 1971.

Frommhold, Erhard. Ed. *Kunst im Widerstand. Malerei, Graphik, Plastik. 1922–1945*. Dresden: Verlag der Kunst, 1968.

Gemünden, Gerd, and Anton Kaes. Eds. *New German Critique* 89 (Spring/Summer 2003). Special Issue on Film and Exile.

Glaser, Curt. *Amerika baut auf!* Berlin: Bruno Cassirer, 1932.

Goldberg, Judith N. *Laughter through Tears: The Yiddish Cinema*. Madison, NJ: Farleigh Dickinson University Press, 1982.

Göpel, Erhard and Barbara. *Max Beckmann: Katalog der Gemälde*. 2 vols. Bern: Kornfeld, 1976.

Gordon, Donald. "On the Origin of the Word 'Expressionism.'" *Journal of the Warburg and Courtauld Institutes* 29 (1966): 368–385.

Greenberg, Clement. "Modernist Painting." *Clement Greenberg: The Collected Essays and Criticism*. Ed. John O'Brian. Chicago: University of Chicago Press, 1993. IV: 85–93.

Gregor, Ulrich. Ed. *Hans Richter: Film ist Rhythmus*. Special Issue of *Kinemathek* 95 (July 2003).

Grissemann, Stefan. *Mann im Schatten: Der Filmemacher Edgar G. Ulmer*. Vienna: Szolnay, 2003.

Grosz, George. *Briefe, 1913–1959*. Ed. Herbert Knust. Reinbek bei Hamburg: Rowohlt, 1979.

———. *A Little Yes and a Big No: The Autobiography of George Grosz*. New York: The Dial Press, 1946.

Groys, Boris. *The Total Art of Stalinism: Avant-Garde, Aesthetic Dictatorship, and Beyond*. Trans. Charles Rougle. Princeton: Princeton University Press, 1992.

Guilbaut, Serge. *How New York Stole the Idea of Modern Art: Abstract Expressionism, Freedom, and the Cold War*. Chicago: University of Chicago Press, 1983.

Gunning, Tom. *The Films of Fritz Lang: Allegories of Vision and Modernity*. London: BFI, 2000.

Guratzsch, Herwig. Ed. *Max Beckmann: Zeichnungen aus dem Nachlass Mathilde Q. Beckmann*. Cologne: Wienand, 1998

Haftmann, Werner. *Verfemte Kunst: Malerei der inneren und äußeren Emigration*. Cologne: DuMont, 1986.

Hambourg, Maria Morris. *The New Vision: Photography between the World Wars*. New York: H. N. Abrams, 1989.

Heilbut, Anthony. *Exiled in Paradise: German Refugee Artists and Intellectuals in America from the 1930s to the Present*. New York: Viking Press, 1983.

Heller, Adele and Lois Rudnick. Eds. *1915: The Cultural Moment*. New Brunswick: Rutgers University Press, 1991.

Hemingway, Andrew. *Artists on the Left: American Artists and the Communist Movement, 1926–1956*. New Haven: Yale University Press, 2002.

Hess, Hans. *George Grosz*. New Haven: Yale University Press, 1974.

Hoberman, J. *Bridge of Light: Yiddish Film between Two Worlds*. New York: Museum of Modern Art/Schocken, 1991.

Hook, Sidney. *Reason, Social Myths, and Democracy*. New York: The John Day Co., 1940.

Horkheimer, Max and Theodor W. Adorno. *Dialectic of Enlightenment*. Trans. John Cumming. New York: Continuum, 1995.

Huelsenbeck, Richard. *Memoirs of a Dada Drummer*. Trans. Joachim Neugroschel. Ed. Hans J. Kleinschmidt. Berkeley: University of California Press, 1991.

Huesmann, Heinrich. *Welttheater Reinhardt*. Munich: Prestel, 1983.

Huyssen, Andreas. "The Inevitability of Nation: German Intellectuals after Unification." *October* 61 (1992): 65–73.

Isenberg, Noah. "Perennial Detour: The Cinema of Edgar G. Ulmer and the Experience of Exile." *Cinema Journal* 43.2 (Winter 2004): 3–25.

Jaeger, Roland. "Von Altona nach Los Angeles: Jakob Detlef Peters (1889–1934)." *Architektur in Hamburg. Jahrbuch 1993*. Ed. Hamburgische Architektenkammer. Hamburg: Junius Verlag 1993. 138–149.

Jaeggi, Annemarie. *Fagus: Industrial Culture from Werkbund to Bauhaus*. New York: Princeton Architectural Press, 2000.

Jaffe, Cynthia McCabe. Ed. *The Golden Door: Artist-Immigrants of America, 1876–1976*. Washington, D.C.: Smithsonian Institution Press, 1976.

Jameson, Fredric. *A Singular Modernity: Essay on the Ontology of the Present*. London: Verso, 2002.

———. *The Political Unconscious: Narrative as a Socially Symbolic Act*. Ithaca: Cornell University Press, 1981.

Janson, H. W. "Max Beckmann in America." *Magazine of Art* 44.3 (March 1951): 89–92.

———. "Benton and Wood, Champions of Regionalism." *Magazine of Art* 39 (1946): 184–186.

Johnson, Ellen H. *American Artists on Art from 1940 to 1980*. New York: Harper & Row, 1982.

Johnson, Philip. "Architecture in the Third Reich." *Hound and Horn* 7 (1933): 137–139.

Jordy, William H. "The Aftermath of the Bauhaus in America: Gropius, Mies, and Breuer." *The Intellectual Migration: Europe and America, 1930–60*. Ed. Donald Fleming and Bernard Bailyn. Cambridge, MA: Harvard University Press, 1969. 485–543.

Josephson, Matthew. *Life among the Surrealists: A Memoir*. New York: Holt, Rinehart, and Winston, 1962.

Kaes, Anton. "A Stranger in the House: Fritz Lang's *Fury* and the Cinema of Exile." *New German Critique* 89 (Spring/Summer 2003): 35–58.

———. *M*. London: BFI, 2000.

Kapczynski, Jennifer M. "Peter Lorre's *The Lost Man* and the End of Exile." *New German Critique* 89 (Spring/Summer 2003): 145–172.

Kessler, Charles S. *Max Beckmann's Triptychs*. Cambridge, MA: Harvard University Press, 1970.

Koch, Hugo. "Hamburger Ausstellungshallen-Gesellschaft." *Die gelbe Posaune der Sieben*. Hamburg, 1919.

Koch, Robert, and Eberhard Pook. Eds. *Karl Schneider: Leben und Werk*. Hamburg: Dölling and Galitz, 1992.

Koepnick, Lutz. *The Dark Mirror: German Cinema between Hitler and Hollywood*. Berkeley: University of California Press, 2002.

Kohtz, Otto. *Büroturmhäuser in Berlin*. Berlin: Zirkel, 1921.

———. *Gedanken über Architektur*. Berlin: Baumgärtel, 1909.

Krohn, Bill. "King of the B's." *Film Comment* 19.4 (July–August 1983): 60–64.

Kuspit, Donald. "Flak from the 'Radicals': The American Case against Current German Painting." *Art after Modernism. Rethinking Representation*. Ed. Brian Wallis. New York: New Museum of Contemporary Art, 1984. 137–151.

Lackner, Stephan. *Max Beckmann*. New York: Abrams, 1991.

———. *New Paintings by Max Beckmann*. Oakland: Mills College, 1950.

Lacoue-Labarthe, Philippe and Jean-Luc Nancy. "The Nazi Myth." *Critical Inquiry* 16.2 (Winter 1990): 291–312.

Landauer, Susan. *The San Francisco School of Abstract Expressionism*. Berkeley: University of California Press, 1996.

Leja, Michael. *Reframing Abstract Expressionism: Subjectivity and Painting in the 1940s*. New Haven: Yale University Press, 1993.

Leslie, Esther. *Hollywood Flatlands: Animation, Critical Theory, and the Avant-Garde*. London: Verso, 2002.

Lewis, Helena. *The Politics of Surrealism*. New York: Paragon House Publishers, 1988.

Loewy, Ernst. "Zum Paradigmenwechsel in der Exilliteraturforschung." *Zwischen den Stühlen. Essays und Autobiographisches aus 50 Jahren.* Hamburg: Europäische Verlagsanstalt, 1995. 261–274.

Mann, Golo. *The History of Germany since 1789.* Harmondsworth: Penguin, 1985.

Mattison, Robert Saltonstall. *Robert Motherwell: The Formative Years.* Ann Arbor: UMI Research Press, 1987.

Max Beckmann in Exile. New York: Solomon R. Guggenheim Museum, 1997.

McCloskey, Barbara. "Hitler and Me: George Grosz and the Experience of German Exile." *Exil: Transhistorische und transnationale Perspektiven.* Ed. Helmut Koopmann and Klaus Dieter Post. Paderborn: Mentis, 2001. 243–258.

Mehlman, Jeffrey. *Émigré New York: French Intellectuals in Wartime Manhattan, 1940–1944.* Baltimore: Johns Hopkins University Press, 2000.

Milton, Sibyl. "Is there an Exile Art or only Exiled Artists." *Exil: Literatur und die Künste nach 1933.* Bonn: Bouvier, 1990. 83–89.

Möckel, Birgit. *George Grosz in Amerika, 1932–1959.* Frankfurt a. M.: Peter Lang, 1997.

Morton, Frederic. *Thunder at Twilight: Vienna 1913/14.* New York: Da Capo, 2001.

Naficy, Hamid. *An Accented Cinema: Exilic and Diasporic Filmmaking.* Princeton: Princeton University Press, 2001.

Naremore, James. *Acting in Cinema.* Berkeley: University of California Press, 1988.

Nerdinger, Winfried. *The Architect Walter Gropius.* Berlin: Gebr. Mann, 1985.

Neugebauer, Rosamunde. "Avantgarde im Exil? Anmerkungen zum Schicksal der bildkünstlerischen Avantgarde Deutschlands nach 1933 und zum Exilwerk Richard Lindners." *Exil und Avantgarden.* Ed. Claus-Dieter Krohn. Munich: Edition Text und Kritik, 1998. 32–55.

Neutra, Richard. *Wie baut Amerika?* Stuttgart: Julius Hoffmann, 1927.

Nora, Pierre. "The Reasons for the Current Upsurge in Memory." *Transit: Europäische Revue. Tr@nsit-Virtuelles Forum* 22 (2002): n.p.

Nowell-Smith, Geoffrey. Ed. *The Oxford History of World Cinema: The Definitive History of Cinema Worldwide.* Oxford: Oxford University Press, 1996.

O'Doherty, Brian. *Hans Richter.* New York: Byron Gallery, 1968.

Oles, James. *South of the Border: Mexico in the American Imagination, 1914–1947.* Washington, D.C.: Smithsonian Institution Press, 1993.

Omasta, Michael, Brigitte Mayr, and Elisabeth Streit. Eds. *Peter Lorre: Ein Fremder im Paradies.* Vienna: Zsolnay/Kino, 2004.

Papenbrock, Martin. "Die Emigration bildender Künstler aus Deutschland 1933–1945. Eine Statistik." *Kunst + Politik: Jahrbuch der Guernica-Gesellschaft.* Ed. Jutta Held. Osnabrück: Rasch Publisher, 1999. I: 91–118.

Platt, Susan Noyes. *Art and Politics in the 1930s: Modernism, Marxism, Americanism.* New York: Midmarch Press, 1999.

Polcari, Stephen. "Ben Shahn and Postwar American Art: Shared Visions." *Common Man, Mythic Vision: The Paintings of Ben Shahn.* Ed. Susan Chevlowe. Princeton: Princeton University Press, 1998. 67–111.

———. *Abstract Expressionism and the Modern Experience.* New York: Cambridge University Press, 1991.

Purcell, Edward. *The Crisis of Democratic Theory: Scientific Naturalism and the Problem of Value.* Lexington: University Press of Kentucky, 1973.

Rathbone, Perry T. Ed. *Mississippi Panorama*. St. Louis: City Art Museum, 1950.
———. "Max Beckmann." *Bulletin of the City Art Museum of St. Louis* 23.1/2 (May 1948): 5–114.
Rentschler, Eric. *The Ministry of Illusion: Nazi Cinema and Its Afterlife*. Cambridge, MA: Harvard University Press, 1996.
Richter, Hans. *Dada Art and Anti-Art*. Trans. David Britt. New York: Thames and Hudson, 1997.
———. "Der Filmessay: Eine neue Form des Dokumentarfilms." *Schreiben Bilder Sprechen: Texte zum essayistischen Film*. Ed. Christa Blümlinger and Constatin Wulff. Vienna: Sonderzahl, 1992. 195–198.
———. *The Struggle for the Film: Towards a Socially Responsible Cinema*. Trans. Ben Brewster. Ed. Jürgen Römhild. New York: St. Martin's Press, 1986.
———. *Begegnungen von Dada bis Heute. Briefe, Dokumente, Erinnerungen*. Cologne: DuMont, 1973.
———. *Hans Richter by Hans Richter*. Ed. Cleve Gray. New York: Holt, Rinehart and Winston, 1971.
———. *Dada Profile*. Zurich: Arche Verlag, 1961.
Rodgers, Paul. "Towards a Theory/Practice of Painting: Abstract Expressionism and the Surrealist Discourse." *Artforum* 18 (March 1980): 53–61.
Rosemont, Franklin. Ed. *What Is Surrealism? Selected Writings of André Breton*. New York: Monad Press, 1978.
Rushdie, Salman. *Imaginary Homelands*. London: Granta Books, 1991.
Russell, Charles. *Poets, Prophets, and Revolutionaries: The Literary Avant-Garde from Rimbaud through Postmodernism*. New York: Oxford, 1985.
Said, Edward W. *Representations of the Intellectual*. New York: Vintage Books, 1996.
———. "Reflections on Exile." *Out There: Marginalization and Contemporary Culture*. Ed. Russell Ferguson et al. Cambridge, MA: MIT Press, 1990. 357–366.
Sandler, Irving. *Triumph of American Painting: A History of Abstract Expressionism*. New York: Harper & Row, 1970.
Sawin, Martica. *Surrealism in Exile and the Beginning of the New York School*. Cambridge, MA: MIT Press, 1995.
Schaffner, Ingrid and Lisa Jacobs. Eds. *Julien Levy: Portrait of an Art Gallery*. Cambridge, MA: MIT Press, 1998.
Schulz-Hoffmann, Carla, and Judith C. Weiss. Eds. *Max Beckmann. Retrospektive*. Munich: Prestel, 1984.
Schutze, Jim. *The Accommodation: The Politics of Race in an American City*. Secaucus, NJ: Citadel Press, 1986.
Seyhan, Azade. *Writing Outside the Nation*. Princeton: Princeton University Press, 2001.
Shapiro, David and Cecile Shapiro. Eds. *Abstract Expressionism: A Critical Record*. New York: Cambridge University Press, 1990.
Simmons, Sherwin. "Chaplin Smiles on the Wall: Berlin Dada and Wish-Images of Popular Culture." *New German Critique* 84 (Fall 2001): 3–34.
Simon, Sidney. "Concerning the Beginnings of the New York School, 1939–1943." *Art International* 11.6/7 (1967): 17–23.
Sontag, Susan. "Fascinating Fascism." *Under the Sign of the Saturn*. New York: Farrar, Straus and Giroux, 1980. 71–105.
Spieler, Reinhard. *Max Beckmann: Bildwelt und Weltbild in den Triptychen. Mit einem Beitrag von Hans Belting*. Cologne: Dumont, 1998.

Stöhr, Karl F. *Amerikanische Turmbauten*. Berlin: R. Oldenbourg, 1921.

Studlar, Gaylyn. *In the Realm of Pleasure: Von Sternberg, Dietrich, and the Masochistic Aesthetic*. New York: Columbia University Press, 1988.

Tashjian, Dickran. *A Boatload of Madmen: Surrealism and the American Avant-garde, 1920–1950*. New York: Thames and Hudson, 1995.

Taut, Bruno. *Die Stadtkrone*. Jena: Diederichs, 1919.

Topp, Leslie. "Moments in the Reception of Early Twentieth-Century German and Austrian Decorative Arts in the United States." *New Worlds: German and Austrian Art 1890–1940*. Ed. Renée Price. New York: Neue Galerie, 2001. 572–583.

Tower, Beeke Sell. Ed. *Envisioning America: Prints, Drawings, and Photographs by George Grosz and His Contemporaries, 1915–1933*. Cambridge, MA: Busch-Reisinger Museum, 1990.

Trouillet, Michel-Rolph. *Silencing the Past: Power and the Production of History*. Boston: Beacon Press, 1995.

Varnedoe, Kirk and Adam Gopnick. *High and Low: Modern Art and Popular Culture*. New York: The Museum of Modern Art, 1990.

Viertel, Salka. *The Kindness of Strangers: A Theatrical Life. Vienna, Berlin, Hollywood*. New York: Holt, Rinehart and Winston, 1969.

Walter Quirt: A Retrospective. Minneapolis: University Gallery, University of Minnnesota, 1980.

Wechsler, Jeffrey. *Surrealism and American Art, 1931–1947*. New Brunswick, NJ: Rutgers University Press, 1976.

Welzer, Harald. Ed. *Das soziale Gedächtnis. Geschichte, Erinnerung und Tradierung*. Hamburg: Hamburger Edition, 2001.

Whiting, Cecile. *Antifascism in American Art*. New Haven: Yale University Press, 1989.

Whyte, Iain Boyd. *Modernism and the Spirit of the City*. London: Routledge, 2003.

———. *Bruno Taut and the Architecture of Activism*. Cambridge: Cambridge University Press, 1982.

Wollen, Peter. *Raiding the Icebox: Reflections on Twentieth-Century Culture*. Bloomington: Indiana University Press, 1993.

———. "The Two Avant-Gardes." *Readings and Writings: Semiotic Counter-Strategies*. New York: Verso, 1982. 92–104.

Younkin, Stephen D. "Der Insider als Outsider: Die Emigration des Peter Lorre." *Peter Lorre: Portrait des Schauspielers auf der Flucht*. Ed. Felix Hofmann and Stephen D. Younkin. Munich: Belleville, 1998. 107–161.

Zlotsky, Deborah. " 'Pleasant Madness' in Hartford: The First Surrealist Exhibition in America." *Arts Magazine* 60.6 (February 1986): 55–61.

Zuschlag, Christoph. *"Entartete Kunst." Ausstellungsstrategien im Nazi-Deutschland*. Worms: Wernersche Verlagsgesellschaft, 1995.

Notes on Contributors

Nora M. Alter is Professor of German, Film and Media Studies at the University of Florida. She is affiliate faculty in the Programs in European Studies, Jewish Studies, and Woman and Gender Studies. Her teaching and research have been focused on twentieth century cultural and visual studies from a comparative perspective. She is author of *Vietnam Protest Theatre: The Television War on Stage* (1996), *Projecting History: Non-Fiction German Film* (2002), *Chris Marker* (2006) and coeditor with Lutz Koepnick of *Sound Matters: Essays on the Acoustics of Modern German Culture* (2004). She has published numerous essays on German and European Studies, Film and Media Studies, Cultural and Visual studies and Contemporary Art.

Sabine Eckmann is Director and Chief Curator at the Mildred Lane Kemper Art Museum at Washington University in St. Louis where she teaches in the department of Art History and Archeology. She is the author, coeditor, and cocurator of *Exil und Moderne* (2005), *Exiles and Emigrés: The Flight of European Artists from Hitler* (1997), which was awarded best exhibition catalogue by the Association of International Critics of Art, and *Collage und Assemblage als Neue Kunstgattungen Dadas* (1995). She is currently preparing the exhibition and catalogue *Reality Bites: Making Avant-Garde Art in Post-Wall Germany* that won the Emily Hall Tremaine exhibition award. The exhibition concentrates on artworks executed in the new Germany since the 1990s, which challenge a new relation between art and the everyday, art and "reality," or art and nonart through the use of new art forms and new uses of traditional mediums. Eckmann's research interests focus on twentieth and twenty-first century European art and visual culture with a particular emphasis on the interrelation between aesthetic practices and social and political contexts. She has published and lectured on artists such as Max Beckmann, George Grosz, André Masson, and Max Ernst, and their exilic practices, on cold war aesthetics in German and American painting of the 1980s, participatory art forms of the 1990s, and recent visualizations of trauma.

Françoise Forster-Hahn is Distinguished Teaching Professor at the University of California, Riverside. She has also taught at the University of

California Berkeley and at Georg August University, Göttingen, Germany. A former Fellow of the Deutsche Forschungsgemeinschaft and the Alexander von Humboldt Foundation and a Visiting Scholar at the Clark Art Institute in Williamstown, Massachusetts, and the Centre Allemand d'Histoire de l'Art in Paris, she has served as Chief Curator of the Stanford University Art Museum and Director of the University of California Education Abroad Program in Göttingen, Germany. Her publications include numerous essays and contributions to books and exhibition catalogues on issues of nineteenth- and twentieth-century art and culture and the role of institutions and exhibition displays in the construction of national and cultural identity. She is the Editor of *Imagining Modern German Culture: 1889–1910* (1996) and is currently preparing two books entitled *Adolph Menzel: A Career between National Empire and International Modernity* and *Max Beckmann in Kalifornien: Exil, Erinnerung und Erneuerung.*

Noah Isenberg is Associate Professor and Chair of Humanities at The New School in New York City, where he teaches modern German and Austrian literature, film, and intellectual history. He is the author of *Between Redemption and Doom: The Strains of German-Jewish Modernism* (University of Nebraska Press, 1999); the Editor and Translator of Arnold Zweig's work of 1920, *The Face of East European Jewry* (University of California Press, 2004); and is currently completing a full-scale critical study of Edgar G. Ulmer, *Perennial Detour: The Cinema of Edgar G. Ulmer* (California), writing the BFI Film Classics volume on *Detour* (British Film Institute), and editing a companion to Weimar cinema (Columbia University Press).

Lutz Koepnick is Professor of German, Film and Media Studies at Washington University in St. Louis. He is the author of *Framing Attention: Windows on Modern German Culture* (2007); *The Dark Mirror: German Cinema between Hitler and Hollywood* (2002); *Walter Benjamin and the Aesthetics of Power* (1999); and of *Nothungs Modernität: Wagners Ring und die Poesie der Politik im neunzehnten Jahrhundert* (1994). He is also the coeditor of *Sound Matters: Essays on the Acoustics of German Culture* (2004), and of *The Cosmopolitan Screen: German Cinema and the Global Imaginary* (2007).

Barbara McCloskey is Associate Professor of Art History at the University of Pittsburgh. Her research and teaching focus on issues of art, war, and exile in early twentieth-century German culture. Her publications include *George Grosz and the Communist Party: Art and Radicalism in Crisis, 1918 to 1936* (Princeton, 1997) and *Artists of World War II* (Greenwood, 2005). McCloskey is currently preparing a new book on the subject of German artists and intellectuals exiled in the United States during World War II.

Angela Miller teaches Art History at Washington University in St. Louis, with affiliations in Gender Studies, Comparative Literature, and American Studies. She has lectured and published on American landscape art, panoramas, western regionalism, and 20th century reception histories. Her research interests center on constructions of cultural nationalism, and on the politics of form in the arts. Miller's 1993 book, *Empire of the Eye: Landscape Representation and American Cultural Politics, 1825–1875*, won awards from the Smithsonian Institution and the American Studies Association. She is a lead author, along with five others, of *American Encounters: Cultural Identity and the Visual Arts from the Beginning to the Present* a comprehensive survey forthcoming with Prentice-Hall in 2007. She also served as a consultant on American art for the Mellon Foundation's ArtStor initiative to create a comprehensive digital database of the arts and visual culture. Her articles and essays have appeared in the *Oxford Art Journal*, the film quarterly *Wide Angle, American Art, New England Quarterly*, and elsewhere as well as in several edited volumes.

Renata Stih (Artist and Professor at the University of Applied Sciences, Berlin) and **Frieder Schnock** (Artist, Curator, and Lecturer at the University of Applied Sciences, Berlin) live and work in Berlin, Germany.

Selected Projects include

1992–1993 *Places of Remembrance*, memorial Berlin-Schöneberg
1994–1995 *Bus Stop*, Holocaust memorial project
1995–1997 *Image Spheres*, FHT Esslingen
1996–1997 *Neues Deutschland Bild*, Zeitgeschichtliches Zentrum Leipzig
1998 *Invitation*, Ads for Self-Help Groups Berlin-Alexanderplatz
1998 *Who Needs Art, We Need Potatoes*, Staatsgalerie Stuttgart
1999 *Hänsel and Gretel at the Reichsbank*, AA project Berlin
2001–2002 *Hand, Heart and Mouth*, Messestadt München-Riem
2003–2004 *Signs from Berlin*, The Jewish Museum New York
2004 *The Art of Collecting—Flick in Berlin*
2005 *Berlin Messages*, Museum of Art | Fort Lauderdale
2005 *Living On—Sarajevo Obituaries*, TAZ Berlin
2006 *Jewish Munich—The Map*, Kulturstiftung des Bundes / City of Munich
2007–2008 *LIFE-BOAT*, Museum of Art, Fort Lauderdale / Peabody Essex Museum, Salem

Iain Boyd Whyte is Professor of Architectural History at the University of Edinburgh. He has written extensively on architectural modernism in Germany, Austria, and the Netherlands, and his books include *Bruno Taut and the Architecture of Activism* (Cambridge University Press, 1982); *The*

Crystal Chain Letters: Architectural Fantasies by Bruno Taut and his Circle (MIT Press, 1985); *Hendrik Petrus Berlage on Style 1886–1909* (Getty Center for the History of Art and the Humanities); *Die Gläserne Kette: Eine expressionistische Korrespondenz über die Architektur der Zukunft* (Verlag Gerd Hatje, 1996); and *Modernity and the Spirit of the City* (Routledge, 2003). Beyond architecture, he has written on twentieth-century German art, Anglo-German literary relations, and on visuality as cognition. A former Fellow of the Alexander von Humboldt-Stiftung and Getty Scholar, he was cocurator of the Council of Europe exhibition *Art and Power*, shown in London, Barcelona, and Berlin in 1996–1997. He has served as a Trustee of the National Galleries of Scotland and is a Fellow of the Royal Society of Edinburgh.

INDEX